WILLIAM BIRCH

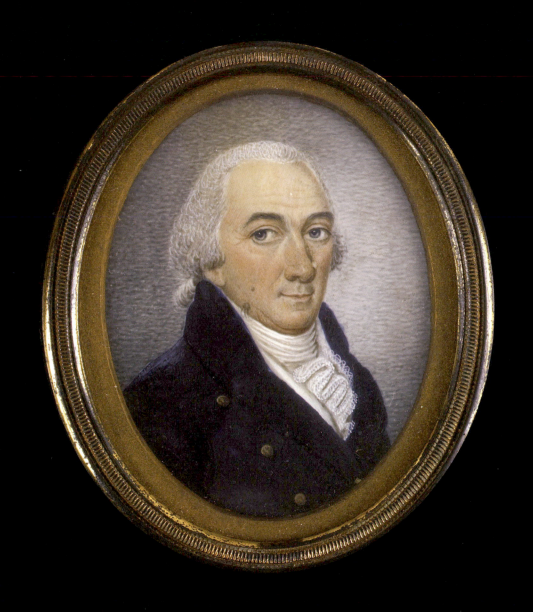

SELF PORTRAIT
BY WILLIAM BIRCH

WILLIAM BIRCH

Picturing the American Scene

Emily T. Cooperman and Lea Carson Sherk

THE ATHENÆUM OF PHILADELPHIA

PENN

UNIVERSITY OF PENNSYLVANIA PRESS

Philadelphia · Oxford

Published by
University of Pennsylvania Press
Philadelphia, Pennsylvania 19104-4112
www.upenn.edu/pennpress

Book design and composition by JUDITH STAGNITTO ABBATE / ABBATE DESIGN

Printed in the United States of America on acid-free paper
10 9 8 7 6 5 4 3 2 1

Library of Congress Cataloging-in-Publication Data
Cooperman, Emily T.
 William Birch : picturing the American scene / Emily T. Cooperman and Lea Carson
Sherk.
 p. cm.
 "The Athenæum of Philadelphia."
 Includes bibliographical references and index.
 ISBN 978-0-8122-4248-5 (hardcover : alk. paper)
 1. Birch, William Russell, 1755–1834—Criticism and interpretation. 2. United
States—In art. 3. Birch, William Russell, 1755–1834. 4. Painters—United States—
Biography. I. Sherk, Lea Carson. II. Birch, William Russell, 1755–1834. Life and
anecdotes of William Russell Birch, enamel painter. III. Title. IV. Title: Picturing the
American scene.
 ND237.B5932C66 2010
 759.13—dc22
 [B]
 2010015802

FRONTIS: FIGURE 1. William Birch, *Self-Portrait*, watercolor on ivory,
n.d. Walters Art Museum, Baltimore.

Contents

Foreword

When the English artist William Russell Birch (1755–1834) emigrated to Philadelphia in 1794, it was the largest city in North America and both the cultural center and political capital of the recently fledged United States. He arrived with a letter of introduction from Benjamin West to the wealthy merchant William Bingham, who briefly employed Birch as a drawing teacher for his daughters and probably provided access to prominent members of the informal Federal court surrounding President Washington. Birch had enjoyed modest success in London as a "painter in Enamel and Miniature" where he existed in the shadow of the artistic giants of the Royal Academy of Arts and scrabbled for patronage from the rich and famous. In Philadelphia he also found a demand for his enamel miniatures, especially copies of Gilbert Stuart's portraits, from wealthy merchants and members of the foreign diplomatic and émigré community.

Unfortunately Birch was socially insecure and enjoyed refined tastes ungoverned by the practice of domestic economy. He also aspired to be more than a copyist. Prior to his departure for America he had published *Délices de la Grande Bretagne* (London, 1791), an aesthetic survey of the British Isles containing thirty-six engravings of picturesque views after Joshua Reynolds, Benjamin West, Thomas Gainsborough, and Richard Wilson, among others, and including three of Birch's own views. Based on the favorable notice and financial success of his first effort as a printmaker and landscape artist, Birch must have had high hopes for a similar American project containing prints entirely of his own devising. By 1798 he was working with his son on what would be his greatest American success and the primary basis of his artistic legacy, a set of twenty-eight, large-format views published as *The City of Philadelphia* (1800). Unfortunately a similar project for New York City never matured; and his second American publication, *The Country Seats of the United States of North America* (1808), proved a financial failure. By the time Birch composed his autobiography, he was bitterly disappointed that Americans had failed to recognize his "genius" as an artist of the picturesque, landscape designer, and architect—nor had they extended to him the social status and financial rewards he felt were his due.

Despite the widespread popularity of Birch's views, which have been reprinted on several occasions since their first appearance in the eighteenth century, little has been known of Birch's life or work as an artist, picturesque landscape designer, and architect, due mainly to the paucity of manuscript sources. Accounts of Birch's life and career that have appeared are based largely on a fragmentary typescript of one of the manuscript drafts of Birch's autobiography. Fortunately William Russell Birch's original manuscript—the source of that typescript—and several hitherto unpublished Birch water-

colors survive in the possession of the heirs of the late Philadelphia collector Marian S. Carson. In addition, a longer and more finished manuscript draft of the autobiography, also in Birch's hand, together with a file of original correspondence to and from Birch and his family were discovered by Robert L. McNeil, Jr., and were given to The Athenæum of Philadelphia by the Barra Foundation in 2009.

At my request, the owners of the original Birch manuscripts generously agreed to lend them to The Athenæum of Philadelphia, where they could be compared and studied under controlled conditions by Emily T. Cooperman, the leading Birch scholar, and Lea Carson Sherk, who agreed to undertake the challenging task of editing Birch's drafts and merging them into a coherent whole. Both Dr. Cooperman's chapters on Birch's life and career and the complete text of the edited Birch diary are published here for the first time under an agreement between The Athenæum of Philadelphia and the University of Pennsylvania Press. The project is underwritten by income from a perpetual endowed fund at the Athenæum established by historian and preservation architect Charles E. Peterson. It gives me great pleasure to thank Dr. Cooperman and Mrs. Sherk, whose scholarship and hard work have finally given William Birch the attention he deserves, and the owners of the Birch diaries, who permitted them to be used for this project. Without the support of Sandra L. Tatman, executive director of the Athenæum, and Jo M. Joslyn, senior editor for art and architecture at the University of Pennsylvania Press, this project would not have been possible.

ROGER W. MOSS
Executive Director Emeritus
The Athenæum of Philadelphia

Preface

The work that follows is in two complementary yet distinct parts. The first part, by Emily T. Cooperman, addresses Birch's life and artistic work. Chapters 1 and 2 discuss the artist's family and professional background in England and his artistic production there. The third chapter sees him settled in the New World and follows the arc of his American career to its end around 1830. Chapters 4 and 5 look at his two American publications, the *City of Philadelphia . . . in 1800* and *The Country Seats of the United States* of 1808, and fleshes out his reflections on these important American art events.

The second part is taken up by Birch's autobiographical manuscript, edited by Lea Carson Sherk with Dr. Cooperman and annotated by Dr. Cooperman. Before now, only the version of Birch's account collected by Mrs. Sherk's mother, the late Marian S. Carson, has been available in somewhat imperfect typescript in a small number of research repositories in Philadelphia and New York City. "The Life and Anecdotes of William Russell Birch, Enamel Painter" is both an important source on this artist and a rich document of the period about the circumstances in which he found himself. It provides an emblematic story of early American cultural history and is indispensible to understanding fully Birch's life and work.

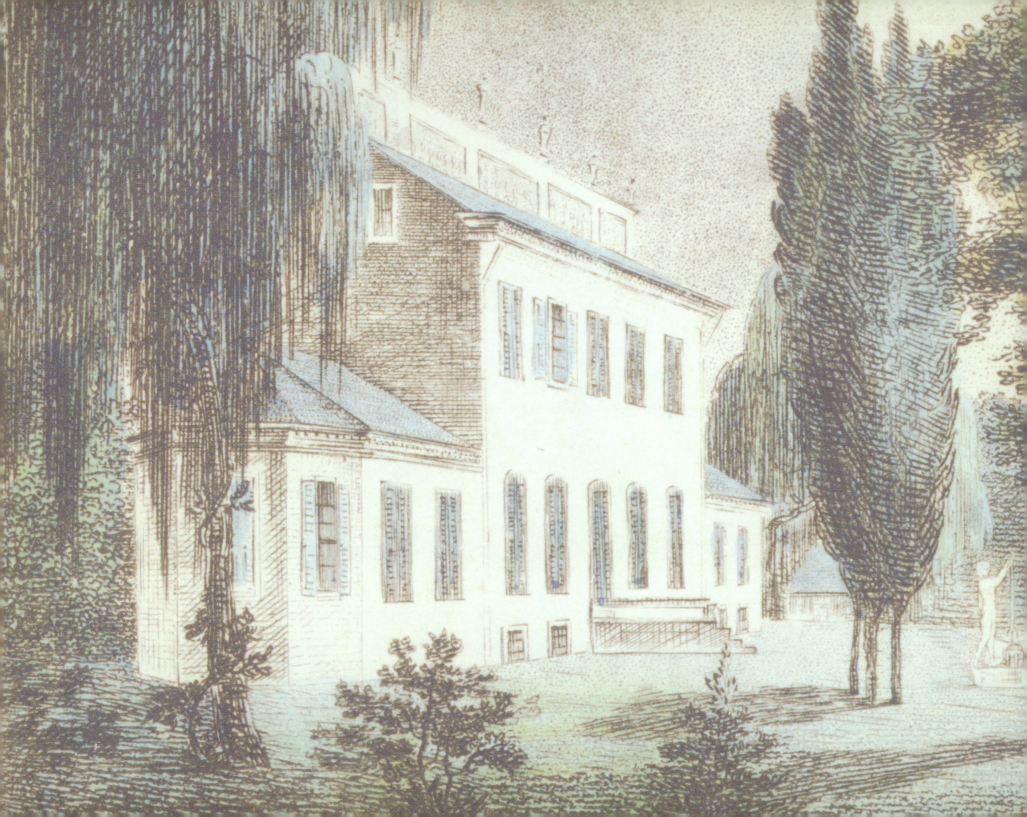

PART I

William Birch's Life and Career

Chapter 1

FRIENDS AND RELATIONS
Early Years and London Career

William Russell Birch (1755–1834; figure 1) was among the most successful landscape artists (in the contemporary senses of both image and place-maker) in the earliest years of the United States. He spent the first half of his life in England and emigrated to the American capital, Philadelphia, in 1794. His career in the United States marks key steps in the adaptation of British habits to the purposes of the creation of an American culture and demonstrates the contested social position of the artist in the early years of the republic.

Birch published the first two sets of engraved views in the United States: his *City of Philadelphia in the State of Pennsylvania as it appeared in 1800* (1800) was followed by *The Country Seats of the United States of North America* (1808). Although American landscapes had been the subjects of both paintings and prints before Birch's work, his views provide a broader, more visual understanding of American subjects than anything before them. His publications mark the beginning of an era in which landscape representation became a significant aspect of the nation's sense of itself.[1]

Birch was among a group of foreign artists and architects who arrived in the United States in the 1790s. Like him, the majority of these immigrants to the fledgling nation were Britons; most like him were drawn to Philadelphia, then the nation's capital and its largest and most affluent city. The newcomers arrived with two expectations about American patronage that led to disappointment. First, they believed that artists would be recognized in society as valued professionals, as they had come to be in Britain; moreover, they expected that artistic patronage would be seen as the welcome obligation of the upper class. Second, they anticipated that the British interest in landscape representation (and related picturesque theories) would be enthusiastically embraced by the citizens of the young country. Unfortunately, in the period before the War of 1812, when Birch produced his sets of views, Americans failed to embrace wholeheartedly either the British perception of the social role of the artist or the taste for landscape.

None of the foreign painters and architects who came to

the United States in its first decades of existence met with unqualified professional success; William Birch's experience was no exception to this. In contrast to the other landscape artists who arrived from Britain in the early national period, however, Birch had a real triumph with the publication of the *City of Philadelphia*. While many of his immigrant peers gave up and returned across the Atlantic, Birch remained in the United States until his death. He bemoaned his difficulties in his autobiography, but both his early successes and his later problems add to our understanding of the place of the artist and the arts in the early republic.

William Birch was cursed to live in interesting times, and, one might add, to be associated with interesting people. Both his friends and relations (his terms for his professional and personal connections) were not only affected by the great cultural forces and events of the later eighteenth and early nineteenth centuries, the period that saw the establishment of the United States of America, the French Revolution, and great political, religious, and economic changes in the transatlantic world. In addition, many of Birch's associates, such as Sir Joshua Reynolds, the great English painter and the first president of the Royal Academy of Arts, were among the most important figures of their time. Others, including Birch's first cousin William Russell, a Birmingham merchant, political progressive, and early Unitarian, are not as well-known, but their actions influenced, and their lives were profoundly touched by, crucial trends and events.

Warwick

William Birch was born on April 9, 1755, and spent his childhood in Warwick, then the county town and one of the principal cities of England's midlands. Birch described it as the "most regular built city in England" (p. 236); in this, he referred to its plan: a near grid, oriented cardinally. Birch would include two views of the town in his set of published views, *Délices de la Grande Bretagne*, issued in London in 1791. In his autobiography, he recalled swimming on early summer mornings during his childhood in the Avon River, which runs on the south side of the city (p. 236). He also remembered Warwick Castle (figure 2) and the dominance in the city's skyline of St. Mary's (figure 3), the principal Anglican church and the resting place of the earls of Warwick. Although originally a Norman structure, the building (and much of the city) had been rebuilt at the turn of the eighteenth century after a disastrous fire. Birch described the church as "Gothic," although it is more accurately characterized as a blend of Gothic and neo-Classical detail, with pointed-arch windows, and crockets and finials at the apex of the tower blended with round-arch niches and balustraded parapets.[2]

William was one of the youngest of a family of at least seven children of Thomas and Anne (née Russell, figure 4), both of whom had been born in Birmingham, which lies to the west of Warwick.[3] Among his siblings, he recalled his

FIGURE 2. William Birch after Abraham Pether, *View of Warwick Castle*, engraving, 1788, from the *Délices de la Grande Bretagne*, 1791. The Athenæum of Philadelphia.

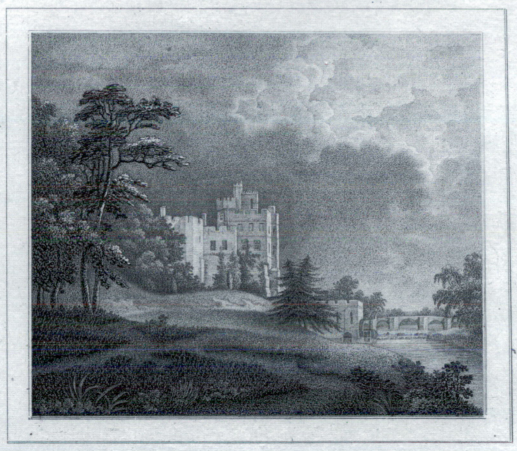

A VIEW of WARWICK CASTLE.

Painted by A. Pether, & engraved by W. Birch, Enamel Painter.

Published Dec.ʳ 11ᵗʰ 1788, by Wᵐ Birch, Hampstead Heath, & sold by T. Thornton, Southampton Strᵗ. Covᵗ. Garden.

FIGURE 3. St. Mary's, Warwick. Collection of Emily T. Cooperman.

interests of each parent affected the professional and personal aspects of Birch's early life differently. Birch's father was a medical doctor who specialized in what would be described in modern terms as obstetrics: Dr. Birch, who received his medical training in France, is described as a "man mid-wife" in the records of Reverend Thomas Chase (d. 1779), who married Birch's much older sister Ann (d. 1772) in Baltimore in 1763.[4] Birch asserted that his father (for whom he named his first son) was "ingenious" and the only physician to perform a "Caesarean operation in England in which both mother and child lived" (p. 240). Dr. Birch's local standing can be inferred from his residence at the center of Warwick on Jury Street, the main east-west thoroughfare, and from his high pew rent at nearby St. Mary's.[5]

Birch's descriptions of his father's interests, activities, and attributes relate directly to his own professional life, and particularly to the new place of the artist in British society. This eighteenth-century transformation in the perception of the artist, described simply, raised his (rarely her) social status from that of a craftsman to a level nearer that of a gentleman. Birch singles out aspects of his father's talents and interests that construct an identity directly related to a gentlemanly artist: specifically, the intellectual basis of his profession, his collecting and interest in the arts, and his aristocratic lineage. Birch thus reinforces his own identity through the implication that he came by these attributes in the most natural of ways—by inheritance. A crucial figure in Birch's London career, Sir Joshua Reynolds, had a central position in the change in the artist's social place during this time. Neil Harris has

"beloved and eldest brother Thomas, who first pinned my attachment to the arts" (p. 238). There is, however, no known direct evidence about Birch's early artistic education. There were subtle but important cultural differences between the maternal and paternal sides of his family; the background and

summarized Reynolds's role: "Sir Joshua Reynolds, polished, wealthy, traveled, befriended by royalty and patronized by the great, sat at ease with London's wits and epitomized the glories which even an English painter could attain. His example made it difficult for contemporaries to place painters on a social level with carpenters and joiners, a common charge of the previous century."[6] Birch's characterization of his father as "ingenious" placed an emphasis on Thomas's mental powers—a key idea embodied in Reynolds's *Discourses*, the lectures given to the students of the Royal Academy during his tenure as its first president. Reynolds asserted that the source of art was primarily the mind of the artist rather than his manual skill.[7] In fact, this emphasis on the role of the intellect linked artists to a larger group that have been called "market professionals," including physicians and attorneys. These professionals strove in the same period to transform the perception of their work from "goods" to "service," thereby emphasizing their mental effort and professional expertise.[8] In this way, Dr. Birch's "ingenuity" is a positive attribute with significant implications beyond mere filial admiration for his artist son: it serves as an analogue, if not as the source for Birch's own "genius," a necessary faculty, by Reynolds's definition, of the true artist.

Birch, who amassed a significant number of prints and paintings himself while he was in London, implies another parallel in recalling that among his father's worldly goods was a "valuable collection of surgical preparations." He also specifically notes that his father was "fond of the arts" and a patron of Thomas Worlidge (1700–1766), a painter and an engraver who was in nearby Birmingham in 1736 (see figure 137).

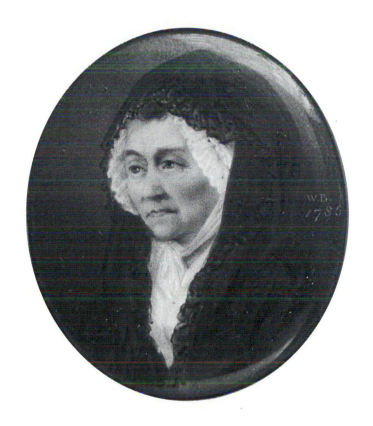

FIGURE 4. William Birch, *Anne Birch*, enamel on copper, 1785. Metropolitan Museum of Art, the Alfred N. Punnett Endowment Fund, 1928 (28.209.1).

Worlidge's best-known work includes heads drawn in pencil. Birch retained such an image of his father in "kit-cat" (a bust-length image named for Sir Godfrey Kneller's portraits of the members of the Kit-Cat Club in the first decades of the eighteenth century) in his own collection.[9] Finally, Birch asserts ancient, landed lineage for his father: "my father's ancestor, having been a captain under William the Conqueror, . . . was presented a tract of land. . . . The situation is called Oat Hill, from which is an extensive prospect of the country near Birmingham" (p. 239).

Birmingham and London

Dr. Birch worshiped (or at least paid to occupy a pew) at St. Mary's, but his family did not join him. Instead, the "brood" accompanied their mother to Warwick's Presbyterian meeting, then under the care of James Kettle (d. 1806), who may also have been a relative and was strongly influenced by Unitarianism.[10] Like Dr. Birch, his wife, Anne, was a native of Birmingham, which in the eighteenth century was a city burgeoning in population and productivity as one of the pivotal centers of the Industrial Revolution. The core of Birmingham's economy was the manufacture of "toys," a term that encompassed a wide variety of small metal objects, including buttons, in addition to children's playthings. Many factors converged in this period to create Birmingham's success, including a long tradition of metalworking, the relatively free manufacturing conditions made possible by the lack of guilds, and the growth in demand for toys. It has been argued that the role of the unusual sociological composition of the city has been overemphasized in explaining Birmingham's industrial rise, but the relatively high concentration of Dissenters and small manufacturers in this unchartered town did have a direct effect on William Birch's life.[11]

From the 1660s on, Birmingham attracted a substantial number of Nonconformists because the Clarendon Code, which banned non-Anglican worship in chartered cities, was not applicable there. William Hutton, the eighteenth-century Birmingham author and historian, described the governmental implications of living in an unchartered town: "We often behold a pompous corporation, which sounds well in history, over something like a dirty village—This is a head without a body. The very reverse is our case—We are a body without a head. For though Birmingham has undergone an amazing alteration in extension, riches and population, yet the government is nearly the same as the Saxons left it. . . . I am not able to bring upon the stage, a mayor and a group of aldermen, dressed in antique scarlet, bordered with fur, drawing a train of attendants."[12] The Acts of Toleration of 1689, which permitted a greater measure of public worship among Dissenters than had previously existed, further encouraged the growth of this sector of Birmingham's population. Moreover, despite the official strictures imposed by the Test Acts of 1673, which prohibited Dissenters from public office, the powerful position of Low Bailiff (one of the Saxon remnants to which Hutton referred) became one traditionally held by Nonconformists. Birch counted a considerable number of his relatives on his mother's side of the family in this post between the 1730s and the 1780s, based a list compiled by Hutton (see Appendix F).[13]

During the eighteenth century, a group of wealthy Quaker and Unitarian manufacturers and merchants emerged as both the Dissenting elite and the "social and political vanguard of the Birmingham bourgeoisie."[14] Birch's relatives were among the most prominent Unitarians in Birmingham in the latter half of the eighteenth century. His maternal "relations" were intimately involved in both manufacturing and mercantile commerce. Anne Birch's brother, Thomas Russell (1696–1760), was a merchant and an ironmaster—one of many owners of small workshops that formed the fabric of

Birmingham's eighteenth-century industry before the establishment of such large-scale enterprises as Matthew Boulton's famous Soho Works.

Thomas Russell's son William (1740–1818), Birch's first cousin, was a key figure in Birch's life and the head of his mother's family from Birch's adolescence on. Russell, the eldest of three sons, was a merchant who exported Birmingham and Sheffield metal goods to Russia, Spain, and the United States in partnership with his youngest brother, George.[15] As in Birch's brief discussion of his father, his descriptions of William Russell and actions reflect as much on the artist and his interests as on his cousin. And what Birch does *not* say about Russell is as significant, if not more, than what he does.

Russell first became an important influence in Birch's life during the artist's adolescence. His first five years were spent in the cottage of a nurse on West Street in Warwick, after which, Birch recounts, he returned to his parents' house. He reports being first schooled, briefly, by a "Mrs. Dodd" and was then placed in the local College of Warwick under the neglectful Reverend Dr. James Roberts, during whose tenure (1763–90) the enrollment of the school declined to two boys. By his own account, Birch's early education was "scanty." He was instructed, according to convention, in Latin, but this began even before he could read English. He managed to find schoolmates who would do his lessons for him in exchange for food, but his own writing attests to the fact that his skills were probably always more visual than verbal.[16]

William Russell arrived on the scene in the late 1760s: "seeing his aunt Birch's house full of children, [he] took me under his own protection," rescuing Birch from his mother's "partiality" to his brother Joseph. Russell took Birch back with him to Birmingham and enrolled him in school, most likely the Birmingham Free Grammar School, where Russell was governor. Birch was probably a boarding student—he described his time in Birmingham as divided between two branches of his family when he was "not at school." In addition to the Russells, Birch lodged with the family of John Humphreys, Jr., who had married Birch's maternal aunt. Birch recalled accompanying William Russell and his younger brothers Thomas and George to services: "my three cousins [were] stately men, dressed in the full costume of the day. From their amiable qualities, [they were] the pride of Birmingham [and] strictly attended their meeting house, generally on foot." He remembered himself as "a stripling half their height, clad by themselves in their own fashion" (p. 219).[17]

In the late 1760s, when Birch was in Birmingham, William Russell's household consisted of his wife, Martha Twamley, whom he had married in 1762, and two young daughters, Martha and Mary, born in 1766 and 1768, respectively. As with his father, Birch's description of Russell's character and possessions reflect gentlemanly nature and behavior; his maternal lineage thus complements his paternal pedigree. In fact, Birch's accounts of Russell's actions toward him make it clear that Russell was something of a second father for him. Birch summarized this simply as Russell's "friendly attention to his connection" (p. 238).

As with his father, Birch identifies three of Russell's gentlemanly attributes in his representations: Russell's personality, his ancestry, and his material possessions. Birch describes him as "a very extraordinary character" and "firm and cautious."

Birch quotes Sir Walter Scott's description of the character Major Ralph Bridgenorth, who appears in the 1822 novel *Peveril of the Peak*, saying of Russell that "his feelings [were] strong and deep, rather than hasty and vehement" (p. 238). Birch's comparison of his cousin to Scott's fictional character is far from capricious. In the novel, Bridgenorth is a Puritan who fought on the side of Parliament in the Civil War. Birch also notes Russell's (and therefore his own) "descent from the Roundheads" but relates that Russell was "fond of hereditary honours but from the unhappy catastrophe in the family at the time of Charles was deprived of his titles" (p. 238). This suggests that Birch believed his family to be descended from William Russell (1613–1700), the Duke of Bedford, who fought on the side of Parliament for a time in the Civil War (but subsequently fought for the king).[18]

In addition to outlining Russell's refined demeanor and his attachment to "hereditary honours" Birch also dwells on Russell's gentlemanly accoutrements, specifically his estate, Showell Green, just outside Birmingham. His admiring description of William Russell's property parallels the terms he uses for its owner, whom he describes as a "man of genuine taste." In language that reveals Birch's interests and later professional activities as a landscape artist, he locates the "handsome house upon an extensive flat of lawn." He goes on to delineate the "wide groups of shrubbery in the front, well-disposed," as well as the "kitchen garden" hidden "from the eye in the general view within these groups of shrubbery." His tour continues "at the back of the house on the same extended lawn" with "a large sheet of water embellished with gravel walks, lofty trees

and shrubs, white seats, aviaries of American birds, &c." He concludes by noting that "the whole" was "composed by" Russell "in one general effect of harmony and beauty" (p. 239).

Overall, however, the refined image that Birch paints of his cousin and his property somewhat misdirects his reader and either omits or understates certain facts about his life. While William Russell may have been "fond of hereditary honours" and his demeanor and estate may have been gentlemanly, he was a merchant, a Dissenter, and an active political and social reformer. Birch does note Russell's "public spirit and zeal" and his "dissenting principle," but is noticeably reticent about the source of his income.

There was a strong and longstanding connection between religious nonconformity and radical politics in England, at least in part because Dissenters' positions outside the established church left them in opposition as well to the state's political center. The Russells had been political radicals since the time of the Roundheads, and William Russell followed in these footsteps. He was a committed reformer who was active in the effort to repeal the Test and Corporation acts. His most important associate in this was Joseph Priestley (1733–1804), arguably best remembered as a scientist today, although Priestley's vocation was in the clergy. Russell joined Priestley's Unitarian New Meeting in Birmingham after the pastor had assumed his post in 1780 and became one of his greatest supporters in the congregation. While Priestley's arrival and Russell's most public political activities occurred after Birch's departure from Birmingham, Russell nurtured Whig leanings and Whig associations in the capital as well,

which may have been of benefit to Birch in establishing connections there.

All told, Birch's time in Birmingham was relatively brief, although his mother apparently wished it to be lengthy: she arranged for Birch to be apprenticed to a button maker there, presumably to seal his fate as a "toy" manufacturer in the city. Russell again came to Birch's rescue, arranging for Birch to be placed with Thomas Jefferys in London (whom Birch described as "in some shape related to us"), a jeweler whose firm would later hold the appointment of goldsmith to the king (p. 193).[19] Russell's likely intention was that Birch would eventually become Jefferys's business partner. Jefferys had established his business in Cockspur Street near Charing Cross by 1765. Birch was in London and presumably in his employ by December 1771, when he was sixteen.[20] His sister Sarah had preceded him in London (at a milliner's) by at least a half a year.[21] A German visitor in 1786 was struck by the opulence of Jefferys's showroom, which was "all illuminated, and from this room, full of sparkling gold and silver moulds and vessels, with two of its walls lined with large mirrors, there is a magnificent view into two brightly lit streets."[22]

In addition to "moulds and vessels" Jefferys sold a range of objects made of precious metals typical for the period, including flatware, buckles, and other "toys," as well as fine dress fabrics.[23] Jefferys's shop also offered small enameled objects, such as snuffboxes and watches, which Birch noted accurately as being "much in fashion" in the eighteenth century. Birch does not say so (because to do so would be to dwell on the workmanlike craft and not the intellectual foundation of his

art), but he was to learn the fundamentals of fine metalworking and enameling at Jefferys's shop during the early years of his apprenticeship. It is not known whether Birch learned anything of these in Birmingham before his departure for London.[24]

"William Birch, Enamel Painter"

After a few years of Birch's service with Jefferys, the master fell gravely ill and believed himself about to die. He made a business offer to Birch: "'I am now most likely on my death bed. I have no one I can trust but yourself. If you will turn your mind to my business I will give you a share of it and your cousin William Russell will find you everything else you want to set you up'" (p. 193). Birch had a different vision of his future, however, which he had already intimated to Jefferys—he was "fixed upon the arts" and not on trade. And, it seems, he had already formulated a plan to which Jefferys agreed and which Birch carried out once the jeweler recovered from his illness. He had worked out an arrangement whereby he associated himself with the accomplished miniature painter Henry Spicer (1743?–1804), whom Birch described as "the first enamel painter in London" (p. 194), to further his artistic skills.[25] Jefferys agreed to send Spicer (and Birch) his orders for decorative enamel painting. Thus, Birch had arranged for Spicer to receive work orders from a prominent merchant, for Jefferys to have fine enamel work, and for the furthering of his own artistic education.

Miniature painting, an art that began its decline with the popularization of photography in the mid-nineteenth century, was a valued specialization in Birch's period, as the success of such artists as Richard Cosway (1740–1821) demonstrates. Horace Walpole devoted a portion of his *Anecdotes of Painting in England* to "Painters in Enamel and Miniature" in the same section of his four-volume work that addressed sculptors ("statuaries").[26] Artists who worked at this small scale often specialized in one of the two predominant media: watercolor on ivory or enamel on metal (copper or gold). Oils were less commonly used. Portraits were the most common subjects for miniaturists, as they were in larger paintings, but the rise of other genres and interest in other subjects in British art in the eighteenth century brought a diversity of images to small format paintings, including landscape views and mythological themes, both of which Birch would later produce. The Swiss artist Jean Petitot (1607–91), whom Birch cites as an important figure in this specialty in his autobiography (p. 169), introduced enamel as a medium for miniature painting into England in the mid-seventeenth century. It was not until the mid-eighteenth century that portraits in enamel reached the upper echelons of the artistic hierarchy in Britain, and many of the enamelists who first distinguished themselves began as (and continued to work as) decorators of the sort of small, precious objects that Thomas Jefferys sold. Birch appropriately singles out several leading enamelists in the period in his autobiography, most of whom were members of the Royal Academy of Arts. These include Swiss-born George Moser (1706–83), first Keeper and an original member of the Royal Academy, who began his English career as a decorator of watches and bracelets; Jeremiah Meyer (1735–89), a German immigrant who was named enamel painter to the king in 1764; Christian Fredericke Zincke (1683/4–1767), a Dresden native who was Meyer's teacher; Gervase Spencer (d. 1763), Henry Spicer's teacher; and Henry Bone (1755–1834) (p. 172).[27]

Henry Spicer, a Norfolk native based in London from the 1760s, worked both on ivory and in enamel. It is not certain how long Birch worked with him, although Birch remarks that he did "tolerably well" (p. 194). It seems likely that Spicer either fostered or furthered Birch's skills with the pencil and with watercolors as well as with enamels. As part of his training, either with Spicer or in Jefferys's workshop, Birch learned how to graph an existing full-scale image—perhaps using an optical device such as a camera lucida or obscura or by direct measurement—for reproduction in miniature, a skill that would be crucial to both his enamel and printmaking throughout the rest of his career. The most direct surviving evidence for this practice is a preparatory drawing Birch made circa 1824 of Ary Scheffer's (1795–1859) portrait of the Marquis de Lafayette for a miniature enamel (figure 5).

Enamel painting in Birch's period was dependent on fundamental techniques developed in France in the mid-seventeenth century that made cloisonné (the small metal divisions between colors) unnecessary and thus allowed for a more "painterly" style. The support for the painting was a metal plate, either copper or gold, cut to the desired shape and rid of oils and other surface impurities by an acid and water bath. The

basis of the enamels themselves was (and still is) "flux" or "frit": the raw enamel glass (flint, sand, or lead) mixed with a variety of minerals and melted. After this first step, the clear frit was then mixed and sometimes remelted with mineral agents to lend color and opacity, ground, and remixed with a volatile oil to make paint. Birch described this process by explaining that the enamel colors are "made of Metallic substances, soluted, calcined and composed with glassy substances, commonly called flux" (p. 169).

To begin the miniature, several underlayers of white enamel were fired onto the surface, much as a white ground might be prepared on a canvas. Then a small sable paintbrush was used to apply the enamel mixtures. Achieving the desired result in enameling in the period was dependent on several variables beyond the miniaturist's essential painting skills: the ingredients in the enamels, their proportions, and the temperature at which they were fired. The formulas for mixing the enamels themselves were the subject of a great deal of experimentation and innovation in the eighteenth century in Britain; as Birch remarks, there were "no regular scientific principles laid down for this Art" (p. 169). He also noted the significance of the proportions of the ingredients: "the colours that are produced by one and the same compound will come from the fire very different in their seperate preparations, from the delicacy of chymical practice" (p. 169).

During the eighteenth century, enamelists developed new colors and refinements of technique and often jealously guarded the secrets of their innovations. To encourage the interchange of information, the Royal Society for the En-

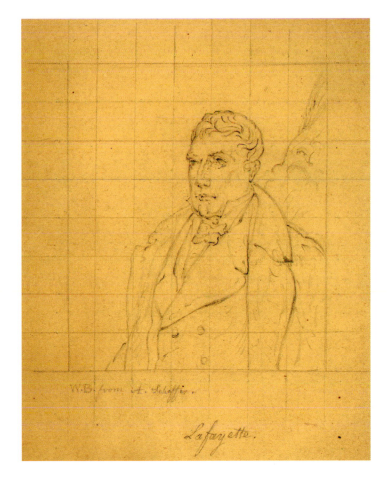

FIGURE 5. William Birch after Ary Scheffer, *Preparatory Sketch for Portrait of the Marquis de Lafayette with Graph*, ca. 1824. Marian S. Carson Collection.

couragement of the Arts, Manufactures and Commerce (conventionally known as the Royal Society of Arts) in London offered prizes for the development of new colors. Birch was awarded an "honorary pallet" from this organization in 1784 for his own new formula for a brown tint, demonstrating his own participation in this experimentation (p. 171). He also claimed another technical innovation: the introduction of a

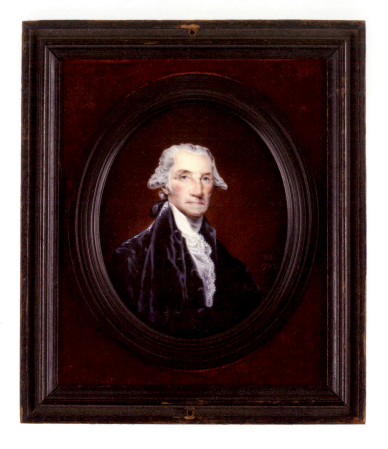

ies of a painting by Jacob van Ruisdael from own collection well into the 1820s (Appendix G), and the majority of his surviving enamels in the United States are copies of one or more of Gilbert Stuart's "Vaughan"-type portraits of George Washington, which Birch began to produce in the 1790s after he arrived in Philadelphia (figure 6).[28] Birch's technical proficiency was key to his work as a "copyist," as he terms himself in his autobiography. Although Birch created a substantial number of original enamels throughout his career on both sides of the Atlantic and, more significantly, despite his important and successful work as a landscape artist (both as image- and place-maker), Birch continued to identify himself and to be identified by others as an enamelist and a copyist throughout the rest of his life. He demonstrates this self-identification by the title of his autobiography ("The Life and Anecdotes of William Russell Birch, Enamel Painter").

Birch's status as a "copyist" enamel artist was, however, somewhat problematic for him. This difficulty arose from a duality he enunciates in a single sentence in his autobiography. He asserts that enameling "is now become a serious object in the Arts," but then qualifies this by noting that its purpose is "more as mechinical imitation for the preservation of Colouring th[a]n the study of painting" (p. 169). This dual identity of enamel painting as both "serious object" and "mechinical imitation" suggests Birch's own ambivalence toward enameling, which provided his livelihood and connections to the upper classes and yet kept him in a position secondary to all who created original work. Early in his autobiography, he notes that "the little applause the copyist will gain will serve him for

layer of yellow under the final underlayer of white to approximate the look of aging oil paint and varnish in the work of the "former masters."

Both his ability to replicate others' work in miniature and his technical innovations in re-creating the impression of aging oils in "old master" paintings (this itself a new taste in the eighteenth century) were important tools for Birch. For example, he would continue to produce and sell enamel cop-

handing down the merits of his master, after the original pictures have faded" (p. 179). The meager recognition for those who (like Birch) replicated others' work was due to a fundamental aspect of Reynolds's teaching as it was developed in his *Discourses* given before the Royal Academy: the intellectual basis for art. The work of the copyist, however proficient and technically adept, lacked the fundamental creative genius of the original.

Despite this duality, the habits and practices of the miniature enamelist remained with Birch the rest of his life. Enamel painting continued to be an important source of income for him, and he always worked at a relatively small scale. His practices as a "copyist," however problematic for his identity as a "true" artist, led directly to his career as a printmaker and thus contributed crucially to his work as a significant landscape artist. Printmaking and enameling as Birch learned and practiced them were allied techniques. It was a conventional procedure in the period to use a transfer print from an engraved plate as the basis for a painted enamel image, particularly for the reproduction of the sort of decoration used on watches, small boxes, and similar, precious decorative objects sold by Jefferys and others. Thus, Birch undoubtedly learned this technique in his apprenticeship and used it for the rest of his career.

Birch's association with Spicer had certainly ended by 1777, when his tutor relocated to Dublin. But before Spicer's departure, in 1775, Birch first exhibited his work publicly: he showed *Head of Psyche* and *Jupiter and Juno* at the Society of Artists and listed himself as an "enamel painter," giving Spicer's address—11 Henrietta Street, Covent Garden—as his own.[29]

Birch also left Thomas Jefferys in the late 1770s, serving by his account six years and one month of his seven-year contract. Birch was still in Jefferys's employ for a time after the arrival of William Jones, whom Jefferys took on as a partner between 1777 and 1779.[30]

On February 27, 1775, at the age of twenty, Birch married Mary Child (b. 1756) at St. Luke's Church in Chelsea. The following July their first child, Priscilla, was born and baptized at the church of St. Martin-in-the-Fields. In July 1779, Thomas, who would later follow in his father's artistic footsteps as a landscape painter, arrived, then daughter Deborah in May 1781. To these offspring were added son George in the spring of 1783 and daughter Louisa, baptized in Birmingham in 1785, and finally Albina, born in 1786.[31] Birch found it difficult at first to support his new family, admitting in his autobiography that he fell into debt. He was even forced to seek permission from his cousin William Russell, as head of the family, to sell part of his inheritance (p. 238). His career in London, however, soon began to flourish.

"FRIENDS" IN LONDON

Birch had begun to establish a reputation among the London aristocracy soon after he ceased to work with Henry Spicer: his fateful first meeting with William Murray, the first Earl of Mansfield (figure 7; 1705–93), took place in his house in Great Russell Street, Bloomsbury, which was destroyed by mob violence in the Gordon Riots in 1780.[32] Before then,

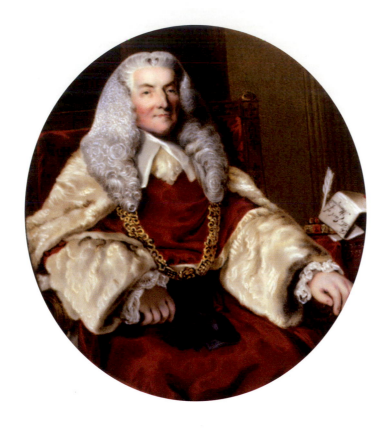

Birch came to meet Murray and show him his work through his acquaintance with Frederick Ponsonby (1758–1844), then Viscount Duncannon, an amateur painter whose work Birch would reproduce in the *Délices*. Birch recounts that he "was one morning looking at some pictures purchased by Lord Duncannon at his father's house in Cavendish Square." Duncannon informed Birch that Lord Mansfield "wanted his picture in enamel" and suggested that Birch go and present himself, which Birch did, thus beginning one of the most important associations for his London career (p. 182). It is not

known how Birch came to be sufficiently familiar with Duncannon to come to be looking at his "pictures"; neither is there evidence for Duncannon's initial acquaintance with Birch's artistic abilities. This anecdote, however, indicates that before 1780 Birch had already established a reputation sufficient for one aristocrat to recommend him to another.

After his apprenticeship, three men whom Birch described as his friends were particularly important to him both socially and professionally (these were, in fact, intimately intertwined) in London: Murray, Sir Joshua Reynolds, and the antiquarian and collector Nathaniel Chauncey (1716/17–90; see figure 104). Birch meant a good deal more by "friend" than a simple social companion, and what he did mean has not been fully understood by those who have written about his life, construing it in a modern (and informal) sense.[33] An incident connected to both Reynolds and Chauncey illuminates the meaning of the term for Birch: "Sir Joshua took every opportunity to serve me. My friend Mr. Chauncey told him I was poor, and that was nothing new. . . . [He replied that] he 'never knew a man that had more friends than Mr. Birch has, and such that would be happy to serve him. If Mr. Birch will intimate his wants on paper I will head a list myself and collect as much money for him as he wants'" (p. 189). Rather than a relationship of equals, a "friend" for Birch was closer to a patron, and both terms were related to career. He allies the two in referring to the Earl of Mansfield as both "friend and patron."

These three men—Reynolds, Chauncey, and lord Mansfield—aided Birch in different and crucial ways. How or precisely when Birch first came to know both Chauncey and

Reynolds is unknown. Birch recorded his first commission for Chauncey and his first enamel after a painting by Reynolds in the same year—1783. Birch claims to have introduced these two men (p. 178). The introduction cannot be corroborated, but it is certainly plausible given the date of Reynolds's portrait of Chauncey (1784).[34] Both men remained significant in Birch's life until they died, Chauncey in 1790 and Reynolds in 1792.

Reynolds, "Father of the English School"

Sir Joshua Reynolds was by far the most significant person in the art world of eighteenth-century Britain. Birch's opening description of him in his autobiography gives some sense of this: "Sir Joshua was understood to be the father of the English School of Painting. He brought forward the Old Masters of Painting which had been but little understood before in England; he lectured upon them, and with his own talents and the assistance of a few others, has brought the English School to a rivalship with the first of the Masters; his merit can never be forgot" (p. 172). As already noted, Reynolds's theories on art and the artist (particularly as they were expounded in his *Discourses*) were enormously influential for Birch, as they were for many others.

Although the underlying argument of Reynolds's *Discourses* accorded Birch only a secondary status as a replicator, his connection to Reynolds was significant because of his status in the London artistic world. Birch includes a detailed list in his autobiography of the Reynolds portraits he copied between 1783 and 1794, while including no direct reference to his original enamels. Birch's initial characterization of enameling as the "mechinical imitation for the preservation of Colouring" is later amplified by its role in "handing down the merits of his Master, after the original picture has faded." Here, and in his remark about its role in "preserveing the beauty of tints to futurity, as given in the Works of the most celabrated Masters of Painting, without a possibility of there changing," Birch alludes to the significance of his work in preserving the colors of Reynolds's paintings specifically (pp. 172, 179).

Just as enamelists tested different mineral additives to achieve new colors, Reynolds experimented with paints extensively, and the instability of his pigments was notorious even in his lifetime. Horace Walpole remarked in 1775, for example, that "Sir Joshua Reynolds is a great painter; but unfortunately, his colours seldom stand longer than crayons."[35] In his autobiography, Birch claims an important role for his enamels in recording the original state of Reynolds's paintings: "his colouring [was] a full portion of his merit, pride and delight in which he excelled, yet too much from the use of Meterials he knew himself would soon rob his Pictures of their beauty but could not leave his practice with them." He then states that "there was no other Pencel in Enamel that reserved his tints before they had faded then that of my own" (p. 172).

In another passage, he amplifies his assertion by describing his work's direct benefit to Reynolds: "how fortunate was it then for me that I was in full practice in the height of his day, and so much favoured of him as to suppose that I might also be useful to him by handing down to futurity those clear

tints and that brilliancy of colouring which he always suspected would leave his pictures but knew could never leave my enamels" (p. 179).

Birch's efforts to replicate Reynolds's colors accurately were directly related to his 1784 award from the Royal Society of Arts: "in my immatations . . . I found a want of a deep brown to throw out the force of his effects. . . . I applied myself to the Furnace . . . [and] in the course of about a Month fortunately produced an Enamel Colour pure and to the full tint of [Van Dyck] brown which gave me infinitely the advantage of copying this master" (p. 171). When interviewed by the society's Committee on Polite Arts, the members concluded that "Mr. Birch's specimens of painting in Enamel in imitation of Oil painting, possess considerable Merit, and are deserving of the Encouragement of the Society." They awarded him a "Greater Silver Pallet."[36]

Although Birch described himself in his autobiography as a "copyist only," he substantially raised the status of his specialty within the Royal Academy. Further, despite his statement of copying as "mechinical imitation," his writing elsewhere makes it clear that he believed that the work of the replicator was not necessary purely mechanical and that the enamelist's work could have elements of artistic genius. He relates that "there was a law in the Royal Academy that opposed the art of enamel painting, which was that all copies should be rejected in the exhibition." Birch argued to Reynolds that "there ought to be an exception" for "good copies in enamel, from their superior durability and beauty . . . as the art was principally calculated for copying and useful in preserving colouring that

might be lost." Birch reminded Reynolds that in "the cabinets of Europe . . . they considered their enamels to be a choice part of their relics, and . . . the best of them were . . . copies" (p. 188). Reynolds was persuaded and had the regulations changed. Birch exhibited every year at the Academy from 1781 until he emigrated in 1794. Many of these were certainly copies after Reynolds.[37]

In several passages in his autobiography, Birch suggests that enameling could come close to original painting as a true artistic practice. In his introit on the general subject of his technique, Birch describes the goal of the "study of the Art [of enameling]" as "a pure harmonious bloom . . . a word so often quoted by the Poet whoe wishes to express beauty and perfection in his poem," thereby allying the medium with the "sister art" of poetry, as Reynolds did for painting more generally (as others had before). He more strongly suggests his own status as a true artist in the next paragraph, where he says that "the beauty of Enamel Painting after this depends upon the genius of the mind and the powers of the Painter" (p. 170).

Birch was not a member of the academy, however, and while he described Reynolds as "the master he studied under," it is not known whether he ever received any instruction in its schools. Birch relates that Reynolds "told me I might take his pictures even from the easel if dry or [in] any other part of the house I found them, for the purpose of copying without asking his leave and keep them as long as I would" (p. 179). A contemporary source indicates that Birch was one of a group of artists who enjoyed this sort of access. James Northcote, Reynolds's pupil and best-known contemporary biographer,

described the generosity of the Academy's first president to younger artists: "Sir Joshua was exceedingly willing at all times to lend pictures, prints, drawings, or any thing in his possession, particularly to young artists; . . . I do not think he ever denied any one who asked; he also readily gave his advice to all those who came to seek it, and they were frequently very numerous."[38] Elsewhere in his biography, Northcote relates an anecdote about Reynolds's generosity to the miniature painter Ozias Humphreys, to whom Reynolds loaned a painting by van Dyck to copy, then insisted on buying the copy at an elevated price. Like Humphreys, Birch was allowed to copy Reynolds's work as he wished and undoubtedly Reynolds was equally kind to him.[39]

Birch was also among a group of engravers who made prints after Reynolds's paintings. In his autobiography, Birch presents these reproductions as another important means of preserving Reynolds's artistic legacy, saying that "his merit can never be forgot, from the number of fine Plates engraved from his works, by the hand of the Celebrated [Francis] Haward and Others" (p. 172). He made at least four prints after Reynolds: two after landscape paintings, one after Reynolds's 1773 self-portrait in doctoral robes, and a 1787 engraving of the 1783–84 portrait of Mrs. Mary Robinson (1758–1800, née Darby), an actress and mistress of the Prince of Wales. Birch describes this last, which he titled *Contemplation*, as "Mrs. [Robinson] by the seaside, from Sir Joshua Reynolds, highly finished," and noted that "Sir Joshua Reynolds told me he would never wish his work better engraved" (p. 177). Birch had copied the painting in 1784 in enamel miniature, identifying it in his autobiography as "Mrs. Robinson by Sea Side."

Birch also described the painting and his miniature: "this picture, though never finished in the ground and drapery, was the best specimen of Sir Joshua's flesh tints. I took the greatest pains with it, and was most successful in it of any of my works. I showed it to Mrs. [Robinson] . . . and afterwards to the Prince of Wales, later George the 4th, who expressed a wish to have it, but it was then sold" (p. 244). The two other prints that Birch produced after Reynolds were landscape images that he included in his first published set of views, *Délices de la Grande Bretagne*, completed in London in 1791. The first was a view from Reynolds's country house on the Thames, Richmond Hill, of 1784, engraved in 1788 (figure 8).[40] In another print, Birch combined a landscape sketch by Reynolds with a drawing by another hand of Conway Castle in Wales as the final plate for the *Délices* (see figure 102).[41] Birch recounts Reynolds as remarking, when Birch retrieved the oil from Reynolds's "garret," that "'that is my painting . . . but I do not know that it is a view. But you may take it and do what you will with it'" (p. 174). Landscape paintings are very rare in Reynolds's oeuvre, since he was primarily a portraitist, the dominant genre of his generation. *View from Richmond Hill* had personal significance for the artist, but it was not critically well received and marks a very brief foray into the picturesque.[42]

Birch's engravings of Reynolds's *View from Richmond Hill* and his other landscape sketch associated Reynolds with Birch's publication, but they also indicate a fundamental, generational parting of the ways. Birch, unlike Reynolds, was keenly interested in landscape representation and the picturesque. Birch's three sets of engraved views and his American

FIGURE 8. William Birch after
Joshua Reynolds, *View from
Sir Joshua Reynolds's House
Richmond Hill*, engraving,
1788, from the *Délices de la
Grande Bretagne*, 1791. The
Athenæum of Philadelphia.

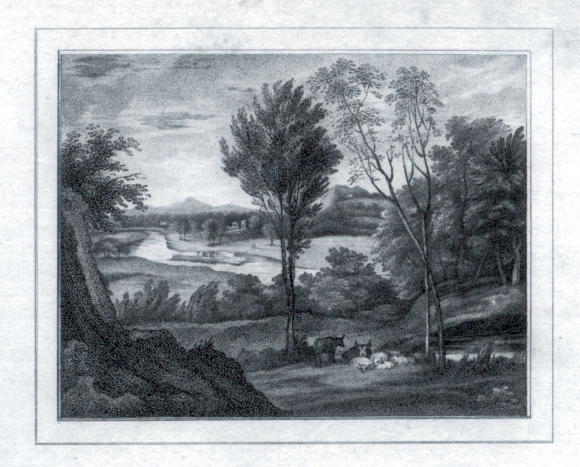

VIEW from SIR JOSHUA REYNOLDS's House RICHMOND HILL.

Painted by himself & Engraved by W.ᵐ Birch, Enamel Painter.

Published July 1. 1788 by W.ᵐ Birch, Hampstead Heath & sold by T. Thornton, Southampton Str.ᵗ Cov.ᵗ Garden.

garden and house designs demonstrate that he aspired to more than copying Reynolds's paintings at a miniature scale, despite his emphasis on this professional identity in his autobiography.

Reynolds's professional work and theories were enormously important for Birch, as they were for most British artists during the period, but Reynolds's personal conduct was equally so. In his exploration of the social aspects of Reynolds's life and career, Richard Wendorf defines his "art of pleasing" as an important aspect of Reynolds's behavior and which in no small measure contributed to the change in the social status of the artist that Reynolds affected.[43] Wendorf points to a 1713 essay by Addison published in the *Guardian*, which defined the concept of "complaisance" (the act of pleasing others) as a kind of social lubricant that "renders a Superior amiable, an Equal agreeable, and an Inferior acceptable," and as an essential attribute of a gentleman. As Wendorf notes, "from the point of view of a young painter born into a provincial family of modest means and few social pretensions, complaisance provided a blueprint for making an 'Inferior acceptable' to his superiors."[44] It also provided one of the few means by which an artist could be accepted as a gentleman. While Wendorf's account refers to Reynolds, the description of the "young painter" could also be applied to Birch, whose Warwickshire beginnings were both provincial and modest in contrast to the pedigree of those with whom he aspired to mix in London. Birch's social contribution as an artist in elite company is explicit in an anecdote included in his autobiography. While eating dinner with Sir John (Admiral) and Lady Lindsay and Lord Howe, a Hogarth sketch portrait of the Earl

of Mansfield is produced for Birch's perusal as the "artist in company." Birch dutifully gives his approval (p. 184).[45]

Nathaniel Chauncey and the Artist-Gentleman

Birch's "complaisance" is most amply demonstrated in his relationship with Nathaniel Chauncey, an antiquarian and collector. Chauncey purchased more of Birch's enamels of Reynolds's portraits than any other patron and was a subscriber to the *Délices*, which appeared in 1791, the year following his death. Birch characterizes his relationship with Chauncey by a tale that begins by describing both his place in his patron's regular routine and Chauncey's interest in providing for his needs. Birch recounts that he would "meet him, by his own appointment, at four o'clock every Wednesday in the year . . . over a table, smoking." Birch was accommodated "with luxuries prepared more for the indulgence of my appetite than his own, for often he would make his dinner of the liver of a fowl. The anecdotes of the day would whet the appetite during the repast." The "anecdotes of the day" play a key role in this scene as an accompaniment to the physical meal. Birch is not specific about *whose* tales are noted here, but one suspects that his whetted Chauncey's appetite more than the other way around (p. 178).

The same give-and-take was probably in operation after the meal, when the conversation turned specifically to art. While Chauncey certainly broadened Birch's knowledge of both individual works and artists, it may be inferred that Birch's opinions and observations as an artist were key parts

of this exchange. After "the gratification of bodily refreshment" was complete, "dessert consisted of the refreshment of the mind," which was "the pleasures of perusing the works of great men in the fine arts and other picturesque beauties from painters stowed up in volumes of prints, etchings and drawings from his cabinet." Birch informs his reader that this sort of interaction was part of Chauncey's routine: "Mr. Chauncey was very regular in all his conduct. He had other friends in the arts (as that was his principal enjoyment) on other days of the week and some days to himself" (p. 178).

Chauncey further aided in Birch's gentlemanly, artistic education by bringing him on his summer travels. "The greatest advantage I derived from [Chauncey's] friendship," Birch recorded, was when "he would wait my leisure to partake with him at his own expense the pleasure of a journey in his handsome [carriage]." Visits to "the mansion or palace of some man of taste, whose possessions were fraught with the finest specimens of the arts, in painting, sculpture and other objects of taste," provided Birch with important sources for his work: "it was thus traveling for a month, some times six weeks together, that stored my mind with a treasure well calculated for my profession" (p. 178).

While he was living in London, Birch, like Chauncey (and Reynolds), indulged in the gentlemanly if not obsessive activity of collecting. Birch's financial means were not always equal to his social aspirations. Birch remarks about his lack of thrift that he "wanted some of [Benjamin] Franklin's economy, but could not submit to water gruel where better food was waiting." Birch continues that he was "as fond of the arts as he was of books, but instead of making water gruel serve me for breakfast in place of bread and cheese and beer (as he persuaded his pressmates to comply with though they needed nourishing food), I could not submit to such prudence" (p. 190).

The reference here to unaristocratic, American values is pointed. Rather than practicing "Franklin's economy" Birch instead preferred upper-class English pursuits, even if he could not afford them, and did not have recourse to the funds that allowed aristocrats to settle their own (often considerable) debts incurred through extravagant living. This is evident in his account of purchases at auction sales with a "handful of guineas" (the currency used by gentlemen to purchase objects of considerable value, pay professionals, including artists, and settle debts between each other), seeking to amass only "fine" images by "each master" rather than to acquire an encyclopedic representation of a single "master's" oeuvre, which he describes as the "amateur's" "general mode of collecting" (p. 190).

After having sorted his purchased lots of prints to "retain such that suited the nature of my collecting," he would "thoughtlessly" put those he did not want into the fire "by way of clearing them out of my way" rather than reselling them. At the end of his life he lamented his profligacy, bemoaning that "such has been my want of economy all my life" and asserting that the volume he collected "could not have cost me less than two thousand pounds," a substantial sum indeed. Although he does not say so directly, Birch also collected oil paintings in addition to prints, amassing by the 1810s a group of fifteenth- and sixteenth-century Dutch, Flemish, Italian, and French works, in addition to several by his British contemporaries (p. 190; see Appendix E).[46]

Another important American, Benjamin West (1738–1820), who succeeded Reynolds as president of the Royal Academy, is presented in Birch's writing as a foil for Birch's collecting acumen, even as he is tarred with the same bourgeoisie brush as Franklin. Birch's allusion to "painter's etchings" characterizes his collection as one of original works of art in this medium rather than of prints intended as reproductions of paintings: "I showed Mr. West my volume of painter's etchings. Mr. West was a great collector himself, but he had more of Franklin in him (and, most likely, had the principal part of this volume); but when he observed the correct arrangement, the beauty of the impressions with the [rarity] and scarceness of some of the collection, he declared he had never seen such a volume before" (p. 190). The imprimatur of quality that West's approval bestowed upon Birch's connoisseurship is reinforced by his account of his relationship with John Chamberlaine (1745–1812), who became Royal Librarian in 1791. Birch may have first known him through his predecessor in this position, Richard Dalton (ca. 1715–91), who was the first treasurer of the Royal Academy, a print dealer, and a close associate of Reynolds. Birch was visiting Chamberlaine in the King's Library in Buckingham House (where his own *Délices de la Grande Bretagne* would be included in the collection) and looking at "a volume of drawings by Claude Lorrain" when Chamberlaine suggested an interesting arrangement. Addressing Birch, he noted that "you collect, I understand, a great deal for yourself. I should suppose you meet with things sometimes beyond your mark. If you will purchase them for this collection, we will be very glad." Birch relates that he did so and that he was paid for his purchases before Chamberlaine

inspected them, saying when Birch protested that Chamberlaine had not "seen the lot" that "we know whom we employ" (p. 191).

In addition to the gentlemanly habits and tastes that Birch avidly pursued, he also rejected certain activities as inappropriate to his aspirations. In addition to scorning middle-class thriftiness, Birch rejected entrepreneurial commerce, the mainstay of the parvenu, as his reticence over William Russell's business dealings suggests. This point is also illustrated by his refusal of proffered offers of items to sell upon his departure for the United States. In this, he notes that "upon my leaving England, many articles in trade then were offered me upon speculation, but that was not my object" (p. 192).

Earl of Mansfield, Patronage and Politics

Birch's other great "friend" and patron in London was William Murray, a renowned lawyer, the first Earl of Mansfield, and Chief Justice of the King's Bench from 1756. Birch recalled as a child seeing Mansfield arrive in Warwick to preside over the court of quarter sessions, preceded by a "troop of sheriff's officers on horseback (to the number of about thirty) in double lines with their long staffs headed with a blue ribbon resting on their stirrups followed the trumpeter." Last appeared "a handsome chariot with the venerable figure of the judge in his long wig." Birch remarked in his autobiography that he would later experience "the pleasure of being carried home from a late enjoyment of his society with his friends from Kenwood [Mansfield's country seat] in that very same chariot" (p. 238).

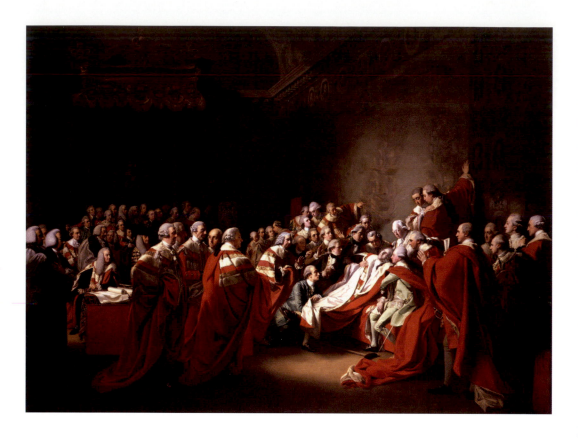

FIGURE 9. John Singleton
Copley, *Death of the Earl
of Chatham*, oil on canvas,
1779–81. Tate [2009]; on
loan to the National Portrait
Gallery, London.

1708–78) in the House of Lords in 1778. One of the crucial and most difficult aspects of the creation of Copley's painting was "persuading fifty-five noblemen to sit for the portraits" so that their likenesses in the painting would be accurate.[47] Birch asserts that Murray played an important role in this, relating that Murray "told [him] he had procured all the sitters for that picture that Mr. Copley could not obtain himself" (p. 186). Copley represented Murray seated, with his back partly turned to Pitt, which was interpreted at the time as a sign of disgraceful indifference.[48] Despite this controversy, or perhaps to compensate for it, in 1783 Copley used his preparatory sketches for the *Death of the Earl of Chatham* as the basis of a painting of Lord Mansfield, the first in a series of portraits of the lords represented in the earlier work. Copley's portrait shows Mansfield facing the viewer.

Birch was engaged to copy this portrait two years later.[49] According to his own records, Birch made several enamels from it, both a portrait bust detail and a copy of the full-length portrait in 1785 (p. 248). Nonetheless, he voices a low opinion of Copley's work (perhaps simply to demonstrate a partiality to Reynolds). Birch, who had already been admitted to Mansfield's social circle at the time of the commission, expressed his views of the painting, remarking to the earl that it seemed to him "too much like a copy from another picture [by which] to hand down your lordship to posterity." Birch went on, taking the occasion of the demand for miniatures of a portrait of Mansfield to suggest a solution: "I cannot help thinking that in an age like this where two so great men have met as your lordship and Sir Joshua, it is your lordship's duty, to your friends and the public, to sit to Sir Joshua Reynolds."

Birch's encounter with Mansfield at his house in Bloomsbury in the late 1770s began a relationship that continued until 1793, when the earl died at the age of eighty-eight. That first meeting resulted in a commission to copy "Mr. Copley's picture of him from the Death of Chatham" (p. 173). In this, Birch refers to the Anglo-American painter John Singleton Copley (1738–1815) and his monumental *Death of the Earl of Chatham* painted in 1779–81 (figure 9). This "contemporary history" painting shows the collapse of the Whig leader (and Murray's longtime political foe) William Pitt ("the elder,"

Mansfield acceded, admitting to Birch that the Archbishop of York had urged him to do so for quite some time and, according to Birch, dispatching the enamelist as messenger to Reynolds (p. 173). Mansfield's correspondence indicates that Reynolds himself had been pursuing him for a portrait for a number of years.[50] The resulting painting was completed in 1785, and Birch finished his first miniature from it in February 1786 (see figure 7). He would produce twelve more of these before 1793.[51]

Mansfield had taken up full-time residence at Kenwood (figure 10), his country seat north of London on the edge of Hampstead Heath, after the destruction of his Bloomsbury house in 1780. He had purchased the estate in 1754 from fellow Scotsman John Stuart, the third Earl of Bute (1713–92), ignominiously renowned as George III's first—and extremely unpopular—prime minister (1762–63). In 1764 Murray hired Robert and James Adam, who, during the rest of the decade, significantly enlarged and substantially altered both the interior and the exterior of the main house. Among the features of their alterations was the creation of the broad, white, stuccoed south front that commands the hill from which central London can be seen (and which Birch would represent in the *Délices*) and the addition of an east wing that houses the apse-ended library. The landscape garden in which the house stood was not associated with a professional designer before Humphry Repton worked there in 1793, after Murray's death. Instead, Murray, who was a protégé and friend of Alexander Pope and an executor of his will, was probably himself responsible for its design.[52]

Mansfield's friendship with Pope, a Catholic, is but one

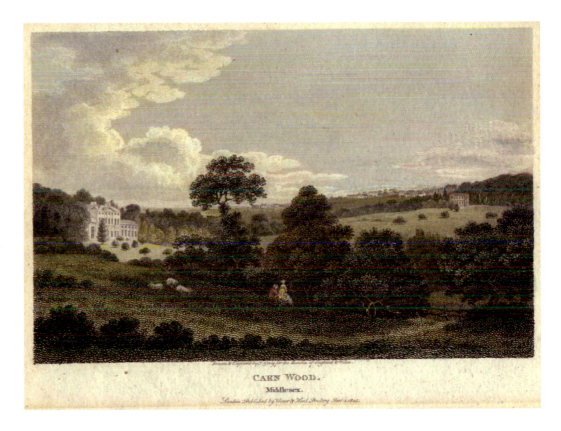

CARN WOOD.
Middlesex.

example of his rather complicated place in British political life of the period. Respected as a lawyer, he was appointed Solicitor General in 1742 and named Lord Chief Justice in 1756. He accepted the position on the condition that he be made a lord. Yet several shadows darkened his political career: both his father, fifth Viscount Stormont, and his oldest brother were imprisoned after the Jacobite uprising of 1715. Murray was therefore subsequently suspected of such sympathies himself. Despite these accusations, Murray was also suspected of being a kind of shadow min-

FIGURE 10. John Greig, *Carn Wood*, engraving, 1805. Collection of Emily T. Cooperman.

ister who had great influence over the king. His perceived tolerance of Catholics (including Pope) and other religious minorities, even the suspicion he might be a "papist," also provoked controversy. His dismissal of charges against a man accused of saying Mass was one reason he was targeted by the mob led by the "mentally unbalanced Protestant fanatic" Lord George Gordon in 1780. The rabble first assaulted his carriage outside the Houses of Parliament and later completely razed Murray's Bloomsbury residence, destroying much of the contents of his valuable library.[53] Notwithstanding (or perhaps because of) these various turmoils, Murray earned a deserved reputation as a scrupulously fair, intelligent, and important jurist.

Murray's retreat to Kenwood after the Gordon Riots earned him, not surprisingly, a reputation for being "difficult of access," as Birch put it (p. 181). His wife died in 1784; thereafter, his household at Kenwood consisted of his niece Anne Murray, his grand-niece Elizabeth Murray (*ca.* 1763–1823), both of whom the earl had adopted, and Elizabeth's "mulatto" companion and first cousin Dido Elizabeth Belle (*ca.* 1763–1804), the illegitimate daughter of Mansfield's nephew Sir John Lindsay (1737–88) (figure 11).[54]

Adjacent to the house and its park is Hampstead Heath, where Birch moved his family by the mid-1780s and where they lived while he produced the *Délices*.[55] In his autobiography, Birch asserts that "for near eight years did I visit at Kenwood whenever my inclinations led me that way." Further, if when he visited, "his lordship was engaged, his order to the servant was to show Mr. Birch to the ladies, with whom I sat till he joined us" (p. 179). Birch uses a special occasion with the ladies (Anne and Elizabeth Murray and perhaps Dido Belle) to characterize his close relationship with Murray. One Christmas Day, it being "fine weather," Birch walked to Kenwood from his cottage. On learning that Murray was "now on his circuit," he was nevertheless invited to dine. Birch notes that when the Misses Murray congratulated him "upon the intimacy I had with the Earl of Mansfield, assuring me there were many of our first nobility [who] would be glad to stand in my shoes," he responds that he "was very sensible of the honour his lordship did me and was proud to bear it" (p. 181).

In a related tone, Birch refers to his access to the estate, saying that "the key of his celebrated library was at my command. His beautiful and spacious gardens [were] often my morning's walk." On these walks, Birch notes a frequent companion, a professional who performed a crucial service for Murray and who lived on the estate: "[I often walked with] the celebrated antiquarian and member of the R. S., Dr. Combe, his physician, who had a room and medical apartment in the house. I often took breakfast with him before I returned to my cottage" (p. 181).[56]

Immediately following his reference to Combe, Birch alludes to his own landscape designs for Kenwood, presenting himself to the reader of his autobiography for the first time as something other than an enamelist: "I would often speak to his lordship of the improvements that might be made at Kenwood. He told me if he had been ten years younger he would submit to my taste in the entire new arrangement of his

grounds" (p. 181). The significance and worth of this aspect of Birch's aspirations are measured in the monetary value of the pay for Murray's professional gardener: "Lord Mansfield in the high refinements of his taste appropriate[d] five hundred pounds *per annum* as Mr. French's salary, to the gratification of three of the senses so essential in the enjoyment of life with the pleasure of the garden" (p. 181).

Birch does not dwell on Murray's political life in his autobiography, but he does relate another example of Murray's friendly attention that indicates that Birch himself was no stranger to controversy and radical politics. While discussing the favors the Earl of Mansfield bestowed upon him, Birch recounts an anecdote related to the distribution of Thomas Paine's *Rights of Man* (1791–92), which defended the principles of the French Revolution and was banned as treasonous. The story describes Murray's expression of concern for Birch "after sitting at tea with the family," saying, "'if any thing should happen to you, mind you send to me, directly, mind, directly.'" Birch later connects this offer with an incident in which he had "been in the Temple, in the Chambers of my friend Robert Gray, Chamber Counsellor, spouting away upon the *Rights of Man*, just published by Thomas Paine," in front of a stranger whom Gray knew to be "one of those appointed by the Chief Magistrate to put down the work as seditious and dangerous to the peace of the government." Gray, Birch's attorney, rescues Birch by asserting that he was speaking in a "private chamber" and therefore not subject to prosecution for public incitement to rebellion (p. 184).[57]

Birch adds that this incident of his own recklessness was

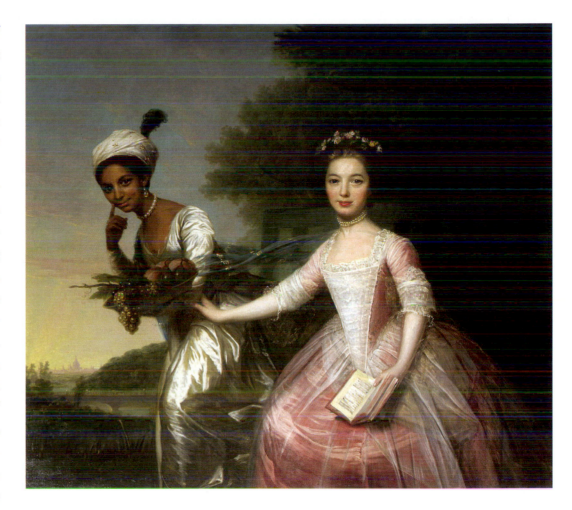

"but half [the] story," relating that "at that very time I had 500 volumes of Thomas Paine's *The Rights of Man* consigned over to me to give away." He adds that he "was not acquainted with Mr. Paine personally, though he was a subscriber for six volumes of my British views," nor "had ever [ex]changed a word" on the treasonous "subject with him" (p. 184). While perhaps

FIGURE 11. Attributed to Johann Zoffany, *Elizabeth Murray and Dido Belle*, oil on canvas, ca. 1780. Collection of the Earl of Mansfield, Scone Palace, Scotland.

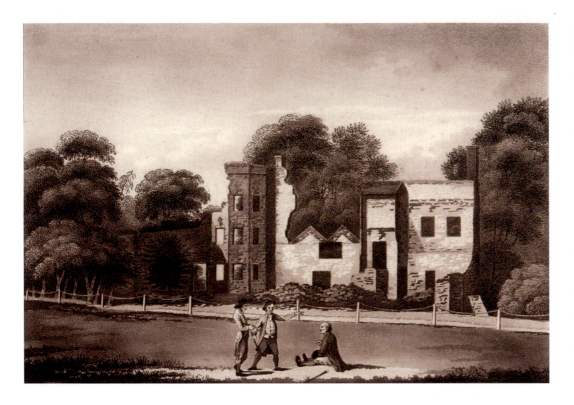

FIGURE 12. Philip Henry
Witton, *The House of William
Russell, Esq.*, engraving,
1790, published in *Views of
the Ruins of the Principal
Houses Destroyed during the
Riots at Birmingham*, 1791.
Reproduced by permission of
the Huntington Library, San
Marino, California.

sentia (he had fled to France) and the book's distribution was banned. After Paine left England, his work was distributed in secret, as Birch had agreed to do for five hundred copies.

The incident in Robert Gray's chambers and Mansfield's response apparently caused Birch to consider more seriously the dangers of radical Whig politics. It seems likely that Birch's radical leanings and his consenting to distribute Paine's inflammatory ideas were directly related to the views of his first cousin William Russell, whose public pronouncements effectively ended his residence in England. Just as Birch remains mum on any political activities that led to his agreeing to disseminate Paine's work, the artist is silent on the reason for his cousin's departure from Birmingham: a mass uprising in 1791 generally called the Birmingham Riots. The principal targets of hostility touched off by a dinner in the city to commemorate the fall of the Bastille were Russell's property and that of his close associate Joseph Priestley. This dinner, attended by Russell, Priestley, and others, should be seen in the linked contexts of liberal Whig political interests, which embraced such republican notions as universal suffrage and the Dissenters' fight for their own civil rights in the pursuit of the repeal of the Test and Corporation acts. The direct relationship between religious nonconformity and revolution in England was not forgotten and was in fact consciously recalled in the period; thus a favorable liberal British response to the French Revolution became the pivotal issue.

Priestley was an actor on the national political stage in this period; he was caricatured in cartoons as "Doctor Phlogiston, the Priestley politician or the Political Priest" in 1791.[58] Russell's activities, which included working for Birmingham

true, Birch's assertions of ignorance mislead the reader by creating a false impression of political naïveté. While it is conceivable that he did not know Paine personally, despite Paine's purchase of six copies of Birch's *Délices de la Grande Bretagne*, it is unlikely that he could have been assigned the task of distributing this inflammatory literature without a good idea of the potential risks of this activity. Paine's central argument was that the civil government survives by the consent of the majority of the people to support the rights of the individual. If the government's actions impinge upon these "natural rights" then revolution is justified. Paine was tried for treason in ab-

support for the Dissenters' national campaign to repeal the Test and Corporation acts, were best known locally. Priestley was, in fact, in sympathy with Paine's ideas, and his efforts and those of others disturbed Birmingham's "established equilibrium between Dissenters and Anglicans." The Bastille Day dinner of 1791 brought hostilities to a head.[59]

First Priestley's New Meeting House, then his residence, and finally Russell's Showell Green were destroyed in the Birmingham Riots (figure 12).[60] Both left Birmingham permanently in 1794 because of these and never returned. Russell then, as Birch recounts, "conveyed" Priestley to the United States, where he remained, in Northumberland, Pennsylvania, for the rest of his life (p. 192). As Birch notes, by the time Russell was in London and preparing to leave, Birch was also planning to make his way across the Atlantic.[61]

Beyond what is suggested by Mansfield's offer of protection, Birch is silent on the role that politics may have played in his relationship to his London life and to his patrons. A number of facts unmentioned by Birch suggest that sympathies he shared with many of his "friends" had some influence on his London career. Among these it might be noted that Nathaniel Chauncey's father had been heavily penalized as a Dissenter holding public office and that Murray, in addition to his court rulings that were perceived as pro-Catholic, was lionized by Nonconformists for his successful effort in Parliament in 1767 to have a London law overturned that was injurious to Dissenters' financial interests. Strong Whig political views were shared by many of Birch's most important supporters. In his autobiography, Birch describes the Duke and Duchess of Devonshire as "my very valuable patrons"

(p. 178). Both Georgiana (1757–1806, née Spencer) and William Cavendish, the fifth Duke of Devonshire (1758–1811), were prominent in Whig politics. The duke was the scion of a Whig family displaced from power upon the accession of George III.

The list of patrons Birch made of those who purchased his copies after Reynolds's portraits also suggests a network associated with politics. Many can be linked with the duchess and her circle, although it is not known whether there was any political connection that brought Birch to her attention. It seems highly unlikely that she would have found Birch useful in these matters. Nonetheless, her apparent interest in Birch is intriguing. Among those on Birch's enamels list are Lady (Lavinia) Althorp (1762–1831, née Bingham), the wife of Georgiana's brother George, who became the second Earl Spencer; a "Miss Poyntz," an unidentified cousin of Georgiana; the Duke of Dorset (John Sackville, 1745–99), one of her lovers; and Lady Charlotte Wentworth, the brother of Charles Watson-Wentworth (1730–82), second Marquess of Rockingham, another prominent Whig. Further, the female subjects of two enamels bought by Nathaniel Chauncey were also associated with the duchess: Mrs. Eliza Stanhope was a fellow Whig canvasser, and the actress Mary Robinson owed a great deal to Georgiana in the establishment of her career (see Appendix A).[62]

Despite the connections to the Cavendishes and the dramatic results of William Russell's and Joseph Priestley's beliefs, Birch's writing contains no direct enunciation of his politics. The specter of his cousin's fate, or the "dangerous times" in London in the 1790s for those with his political feelings, may

have stilled his voice on the subject, or the beliefs Birch held fervently as a young man may have been discarded later.

Birch is as terse about the reasons for his decision to leave England as he is silent about his own politics. In addition to his remark that by 1793 he had lost his "three best friends," he notes that "it was about the time of the French Revolution and things in England [were] very dull," and, only slightly more revealingly, "from the Revolution in France and the loss of my friends, the times grew dull in England" (p. 192). As for the connotations of the term "friend," "dull" meant more to Birch than simply uninteresting.

While a confluence of difficulties may have tipped the scales in his decision to emigrate, America must have offered many attractions. Given his "spouting" of Thomas Paine's ideas, one of these could have been political. Moreover, if he remained in the relatively rigid hierarchy in London, his opportunity to expand his artistic practice was limited. And if, as his stories about William Russell suggest, he aspired to join the ranks of the landed gentry, his chances of doing so in the United States would have seemed much greater. Like so many others, he saw the young nation in its mythic guise as the land of opportunity, and departed for it in 1794.

Chapter 2

"ENCHANTING SCENERY OF BRITON'S ISLE"

Education in the Picturesque and
Les Délices de la Grande Bretagne

William Birch began his artistic career as an enamelist. Much of his work was copying the portrait paintings of others, notably those by Sir Joshua Reynolds. He differed significantly, however, from the man he termed his "master" in his greater interest in landscape art. In this, Birch was very much in keeping with his times; one might accurately say that he belonged to the first popular picturesque generation. During the last decades of the nineteenth century when Birch launched this crucial aspect of his career, the Reverend William Gilpin produced his best-known writings, Richard Payne Knight and Uvedale Price published their theoretical texts, and, most important for Birch, the market in Britain for sets of picturesque engraved views and landscape paintings grew substantially.

Birch entered into landscape art with his *Délices de la Grande Bretagne*, published in London in 1791. The *Délices* constitutes a kind of aesthetic survey of the British Isles, onto which are projected a series of ideas about the relationship of humankind and nature, or, more specifically—and importantly for his later American sets—about men (usually not women) and their acts, specific places, natural objects and forces, and time. These ideas are conveyed both visually and verbally in the complex lingua franca of latter eighteenth-century English aesthetics: the picturesque.[1] The *Délices* consists of prints after landscape paintings and drawings by Birch himself and by a group of his London contemporaries. Birch created three original images of the thirty-six in the set. While he had painted views in enamel before the publication of the *Délices*, its publication marks his debut as a landscape artist for a wide audience. But it must also be said that the *Délices* is principally a compilation of others' work, which is consistent with the way in which Birch earned a significant portion of his livelihood in London as a "copyist." The compilation of others' work to create a set of picturesque views was

not by any means unique to Birch. The cooperative nature of such ventures is attested to not merely by the number of artists whose works were brought together for these publications but also by the contemporary practice of extra-illustration. As one collection among many, the *Délices* is a compendium of contemporary thinking. It is evidence of the practice of picturesque exploration and understanding of places as a shared undertaking on the part of a sizable community of upper-class and increasingly middle-class Britons. The *Délices* also shows that picturesque touring and image-making was a means of articulating national and social histories and narratives, and that these histories and narratives were associated with the perception and representation of landscapes. This associative aspect is particularly important for understanding Birch's American sets of views.

The *Délices* demonstrates that for Birch (and his peers) the picturesque constituted both an aesthetic and ideological balance of conflicting elements. Recurring phrases of the text in the *Délices* mark a psychological, sensual journey through contrasting landscape features. Using the language of the period, he frequently notes positively the "surprise" inherent in the landscapes he reproduced; another asset is the "pleasing variety" shown in the images. Many of its recurring themes were commonplaces: Birch brought together both others' work and contemporary shared notions for this publication. Indeed, for all those who sought to capitalize on the increasing popularity of the picturesque by publishing engraved views, too much originality would have been commercially disadvantageous.

"SO MANY FRAMED PICTURES": BIRCH'S EDUCATION IN THE PICTURESQUE

Birch's landscape art and writing (for his *Délices*, in his autobiography, and in his *Country Seats*) reflect the intertwined, fundamental aspects of the picturesque—the powerful patterns of perception, description, and representation that developed in Britain in the eighteenth century. The first of these, the perception of the world around one as "picture scenes" (Birch in his introduction to the *Délices*) was a learned skill. This brief phrase captures two key elements of the picturesque: the visual understanding of the world in terms of its relationship to images (principally landscape paintings) and the perception of the action in it as drama upon a stage. The second vital aspect was the verbal classification of visual experience according to a tripartite aesthetic system, consisting of the "beautiful," the "sublime," and the "picturesque," that developed specific (although debated) meanings over the course of the eighteenth century. The final result, the representation of (native) landscapes, employed both the perception of sites according to a number of visual models, their aesthetic categorization, and, crucially, the association of values or narratives expressed by human figures in the image *and* verbal description, as Birch's *Délices* amply demonstrates.

Birch acquired the skills of seeing the world as "picture scenes" after he arrived in London, where he came in contact

with a generation of landscape painters whose stock in trade were the conventions of the picturesque. A number of these artists' works would be sources for his *Délices*. Notably, it was not this cohort but instead his patron Nathaniel Chauncey who provided much of this vital aspect of his visual education. In his summer travels with Chauncey in his "*vis à vis*" carriage, Birch viewed the "enchanting scenery of Briton's Isle" like "so many framed pictures" through its polished glass front. Birch also recounts that "it was thus travelling for a month, some-times six weeks together, that stored my mind with a treasure well calculated for my profession" (p. 178).[2] This was a kind of second apprenticeship for Birch.

Birch's Wednesday evenings examining paintings and prints with Chauncey indicates another important aspect of the picturesque that Birch absorbed. Specifically, ear-lier artists' work served as models for both the experience and the representation of the British landscape in the eigh-teenth century, as well as for garden-making. Seventeenth-

FIGURE 13. Claude (1604/5?– 1682), *Landscape with Psyche outside the Palace of Cupid ("The Enchanted Castle")*, oil on canvas, 1664. Bought with contributions from the National Heritage Memorial Fund and the National Art Collections Fund, 1981. © The National Gallery, London.

century painters from the Dutch, Flemish, Italian, and French schools were the main sources of inspiration. Among these, the works of Claude Lorrain, Nicolas Poussin, Salvator Rosa, and Gaspar Dughet were often invoked.[3] Birch records that Chauncey had "a small but very fine collection of pictures himself [including] two of Claude Lorrain's finest paintings—'The Angel in the Troubled Waters' and 'The Enchanted Castle,' which George the second envied him of" (figure 13). Birch's direct exposure to original Claude paintings was a privilege available to very few, but he was far from unusual in his knowledge of the formal conventions of Claude's paintings or their application to the experience of landscape.[4] On the contrary—by the time Birch wrote, the British visual habit of framing the world in this fashion had existed for at least a half century and was fully ingrained in the elite social circles in which he moved in London. Yet, to see the world in the terms of a (Claude) painting was not merely an exercise in form but also a matter of content.

The close relationship in the period between landscape representation and set design, and between the experience of landscape and action within it as theater has been noted by a number of authors.[5] Claude's landscapes (and those of other seventeenth-century painters who influenced eighteenth-century British painting) are not "pure" in that they are always inhabited by human (and frequently mythological or divine) figures, however small these may be within the scale of the image. Both Birch's *Délices* and the anecdotes that form the narrative of his autobiography show that he shared the perception of "picture scenes" as the stage for human drama.

In his autobiography, events are generally presented to the reader without analysis: Birch narrates the episodes of his life to his reader as if they were occurring on a stage before him.

For example, when first setting himself up in London, he sought to sell part of the estate passed to him from his father but needed to obtain permission from his cousin William Russell as head of the family. Russell resisted Birch's entreaties because he sought "to preserve the property wholly for myself as eldest son till I was more settled, [and] that the honour that attended the property might be handed down to posterity with the family in the order it had stood from the conquest of Britain." Birch did not understand Russell's motives and traveled to Birmingham to confront Russell. The drama that Birch describes of his encounter with his cousin takes place in the setting of Russell's house, Showell Green.

> I now entered the house angrily [and] saw my cousin in the parlour. [I] moderated my feelings as much as I could [and] told him I thought it very hard that I should have to journey so far at heavy expense for what might have been sent by post. Finding no immediate reply to my purpose, [I] flew out in a loud exclamation of anger, charging him with a want of feeling. This brought the amiable Mrs. Russell, a lady for whom I had always the highest esteem and respect, down from the chamber above. [She] entered the room with terror, exclaiming, "What is the matter?" Never was an unfortunate fellow so abashed. I dropped like a wounded butterfly. Cousin William, taking the advantage of it, laughed at me saying

he did not know, it was cousin William, something is the matter with him, he could not tell. I got out of the room as soon as I could. (p. 239)

Birch's education in the picturesque was also verbal as well as visual, whereby he learned the terms defined and debated by eighteenth-century writers. In his carriage rides with Chauncey, he notes that the elder man "took a pleasure in so directing the carriage as to surprise and astonish my delighted senses with everything new, beautiful, or picturesque" (p. 178). These terms, along with the "sublime," all have complex etymologies that reach back before Birch's time; their meanings and applications engendered substantial published writing in eighteenth-century Britain. In the early part of the century, Joseph Addison and Alexander Pope (the Earl of Mansfield's associate) contributed substantially to the subject of aesthetics. Edmund Burke's famous 1757 *Philosophical Enquiry* defined the "sublime" and the "beautiful" as essentially opposite aesthetic poles: the private experience of the vast and awe-inspiring versus relatively the social experience of the small and smooth. Another important contribution of Burke's *Enquiry* was his emphasis on the psychological effect of the phenomena he described, for example, the "pleasurable horror" brought by the experience of the sublime.[6]

The "picturesque" acquired the place of an unsorted middle term between the sublime and the beautiful, sharing some qualities of both. William Gilpin's 1792 *Three Essays: On Picturesque Beauty; on Picturesque Travel, and on Sketching Landscape* organized and popularized several of aspects of the

picturesque that had already been practiced or enunciated by his predecessors and contemporaries. First was seeing "picture scenes" and representing them in sketching and in verbal commentary. Second, his widely read *Three Essays* categorized the picturesque aesthetically as rough and rugged, in addition to defining the term as that which "is capable of being *illustrated by painting.*"[7]

Once Birch had learned to see what was around him as "picture scenes" and to classify and categorize its features as "sublime" or "beautiful" or "picturesque," he never stopped doing so. As he describes it in the introduction to the *Délices*, he had discovered the ability to perceive a "scene of delight, where it may generally be thought almost impossible to be found, or to be formed in their imagination," and embraced the feeling that "not to be in love with landscape can only infer a neglect of observation."[8] Memories of his childhood in Warwick are described vividly as landscapes and coincide with many facets of the plate descriptions in the *Délices*. His recollections are recounted sensually and dominated by the visual. The description of his nurse's cottage just outside the medieval walls, for example, reminds the modern reader of Gainsborough's mid-century images of peasants in rustic settings. His directives to himself regarding this house and the tree in its yard are particularly notable in their allusions to rustic peasants and their circumstances, a theme he would include in the *Délices*. Birch recalls that "in the cottage of my nurse there was no interruption to peace and comfort the first five years of my life. I must not forget here to describe her cottage." He goes on to narrate that "it was one of two small tenements at the

bottom of West Street, Warwick, enclosing a small garden in front. It consisted of three rooms [and the] front was covered with roses, honeysuckle and jasmine to the roof, admitting, through the green foliage and flowery group, the gentle rays of the morning sun to the lattice casement of our chamber." He then recalls the view from the cottage, saying that "at the back [and] at the end of the lot a beautiful run of water [took] its course to the Avon. Crossing the bottom of West Street [there was] a wide and open space with country scenery," and returns to its yard, again urging himself, "Nor must I forget the large growth of a spreading codlin tree, in the centre of the lot at the back of the cottage, whose choice fruit was carefully preserved for my comfort" (p. 234).

His accounts of the town of Warwick are presented similarly. His memory of boyhood swimming excursions, for example, is bracketed by adult references to place that derive from his absorption of the specialized vocabulary and the itinerary of picturesque touring. He begins his swimming anecdote with an allusion to the proximity of Shakespeare's Stratford and ends with the history of St. Mary's Church and Warwick Castle, the two prominent landmarks of the town, saying that "I made myself happy with the beauties that surrounded Warwick, . . . founded on a rock of freestone, [and] watered at its foot by the Avon's stream where the goddess of Shakespeare's genius is said with its pure waters to flow." He then takes his reader through the surrounding pastoral landscape, saying that "in the summer mornings at 5 o'clock I followed a path through a rich flowery pasture of a vast extended meadow chequered with primrose and violets, leaving the town and castle in [a] beautiful picture upon the hill to the

choice spot in the Avon for bathing." After having swum, he winds his way "through a verdant path in the bank of the river, returned to the ancient city," and then guides his audience on a visit to "St. Mary's Gothic Church with the tomb of bold Beauchamp in the brazen chapel, and the priory at one end [leading] on to the ancient towers of the Kingmaker at the other. The two arched chapels at the extremity of its cross-line, east and west, terminated its beautiful plan" (p. 237).

Elsewhere in his autobiography, Birch paints the setting of the castle and its grounds and evokes the connection of the landscape garden to the more extensive, "borrowed" view. This description is part of his discussion of the town's Presbyterian Meeting House, which he attended with his mother: "[it] stood high on the rock of freestone, overlooking, from a considerable descent, the park and gardens of the castle. [They] were divided by the silver stream of the Avon running between them, with rich embellishments of art and large groups of deer sporting in the park with an extended scene of verdure for miles" (p. 241). A longer description of the landscape around the castle includes more of the jargon of eighteenth-century British aesthetics, such as the "gloomy shade over a descending path led to a romantic arch overhung with trees. Through its shadow a confined light with picturesque beauty was seen." After giving a number of details on a dam on the Avon and a "murmuring fall of the spring," he approvingly comments that "this enchanting spot was wrought by the Warwick family, so distinguished for taste" (p. 241). While Birch does not identify him, the landscape gardener Lancelot "Capability" Brown was the creator of this "enchanting spot."

Brown *is* named by William Gilpin in his 1786 *Observations, Relative Chiefly to Picturesque Beauty, Made in the Year 1772, on Several Parts of England; Particularly the Mountains, and Lakes of Cumberland, and Westmoreland*, which takes his reader to the same location and also remarks upon on it approvingly. Like the publications that defined the terms of eighteenth-century British aesthetics, Gilpin's books on touring are also relevant to Birch's education and work. Gilpin provided a formative recipe for the popular picturesque experience of British landscape; his first "tour," *Observations on the River Wye* was published in 1782.[9] Published tours of the British Isles had begun to appear in the late seventeenth century, but Gilpin's writings were a popular and influential formulation of both route and language. In his 1786 *Observations*, the church of St. Mary's is noted briefly yet approvingly by Gilpin ("an elegant Gothic structure"). In contrast, the castle receives extensive treatment (it is nearly the only subject of discussion) in his description of Warwick, although the landscape garden is addressed in terms less glowing than Birch's.

> The great ornament of Warwick, is the *castle*. This place, celebrated once for it's strength, and now for its beauty, stands on a gentle rise, in the midst of a country not absolutely flat. The river Avon washes the rock, from which it's walls rise perpendicularly. . . . This noble castle . . . was at last converted by it's proprietor, the earl of Warwick, into a habitable mansion. . . . The garden consists only of a few acres; and is laid out by Brown in a close walk, which winds towards the river.[10] (emphasis original)

Birch's own journeys with Chauncey were contemporary with Gilpin's tours—a reminder that he relied on activities and habits of perception that had been the established province of the upper classes before Gilpin's publications. Birch may never have read his Warwick tour, as his omission of any reference to Brown suggests, yet a common inventory of picturesque places, as well as shared patterns of articulation, may be inferred from the coincidence of sites singled out by both.

LES DÉLICES DE LA GRANDE BRETAGNE AND BIRCH'S LONDON PRINTMAKING VENTURES

Birch said little about either his motivation or his decision to issue the *Délices*, but he undoubtedly recognized the popularity of such publications and saw an opportunity for a profitable undertaking. In the end, he would produce approximately 348 copies for just over 240 subscribers, confirming this projection of success. More important for his later work in the United States, however, this first book of engravings marked not only the beginning of Birch's career as a printmaker but also (and most significantly) his entrance into the realm of professional landscape art.

Birch's expansion of his artistic work into printmaking occurred by 1787, the year of his earliest dated engraving, *Contemplation*, which copied Reynolds's 1784 portrait of the actress Mary Robinson as she gazes out to sea (figure 14).[11] It has already been noted that printmaking and enameling were allied through common method, and Birch's first engrav-

clearly perceived and pursued a professional opportunity in expanding his repertoire through printmaking, giving him the opportunity to reach a larger market.

A factor in the beginning of Birch's printmaking may have been another miniaturist's association with the publication of his own work. Beginning in 1786, Samuel Shelley's (1750/56–1808) paintings were reproduced by several printmakers for a literary compilation, *The Cabinet of Genius containing Frontispieces and Characters adapted to the most Popular Poems . . .*, which was completed in 1788 and published by Charles Taylor (1756–1823), who was also the principal engraver. Birch contributed *Secander* to the volume, an illustration to William Collins's *Oriental Eclogues* (figure 15). These engraving projects give a small indication of the thriving market for prints in Britain in the later eighteenth century (as do Birch's own collecting purchases at London auction houses). They also suggest the large networks of artists—those who painted, those who made prints, and those who did both—involved in the production of illustrated publications.

The compiling of material, both images and text, as was done for Taylor's publication and as Birch would do for the *Délices*, reflects the more general process of book creation as well as another of Birch's printmaking projects during this period. The modern notion of a book as something essentially complete in itself is at odds with several aspects of the perception of both sets of views and other publications in the eighteenth century. Most view books were issued over time in parts, as were Birch's. In addition, the fairly common practice of extra-illustration, or the addition of prints to a preexisting publication, indicates at least one way in which the owner

ings arose directly from his enamel copy of the painting of the same year. A number of Reynolds's other portraits that Birch reproduced in enamel had been or were being engraved in the period by other artists. For example, John Raphael Smith (1752–1812), who copied several of Reynolds's works and who subscribed to the *Délices*, made prints of portraits of Giovanna Bacelli, mistress of the Duke of Dorset, and of Mrs. Henry Stanhope (née Eliza Falconer) in 1783, the same year that Birch created enamels of these paintings (p. 242).[12] Birch

history of the subject, the front of St. Paul's Cathedral as it was remodeled by Inigo Jones in 1633–40, by consulting the 1658 *History of St. Paul's Cathedral* by the antiquarian William Dugdale and its accompanying plates by Wenceslaus Hollar (1607–77). As Birch describes, the Griffier painting (and his print) shows "Inigo Jones's new front on fire in two places, Bow Church in the background and Ludgate in the front, surrounded in flames."[13] Birch recounts that "Mr. [Thomas] Pennant was then publishing one of his late editions" of his book *Of London*, an illustrated history and guide first issued in 1790.[14] Birch either presumed or had been informed that Pennant might be interested in the image; Birch must have been familiar with the publication. Birch reports that Pennant "was struck with a view of Ludgate, a subject he had been ten years looking for."[15] Pennant then promised to promote the print with the Antiquarian Society, many of whose members Birch "had then to supply . . . with it, at one guinea each," to be added to Pennant's publication (p. 177).

Birch mentions two more print projects other than the *Délices* in his autobiography during the period he was in London. In 1785, Birch copied a portrait of the Nabob of Arcot by painter Tilly Kettle (1735–86) in enamel on the inside of a watch for Queen Charlotte to send to India in return for a "large diamond brought over for her Majesty by Sir Acton Munro." Birch also made a print for Munro of Kettle's portrait of the Nabob of Surat, "which he took back to the Nabob to give to his friends at the time he presented the watch to the Nabob of Arcot from the Queen."[16] Birch also engraved Reynolds's 1773 self-portrait in doctoral robes (see figure 99) and "drawing by H. Wieyx, small and beautiful" (p. 177).[17]

FIGURE 15. William Birch, *Secander*, engraving, n.d. Carson Collection.

of a book participated in both its content and meaning. Another of Birch's prints from his time in London was produced for this purpose. Birch reports that a friend brought him a painting of the 1666 Great Fire of London by Jan Griffier (ca. 1645–1718), a Dutch immigrant who worked primarily in England (see figure 103). Birch engraved the painting at what was for him an unusually large scale, describing his print as "coarse but interesting and correct." Birch also investigated the

Drawn by A.Van Assen. Engravd by W.Birch.

MAY DAY,
From the Life.

Publishd April 1.1794 by Wm Birch, No. 2 Macclesfield Street, Soho.

FIGURE 16. William Birch, after Benedictus Antonio van Assen, *May Day, From the Life*, hand-colored engraving, ca. 1793. Carson Collection.

One uncompleted publication project goes unmentioned in Birch's autobiography. In 1793, Birch began a series of genre views based on drawings by Benedictus Antonio van Assen, to be titled *The Busy World, or London Dissected, Composing the Customs, Particularly Characters, Public Places, Cries & c. of London, as appear about the Year 1793* (figure 16). Among the subjects to be represented were "Bear Baiting in Peter Street, Westminster" and "A scene in Wapping"; the set was thus to be in the tradition of William Hogarth's satirical and humorous urban views.[18] The work on the set was stopped by Birch's emigration and it was never sold to the public as a book.

Les Délices: *Project and Subscribers*

The largest printmaking venture of Birch's career was his first set of views—*Les Délices de la Grande Bretagne*. While his later sets are more significant for the history of American culture, he never produced as many copies of *The City of Philadelphia in 1800* or *The Country Seats of the United States of North America* as he did of his British views. As for all of his publications, Birch was terse in explaining his decision to issue his first book. His brief account of the genesis of the *Délices* suggests that Nathaniel Chauncey, in addition to his

aesthetic tutelage, may have played a role in his decision to expand his professional activities. In 1784, Birch created an enamel for Chauncey of *Ouse Bridge at York* (figure 17), a painting by Joseph Farington (1747–1821) shown that year at the Royal Academy of Arts.[19] Birch described it as "one of the most beautiful or perfect enamels I ever painted." He notes that "the size of my plate was that which I engraved for my *Délices de la Grande Bretagne*" and, significantly, that this "was the principal cause of my undertaking that work" (p. 247), thereby indicating that he realized, when reproducing this image, that his skills as an enamelist could be

used to produce engravings and, more important, engraved views.

Between 1784 and 1788, the earliest date of the plates included in the *Délices*, Birch must have been preparing for this undertaking. He could well have been improving on his engraving and printing techniques (he is invariably silent on the subject of his acquisition of artistic skills) and probably began selecting the paintings he would reproduce. The inscriptions on Birch's plates, which include precise publication dates, indicate that the project was in full swing by June 1788 and ended in June 1790. Publication of the bound volumes

FIGURE 17. William Birch, after Joseph Farington, *Ouse Bridge at York*, engraving, 1788, from the *Délices de la Grande Bretagne*. In his print, Birch reproduced his enamel of 1784.

The first painting to be engraved was Farington's *Ouse Bridge.* Birch described it as "a picture in the bold and correct style of Canaletto, clear and bright in effect" (p. 247).[21] The engraving's heavy stippling seems labored in comparison to some of the plates produced later for the *Délices,* for example, *Appleby Castle, Yorkshire* (figure 18, after Thomas Hearne), completed in 1790, in which Birch combines stipple with other burr techniques to produce clearer recession from foreground through mid-ground and background. His technical facility clearly grew as the project progressed.

The second image to be engraved was Reynolds's *View from Richmond Hill* (see figure 8), which was to become the first plate in the set. The last in the binding order, *Conway Castle* (see figure 102), was, as noted in Chapter 1, a pastiche based on a landscape sketch by Reynolds and a drawing of the building by another hand. Landscapes were not the most important part of Reynolds's oeuvre, but the significance of these images for the *Délices* exceeds Reynolds's simple association with the project. As he would in his later publications, Birch bracketed his first set of views with prints that are distinct from the rest. In the *City of Philadelphia,* the frontispiece and final plate lie outside of the geographic range of its subject and are introduction and epilogue for the work. The *Country Seats* begins and ends with views of his own property outside Philadelphia on the Delaware River, which will be discussed in the last chapter. In the *Délices,* Reynolds's images provide the overarching vision of the most prominent painter in Britain in the eighteenth century. Beyond (and because of) this, Reynolds's *Richmond Hill* epitomizes the artist's view of his native, even personal landscape (Richmond Hill was the site of his

FIGURE 18. William Birch, after Thomas Hearne, *Appleby Castle, Yorkshire,* engraving, 1790, from the *Délices de la Grande Bretagne.*

occurred in 1791. By December 1788 he had worked up to a pace of one or two plates per month, with some months of no such activity and some in which a maximum of three were produced.[20] The final total reached thirty-six, with three original views by Birch himself, two printed in 1789 and one in 1790. The period in which Birch worked on the *Délices* coincides with a gap in Birch's list of enamel copies after Reynolds, although it is not known whether this indicates a suspension of his other original enamel work as well. Given that Birch produced nearly 350 copies of the volume for his subscribers (see Appendix B), his time for other work must have been severely constrained.

country house) and the representation of that view through an artistic image.

In his introduction to the *Délices*, Birch describes the work of the other contributing artists as the "first landscape Painters of the Modern School." In this, he must be understood to promote his publication; his choices were not all among the most important of the artists' productions and a few of the painters, it must be conceded, cannot be claimed as "first" among the ranks of their contemporaries. His choices were dictated by circumstances that are impossible to recapture completely, and he is typically silent on the factors that governed his selections. He presumably engraved paintings available through his social and professional associations. He seems not to have considered the majority of these connections sufficiently important to remark upon, however; other than the two academy presidents, Reynolds and Benjamin West (both of whom also subscribed to the *Délices*), he mentions none of the painters whose work he engraved for this project by name in the main text of his autobiography.[22] As with Reynolds, landscape images were not the most central aspect of West's oeuvre. Birch's print after his *Bathing Place at Ramsgate* (plate 26, figure 19) was presumably also included because of his association with the project and its author.[23] In a similar vein, prints after Thomas Gainsborough (plate 8, *View at Wolverstone, Suffolk,* figure 20) and Richard Wilson (plate 4, *View in Kew Gardens*) were selected not only for the stature of these artists in the academy but also (and more important) for their role in the rising popularity of landscape painting in Britain. Gainsborough died in 1788, the year of Birch's engraving, and Wilson in 1782; the specifics of Birch's

FIGURE 19. William Birch, after Benjamin West, *Bathing Place at Ramsgate,* engraving, 1788, from the *Délices de la Grande Bretagne.*

FIGURE 20. William Birch, after Thomas Gainsborough, *View at Wolverstone, Suffolk,* engraving, 1788, from the *Délices de la Grande Bretagne.*

FIGURE 21. William Birch, *View on Winander Meer*, engraving, 1790, after Philip J. de Loutherbourg, *View of Wynandermeer*, from the *Délices de la Grande Bretagne*.

FIGURE 22. William Birch, after Richard Corbould, *Landguard Fort*, engraving, 1790, from the *Délices de la Grande Bretagne*.

access to their work are unknown, although the primary link was surely through the academy.

These luminaries do not represent the majority of the painters whose work Birch included: landscape specialists of his own generation. Of these, most were members of either the Royal Academy or the Society of Artists (or both) and showed their work at the annual exhibitions. Farington is represented in the *Délices* by the greatest number of images (four); he was probably the closest to Birch personally and professionally among this group. Philip James de Loutherbourg (1740–1812) and Philip Reinagle (1749–1833) were also among the elected academy members whose work Birch

selected. Several of the works Birch engraved (often using slightly different titles) were exhibited there in the 1780s. De Loutherbourg's *View of Lake Wynandermeer, Westmoreland* (figure 21), Farington's *Ouse Bridge*, and Richard Corbould's (1740–1814) *View of Landguard Fort* (figure 22) were shown in 1784, the year Birch most likely first conceived of his book project.[24] George Barret's (ca. 1732–84) *Llanberis Lake, North Wales, in the Mountains of Snowdon* (figure 23) was seen in 1776, and George Samuel's *View on the Thames from Rotherhithe during the Frost, January, 1789* (figure 24) was on view in 1790.[25] In addition to Reynolds and West, several of the artists published in the *Délices* were also subscribers, includ-

ing Nicholas Pocock (1740–1821), Reinagle, and Farington. Other artists and academy members not otherwise involved with the publication also subscribed, including John Singleton Copley, whose portrait of the Earl of Mansfield figures unfavorably in Birch's writing, the well-known painters Henry Fuseli, Paul Sandby, and George Stubbs, and the printmaker Francis Haward, whom Birch praises in his autobiography. Several fellow miniaturists, including Robert Bowyer, George Engleheart, and Andrew Plimer, were subscribers. Architect Robert Adam, whose work is featured in Birch's own view of the Earl of Mansfield's Kenwood, also supported the venture, as did architect James Wyatt. Birch notes in the description of

several plates that the source paintings were in the possession of their creators or other artists.[26]

Among the owners of the paintings Birch reproduced, the Earl of Warwick helps us understand at least some of Birch's movements during the period in which he prepared his publication. The earl's 1788 view of Warwick Castle by Abraham Pether (1713–95) shows that Birch traveled to his boyhood home while working on the *Délices*, as the earl would not have brought the painting to him in London.[27] Birch's own view, *Town and Castle of Warwick from Emscote*, was printed early in 1789, based, presumably, on a drawing made in 1788. Birch also traveled to the coast southeast of London before early

FIGURE 23. William Birch, after G. Barret, *Llanberis Lake*, engraving, 1788, from the *Délices de la Grande Bretagne*.

FIGURE 24. William Birch, after George Samuel, *View on the Thames from Rotherhithe Stairs, January, 1789*, engraving, 1789, from the *Délices de la Grande Bretagne*.

1790, when he completed *A Cave in the Chalk Cliffs near Margate* (figure 25). As he would later for his *City of Philadelphia*, Birch may have also been soliciting subscriptions during his travels.

Several of the artists whose work Birch reproduced were associated with similar publications. Joseph Charles Barrow issued a set of views in 1790 of Twickenham, collaborating with George Isham Parkyns. Later, in the United States, Parkyns would attempt (unsuccessfully) to publish a set of views of American scenery; he was also involved with Birch in an abortive venture to establish an arts academy in Philadelphia in 1795. Richard Courbauld contributed to the *Picturesque Views of the Principal Seats of the Nobility and Gentry in England and Wales* (London: Harrison & Company, 1786–88). Benjamin T. Pouncy (d. 1799), the artist of *St. Augustine's Monastery & Cathedral at Canterbury* (figure 26), primarily worked as an engraver rather than a painter; his prints include the illustrations to Richard Payne Knight's

famous *The Landscape: A Didactic Poem* (London, 1794), from drawings by Thomas Hearne, whose *Appleby Castle* has already been noted. William Hodges (1744–97), elected to the academy in 1787, published his *Travels in India during the Years 1780, 1781 & 1783* in 1793. Birch included an engraving after Hodges's 1787 collaboration with Richard Cosway, *View from the Breakfast Room in a Gentleman's House in Pall Mall, with the Portrait of a Lady (Mrs. Cosway) by Mr. Cosway* (plate 23, figure 27). More contributions to picturesque sets by artists whose work Birch chose to reproduce could easily be traced. Birch lived and worked among a community of artists involved in the creation of such works, and there was a strong market for these publications, which grew stronger as the eighteenth century came to a close.

Two of the artists whose work he copied were amateurs, both of whom were from the upper class and connected to Birch through patronage. Lord Duncannon (Frederick Ponsonby),[28] whose *View of Portsmouth and the Masts of the Royal*

FIGURE 26. William Birch, after Benjamin T. Pouncy, *St. Augustine's Monastery & Cathedral at Canterbury*, engraving, 1788, from the *Délices de la Grande Bretagne*.

George (figure 28) is included in the *Délices*, figures, as previously noted, in Birch's introduction to the Earl of Mansfield.[29] That Birch was "one morning looking at some pictures purchased by Lord Duncannon" (p. 182) when Duncannon suggested he approach William Murray suggests a measure of camaraderie based on artistic interests that is supported by the inclusion of the *View of Portsmouth*.

The painting (*View in Wentworth Park, Yorkshire*, figure 29) of the other amateur, "Mrs. M.[ary] Hartley," is noted in the plate description in the *Délices* as "in possession of Lady

Charlotte Wentworth," who also commissioned several enamels after Reynolds of her brother Lord Rockingham.[30] Other paintings were made available for engraving by Birch's (or Reynolds's) patrons and their associates; he notes the ownership of sixteen of the thirty-six source paintings in his plate descriptions; only three of these were not also *Délices* subscribers. The owner/subscribers included Horace Walpole (as might be predicted, the owner of J. C. Barrow's painting of Strawberry Hill), in addition to Lady Wentworth and Lord Duncannon.

The rest of Birch's subscribers give a sense of the British audience for picturesque view books like the *Délices* and, more important, the type (and quantity) of supporters for his work that Birch enjoyed during his period in London. Through his acquaintance with Royal Librarian Richard Dalton and his successor John Chamberlaine, Birch placed copies of his book in both the king's and queen's collections in Buckingham House. In addition to those among the highest rank of British aristocracy, Birch's supporters extended beyond the patrons who figure in his autobiography (such as Lord Mansfield and Lord Fitzwilliam) to include over forty members of the nobility; about the same number are styled "Esq." A number of relatives and Birmingham natives were among the supporters, including brother Joseph, first cousins William and George Russell, and members of the Humphreys family. Birch's former employer Thomas Jefferys purchased four copies, and his partner William Jones six more, probably for sale. Three London booksellers were certainly involved in distributing the *Délices*. Charles Dilly, who acted as publisher for works by

Boswell, Dr. Johnson, Thomas Paine, and Philadelphia physician Benjamin Rush, ordered twenty-four copies, the greatest number to any subscriber. Birch's title page indicates that both Dilly and James Edwards (twelve copies) were the primary outlets for his work. Initially, T. Thornton (who subscribed for eighteen copies) was also to have been a seller, as the inscriptions for the plates produced in 1788 and 1789 indicate, but an unidentified event occurred to change this before the end of the project.[31] Other subscribers connected with bookselling and book collecting can be identified in Birch's list, including John Debrett, London publisher and bookseller, James Bindley, book collector and Fellow of the Antiquarian Society, and Clayton Mordaunt Cracherode, book and print collector.

Les Délices: *Picturesque Compendium*

The *Délices* is unusual among published sets of views for two important reasons. First, its explicit subject was the picturesque experience of British landscape, thus allying it with important contemporary works like Gilpin's *Three Essays*. Second, Birch gathered a set of landscape images intended to represent the spectrum of British picturesque subjects. Typically, the authors of these publications addressed, at least in the title of their works, specific themes: the antiquities of a region of the British Isles, views of country houses and/or their landscape gardens, or the wild scenery of Wales, Scotland, or the Lake District. Instead, Birch engraved paintings from all

FIGURE 28. William Birch, after Lord Duncannon, *View of Portsmouth and the Masts of the Royal George*, engraving, 1789, from the *Délices de la Grande Bretagne*.

FIGURE 29. William Birch, after Mary Hartley, *View in Wentworth Park, Yorkshire*, from the *Délices de la Grande Bretagne*.

of these view genres and included townscapes, a lesser-known but equally significant subject.

Birch begins his introduction by asserting the superior picturesque qualities of "British Landscape" for the "pen" (i.e., writing) or the "pencil" (by which he means drawing or sketching). He states that it "comprehends whatever is beautiful in nature." Further, he claims that whatever "grand characters of [the] sublime" or the "lovely, peculiar to other countries" can also be found in Britain, thus declaring both its preeminence over other nations and its quality of being a "collection of landscapes"—as he describes his book—itself. Birch goes on to promote the viewing of the native landscape as a skill to be learned but one available not just to "the artist, or designer." Instead, he characterizes this "source of pleasure" as an inherent talent possessed by "many . . . even unknown to themselves" who must simply learn this new way of seeing: "familiar objects are unnoticed; as it is possible to be possessed of the most lovely form, yet unacquainted with it." Thus, the principal subjects of Birch's introduction are picturesque touring and sketching, as they would be shortly thereafter in Gilpin's *Three Essays* (among other publications), and Birch addresses an amateur audience, as Gilpin would.

In his introduction, Birch establishes not only Britain's literally natural superiority but also a "natural" order among its inhabitants and constituent parts. Birch begins with a sort of inventory of the natural assets of his country. In this, his work reflects an earlier publication (among others) related to his own by its title. In his autobiography, Birch accounted for the title of his first book by calling it "a compliment in England to France to adopt French titles to works of art and elegance." It

is more plausible, however, that the title was taken from James Beeverell's 1707 eight-volume, illustrated guide, *Les délices de la Grand' Bretagne et d'Irlande*, which was written in French for foreign visitors to the British Isles.[32] That he did not make this connection suggests that he may not have considered the association with Beeverell's work an asset, presumably because the two publications differed in purpose and the earlier work would have seemed old-fashioned. Their introductions share one important point, however, suggesting that Birch was familiar with the earlier work. Beeverell begins his definition of the qualities of the "délices d'un pays" by indirectly asserting the natural advantages of the nation that is his subject:

> Pour me former l'idée d'un Pays délicieux, je me représente un terroir fertile, & raportant abondamment à la vie; j'y joins un air doux & tempéré, où l'on n'est pas point brulé par les chaleurs excessives de l'Eté, ni glacé par la froideur insuportable de l'Hiver.
>
> [By a delightful country, I mean one with fertile soil that amply sustains life; to this I join a sweet and temperate climate, which is neither excessively hot in summer nor unbearably cold in winter.][33]

Birch in his turn inventories several of the different landscape subjects in his introduction to the *Délices*. The natural elements, in addition to the climate, encompass the aqueous (for example, "our famous rivers"), the vegetative ("perpetual verdure in our fields; the fine growth and vast variety of trees"), and the geological ("the tops of mountains" and the "abyss of caverns"). His paeans to water and stone accompany

a cheery assertion of the accessibility of the countryside in its wild state: "Our good accomodation [*sic*], and, more pleasing to repeat, the estimable hospitality of this country, permits to visit its utmost limits; to trace its native wildness; to examine the striking effects that nature sports with; to scale the height of mountains, and stretch the view to distant shores; to descend the vast abyss of caverns, where every variety of gloom and subterranean novelty surprises."[34] As was the case with all the assumptions underlying Birch's text, his characterization of the landscape as "hospitable" was not unique to him. One of the key aspects of the picturesque was its reversal of an earlier, menacing perception of wild places: a kind of aesthetic domestication of the horrid or sublime.

After enumerating these natural phenomena, Birch then registers a complementary group of cultural items. These begin with the rural "peasantry" in "village and cottage scenes" (vii); proceed to the "Roman, Gothic, and Druidal antiquities" and the "ruins of castles and abbeys" (ix); and finally reach "the palaces of the nobility" (x). This encyclopedic approach also relates Birch's *Délices* to Beeverell's, but rather than attempting to encompass every site of note in the British Isles as the earlier publication had done, Birch brings together representative examples.

The system in Birch's introduction of hierarchical and complementary natural and cultural elements is a happy one: all does seem to be well in the best of all possible picturesque, British worlds. At the bottom of the social ladder, the "peasant" purportedly enjoys "liberty and ease." Then, in a formulation also typical of his time, he characterizes the "peasantry" as aesthetic source material, allying their accessible wildness with

that of the natural sites he has sketched verbally. In singing the praises of these British liberties his prose has its awkward moments, probably reflecting his inability adequately to articulate more complex abstractions (despite the fact that these were, for Birch, *idées reçues*).

Village and cottage scenes of Britain can no where be equalled. The constitution of our country is there in effect particularly visible; their rustic mansions and appendages—cultivated field, orchard, and garden, make sweet subjects for picture, varying as the ingenuity or industry of its inhabitants prevails: and when combined into a village with the addition of their church, mill, bridge, or any other public property, it becomes one of the most amiable views.

'Tis impossible to imagine a greater variety of characters than are seen in our peasantry: their dress is commonly very picturesque, irregular, as Wear will have it, or artlessly fashioned by the oeconomical genius of the cottage semptress. Among the lowest sort, even naked beauty is not wanting to grace the picture.

Liberty and ease, which none enjoy in any proportion equal to the peasant, gives air and sublimity of action to be learned only here. Art has it not.

Every gesture shews their independence, even [among the] children. The controul of fear and hope has never trammelled their positions. The firmness of health and exercise receives a wild grace from nature.[35]

Inherent in Birch's somewhat gauche prose, of course, is the assumption that British social liberty is natural, even

emanating from and fixed to the land itself. In spite of these aesthetic advantages (including "naked beauty"; "firmness of health and exercise receives a wild grace from nature"), his assertion of the absence of "art[ifice]" among the "peasantry" both affirms their naturalness and implies that refinement is present only in the upper classes. Birch completes this idea near the end of his introduction by presenting the aristocracy as exemplary: "the whole island is scattered over with palaces of nobility, from whose improvements the combination of art and nature can effect wonders."[36] He thus imbues the highest social class with nearly supreme powers.

The Picturesque Survey of Britain

The subjects named in the introduction reappear in the plates, which, with their accompanying descriptions, elaborate these themes and advance additional ones. The prints do not, however, show these subjects in the order of the text. Neither are the prints bound in the order in which they were produced. Beyond beginning and ending the volume with engravings after Reynolds, as Birch notes in his autobiography, his primary goal was to achieve a "pleasing variety."

While there may be no definable order in the prints' arrangement, there is an identifiable range in the geographic distribution of subjects and a consistency in the way that these are represented both in the prints and in the accompanying descriptions. The subjects of the thirty-six plates show areas in England, Scotland, and Wales, from St. Michael's Mount

near Penzance in the southwest end of Cornwall to the coastal towns of Dover, Ramsgate, and Margate at the southeastern tip of the island in Kent, and from Conway Castle at the edge of northern Wales to a falls on the River Braan north of Perth in Scotland. Many of the sites in the paintings constituted the "utmost limits" of the British Isles for upper-class Londoners.[37] These places—northern Wales, the Lake District, Scotland, and Cornwall—are represented as wilder, and almost all the prints and descriptions of them incorporate elements of Burke's sublime. Many of these areas would become popular picturesque touring destinations by the beginning of the nineteenth century. Picturesque definition rendered these places of "native wildness" inviting rather than frightening. For example, in the print after Joseph Farington's *View at Nunnery in Cumberland* (figure 30), a "surprising cascade" conveys the "hospitality" of such wild places. Birch's text and prints con-

sistently present (and represent) a series of contrasting and balancing elements, most often between natural features and cultural efforts.

The greatest contrasts come in the sites geographically or intellectually far from Londoners, where landscape features or types (mountains, waterfalls, the sea) are most closely related to the sublime. Among the wild places shown by Birch that would become popular tourist destinations is the Wye Valley in southeastern Wales, shown in the print of Nathaniel Pocock's *View on the Chace near Chepstow, in Monmouthshire.* Northern Wales, also favored by holiday makers, is figured in several prints: *Llanberis Lake* (figure 23), after a painting by George Barret, *Conway Castle,* Birch's pastiche after Reynolds's sketch, and *Llanrwst Bridge,* after Philip Reinagle.[38] The Lake District is represented by its most famous body of water, Lake Windermere (*View on Winander Meer,* figure 21, after P. J. de Loutherbourg's 1784 painting), and by *View at Nunnery in Cumberland* (figure 30).

Mountains—the epitome of the sublime in their vastness and verticality—dominate several images, including *Llanberis Lake, View on Winander Meer,* and *Conway Castle.* Birch's accompanying descriptions rely on the concepts articulated in Burke's *Enquiry,* noting the "awful solemnity" of the "surrounding amphitheater" of the mountains around Llanberis Lake, the "wild horror of rocks" near Lake Windermere, and the "towering heights of Snowdon" above Conway Castle.

Most of the six seascapes and Birch's accompanying text are similarly linked to the sublime. The apparent contradiction (or, in contemporary terms, sharp contrast) of Burke's "plea-

surable horror" is paralleled, for example, by Birch's description of Lord Duncannon's *View of Portsmouth and the Masts of the Royal George* (figure 28) as "at once curious though sorrowful."[39] The *Royal George's* three cross-like masts rise above the water, strikingly memorializing the tragic consequences of the "violence of the sea" (and imply the Christlike sacrifice of the victims), but this is tempered by the rest of the image and by Birch's description. Rather than being shown in a turbulent or

FIGURE 31. William Birch, after J. Phillips, *Rumbling Brig, Scotland,* from the *Délices de la Grande Bretagne.*

overwhelmingly vast ocean, the remnants of the shipwreck are seen amid the bustle of Portsmouth Harbor.

This balancing of elements is also evident in the engraving of J. Phillips's *Rumbling Brig, Scotland* (figure 31), which shows the River Braan northwest of Perth.[40] The falls, rugged trees, and rocks that take up the lower two-thirds of the image are important but not dominant features, while a bridge toward the top of the engraving, traversed by a horse and rider, is also seen. The accompanying text suggests the complementarity of nature and human acts: "The River Bra[a]n, over which this Bridge is almost formed by nature, may be called the most violent and noisy stream in Scotland. . . . Under this arch, that has been *joined by art*, it tumbles down fifty feet perpendicular: the rocks about it are rich in shrubs, and finely coloured, adding beauty to the foaming of the water" (emphasis added).

These two plates represent the pair of essential processes found in the *Délices*: the mitigation of one pictorial element by another, as in the *Rumbling Brig*, or the countering of the content of the image by the description, as in the *View of Portsmouth*. This "middling" corresponds to the place of the picturesque as the middle term between the "sublime" and the "beautiful"—exceeding the smallness and delicacy of the latter and providing, as Samuel Monk (quoting Shakespeare) puts it, a "local habitation and a name" for the former.[41] The principal balancing or contrasting element to the vastness and danger of these places and events is human effort, domestication. For this operation, Birch often uses the term "art" (as he

does for the *Rumbling Brig*) in his plate descriptions, by which he means the achievements of the engineer, the scientist, and even the farmer as much, if not more, than he intends the production of the painter. Birch's picturesque Britain is not one in which man dominates nature. Instead, they exist as complementary forces in the equilibrium of a philosophical middle.

Broadly speaking, sharper contrasts between image elements and/or between print and description occur in the prints of places that are more remote from London, either physically or imaginatively. Sites closer to this center (which it certainly was for Birch and his subscribers) are shown or described with fewer contrasts. They are "middle" landscapes, not only aesthetically but also geographically. The prints thus represent an aesthetic spectrum that is related to the location of the sites shown and described, and if the images and accompanying descriptions of Birch's compilation are considered both by geographic region and by subject type, several patterns emerge.

Taken as a whole, the images of the *Délices* form a kind of survey of Britain, both aesthetic and ideological. As noted, the sites in northern Wales and the Lake District are those that most closely approximate the elements of Burke's sublime, and they are at what were clearly considered the "utmost limits," even if they were not, strictly speaking, at the greatest physical distance from central London.[42] For example, the man on horseback in the foreground of *Llanberis Lake*, gesticulating in the direction of the "ruins of Dolbadern Castle," is windswept and seemingly agitated, and the goatherd striding along the

rocky ledge in *View on Winander Meer* suggests the appropriate sort of person to enter this landscape, a man quite different from the intended audience for the *Délices*. The two Scottish subjects also convey a sense of remoteness, both physical and perceived. All of these places are made accessible, of course, through the visual representation and (often mitigating) verbal description found in the *Délices*.

In contrast to the aesthetics of remote places, the rep-resentation that comes closest to Burke's characterization of the "beautiful" in its overall smoothness and modest scale is *A Meadow Scene at Hampstead Heath*. This is part of a small group of sites closest to Birch's own geographic center, his home and workshop.[43] For these images, the terms of Birch's text are as significant as are the aesthetics of the engravings. The humble character of *A Meadow Scene at Hampstead* ("this particular spot has no more than the consequence of

FIGURE 32. William Birch, after Thomas Rowlandson, *Market Day at Blandford, Dorsetshire*, engraving, 1790, from the *Délices de la Grande Bretagne*.

a field") is counterbalanced by Birch's exhortation to sensual intensity: "but feel its beauties. The silent admiration of those, whose sensations are really in unison with nature, gives the highest commendation." This heightening of experience is, of course, the opposite maneuver to the visual and verbal mitigation of the wild, sublime elements of the *Rumbling Brig* and *View of Portsmouth*. This "beautiful" landscape is thus also "middled."

One aspect of the balance between human efforts and natural forces is embodied in *Market Day at Blandford, Dorsetshire* (figure 32) after Thomas Rowlandson (1756–1827). The print seems simply to show a bustling market in a provincial town or, in Birch's words, "there is no country exhibition more pleasing than the simple traffic of such a day." He goes on, however, to emphasize a dramatic event not explicit in the image: "This town receives its present beauty from former calamity. How striking are the changes even towns experience! Not sixty years ago, three thousand persons were driven by fire from hence into the open fields, and were a considerable time homeless, their losses adding to the affliction." Just as was the case with the *View of Portsmouth* plate, human effort—"art" (here reconstruction)—vanquishes natural disaster.

While the *Blandford* plate demonstrates the power of human enterprise to overcome a destructive natural event, *View of the Thames, from Rotherhithe Stairs* (figure 24) after a painting by George Samuel shows the obverse, in which a natural "phenomenon . . . worthy [of] remembrance from its singularity" disrupts commercial activity in the heart of the London port. This image shows the freezing over of the Thames, a relatively rare occurrence. Commercial vessels are captured and townsfolk walk about on the ice at what Birch characterizes as a "place of entertainment": a genre scene whose humorous character is indicated by a sign at left that advertises "The Originall Cat in the Cradle," with the eponymous feline in a wire basket below the sign, above an impromptu tavern in a tent. In a nationalistic tone Birch's text focuses, however, on the commerce on the river temporarily stilled by natural force: "The forest of masts continually seen in this famous port, fills every British heart with delight, for it is a display of our extensive trade. But so noble a tide thus controlled, the vessels moored in ice, becomes a scene of our astonishment." If the *Blandford* plate embodies the success of art (in several respects) over calamity, the frozen *Thames* provides a reminder of the power of natural forces over even so "noble a tide" as the British commercial fleet.[44] But the limit of this power to "control" is clear in the atypical and transitory character of the event represented; it is a "phenomenon . . . worthy [of] remembrance from its singularity," and, in any event, spring will come.

A View from Mr. Cosway's Breakfast-Room, Pall Mall, with the Portrait of Mrs. Cosway (figure 27), after the collaboration between William Hodges and Richard Cosway, is the only other plate of central London. Nature intrudes into Pall Mall as strongly, if very differently, as into the icebound Thames. Trees dominate the vista outside the window (itself lined with potted plants), and Maria Cosway gazes toward the view. Birch's description of the plate characterizes Nature as a skillful editor of urban construction: "The prospect from hence is curious, and uncommonly fine, for a town-house. The tops of

the trees hiding the inferior buildings, nothing appears to the sight but what is rich and grand. It extends over the Duke of Marlborough's Gardens and St. James's Park, to Westminster Hall, St. Margaret's Church, Westminster Abbey, the Treasury, St. John's Church, and the Surr[e]y Hills."

Testimony

The *Thames from Rotherhithe Stairs* also presents a crucial theme in Birch's plate descriptions and introduction in the *Délices*: the images frequently record specific events and even transitory moments, both contemporary and historic. As a whole, the *Délices* provides a testimonial to the advantages, both "ancient" and "modern," of Britain and the accomplishments of its citizens, and even, as his introduction indicates, its "natural" advantages. Nine years later, Birch would also present his *City of Philadelphia* as a factual record of national achievement (made possible in part by the natural bounty of the New World), although his first American work would address both a fiercely local audience and a broader one, as will be discussed in the next chapter.

The images of the *Délices* are presented as documentation of these British advantages in the specificity of the publication dates on the plates, which include not only the year but also the day and month, a dating practice not common among contemporary printmakers but increasingly so among amateur artists. The date of the original painting is also often noted, and the descriptions of several views assert that they

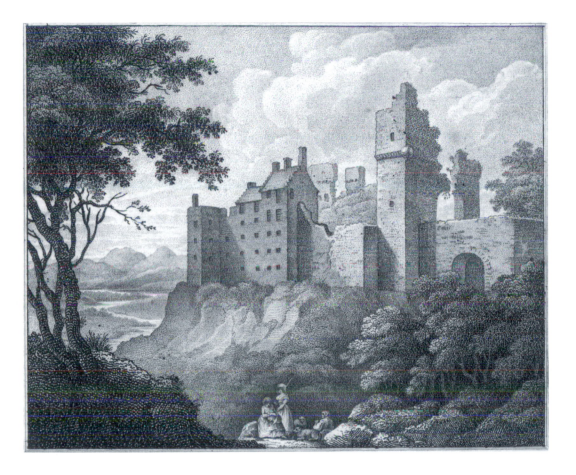

FIGURE 33. William Birch, after J. Phillips, *Roslin Castle*, engraving, 1789, from the *Délices de la Grande Bretagne*.

were "taken" at specific moments and that they accurately represent their subjects, according to the standards Birch saw as appropriate.[45] The title of Birch's second publication would explicitly name it as a record of its subject "*as it appeared in 1800*"; the precise dates of the plates of the *Délices* function similarly.[46]

Richard Wilson's *View in Kew Gardens*, for example, is

presented as the record of an atmospheric moment; it is "taken in the evening, when the sun approach[ed] the various objects which fronted its rays, dignifying the greater masses of shade, and blending the whole into one general glow of pleasing tranquility." Similarly, "the scene" in Samuel's frozen *Thames* "is exactly copied, and the figures principally sketched from nature."[47]

In addition to Birch's emphasis on the accurate representation of specific events, there are also assertions in the plate descriptions of the veracity of the images as records of

FIGURE 34. William Birch, after Joseph Farington, *The Remains of the Seagate at Winchelsea*, engraving, 1789, from the *Délices de la Grande Bretagne*.

physical, often local reality. For example, he begins his notes on *Roslin Castle* (see figure 33) with its location: "five miles south-west of Edinburgh." The Gainsborough painting that Birch included is not a representation of a single place, but he interpreted it this way, calling the print *View at Wolverstone, Suffolk* (see figure 20) and noting "the appearance of Wolverstone church . . . , [and] the winding of the Ipswich river."[48] In a variation on this theme, Birch asserts for *View in Wentworth Park, Yorkshire* (figure 29) that "this view is taken from a retired spot near the mill."

Birch's descriptions of the antiquities he represents serve a similar, complementary purpose as records of British history, and he invariably discusses events near these subjects rather than describing the medieval structures themselves. *The Remains of the Seagate at Winchelsea* (after Farington, figure 34), in which a masonry ruin partly overgrown with vegetation occupies most of the frame, is characterized as a register of the historic occupation of a site and the destructive, though distant, events that lead to the end of that occupation. His tone recalls his account of the tragic events in his descriptions of *Market Day at Blandford* and *View of Portsmouth and the Masts of the Royal George*.[49]

Winchelsea was built in the reign of Edward the First, in consequence of a larger town of the same name, of eighteen parishes, two or three miles south-east of it, being swallowed up by the sea, by which it was once almost surrounded: but as the angry ocean hid in oblivion the other, so it has withdrawn its aid from this, by its re-

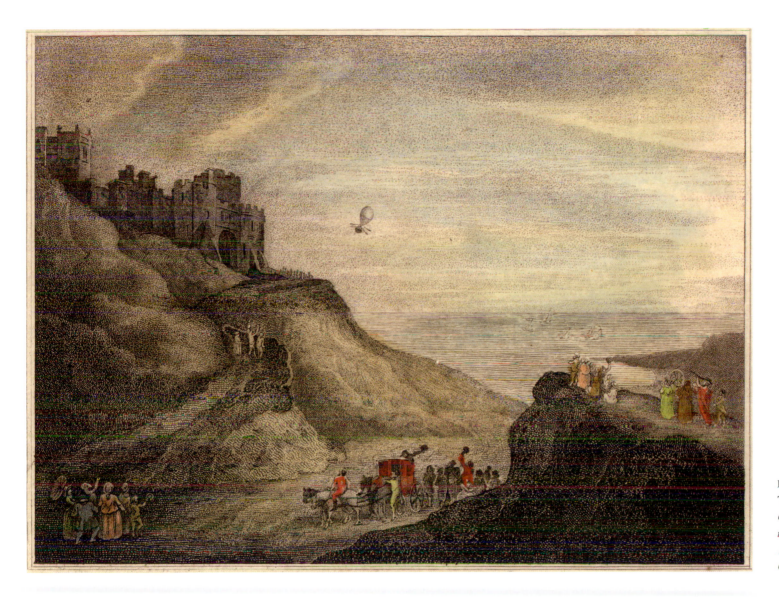

FIGURE 35. William Birch, after Thomas Rowlandson, *Dover Castle, with the Setting off of the Balloon to Calais, in January 1785*, from the *Délices de la Grande Bretagne*.

moval a mile from the place; by which means, its traffic being lost, it dwindled away from a principal sea-port to the mere skeleton of a town; the chief remains of which is this gate.

Birch's text for *St. Augustine's Monastery & Cathedral at Canterbury* (see figure 26) comes closest to a straightforward narrative of the British past and concludes with the date of the painting.

The monastery was founded about the year 605; its walls inclosed about 16 acres of ground. It was visited by many of our kings upon various occasions, and in 1573 Queen Elizabeth kept her court here with great splendour, in a

FIGURE 38. William Birch, after Richard Cooper, *Saltram, Devonshire*, engraving, 1790, from the *Délices de la Grande Bretagne*.

royal progress, and attended divine service at the Cathedral every Sunday during her stay at Canterbury. In this Cathedral were buried the bodies of Henry the Fourth, and his Queen Joan; those of six other kings; those of Edward the Black Prince, and other princes, and that of St. Thomas à Becket. It was rebuilt in its present preferable state of magnificence about the year 1420, after undergoing many revolutions by fire, &c. The picture was taken in the year 1778.

Historic and modern accomplishments are brought together in other plates to suggest a continuum of national superiority. The titles *Dover Castle* (figure 35, after Rowlandson) and *Bishop's Gate Norwich* (figure 36, after Farington) suggest antiquity, and ancient monuments are shown in both prints. Birch's engraving technique in *Bishop's Gate* highlights the eponymous structure, presented at a conventionally oblique picturesque angle. He summarizes the aesthetic character of the subject in his description but then turns to a documentary account of contemporary, local prosperity:

[The Bishop's Gate] is one of the most beautiful and picturesque entrances to this useful, flourishing, and industrious City, whose walls enclose a larger space of ground than the city of London, being three miles in circumference; not only possessing a superior number of opulent inhabitants to almost any of our cities, but whose surrounding villages are wonderfully populous, and their manufactures admired by all the world.

Birch's description of *Dover Castle* first recounts the subtitled event (*with the Setting off of the Balloon to Calais, in January 1785*)—clearly an instance of "art" overcoming (and, arguably, making use of) natural forces ("the attractive powers of the earth")—and then addresses the history of the castle. This textual order is supported by the formal language of the image: the castle, at left, is at roughly the same height as the hot air balloon but literally more marginal and darker.

This wonderful event, which cannot be too much contemplated, was performed by Mr. Blanchard and Dr. Jefferys, who, in defiance of the attractive powers of the earth they left, and without consulting the watery element, sailed, sporting in a new sphere, through the air to a foreign land, placing their pavillion in the clouds, and descending like aerial visions to the earth again to visit their neighbouring inhabitants.

Dover Castle was formerly a very principal fortification, by Julius Caesar, and finished by Claudius. It has many curious marks of antiquity, and the greatest attention that has been paid to it was by Queen Elizabeth, who very materially enlarged the place.

This view . . . was taken at the time the balloon was ascending from the cliffs.

Past and present, art and nature, and social order all come together most forcefully in Birch's descriptions of the properties of wealthy landowners, thus echoing his emphasis in the introduction. His account of John Opie's *St. Michael's Mount*,

Cornwall (figure 37), like that of Pouncy's *St. Augustine's Monastery*, presents an account of the history of the priory (shown on the mount at left), but concludes with its current ownership as "the seat of Sir John St. Aubyn." This seems a relatively trivial fact, but it neatly weaves the owner into the fabric of British history and tradition. In addition, Birch notes that "the original painting, by Mr. Opie, now is" in the possession of St. Aubyn, who also subscribed to the *Délices*. This plate and its description thus bring together several important elements of land ownership, class, patronage, and the creation of a historical narrative. The "seat" becomes, through Birch's publication of text and image, a construction of both a particular national history and the proper place in it of wealthy landowners, who appear in Birch's introduction at the apex of a clear social order based on art and nature. This theme would be of crucial importance to his later *Country Seats*. In and of itself, it is unremarkable that country estates, which as large agricultural landholdings constituted great concentrations of wealth in eighteenth-century Britain, should figure prominently in the construction of a national history. Birch's *Délices*, however, testifies to the place of picturesque sets (and the activity that both supported and gave rise to it: picturesque touring) in the creation of such narratives.

The place of such picturesque images in shaping the national meaning of the country seat is expressed particularly through three of Birch's selections.[50] His description of Richard Cooper's *Saltram, Devonshire* (figure 38) dwells on the occasion of a royal visit in addition to recording the cardinal orientation of the view: "their Majesties made this their residence for a fortnight, in the course of their late tour. The view from the north was taken . . . during their Majesties stay at Saltram, in the Autumn of 1789."[51] There is a brief evocation of the aesthetic qualities of the house's circumstances ("water meandering in various directions through wood and lawn"), but the designer of the landscape garden, "Capability" Brown, is never mentioned. In like fashion, Kenwood, the Hampstead home of Birch's patron the Earl of Mansfield (see figure 106), is described as the product of "his Lordship's fine taste [which] has in the same manner [as the creation of the lake in the landscape garden] embellished the whole with every thing of art that can adorn nature." The image, however, shows the house from the garden side, thus emphasizing the work of the Adams, whom he does not mention. Instead, Birch concludes with the proper, supreme place of Mansfield in this landscape: "but still the greatest ornament of the place is the noble possessor, to whom Britain is so much indebted for the protection and improvement of its laws, as well as for his munificent patronage of the arts." The greater implications of the significance of British law are adumbrated in Birch's introduction, where he says a "more particular enquiry might relate many other advantages in our possession [in Britain]: but if these already enumerated are to be equalled in any other country, the safety and freedom with which we enjoy them stands unrivalled."[52]

While Birch's account of Kenwood links Mansfield's achievements as a jurist with beauty of place, his description of Pether's *View of Warwick Castle* (see figure 2) makes a notable connection between aesthetics and nationally significant events. His discussion of the building demonstrates his ex-

pectation that the reader should be intimately familiar with a particular historical narrative. He suggests that the castle's "boldness and variety of figure lead the mind to recognize the many revolutions it hath witnessed, and which have so celebrated this ancient seat." He then returns to his first subject, the owners: "[The seat's] beauties are many, from the superior taste of the Warwick family for several centuries back, which is peculiarly apparent in the present Earl, who, with most distinguished judgment, is constantly embellishing it . . . [and] exposing to better view its most picturesque characters."

Birch's *Délices de la Grande Bretagne* testifies to the power of picturesque landscape representations to convey a rich repertoire of ideas about national culture in late eighteenth-century Britain. These ideas are not necessarily revealed by a simple analysis of formal content. On the contrary, the relationship between text and image, narrative and place, was one of deliberate association. The "story" was to be absorbed as a part of upper-class education.[53]

Birch's tutor in this study of landscape was his patron Nathaniel Chauncey, with whom he traveled through the countryside and visited the country houses of the members of the upper echelons of society. Birch conveyed the results of this education in what was arguably the most powerful form. This set of engraved views combined the forces of word and image to tell a story of that best of all possible worlds—one of British national supremacy and prosperity, individual freedom, and a sound social order in which art, in the proper hands, balanced nature and humankind. Works like Birch's and the enterprise of picturesque touring more generally both defined and expanded the limits of the British landscape itself. Birch would take many of the fundamental operations of the *Délices*—the association of learned narrative with landscape image and the communication of nationalist messages among them—with him as essential freight to the United States. He put these tools to use to create the first American sets of published views.

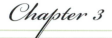

Chapter 3

SUCCESS IN THE NEW WORLD
American Career and Patronage

William Birch arrived in the United States in 1794 at a moment of great cultural flux. Nationhood was still recent, and the institutions and habits of the fledgling United States had only lately been established or were still in the process of formation. It was a time of risk, not fixity, when great personal fortunes could be made and lost. The place of the arts in the young republic was not defined; indeed, it was debated in a number of public forums.

The Philadelphia to which Birch came was on the eve of several important changes. In 1800, it would cease to be the national capital with the removal of the federal government to Washington, D.C.; the Pennsylvania legislature had departed the year before for Lancaster on its way to its eventual location in Harrisburg. During the first decade of the nineteenth century, the city would lose its status as the largest metropolis and most active port to New York City. The rapid rise of Baltimore's trade volume in the same period further threatened Philadelphia's commerce. In the 1790s, however, Philadelphia provided Birch with the closest approximation in the United States to the world he had left in London in its concentration

of wealthy and powerful citizens and in its role as the seat of national government.

In addition to its status as the largest, wealthiest city, Philadelphia, of all the urban centers of the new country, closely resembled greater London in its relationship to what were to become its suburbs. The country houses of Philadelphia's elite on the Schuylkill and Delaware rivers north of the city would have seemed to Birch to be the equivalent of the estates on the Thames upriver from London, including Reynolds's property at Richmond Hill. Birch would have seen these American estates as one among several signs that despite the Revolution, prosperous Philadelphians remained fundamentally British. While many Americans looked to Britain as the generating center of design ideas, most of the citizens of the young country did not share notions of the important place of art and artists in their society with Birch and his former patrons, as the difficulties encountered by other immigrant artists in the period demonstrate. Great wealth was amassed, city and country houses were built, and portraits and prints were bought, but patronage was not institutionalized in the United States as

it was in British urban centers. In America, Birch never enjoyed the longstanding benefits of a professional "friendship" as he did with Nathaniel Chauncey and the Earl of Mansfield. While Birch did not find individual patrons in the United States as generous as those in England, in the first decades after his emigration he enjoyed opportunities that were unavailable to him in London. In America, he designed houses and landscape gardens and published two entirely original sets of picturesque views. In contrast, the majority of the plates of his *Délices* had been engraved after the work of other artists, and he never had the chance to implement landscape "improvements" such as those he envisioned for Kenwood in the 1780s.

THE ARC OF FAME

Auspicious Beginnings

Birch enjoyed significant success in his first years in the United States, in contrast to most of the other artists who left Britain for America during the same period. He was alone in this group in successfully publishing a set of picturesque views, although others attempted to do so. His *City of Philadelphia* was the first American publication of its type. He began his career in the United States in a relationship with a patron that recalled certain aspects of the support of his "friends" in Britain. He soon discovered, however, that the character of Philadelphia art patronage was different from what he had experienced in London, and found that he had opportunities in his new circumstances that he had not enjoyed in Britain. He

realized that his training and abilities placed him in an advantageous position relative to many other artists in Philadelphia at the time. Moreover, the financial success of his first set of American views allowed him to travel through Maryland and Delaware and into northern Virginia. There, he found patrons who employed him as a designer and who appreciated his work to an unprecedented degree.

When Birch first arrived in Philadelphia in 1794, in an apparent effort to replicate the kind of patronage he had received in London, he sought out William Bingham (1752–1804), to whom he had been given a letter of introduction by Benjamin West (Appendix C). Bingham, whose house on Third Street is figured prominently in the *City of Philadelphia* and whose country estate, Lansdowne, is shown in the *Country Seats*, was one of the wealthiest Americans of the time. Birch relates in his autobiography that Bingham supported him shortly after his emigration, welcoming him into his household much as an English patron might. Birch records that "Mr. Bingham was my first employer in America" and that he was hired "to instruct his two daughters in drawing at his own house, attended with one of their friends." He did well, with "three scholars twice a week, at half a guinea per lesson each" (p. 193).

Bingham had maintained close links to Britain (his daughter married the son of banker Sir Francis Baring), and the family took contemporary English and Continental fashions as their own. He and his wife, the former Anne Willing (daughter of another wealthy Philadelphia merchant, Thomas Willing), had traveled between 1783 and 1786 in Britain and Europe, where Anne in particular "captivated and was captivated by the courts of St. James's, Versailles, and the Hague."[1]

A contemporary description of Bingham and his circumstances by a Polish visitor suggests the extent to which he resembled Birch's former patrons.

> The most opulent and the most ostentatious of the inhabitants [of Philadelphia] is Mr. Bingham. . . . I was invited one time to his house. One mounts a staircase of white native marble. One enters an immense room with sculptured fireplace, painted ceiling, magnificent rug, curtains, armchairs, sofas in Gobelins of France. The dinner is brought on by a French cook; the servants are in livery, the food served in silver dishes, the dessert on Sevres porcelain. The mistress of the house is tall, beautiful, perfectly dressed and has copied, one could not want for better, the tone and carriage of a European lady. She has traveled in France and Italy. The daughters are brought up more to be ladies than American citizens. In a word, I thought myself in Europe.[2]

There was a fundamental discrepancy, however, between the source of Bingham's money and the income on which Birch's British "friends" relied. Bingham had made the core of his fortune in trade in the West Indies, where he was Continental representative during the first half of the Revolution. Like many of the men whose houses appear in Birch's two sets of American engravings, the seemingly simple phrase "in trade" and the contemporary occupational description "merchant" mask a complex and risky world of finance and commercial speculation that made and broke (and sometimes remade) many American fortunes in this period. Another who depended like Bingham on privateering for a sizable portion of his fortune was Samuel Smith (1752–1839), whose Baltimore house, Montebello, Birch both designed and depicted in the *Country Seats*.[3] Both men went on to become prominent citizens of the new republic: Smith was a U.S. representative during Birch's first years in Philadelphia and became a U.S. senator during Thomas Jefferson's administration. Bingham was a founder of the Bank of North America, a member of the Continental Congress and the Pennsylvania Assembly, and also served in the Senate. Americans like Bingham and Smith could begin their careers as merchants and style themselves as gentlemen after they had accumulated enough money, escaping the stigma—common in Britain—that was attached to someone who had once been "in trade."

Not all early national merchants retained their fortunes. Like most of his cohort, Bingham invested heavily in land speculation: he owned two million acres in New England, much of which is now in the state of Maine. Other land speculators in the period fell victim to the risks inherent in land investment; the most famous such financial failure of the period was Robert Morris (1734–1806), whose grand, unfinished mansion Birch represented in the *City of Philadelphia*. Morris, another senator and the great fiscal backer of the Revolution, was broken by a term in debtor's prison after being brought down by land speculation. Morris's failure affected others, including William Cramond, who had hired Benjamin Henry Latrobe in 1799 to design his Schuylkill River house Sedgeley, the subject of another plate in the *Country Seats*.[4]

Bingham and Smith were among many whose mercantile fortunes were created in the mid-Atlantic. From the mid-eigh-

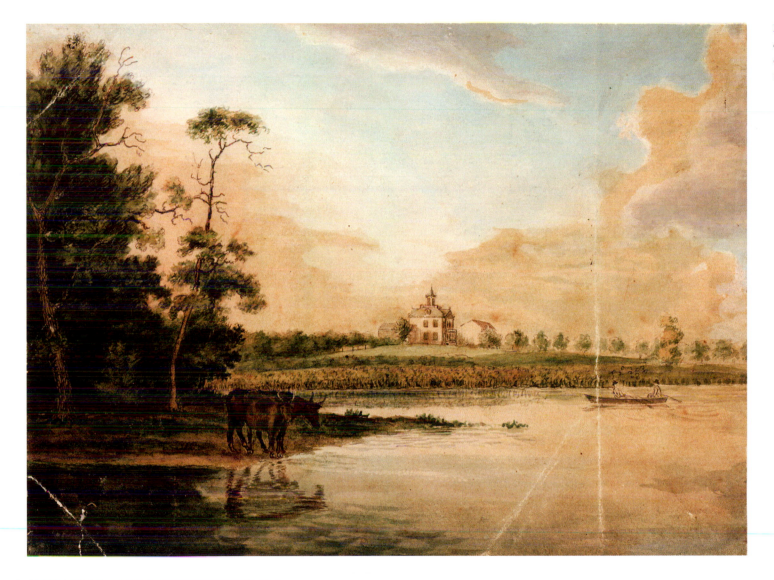

teenth century, Philadelphia was the center of the growth of American trade and consequently became the country's largest and wealthiest city. While there were other thriving ports, Philadelphia offered the successful combination of access to abundant agricultural and timber sources and a protected harbor with deep and fresh water where both freight handling and shipbuilding could take place.[5] In the last decade of the eighteenth century, these assets were joined with the presence of the national government. Yet new Philadelphia mercantile money was never dynastic, since primogeniture had been outlawed early in the colonial period in Pennsylvania. In this context, art and architectural design were not commissioned as enhancements to an estate passed on undivided to succeeding generations. Instead, they expressed the achievements and interests of individuals. For example, Birch's patron, diplomat and China merchant Andreas van Braam Houckgeest (1739–1801), built a country house on the Delaware in the 1790s (the subject of another *Country Seats* plate), which he named China Retreat and crowned with a cupola in the form of a miniature pagoda to reflect his Far Eastern trading achievements (figure 39).[6]

The comparative scale of British and American individual holdings also had a significant impact on art patronage. While the Adamesque details of Bingham's Philadelphia mansion and the furnishings of his dinner table may have recalled Kenwood, his fortune, however vast by American standards, was not the equal of a large English estate. The Earl of Mansfield had a significantly larger number of servants than Bingham ever did and employed a professional gardener. As the drawing instructor to Bingham's daughters, Birch held a position in his household akin to a tutor's in the family of a British aristocrat but did not live in the mansion. While Birch never lived with the Murrays, one suspects he was much more a part of the life at Kenwood than in Bingham's mansion. Moreover, there is no indication that Bingham was interested in becoming as beneficent a patron as either Nathaniel Chauncey or William Murray, and he is not known to have taken any artist under his wing in the manner of Birch's former associates.

Another important difference between Bingham and the Earl of Mansfield was their politics. While the latter may have been a peer of the realm and a patron of the arts, he was a political progressive and something of an outsider despite his rank; he was a Whig Scotsman. In contrast, Bingham and his wife were among the most conservative of the "ruling" elite in Philadelphia during George Washington's administration. Anne Bingham (with Martha Washington) was one of the principal figures in a Federalist circle that imitated "the social life of a monarchical court."[7] Another portion of the Polish visitor's description suggests just how undemocratic Bingham's circumstances appeared to his contemporaries.

[Bingham's] house and garden, situated in the middle of the town, occupy a large area of ground. Their pompous appearance wounds a little the spirit of equality and excites envy. He is the Pisistratus of these parts with the difference that he has neither his talent nor his finesse, keeping his gardens closed while the Athenian had them opened, entertaining at table persons of quality instead of treating the people; he could never become the Tyrant of this city.[8]

Like the Earl of Mansfield's house in Bloomsbury, Bingham's house was the target of violence, although it was not destroyed: "in 1795 . . . a mob attacked the . . . house to protest John Jay's Treaty with England, whose commercial concessions to the British men of the streets thought an all-too-logical product of Anglophilia like the Binghams.'"[9]

It would be hard to overstate the degree to which politics touched both the public and personal lives of most people in Philadelphia at the time of Birch's emigration, as this incident begins to suggest. Politics was a matter of nearly constant public performance and touched virtually all of those Birch spent time with in Philadelphia in the 1790s. In contrast to the indication Birch gives about his radical sympathies in London through his planned distribution of the *Rights of Man*, he made no known direct statement of his American political allegiances. Although Birch was English, he presumably harbored more republican sympathies than did his first American patron, as his distribution of Payne's work, his family history, and his association with Mansfield suggest.[10] The contrast in tone between his encounter with George Washington and that with Thomas Jefferson would tend to support this as well. For this reason, he may have felt it expedient to distance himself from Bingham. Equally, and perhaps more significantly, Bingham may have felt no long-term obligation as a patron of individual artists.

Regardless of the causes of the end of Birch's relationship with Bingham, the artist soon discovered that he need not depend solely on his benefactor for support. Sometime not long after Bingham hired him as a drawing instructor he built his own enameling furnace, thus resuming the work that had

been the mainstay of his livelihood in London. He began his American painting career by making a portrait and a smaller replica, just as he had made multiple copies of Reynolds's portraits for English purchasers: "[I] painted a full size picture in enamel of Mrs. Bingham and a smaller one from it for Miss Bingham." Crucially, however, these paintings led to independence: "finding orders for portraits came in fluently, I gave up my [drawing] scholars" (p. 193).[11] This initial "fluency" must

FIGURE 40. William Birch, after Gilbert Stuart, *George Washington*, enamel on copper, after 1796. The Cleveland Museum of Art. In memory of Ralph King, gift of Mrs. Ralph King; Ralph T. Woods, Charles G. King; and Frances King Schafer 1946.295.

have indicated to Birch that in America he need not depend on the "friendship" of a small group of wealthy supporters or on Bingham's largesse. The market for his work in the United States would allow him to operate independently.

No comprehensive record of Birch's enamels in this period is known, but arguably the most important feature of this work were his copies after Gilbert Stuart's (1755–1828) bust-length "Vaughan"-type and "Athenæum"-type portraits of George Washington of 1795 and 1796 (figure 40; see figure 110).[12] He reports in his autobiography that "I painted about sixty portraits of it, from thirty to one hundred dollars each," and asserts that most of the purchasers for these enamels were foreign visitors to the national capital (p. 202).[13] For example, for the British commissioner John Guillemard (who also subscribed to the *City of Philadelphia*), he notes that "I attended as usual as to foreigners with my picture of Washington in enamel" (p. 202). Guillemard paid the high price of $100 in 1798; interestingly, this was the same fee Stuart received for the replicas of the "Vaughan" portrait, for which he received many orders.[14] Birch clearly recognized the opportunity presented by the popularity of Stuart's painting and capitalized on it. As one might expect, he does not draw attention to his business acumen in recounting the circumstances that led to these copies—instead he emphasizes his access to both Washington and Stuart in much the same manner as he stresses his relationship with Reynolds and the gentry and nobility in London. Birch may have initially envisioned a relationship with Stuart, reproducing his portraits of wealthy citizens, much in the way he had copied Reynolds's work.

The moment when Birch first met Washington must have been remarkable for him, as he had never before had direct contact with the leader of a nation; and it must have suggested grand things. Birch notes that when the president "was sitting to Stuart he told him he had heard there was another artist of merit from London, meaning myself" (p. 195). Washington agreed to sit for his portrait for Birch.[15] Birch also records that other foreigners purchased his original enamels. For example, the Spanish envoy in Philadelphia, Josef de Jaudenes y Nebot (1764–before 1819), sat for his portrait in 1796 and subsequently "employed [Birch] the whole summer" (p. 197).[16]

Shortly after his emigration, Birch became involved in one of the earliest American efforts to found an arts academy, the Columbianum, which was launched in Philadelphia late in 1794. Although the venture was short-lived and one of the most contentious of such schemes, his participation demonstrated that, compared to many of his contemporaries in the United States, he had a substantial amount of both skill and training.

The Columbianum was composed of a group of artists, including Charles Willson Peale, a number of immigrants, and a small group of amateurs.[17] A schism developed in the group early in 1795 over political rather than strictly artistic questions. The Federalist faction "envisioned not only a republican Royal Academy, with the president, George Washington, as the principal patron in the place of the king, but also an institution of large intellectual and national proportions." The Jeffersonian group was "opposed to naming a Federalist president as primary patron."[18] Peale sided with the latter and most

of the recent immigrants with the former. Birch, however, remained with Peale's group, confirming more republican political sympathies than he acknowledges in his autobiography.[19]

Like Birch, many of those involved in the Columbianum were recent arrivals from Britain who had spent time at the Royal Academy. A constitution based closely on the structure of the academy was drawn up and published early in 1795.[20] While in London, Birch was one among many familiar with Reynolds's teaching; in Philadelphia, however, he was a member of a small elite who had this knowledge. Although Birch was apparently not on the drafting committee, Article IX of the constitution recalls Birch's successful plea to Reynolds for the exhibition of enamels at the academy: "no Paintings shall have a place in this exhibition except done by the modern Artists, and which have not been before exhibited in any public exhibition in the United States of America, *nor any copies of any kind received, except those done in enamel*" (emphasis added).[21] The description of the duties of the professor of chemistry also recalls Birch's account of recording Reynolds's fugitive pigments in enamel: "He is to give one lecture on such branches of that science as may respect the durability of formation of colours."[22]

Birch and his family were also prominent in the record of the only exhibition mounted by the Columbianum, which took place in May 1795.[23] His seventeen entries are more numerous than those of most other exhibitors. The penultimate is particularly intriguing: in at least one copy of the catalogue, the printed text is crossed out in ink, in a contemporary correction, which notes that "A proof print done from a portrait

of Mr. Jefferson in Peale's Museum. This is offered as a specimen of a series of prints, to be made from Peale's collection of celebrated personages in the American Revolution." This reference to a proposed series is followed by "a subscription paper is opened, and may be signed at the door, and also may be had other prints, by Mr. Birch," but this is also deleted. No print relating to the "gallery of great men" in Peale's Museum is known to have been produced. In fact, Peale's name is conspicuously absent from Birch's autobiography, suggesting some sort of rupture. Further, he never refers to the Columbianum venture, certainly because of its short life and contentious dissolution. Despite its failure, however, Birch's involvement demonstrated that he was not a minor practitioner in the American context, even if he specialized in a "minor" art.[24]

Birch's activities were soon not limited to paintings, prints, and enamels. An incident in Birch's autobiography reflects the opportunities he found in the United States to expand the horizons of his professional activities. Around the time that he and his family moved to Burlington, New Jersey, on the Delaware River (ca. 1797), he was approached by the "mayor and aldermen of that city, wishing to have a plan of the city and island," who asked Birch to "undertake it." Birch responded that they had mistaken his "profession," as he was not a surveyor: "'I have never practiced in that line, and do not know if I could do it.' 'We do not ask you, Mr. Birch, what you can do; we ask you if you will undertake to do it.' I said I had no objection to an order if I could execute it. They then asked my terms" (p. 200).[25] This must have been a remarkable event for Birch. Taken at face value, it is as if his mere presence were sufficient

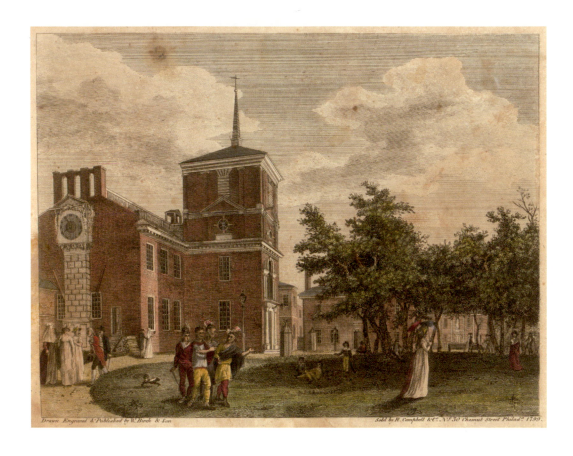

Drawn Engraved & Published by W. Birch & Son Sold by R. Campbell & Co. No 30 Chesnut Street Philada. 1799.

FIGURE 41. William Birch and Thomas Birch, *Back of the State House*, hand-colored engraving, 1799, from *The City of Philadelphia*.

to reveal his talent to the town elders—as if Birch walked in a visible nimbus of genius. It is more likely, of course, that some aspect of his work had become known to the mayor and aldermen of Burlington, specifically his engraving skills. It is clear from the drawings Birch made for his own landscape garden at his country house, Springland, on the Pennsylvania side of the Delaware River, that he was capable of drawing plans competently, although it is not known how he acquired the necessary training in surveying.

Despite his response to the aldermen that they had "mis-

taken his profession," this incident demonstrated to Birch that in the New World his artistic practice could expand beyond its previous limits. This must have seemed even more significant than the "fluency" of recent enamel orders and the demonstration of his status in the Columbianum. Although at first he hesitated, modestly, to conduct the Burlington survey, he quickly came up with a scheme for payment, as he was "unwilling to turn away an order": "I told them one hundred subscribers at five dollars each, I thought, might enable me to deliver each one an impression of a plan but that they must

secure the subscription themselves. They agreed" (p. 200). This commission provided the best of all possible worlds for Birch—not only could he be paid very well for his work, it might come to him unbidden. This must have seemed a particularly auspicious event.

Birch's Burlington survey (see figure 114), published in Philadelphia in 1797, confirmed his abilities and satisfied his patrons. He had begun a new professional identity. He recounts that "he "surveyed the island and town-each town lot correct and each meadow distinct. [I] penciled it neat[ly] upon paper with a view of the city from the Delaware at the bottom of the plan." After the engraving of the drawing, some of the subscribers "called and said they thought there was something incorrect in the lines of Assicunk Creek." Upon Birch sending them back as "men of science" to "examine [them] again," they "returned and soon after told it was correct and that it should no longer be called 'Assicunk Creek' but 'Birch's Creek,' by which name it now goes. This order assisted and gained me credit" (p. 202).[26]

PROFITS PROJECTED:
THE CITY OF PHILADELPHIA

In 1798, the year following the completion of the Burlington survey, Birch began the project that would constitute his greatest commercial success in the United States: the *City of Philadelphia* (figure 41). This volume of twenty-eight views of the "Metropolis of America" (its original title) was arranged in a didactic order to demonstrate the mercantile strength and cultural richness of the city. It was completed around the close of 1800 and remains his best-known work.[27] The project, like the Burlington survey, marked an expansion of his artistic identity—as the master of a workshop. He described the production method in his autobiography: "I superintended it, chose the subjects, instructed my son in the drawings, and our friend Mr. [Samuel] Seymour in the Engravings" (p. 204).[28] "W. Birch and Son" appear together as authors on the title page; this shared authorship reflected both the coming of age and the growing artistic maturity of Thomas, who turned twenty-one in 1800 and went on to a successful career as a painter of full-size oils.[29]

Birch purchased property on the Delaware River north of Philadelphia in Pennsylvania in 1798, probably using the fee from the Burlington survey project.[30] Rather than buying a city property that might have been used as a workplace, he chose to acquire a country "seat," an emblem of gentlemanly status. At the same time, he also intended that the designs for his buildings and landscape garden on the property, which he named Springland, would demonstrate his professional skills: he described it in his autobiography "as a sample to serve the country" (p. 231).

Birch's planned publication and the development of this estate are linked in his autobiography: "I settled my family [on the bank of the Neshaminy Creek], in a small tenement 'til I could form a plan for building, and forward the work of my Philadelphia views, which I had projected as a work of duration" (p. 204). Birch prepared a set of drawings for the house and landscape (see figures 117–21), and by 1800 he had gathered enough subscriptions for his publication to begin to

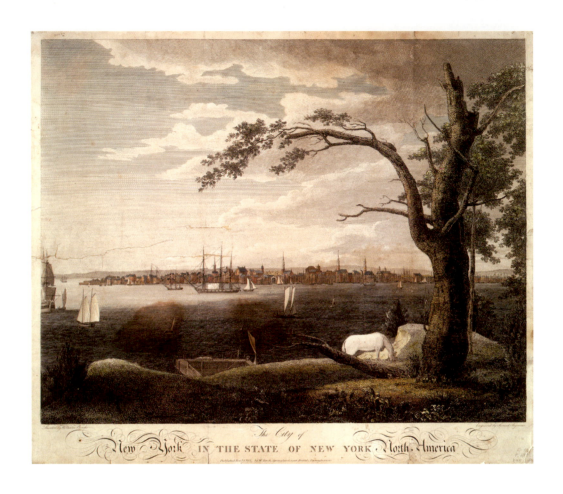

The City of
New York in the state of new york · North-America

FIGURE 42. Samuel Seymour, after William Birch, *City of New York in the State of New York North America*, hand-colored engraving, 1803. I. N. Phelps Stokes Collection, Miriam and Ira D. Wallach Division of Art, Prints and Photographs, New York Public Library, Astor, Lenox and Tilden Foundations.

build, noting in his autobiography that "the cottage [was to be built with] the profits of the Philadelphia views" (pp. 217–18).

A chronology of the publication can be determined from several documents in addition to Birch's autobiography and the dates inscribed on the plates themselves. The most important of these is a manuscript subscription list contained in a bound volume titled "Subscribers to Philadelphia, Second Edition," which includes lists for all four of the editions of the Philadelphia views, issued in 1800, 1804, 1809, and 1827–28.[31] The first heading gives Birch's original title for the set—"Philadelphia dissected or the Metropolis of America"—and identifies its projected scope as "25 or 30 of the principal Buildings and Views thereof."[32]

In the end, the volume included twenty-seven original views, a title page, a plan of the city, a page of introductory text, and the subscribers' list. Birch dated the vast major-

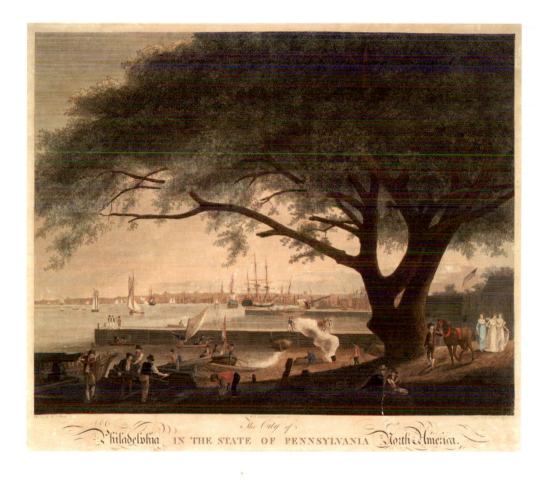

The City of Philadelphia IN THE STATE OF PENNSYLVANIA North America.

ity of the views, as he had for the engravings of the *Délices*. Four of the dated plates were produced in 1798, including two views around the Pennsylvania State House. In the following two years Birch revised two of these first images: the plate for a view of High (Market) Street looking west from Fourth Street was reworked to show the memorial procession for George Washington held after his death in 1799. Birch also put aside his first treatment of the view of First Bank of the United States and an entirely new image of the subject was prepared.[33] The first names on the subscribers' list were probably also entered in 1798.[34] In February 1799, Birch issued a notice of the project and the publication of the first two views in the press.[35] By then he had also conceived the final form of the frontispiece (see figure 56), one of the best-known images of the set, which he described as "a general view of the City, from the great tree at Kensington, with the Port, and

FIGURE 43. Samuel Seymour, after William Birch, *City of Philadelphia in the State of Pennsylvania North America*, hand-colored engraving, 1801. I. N. Phelps Stokes Collection, Miriam and Ira D. Wallach Division of Art, Prints and Photographs, New York Public Library, Astor, Lenox and Tilden Foundations.

FIGURE 44. William Birch, *Plan of the Chesapeake Bay and Surroundings*, graphite and watercolor on paper, ca. 1800–1810. The Athenæum of Philadelphia, gift of the McNeil Americana Collection.

depict buildings completed in 1800, rounded out the twenty-seven views.

Despite his emphasis on Philadelphia, Birch also planned to produce views of New York. An undated broadside proclaimed his "intentions to picture the two principal Cities of North America." His statement that he had already "completed a part of his undertaking in a work of Philadelphia" suggests that this prospectus was issued in 1798 or after. He describes his planned set of views of New York as a "companion volume" to the Philadelphia set, noting that the former "is to be published the same size and in the same stile" as the latter, but that "[it] will have only 19 Sections." He concludes by asserting that "the Drawings . . . are nearly completed" for the New York set.[37] No such New York publication was ever produced, however. In his autobiography, Birch remarks that he "took many turns to New York where I met with friendly reception and politeness"; "I had nearly completed a set of drawings of that city which I meant to publish as a companion volume to the Philadelphia views." He concludes by adding that he "found that the profits of the undertaking were not equal to the expense of travelling and the support of my family" (p. 230). Only two plates were produced for the incomplete New York set.[38]

The broadside also announced a second ancillary publication to the *City of Philadelphia*, which Birch described as "two large Plates . . . of the general Views of the two Cities" (figures 42 and 43). The Philadelphia print is a "view . . . taken from the great elm at Kensington," the same subject as the frontispiece for the *City of Philadelphia*. The view of New York is

River." In addition, he now made it known that the set would "consist of about thirty plates." Because this approximates the eventual total, he may by this point have selected the specific subjects for the prints. The bulk of the work for the volume took place that year, when fifteen of the dated engravings were completed. The remaining six dated images (including the reworked 1798 High Street plate), were finished in 1800, as well as the frontispiece.[36] Three undated prints, two of which

"from the opposite shore of the Sound … the Bay is seen, and the opposite bank of the North River over the busy town." Both prints were completed and sold separately; a section of the manuscript subscription list records buyers of single sheets, both framed and unframed, which could correspond in part to these "large Plates."[39]

There were approximately forty subscribers in New York and its immediate vicinity, as well as in locations in New Jersey between the city and Philadelphia, confirming Birch's account of journeys back and forth.[40] Sometime shortly after 1800 the work on the views "became forward enough for delivery in part," where he had decided to travel to sell additional subscriptions. Fees already collected for the first edition also gave him the confidence and the wherewithal to combine commerce with gentlemanly visiting and touring. Having procured a "gig and a little black mare of the Canada breed," he "packed up my work and journeyed towards the south." He stopped en route, visiting "those characters most distinguished in my former connection [and] with those I wished to improve my knowledge of" (p. 218). Birch's statement is somewhat misleading because he was not delivering first edition copies to purchasers, since many names that appear in his manuscript list are absent from the published version.[41] Instead, he was probably using partially completed sets to promote his work. The manuscript list suggests that the journey (or journeys) to sell the *City of Philadelphia* took place after the completion of the bulk of the work for the first edition (including making the printed subscribers' list) but before he had begun the second edition (issued in 1804).[42] During the first decade of the nineteenth century, the profits of the *City of Philadelphia* allowed him not only to acquire an estate but also to conduct gentlemanly tours as he had done in England. He continued to go south after he had found other work there, until perhaps as late as the appearance of the *Country Seats* in 1808.

JOURNEYS TO THE SOUTH:
EXPANDING PROFESSIONAL
HORIZONS

The manuscript subscription list for the *City of Philadelphia*, Birch's autobiography, and drawings from his scrapbook indicate that stops on his tours south of Philadelphia included New Castle, Delaware, Baltimore and Annapolis, Maryland, and Washington, D.C. (figure 44).[43] He went as far south as northern Virginia and also journeyed on the eastern shore of Maryland, from southern Dorchester and Somerset counties north through Talbot and Kent counties. On the western shore, he visited parts of Harford and Cecil counties near the confluence of the Susquehanna River and the Chesapeake Bay. While traveling in Maryland and Delaware, Birch received a number of landscape commissions—none had come his way in Philadelphia. He was also welcomed by members of the highest social rank, recalling his success with the British gentry and aristocracy.

As Birch's reference to his "former connection" suggests, one of his motives in traveling was to reestablish ties with family and friends, all of whom were in Maryland. His rela-

tives included the family of his maternal aunt (whose married name was Onion) who lived in Harford County, as well as the family of his cousin Thomas Russell, who had settled at North East, Cecil County, to oversee the Principio Iron Works. His closest and most professionally fruitful family connection was to U.S. Supreme Court justice, Revolutionary leader, and Annapolis native Samuel Chase (1741–1811). Chase, although older than Birch, was technically his nephew by Chase's father's second marriage to Birch's much older sister Ann in 1763.[44] One of the pleasures of his travels was meeting his nieces Elizabeth and Ann, Samuel's (much younger) half sisters who had been raised with Samuel's own children.[45] Birch

reports that Samuel had "frequented my house in London . . . [and] persuaded me to go to America" when Samuel was in England in 1783 "over on the Maryland business," that is, the attempted recovery of the state's Bank of England stock from fugitive loyalists (p. 192). He had made his first copies after Reynolds that year, and leaving London at that moment, when prospects were good, held little attraction.

Birch reports that "Judge Chase had kindly offered me a room in his house whenever I made a stop in Baltimore." Because of this family connection, he found himself "much better known [in Baltimore] than in Philadelphia" through Chase's introductions.[46] While Birch sold many copies of the *City of*

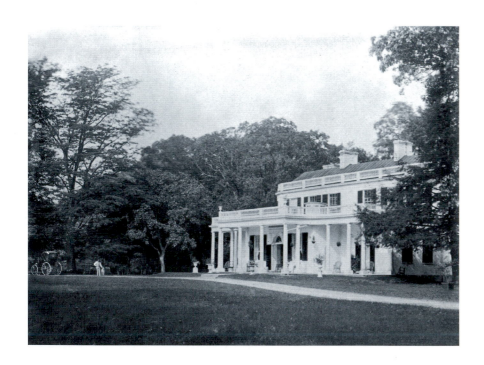

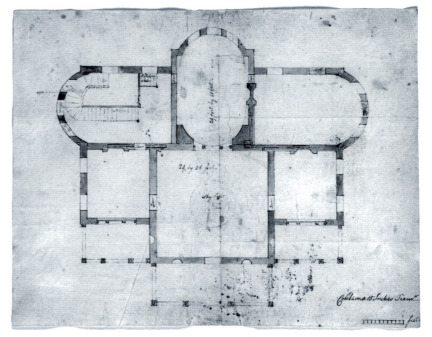

Philadelphia in the city that was its subject, he pointedly contrasts the support for these views among the Maryland gentry and a failed subscription in Philadelphia: "Mr. [Charles] Carroll of Carrollton took great pains to secure a subscription for the Baltimore library and took one for himself also, though I had not succeeded in securing one for the Philadelphia library." Charles Carroll, Jr., builder of Homewood, which survives on the Baltimore campus of Johns Hopkins University, also subscribed. Birch's introduction to this prominent family was undoubtedly made by Chase.

Family associations also account for subscriptions around Annapolis, including one from Maryland governor John Francis Mercer (1759–1821).[47] Birch had the opportunity to meet his niece Elizabeth for the first time at Mercer's home in the Maryland capital and notes that she was "one amongst the first class of the elegants of that popular city" (p. 227). His reception in Annapolis indicates that he shared her social status by association. Mercer also invited Birch to his "elegant farm" near the town, where he dined with the governor and his sister, "a lady of great taste" (p. 228).

Birch reports that "[Mercer's sister] had late returned from London, and when the [table] cloth was removed she produced for me a volume of British views. I found [it] to be my own work, under the title of *Délices de la Grande Bretagne*, …which she purchased in London from seeing my name to it" (p. 228). As in Burlington, New Jersey, Birch found his reputation had preceded him to Annapolis, but here it was *created* (not merely heralded) by his relatives. In Britain, as in Philadelphia, his picturesque views had sold well. But while copies of the *Délices* had been purchased for the royal libraries, his work was one among many of such publications, and he certainly had no personal connection with the monarchs. In Maryland, both Birch and his work were received as rarities, and he had the support and personal attention of members of the highest social stratum. Instead of being known primarily as an enamelist (a "copyist"), he was acknowledged there both as an engraver and as the creator of original, important work to a degree that he had not been before. Carroll's insistence that the *City of Philadelphia* be included in a public collection and Mercer's sister's interest in the *Délices* marked a new level of recognition.

One of the most significant features of this recognition was the landscape design work that it brought. During his visit to Annapolis, Jeremiah Townley Chase asked Birch to consult on possible improvements to the garden of his nearby country seat.[48] Birch's only landscape designs in the Philadelphia area were for his own property, Springland, but in Maryland and in Delaware he was hired as a landscape gardener and, on at least one occasion, as an architect. His autobiography and his patrons' correspondence indicate that his talents, skills, and experience as a landscape artist were directly connected with his commissions as a designer.

The precise dates for most of these designs are uncertain, but his first project, for the Baltimore merchant Samuel Smith, occurred before 1800. Smith was in Philadelphia as a U.S. representative between 1792 and 1800, and subscribed to the *City of Philadelphia*. How Birch first met him is not known; Birch makes no mention of him in his autobiography.

See Hampton's Splendid Seat,
in Mary land's State,

On an eminence in pure air, and Scens of Woods,
And distant Lands, and Lawns checkerd in rich
Culture ore extend space; — with sparkling
Forges for the London Trade, now for home consumption used.

In the letterpress for the *Country Seats*, he identifies Smith's turn-of-the-century country house north of Baltimore, Montebello (figure 45), as his design, and Birch's plan for the house survives (figure 46).[49] He may also have had a hand in designing the landscape garden there but did not claim it.

The house, which survived into the twentieth century, was unusual in the somewhat awkward juxtaposition of its two principal volumes of different heights: it consisted of a two-story and basement, apse-ended volume fronted by a one-story volume with a large reception hall illuminated by a roof lantern. The design owes much to the work of the Adam brothers in its curvilinear interior geometry and column screens; it recalls Kenwood specifically in the off-axis stair seen in the northwest corner of the plan. Many of the details of Birch's design, including its abstracted classical vocabulary, recall motifs of Latrobe's work in the early years of the nineteenth century. The two emigrants met in Philadelphia, and the architect's work there at the turn of the century is featured prominently in both the *City of Philadelphia* and the *Country Seats*; Birch probably also saw some of his drawings.[50] Birch was, in any case, quite familiar with the English architecture that informed the work of his fellow expatriate.

Birch credits an introduction by Samuel Chase for a commission at Hampton, the vast estate in Towson, Maryland, owned by Charles Carnan Ridgely (1760–1829). There, Birch designed a portion of the landscape garden, although no plan survives. Hampton (figure 47) later became the subject of another plate in the *Country Seats*, and the engraving, which shows the lawn on the north side of the house and a mixed

bed of shrubs and herbaceous plants, probably represents an aspect of his scheme. Birch records this project in his autobiography, saying that "Hampton is beautiful and richly deserves the embellishment of art in its improvement. I made several designs for that purpose which were approved" (p. 222).[51]

Birch's garden design for Riversdale, a property in Bladensburg, Maryland, is the only such project for which a date is known.[52] The house was begun by Henri Joseph Stier (1743–1821), an aristocratic Belgian refugee who lived with his family in the United States for slightly less than a decade. After arriving in Philadelphia in 1794, the Stiers moved to Annapolis for a period and finally began to build at Bladensburg in 1801.[53] Henri and his son Charles Jean commissioned Benjamin Henry Latrobe for designs for the house but ultimately did not build strictly according to his plans.[54] Father and son returned to Europe in 1803, leaving the property to Henri's daughter Rosalie, who had married George Calvert of the prominent Maryland family (the former lords Baltimore) in 1799. Henri Stier met Birch in Baltimore shortly before his departure and discussed plans for a landscape garden at Riversdale.[55]

Jeffrey Cohen and Charles Brownell note that Henri and Charles Jean Stier were "possessed of decided architectural preferences" and had hired Latrobe to give final form to their own architectural design.[56] Henri Stier's correspondence with his daughter indicates that he also had specific ideas about landscape gardening. He wrote to Rosalie in August 1803, after his return to Europe, describing his scheme for the garden and giving a sense of Birch's accommodating manner

with his potential client, guiding rather than imposing his own notions.

> I am pleased with his [Birch's] industry and I was thinking of advising you to employ him to make a plan for the two parts of the grounds, to the north and the south of the house. To the north he could lay out for you a meandering lake, a little like the one I had planned but larger. I think he will have to locate some clumps of trees in the level area especially to hide the orchard. The south side offers more opportunity to the architect; he will be able to design clumps of trees which will make the landscape, and to give you an economical plan for the improvement of the milk-house and steward's house.

Significantly, Stier then articulates the essential relationship between landscape representation and design, perhaps based on Birch's own opinions: "I believe it is absolutely necessary to have an architect who is also a painter to design the landscape plan, and I believe Mr. Birth [sic] is the best one for the job. The grounds have great potential for a beautiful landscape and some money spent in this project will bring it about. If you decide to have him make the plans please send me a copy."[57] Birch reports the Riversdale commission in his autobiography, remarking that the house stood "on a situation capable of great improvement" and that the subject of the landscape garden was "an object [Henri Stier] seemed to dwell upon and treated largely upon with me" (p. 225).

Birch was not hired for the project until 1805, howev-

er, when he began to prepare plans in the fall.[58] Latrobe was brought back by the Calverts at the same time to provide interior details, and with the elder Stier back in Antwerp, both professionals had freer rein to carry out their designs. By September 1806, Birch had completed his scheme, which included an artificial lake on the south side of the house, rather than on the north as Stier had recommended.[59] Riversdale sits on a rise with its south front facing the District of Columbia and its main entrance to the north. The house therefore resembles Kenwood, which overlooks London, in its relationship to the capital and in its general physical circumstances. Birch's placement of the lake to the south of the house further recalls the arrangement there.

Birch did not participate in the implementation of his plans and probably never saw the grounds after the work was finished. He notes in his autobiography that he believed "very little was done" according to his design (p. 225). His drawings do not survive, but brief descriptions of the garden in Rosalie Stier Calvert's correspondence suggest that some of his ideas may have been carried out, including the water feature to the south. It may be that a system of paths with Brownian "clumps" of trees and shrubbery on the north side of the house can also be credited to Birch.[60]

Birch was also successful as a landscape gardener in Delaware. In his autobiography, he notes that in his journeys south "I made my first halt at Wilmington," suggesting that his work there probably occurred at the turn of the century when he first traveled in that direction. His clients included James Tilton (1745–1822), a medical doctor and former member of the Continental Congress. Birch notes in his autobiography that Tilton's house outside Wilmington stood on a hill, like Riversdale, in a "fine situation." He then remarks that "the ground[s] wanted a plan about the house. I made him a drawing, by his desire, for which he rewarded me handsomely, and [he] was well pleased." Tilton also led Birch to another patron: "He introduced me to Mr. Rodney who had a lot next to his more favourable for improvement. He was about to build upon it, [and] I made him a plan for the arrangement of it, which he approved, but I believe was not adopted" (p. 219).[61] Like the Riversdale and Hampton schemes, neither of these two is known to survive.

In addition to these two Wilmington commissions, Birch made a drawing for a garden for George Read, Jr. (1765–1836), in New Castle (see figure 127). His perspective shows a lot that Read owned on the Delaware River opposite (east) of the main façade of his house, which was completed in 1801. Birch's symmetrical design consists of a lawn protected from the street by decorative fence and gate, with an elliptical path leading to steps to the river. The flanking buildings on adjacent properties are screened by mixed beds of trees, shrubs, and smaller herbaceous plants. His drawing was probably made when the house was nearly complete. He makes no mention of Read in his autobiography, and Birch is likewise absent from Read family documents. Nor was the design ever executed. Birch probably made his plan on speculation, inspired by Read's investment in a new, grand house. Although Read was apparently not interested in Birch's design, he did subscribe to the *City of Philadelphia*.[62]

Birch's work as a landscape designer did not continue into the second decade of the nineteenth century. Despite the removal of the federal government, the expansion of commerce and population in New York City and Baltimore, and his early successes in Maryland, he chose to remain in the city to which he had emigrated, undoubtedly because of the popularity of his first set of American views, which was intimately connected to that city by its subject and its support. Philadelphia remained the national cultural center, the "Athens of the Western World," until well after the War of 1812. Birch's most successful years had passed, however, by 1808, when he issued the *Country Seats*. For unknown reasons, he did not, like Gilbert Stuart, follow the government to Washington, nor did he move to Maryland where he had been so warmly received. Instead, he chose to stay where he had established a life with his family, but he never repeated the level of success of the *City of Philadelphia* and his design work in the south. By the 1820s he had grown embittered, and his autobiography bemoans the poor support for the arts in the United States.

By 1804, Birch had decided to publish the second edition of the *City of Philadelphia*, undoubtedly to finance his ongoing improvements at Springland and his trips south. Because the majority of subscribers to the first edition had ordered the colored version of set, Birch had the confidence to issue the twenty plates of the second in color only.[63] He prepared four new plates for the 1804 publication, including one of the main front of the Chestnut Street Theater showing the completed 1801 alterations by Latrobe and another of the first permanent bridge over the Schuylkill River.[64] Several prominent Philadelphians purchased this edition, including wealthy merchants Henry Pratt and Stephen Girard, as well as the aptly named physician Philip Syng Physick, but the number of supporters did not reach half the number of the first.

Birch undoubtedly had hoped for more; he could no longer finance his work at Springland and lost it to creditors in 1805. He continued to live there after the sale, however, presumably as a tenant; the text for the *Country Seats* notes that the "volume with [Birch's] other works may be had at this place." He records in his autobiography that he supervised improvements to the property for approximately a year for the "whimsical purchaser," John Barker. As this characterization suggests, they disagreed, and Barker brought suit against Birch, who nonetheless repurchased the land in 1813 and sold it again in 1818 at a significant profit. Whether he lived in his "Green Lodge" during this entire period is not known.[65]

Despite his financial difficulties, or perhaps because of them, Birch had decided by 1808 to publish a set of plates titled *The Country Seats of the United States of North America*. He issued an advertisement in September in the Philadelphia newspaper *Poulson's American Daily Advertiser* soliciting subscriptions. His troubled circumstances were reflected in his pricing: "In order to bring [the work] under the slightest abilities for patronage, [the author] has put the price very low."[66]

It is not certain when Birch conceived the project, but he

was probably interested in publishing his own garden designs from an early point, perhaps before the *City of Philadelphia* was completed around 1800. The drawings in his scrapbook, all of which are undated, included several views of Springland. Two of these were reproduced among the twenty plates of the *Country Seats*. The material from his scrapbook also included a plan of Springland, and a title page for a projected work—"Views of and from the Country Residences of William Birch. Drawn by Himself"—indicating that at some point he projected a publication devoted exclusively to his own designs (figure 48).[67] The success of the *City of Philadelphia* instead led him to publish a second volume of American scenery in which his own designs were but one part. The relatively small number of his design commissions was also certainly a factor.

The nationalistic title for the set, *The Country Seats of the United States of North America*, reflects both the common rhetoric of the period and his wish to equal the scope of his *Délices*. Rather than presenting a variety of subjects as he had in that first set of views, Birch concentrated on one picturesque genre. His emphasis on rural (in the contemporary sense, which is closer to the modern understanding of "suburban") estates was based on several factors, including the success of similar publications in Britain. *The Country Seats* allowed him to present his designs in the larger context of country life, an evident preoccupation of Americans in the early national period.

Americans then tended to emphasize democratic, quasi-populist principles in their public rhetoric. One need only think of the frequent invocation of the model of Cincinnatus in connection with George Washington or Jefferson's famous

characterization in his *Notes on the State of Virginia* of "those who labour in the earth" as the "chosen people of God" to see how contemporaries valued the humility of the Roman general returning to his farm and the "natural" nobility of the common farmer.[68] Birch did not echo this sentiment in the *Country Seats*. Instead he repeated a point from the introduction to the *Délices*: the national leadership (and implied superiority) of the most "upper sort." He had remarked in the *Délices* that the "whole island is scattered over with palaces of nobility, from whose improvements the combination of art and nature can effect wonders." In the *Country Seats*, he also associates the upper class with "improvement."

The awkward first paragraph to the introduction exhorts the wealthy to take on a national, exemplary role through their use of the "Fine Arts." Birch begins by drawing a parallel between the youthfulness of the republic and the underdeveloped state of its professional artistic practice. His concluding appeal to the upper class was undoubtedly influenced by his satisfactory relationship with patrons in Maryland and Delaware: "The Fine Arts are, as to the American Nation at large, in their infancy; to promote them in propogating [*sic*] Taste with the habit of rural retirement, supported by the growing wealth of the Nation, will be to form the National character favourable to the civilization of this young country, and establish that respectability which will add to its strength."

Birch's successes as a designer in the south notwithstanding, many Americans were not ready to subscribe publicly to such elitist notions, whatever the private realities. No subscribers' list survives for the original edition of the *Country Seats*, and therefore it is not known how many copies were

FIGURE 48. William Birch, *Views of and from the Country Residences of William Birch,* ink on paper. Carson Collection.

produced. The relative scarcity of surviving copies of the *Country Seats* indicates that it did not sell nearly as well as the *City of Philadelphia*. Neither is it known if he tried to sell the volume exclusively in Philadelphia or if, as for the earlier views, he sought patrons in the south or elsewhere. He probably solicited the owners of the properties where he had worked, but the support of this small group would have been insufficient for the *Country Seats* to match the success of the first American set. The lack of support for the *Country Seats* was probably a significant professional disappointment, but Birch is remarkably terse about it in his autobiography. He merely notes factually that "I have published a set of Country Seats, the principal plates of which, so far as it continued,

were the seats on the Schuylkill River. The work extended to twenty plates, the only work of the kind yet published, but want of encouragement stopped its progress" (p. 203).

Birch never again attempted to publish a set of original views. After he issued the *Country Seats*, Birch continued to produce editions of both of his American publications until the end of his working life about 1830.[69] The support for the later versions of the *City of Philadelphia*, published in 1809 and 1827–28, was minimal in comparison to the book's initial success. The 1809 edition mustered at most twelve supporters. The interest in the final edition was even less, with only five subscribers, although one of these was the architect William Strickland.[70] Additionally, the final edition had a decidedly nostalgic tone: Birch reworked the inscriptions on several of the plates to reflect the passing of the landmarks he had celebrated. For example, the plate for the frontispiece, which shows the city framed by the mythic Treaty Tree, was reworked to record that it had "Decayed & blow'd down in 1810."

The second and last edition of the *Country Seats*, produced at the same time as the final issue of the *City of Philadelphia*, consisted of twelve of the original twenty plates, mostly of sites in the Philadelphia vicinity.[71] It fared somewhat better than the later versions of the Philadelphia views, with some twenty-odd subscribers. Included in the list was Cephas Grier Childs (1793–1831), with whom Birch exchanged his publication for Childs's 1827 *Views in Philadelphia and Its Environs* (figure 49), the first exploration of the subject since Birch's own works.[72]

FIGURE 49. Cephas Grier Childs, after George Mason, *Eaglesfield*, engraving, from Childs, *Views in Philadelphia and Its Environs*. Philadelphia: C. G. Childs, engraver, 1827–30. Courtesy the Philadelphia Print Shop.

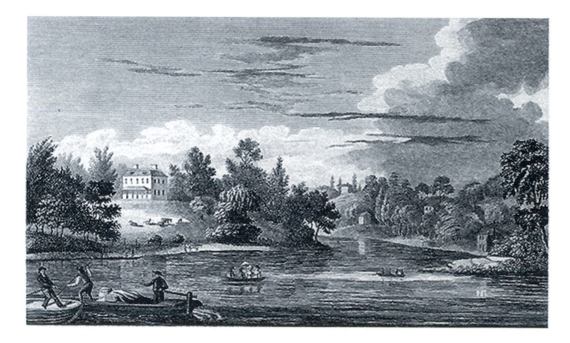

death.[74] He mentions none of these activities, however, in his autobiography.

Rather than discussing this later work, Birch dwells on his difficulties. He further complains in his autobiography that "the art of enamel painting here [was] not understood, [nor] encourage[d] enough to excel. I found my profession dwindling into contempt" (p. 230). Although he refers here to the market for his enamels, the "dwindling" of his "profession" as a landscape artist—a creator of both images and gardens—was undoubtedly more important to him. It is not certain why his design work ceased around the time he published *Country Seats*; it may be that he no longer had the financial means to continue traveling south where he had established a reputation. He places the blame in his autobiography on the poor support for the arts in the United States.

FIGURE 50. William Birch, after Ary Scheffer, *Marquis de Lafayette*, enamel on copper, 1824. Yale University Art Gallery, Lelia A. and John Hill Morgan, B.A. 1893, LL.B. 1896, M.A. (Hon.) 1929, Collection.

THE TRAVAILS OF THE "FINE ARTS"

Birch did, however, continue to paint enamels until late in life, including American landscape views and copies of Ary Scheffer's portrait of the Marquis de Lafayette produced for the Revolutionary hero's return to the United States in 1824 (figure 50), as well as copies of the European paintings in Birch's own collection.[73] He also sold drawings and expanded his repertory to include easel paintings by the end of his life, and he exhibited at the Pennsylvania Academy of the Fine Arts from 1811 through 1830, just four years before his

Birch was hardly alone in finding artistic patronage for his profession less than abundant. The contrast between the attitude toward artists in London and that of many upper-class Americans is illustrated by a description in Birch's autobiography of his visit to William Pinkney (1764–1822) in Maryland. Samuel Chase suggested in 1805 that Birch visit his fellow jurist and former pupil: "Judge Chase . . . told me I must not forget to call upon his friend Mr. Pinkney who was then Attorney General of the United States [and] to whom I could be of great service. He was building a splendid

and elegant house" (p. 225).[75] Chase provided Birch with a letter of introduction to Pinkney, who lived on the eastern shore of Maryland in the vicinity of Easton, where Birch traveled to sell subscriptions to the *City of Philadelphia*. He describes his approach in foreboding terms: "[I] took my route over the level roads under the towering pines of the gloomy forest, inhabited by the turkey buzzards, the bald eagle and the deer among the thickets. [I] call[ed] at the neighbouring seats with my work until I heard of Mr. Pinkney's place, which I found was ten miles out of my way" (p. 228). Birch is brightened by the sight of house: "[I] found it [was] situated on a beautiful island, [with] a splendid and extensive building in the most modern style worthy of an Attorney General. I looked out my letter, got ferried over and delivered it to Mr. Pinkney." Things, however, went downhill from there. He records that he found Pinkney "in an angry humour" and, upon discovering Birch's profession, "began complaining of the [artist] he had engaged in the house to paint five miniatures, whom he said worked one hour in the day and spent all the rest of his time in gunning, which did not suit him." After being rescued by the "ladies," who made "inquiries after my two nieces" and "sat me down to a comfortable dinner with them," Birch "returned across the water as soon as I could" (p. 228). Although Pinkney had purchased his work, he had little use for the gentlemanly behavior of that other, unnamed artist, since his expectations were clearly for a productive artisan.

Pinkney was not alone in that view, and the place of both the artist and the arts more generally in society was a subject of vigorous public debate at the end of the eighteenth century and the beginning of the nineteenth.[76] Americans largely felt that art was unessential, and undertakings that did not contribute materially to the democratic enterprise were at best suspect. Birch declares his interests to be opposed to those of many Americans in his autobiography, using terms to define the two camps that are derived from the contemporary debate: the "mechanical arts" and the "fine arts." For Birch, the latter implied not only painting and sculpture (and architectural and garden design) but the practice of these by trained professions who imbued their work with the "genius" Reynolds defined in his *Discourses*. Birch recognized that the relationship between these two arts was complex.

> This country is new and flourishing. The mechanical arts are at their highest pitch, but the fine arts are of another complexion. They are the last polish of a refined nation. . . . The distinction between the [mechanical] arts and the fine arts is not generally understood . . . our imitations of nature, however beautiful, are mechanical altogether. But [these imitations] may be considered as the first lesson necessary for the fine arts, and useful [in their progress] as furniture, as a watch or a lock, etc. may be. . . . A little mind cannot be a member of the fine arts whatever is his practice. (pp. 230)

Birch's complaint concludes with his bemoaning Americans' *retardataire*, middle-class consumer interests (by the standards of British elite taste as he absorbed them before his

emigration) by scornfully noting the businesslike nature of contemporary artistic practice in the United States: "portrait painting will made a trade, and furniture painting (as copyists[' work]) another, but they must not be depended upon for the fine arts" (p. 230).

The ambiguities and hesitations that bedeviled many American artists in the early nineteenth century were variously expressed. An example close to Birch in Philadelphia is a speech by George Clymer, first president of the Pennsylvania Academy of the Fine Arts, given at the 1807 opening of the institution. He begins by asserting the presence of artistic "genius" in the United States and presents the academy as an example of the advancement of American civilization. He dwells extensively, however, on the need for discipline in the arts in an argument against the excesses manifest by corrupt European nations (that is, the Italian baroque and the rococo). His discussion indicates some of the pejorative associations with the arts in the period. Clymer presents the cultivation of the arts as a choice of the lesser among inevitable evils.

> Between simplicity and refinement, or, if you will, luxury, the question has been frequent and undecided; but if luxury be a consequential evil of the progress of our country, a better question perhaps it would be, How is it to be withstood? Where an unrestricted and unoppressed industry gains more than simplicity requires, the excess, as it cannot be pent up, will be employed upon gratifications beyond it—how retain the cause and repress the effect? . . . Where a constantly rising flood cannot be banked out, the waters should be directed into channels the least hurtful—so ought the exuberant riches, which would incline towards voluptuousness, to be led off to objects more innoxious. . . .

> Such being the consequence of a growing opulence, the alternative would be, not as between simplicity and luxury, but between the grosser and more refined species of the latter. Where is the room then for hesitation in the choice?[77]

Shortly after this lukewarm endorsement, Clymer strives to merge the artisanal image of the artist both with Reynolds's concept of genius and with collective, nationalist effort: "the mechanick arts, we mean those of the more ingenious and elegant kinds, not failing of the inspiration, the workman in them is converted into an artist, and partake of the common benefit."

As Birch's writing indicates, this attempted melding of values did not sit well with immigrant British artists. While many other landscape artists, including George Parkyns and William Groombridge, struggled and even failed, he was among the few who effectively incorporated a sense of communal purpose—"common benefit"—in a work of art. This was one of the most significant causes of the success of the *City of Philadelphia*. Despite the nationalistic rhetoric of the letterpress of the *Country Seats*, the elitist notions inherent in its subject caused it to fail to find the audience for which Birch hoped.

Birch's American patrons fall into three broad categories. First were foreign visitors who bestowed upon him the sort of upper-class beneficence he had enjoyed early in his career, as did the second group, elite Marylanders, whom he encountered on his journeys south. Both approximated the British aristocrats and gentlemen who employed Birch in London and embraced the support of the arts as one of the obligations of their rank. Third were the merchant subscribers to the *City of Philadelphia*, who were both the most important and yet the most problematic supporters for Birch because their behavior diverged most substantially from that of his former British "friends." Seen together, these groups highlight regional American differences and underscore the different patterns of patronage for the arts on either side of the Atlantic.

Birch's Foreign Patrons and Social Status in the New World

Birch clearly took advantage of the presence of foreign dignitaries in Philadelphia while it remained the seat of the federal government. Like his London supporters, these foreigners in America bought his original and replica enamels, subscribed to his picturesque views, and included him in their social activities.[78] There was, however, a subtle but significant shift between the New World and the Old. In the democratic United States, the upper class was marked by wealth and social sophistication, and in the early years after his emigration Birch discovered that, because he possessed both in sufficient amounts, he was more nearly the social equal of his foreign aristocratic patrons in this new context than he had been previously. Indeed, passages in his autobiography suggest he thought of himself in some respects as superior to most Americans, even to the leaders of the nation.

The pleasures of upper-class country life along the Schuylkill River outside Philadelphia figure particularly in his discussions of foreign patrons. John Guillemard, the British commissioner who paid handsomely for an enamel of Washington, invited Birch to the Solitude on the west bank of the river. Guillemard had rented the house built by John Penn ("the poet") in 1784. This was another property that later became the subject of a plate for the *Country Seats*.[79] Birch remarks that they "spent some time together, [and] we visited about Schuylkill; we dined by invitation with Governor [Thomas] Mifflin at his beautiful spot by the falls, where we were entertained by feats of the revolution" (p. 203). Birch did not apparently socialize with Andreas van Braam Houckgeest (1739–1801), the Dutch China merchant whose China Retreat on the Delaware River near Birch's Springland was also included in the *Country Seats*. However, van Braam did purchase multiple copies of his portrait in enamel "for his friends" from Birch (p. 202).

In the United States, Birch also encountered and could

occasionally share the tastes of the virtuoso that are represented in his Wednesday evenings with Nathaniel Chauncey and his "looking at pictures" with Lord Duncannon. Birch's patron Henri Stier, the owner of Riversdale, "indulged" Birch by unpacking a case of the paintings Stier had brought with him, which Birch described as "the most splendid collection of pictures that ever came to this country. I understood [it] was the private collection of Rubens" (p. 225).

Birch's greatest intimacy with an aristocrat occurred when he and his wife shared the summer rental of Echo, yet another Schuylkill property represented in the *Country Seats*, with his patron the Spanish envoy Josef de Jaudenes y Nebot and his family in 1795 (see figures 112 and 113).[80] Birch was deferential ("we gave them the choice of apartments"), and their relationship was between artist and patron (de Jaudenes "was very fond of the arts, very rich, and employed me the whole summer"), but he pointedly (if indirectly) indicates a kind of social equivalency with the Spaniard. He was asked by de Jaudenes to appraise the diamonds belonging to "a lady refugee from France" (presumably another aristocrat) brought to him to purchase, because the envoy "was afraid to depend entirely upon his own judgment." The discrepancy between Birch's figure and the ambassador's "was twenty dollars only," suggesting a trifling difference between the appraisers themselves (p. 198).[81]

Birch clearly felt himself superior to most Americans in his artistic abilities and education. This is demonstrated in his account of his meeting with George Washington. His polite patience with the president is notable, as is Washington's apparent naiveté in artistic matters (in contrast to Birch's European patrons). Birch reports that he had the opportunity to show the president "a specimen of his talents" and that he "put the [enamel] picture into his hand." Washington "looked at it steadfastly" but had no other response, and so Birch, "feeling myself awkward, . . . began the history of enamel painting. By the time I got through he complimented me upon the beauty of my work" (p. 197).

Unlike Washington, Thomas Jefferson earned Birch's respect, specifically because of his interest in and knowledge of the arts (and Birch also favored his politics). Birch relates an encounter with him in Washington, D.C.:

On the route of business, I visited the President Jefferson about October 1805. . . . I found him alone and had an opportunity of talking with him. . . . Our conversation turned upon the arts, which induced him to show and present to me his portrait in a small print which I accepted graciously. But disapproving the execution of it, [I] told him (as I had so far ingratiated myself in his favour) I should request one more favour of him and that was not to give away another of those prints. "Why, Mr. Birch?" said he. "Why sir," I replied, "you are giving away your own caricature." He smiled and said he really always thought so. (p. 229)

"Characters Distinguished": Birch's Southern Patronage

Birch's patrons south of Philadelphia were particularly significant because they valued him as a landscape designer in addition to recognizing his merits as an artist. Of all the patrons and places Birch encountered in the New World, Charles Ridgely and his estate, Hampton, most closely approximated Birch's British experiences. Birch recalls that "the general's attention to me was very polite and marked with every appearance of respect. I stopped several days with him" (p. 222). Hampton provided its owner with his primary income, through both agriculture and an ironworks on a portion of the property. Although not as large as Chatsworth, the country residence of the Devonshires (Birch's "valuable patrons" in England), Hampton's house and land holdings were vast by American standards. The dwelling was built after the Revolution, but it recalled the traditions of the Chesapeake tidewater in its five-part Palladian scheme and early eighteenth-century British details, including a large central cupola derived from Sir John Vanbrugh's Castle Howard. Ridgely's allegiance to British aristocratic values also led him to adopt the behavior of his class that was most crucial to Birch: artistic patronage.

Birch was also welcomed by James Tilton: "I found a good friend in Dr. Tilton, a pious and good man; well-informed in taste and other matters of useful knowledge. I had occasion to stop some days" (p. 219). Birch is particularly effusive about his reception in Annapolis in Governor Mercer's circle.

Mercer, about "whose virtues and affability too much cannot be said," invited Birch "to an evening party . . . intended for the pleasure he should have in introducing me to my niece. I found [her] placed at the harpsichord in a large assembly of both sexes" (p. 227). Birch describes no Philadelphia patron or social scene that shares the conviviality of his southern experiences, with the exception of the hospitality he received there from foreign visitors. Birch is generally silent concerning his interaction with Philadelphia patrons, with the exception of his account of Bingham, with whom there was a noticeable absence of a social relationship. The material trappings of the Philadelphia "Federalist Court" did not necessarily imply the sense of obligation to the artist that it would have on the other side of the Atlantic.

A Work of Utility: The Patrons of The City of Philadelphia

In contrast to Birch's reception in the south, the wealthy citizens of Philadelphia apparently felt no obligation to maintain him personally, and they did not hail his "genius"; they did not accord him the status of gentleman-artist to the extent for which he hoped. Philadelphia merchants, however, held significance for Birch that their counterparts in Britain had not, and were among his most important patrons in their support for the first American set of views.

In his autobiography, Birch asserts a specifically mercantile purpose for the *City of Philadelphia*, saying there was

"scarcely one set of the work in Philadelphia that was not sent to Europe" for promotion: "no other work of the kind had ever been published by which an idea of the early improvements of the country could be conveyed to Europe, to promote and encourage settlers to the establishment of trade and commerce. [The nation's] early progress [led] the restless minds of those with capital to expect nothing but a forest" (p. 204). He goes on to claim that his work not only successfully fulfilled this purpose but that it also promoted an image of national civilization. He recounts that Europeans, "seeing number after number of the elegant establishments of a city" in his work, responded by sending every "aid that a new country could wish." Further, he asserts that

> it may easily be conceived what the opinion was of this work with our late friend and best-wisher to mankind [who] formed the Constitution of the country. It [should be] recollected that, during the whole of [Jefferson's] presidency, [the *City of Philadelphia*] lay on the sofa in his visiting room at Washington until it became ragged and dirty, but was not suffered to be taken away. I boast no merit in the work, further than its answering the above purpose or intention. (p. 204)

Birch's claim for this national role is germane to the battle in which Philadelphia was engaged for its place among the country's urban centers after the federal government departed for the District of Columbia in 1800. At the turn of the century, Philadelphia's merchants and its other cultural leaders were losing commercial and political ground with New York City and Washington, respectively. This rivalry was intense, and was explicitly discussed in a remarkably polemical passage from a city directory of 1804.

> Philadelphia is the capital of Pennsylvania, and the Chief City of the United States, in point of size and splendour; though it now fills but the second rank in respect to commercial importance: the trade of America having latterly flowed more freely into the open channels of the bay of New-York. It must also yield metropolitan precedence to the doubtful policy of *a seat of government, far removed from the chief resort of wealth and population.*[82] (emphasis original)

Birch's set of plates provided an image of the "Chief City" that both promoted it as an up-to-date, thriving business center and presented it as a cultural center, heralding the period in the early nineteenth century when it would be known as the "Athens of America."[83] Thus, the volume was directed at both foreign and domestic audiences, although it would be difficult if not impossible to gauge whether it achieved its intended purpose. Unlike the *Country Seats*, it expressed the early national emphasis on collective progress and achievement. More important, it had, as Birch put it, a specific "utility," a concept taken from ancient authors that was crucial in this formative American period. The *City of Philadelphia* was, therefore, a useful and tangible business tool for the wealthy merchants of the city, and they presumably purchased it

primarily on this basis and perhaps saw their role as art patrons secondarily.

Closer examination of the subscribers to the *City of Philadelphia* gives a more specific understanding of the set's reception. The purchasers can be classified broadly in two groups: those whose wealth was derived from the large eastern ports—Philadelphia, New York, Baltimore, and Annapolis—and the wealthy landowners Birch sought out in his travels. City merchants and rural gentlemen not only formed the largest classes of Birch's supporters, they also represented the wealthiest Americans in the period. These two groups probably bought the set for different reasons: the landowners supported the work of the artist, while the city dwellers purchased a product that communicated and celebrated urban and commercial development.

In Philadelphia, nearly half the subscribers to the first and second editions were merchants, and no other profession begins to approach this percentage. Significant proportions of the supporters in New York, Baltimore, and Annapolis also earned their living in this way. Merchants outside Philadelphia may have purchased Birch's set of views as a record of general, national development (as he suggests). Beyond these crucial merchant subscribers, many interested in promoting Philadelphia's commercial vitality subscribed. These included local and state government officials and bankers, such as Samuel Mickle Fox (1763–1808), director of the Bank of Pennsylvania. Under Fox's direction the bank hired Benjamin Henry Latrobe to design its building on Second Street, the subject of one plate of the set; Fox's name appears immediately after

Latrobe's in the manuscript subscription list.[84] Several members of the board of directors of the Bank of Pennsylvania also subscribed.[85] Most of these men are described as merchants in city directories. Interestingly, William Gibson, the clerk of Baltimore City, and the mayor of New York, Richard Varick, also supported the venture.

Some probable or known personal connections to Birch can be traced for other Philadelphia patrons. As he noted in his autobiography, several foreign diplomats subscribed, as did the British-born actress Ann Merry.[86] Quite a few men in professions allied to his own and individuals directly involved in the project supported Birch's undertaking: among the former were successful jeweler Joseph Anthony and engraver James Thackara, and the latter included William Barker, who was responsible for the map plate in the views, coppersmith Jesse Oat, who provided the plates, and printer Richard Folwell, who was also connected with the views' production.[87] Bookbinder John Grant may have worked on one or more of the editions.[88] All of these artisans may have received copies of the publication in lieu of payment for their services. Other artisans in both Philadelphia and New York subscribed, including carver and gilder David Kennedy, who purchased fourteen sets, presumably for sale.[89] In contrast to the support among the members of the Royal Academy for the *Délices*, Gilbert Stuart was the only established painter to subscribe to the *City of Philadelphia*.

A handful of "gentlemen" subscribed in the port cities, including John Stevens in New York, whose house Hoboken would be featured in the first plate of the *Country Seats*, and

William Hamilton in Philadelphia, whose estate the Woodlands would be the subject of another. John Beale Bordley, Charles Willson Peale's great patron, also subscribed in Philadelphia where he had moved from his Wye Island, Maryland, plantation in 1783. The vast majority of the subscribers who lived outside the port cities were (or had been) "planters" like Bordley, although many of these men had trained (as had he) in London in the law.[90] These lawyer-gentlemen included Luther Martin, a Maryland attorney general who spoke in support of Supreme Court Justice Samuel Chase at his U.S. Senate impeachment trial in 1805.[91] Interestingly, Chase did not subscribe to the *City of Philadelphia*, despite Birch's boasts of the judge's support.

Because the set of Philadelphia views is unique among the art of the period, there is no precisely comparable example of patronage, although there are some analogous contemporary endeavors. The best documented of these is Peale's Museum, whose subscribers have been investigated by David R. Brigham.[92] Both were grand undertakings by artists in the early years of nationhood, and while the *City of Philadelphia* was not, strictly speaking, publicly accessible, it had a public purpose. Both were didactic, and art per se was not their exclusive emphasis. A comparison of these two patron groups further reflects the significance of the two principal types of Birch supporters.

The interest in Peale's Museum was generally greater, and Brigham identifies a wider range of professions among its supporters than there were among Birch's subscribers. In contrast to the 353 subscribers to the museum, Birch sold the first two editions to 280 individuals and firms. There is remarkably little overlap (only twelve) between the museum's 1794 subscribers and those for the first two editions of Birch's views, although some of the discrepancy can be accounted for by the four-year gap between the beginning of one and the end of the other.[93]

In some cases, these divergent demographics can be ascribed to the differences between the two ventures: for example, Birch sparked the interest of no scientists and only three physicians; in contrast, both scientists (three) and a greater number of doctors (sixteen) were subscribers to Peale's Museum, where the emphases were more relevant to their own work. Significantly fewer members of the clergy were Birch subscribers, probably because his views were secular in focus, whereas the museum's material was in part organized to reflect a divine order. The number of attorneys in the city is roughly proportional for the two: four for Birch, eight for Peale, as is the number of gentlemen, four versus nine. Within these two groups, there is only one man who subscribed to both: Bordley. More artisans were interested in Peale's enterprise, although more artists and engravers supported Birch.

The sharpest contrast between the two groups is, however, in national government officials. The museum garnered subscriptions from both George Washington and John Adams, then president and vice president, in addition to twenty U.S. senators and sixty-eight U.S. representatives, in comparison to the four government officials who purchased Birch's views. The latter group, however, included, in addition to one U.S. senator (John Rutherfurd of New Jersey) and one U.S.

representative (Samuel Smith of Maryland), Thomas Jefferson, then vice president, as well as Secretary of War James McHenry, Postmaster General Ebenezer Hazard, and U.S. District Attorney William Rawle.[94] Obviously, the large national government support for the museum could partly be explained by its location in the upper floor of Philosophical Hall, in close proximity to Congress Hall.

The number of Pennsylvania state officials (four) who subscribed to the museum is close to the three on Birch's lists. More diplomats were Birch subscribers (five versus three for Peale), although in both cases the Spanish consulate was well represented, and the difference is made up in British envoys, with whom Birch was undoubtedly better connected.

The discrepancy between local and national government officials' support for the two ventures is linked to the most notable contrast in patronage—the proportion of merchants. Brigham identifies 42 subscribers out of 353 as merchants and a handful of men for whom "merchant" was a secondary occupation, or about 12 percent of the total. This clearly contrasts markedly with the support for the *City of Philadelphia* and underscores the different nature of these two undertakings.

Chapter 4

FULL EFFECT OF INTENTION

The City of Philadelphia in 1800

The *City of Philadelphia*, first issued in 1800, and *The Country Seats of the United States*, published in 1808, are Birch's most important contributions to American art and culture. They were the first two sets of views to be issued in the United States, although other artists had attempted such works unsuccessfully. While many of Birch's prints are well-known individually, examining his publications reveals why, on the one hand, the *City of Philadelphia* was a great success in this period and why, on the other hand, the *Country Seats* was not as popular (although many of its themes seem prescient today). Further, the *Country Seats* is intimately connected to Birch's writing on, and designs for, his own property, Springland.

Birch's American publications have two origins: his training and work in Britain, and the body of images of American places that had been created before his works and the meanings of these images for their contemporary audiences. Birch's *Délices* demonstrates that the visual and verbal patterns of picturesque representation were responses to specifically British places. The images of this set of views have many precedents—the most immediate were the British paintings Birch

engraved. In London, he was surrounded by a community of artists who shared an understanding of an inventory of places considered picturesque. These sites were appreciated not only for their beauty but also, and perhaps more important, for the values and narratives associated with them.

The artistic environment for Birch's American sets—both the painters in the United States and the images of American places created before his publications—was more limited than for the *Délices*, but not nonexistent. While the precedents for Birch's American prints were not as abundant as they were for the views of British scenery in the *Délices*, he was hardly entering terra incognita, in any sense of the term. As the Columbianum (the brief attempt to establish an arts academy in which Birch participated) shows, a community of artists, however fractious and unstable, existed in Philadelphia at the time of Birch's arrival. A corpus of images of the sorts of American places Birch would depict in the *City of Philadelphia* and in the *Country Seats* had also been created, and a number of conventional meanings associated with these images had been established.

The *City of Philadelphia* is a successful hybrid of British and American elements, using conventions from both sides of the Atlantic to convey a fiercely local reality, although one with significant national implications.[1] Birch's first American set is carefully ordered and its messages clear, although variant understandings may depend on the viewer's specific knowledge.

PRECEDENTS

The images of the capital produced before the publication of the *City of Philadelphia* provide an essential context in which to understand Birch's response to the "Metropolis of America." His first set of American views both relied on this background and vastly enlarged its range, its visual richness, and the complexity of its meaning.

Among the most important antecedents for Birch's American sets were published city views produced in Europe from the seventeenth century on. In addition to such views of British and European cities, a significant number of published images of the North American colonies were available in London in the eighteenth century.[2] It is probable that Birch had access to many of the former, and there is little doubt he knew many of the latter.

In contrast to the large number of prints and paintings of London (going back at least to the work of Wenceslaus Hollar) Birch would have seen before his emigration, relatively few published images of Philadelphia were created prior to Birch's arrival.[3] Paintings of Philadelphia sites were even scarcer: there are no known landscape paintings of relevant subjects created before the Revolution and only a handful are known from the period after 1776, although landscape settings in portraits or history paintings were very significant. These few earlier images have three important connections to the *City of Philadelphia*. First, many were produced to promote the city across the Atlantic, which was one of Birch's expressed purposes for the book. Second, the subjects of these earlier views also appear in the *City of Philadelphia*, suggesting a commonly held understanding of the important places of the city. Finally, one of the most significant developments before the Revolution was the association of images of American places with an emerging (and rebellious) colonial identity. In the new republic, images of sites were employed in the task of forging an understanding of the new nation.

"Brobdingnagian" and Utopia Visions: Promoting the City

The earliest published views of Philadelphia city sites were promotional. Among the best known of these early images is the gargantuan *East Prospect of the City of Philadelphia* (figure 51), drawn by George Heap and Nicholas Scull and published in 1754.[4] This panoramic view of the city along the Delaware River waterfront was commissioned by William Penn's son Thomas. The first version of the print was the largest of a group of what Sinclair Hitchings has aptly called "Brobdingnagian" views of American port cities.[5] The enormity of these views was not just promotional but also a reflection of the perceived scale and opportunities of the New World (which

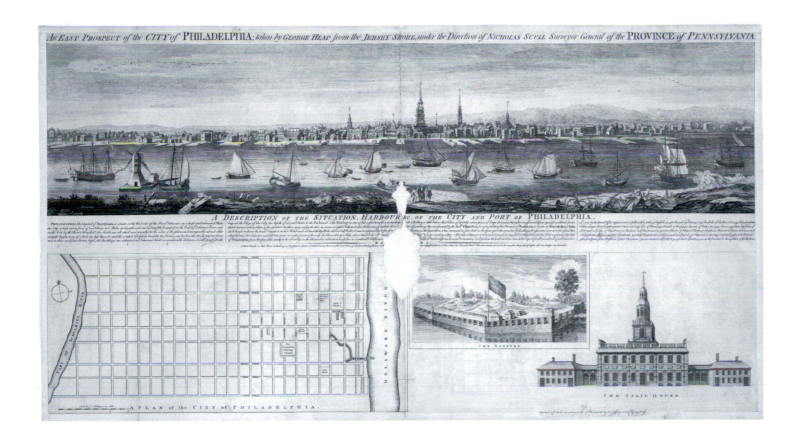

both Birch and Thomas Jefferson, among others, expressed with the language of the sublime).

In order to further promote the colony, a slightly modified version of the *East Prospect* was published in the *London Magazine* in October 1761, accompanied by a lengthy text.[6] The "Description of the beautiful City of Philadelphia" creates a detailed if not utopian sense of orderliness, balance, and certainty. The description of the projected symmetrical arrangement of settlement along the two rivers is exemplary: "Every owner of one thousand acres has his house in one of the two fronts, facing the rivers, or in the high street, running from the middle of one front to the middle of the other." The account of the street grid (like that of the pattern of settlement, more theoretical than realized) furthers the sense of ideal order: "the high street, which runs the whole length of the town, is an hundred feet wide, parallel to which run eight streets, which are crossed by twenty more at right angles, all of them thirty feet wide, and several canals are let into the town from each river, which add to the beauty and convenience of the place."

A second round of published views of Philadelphia sub-

FIGURE 51. George Heap and Nicholas Scull, *East Prospect of the City of Philadelphia*, engraving, 1756 (first version published 1754). Library of Congress.

jects in the 1760s promoted a cluster of "charitable" institutions built at the western edge of the city settlement, between Eighth and Eleventh and Pine and Spruce streets. Unlike the *East Prospect*, none of the views of these institutions was accompanied by description. The first and best known of these institutions (and the only one still extant) is Pennsylvania Hospital, on which construction was begun in 1755.[7] The second was the complex to the west of the hospital site composed of the Almshouse and House of Employment, completed in 1767.[8] Both of these institutions would appear as subjects in the *City of Philadelphia*. Views were published of these complexes concurrent with their establishment. For example, the construction of the hospital prompted two similar prints by rival Philadelphia dealers issued in 1761.[9] In Robert Kennedy's version (approved by the hospital's directors), the foreground figures represent the function of the institution: well-dressed couples present alms to poor, elderly men, and public charity is solicited by the motto "Take care of him/ & I will repay thee."

Emblems of National Civilization

The idealizing, promotional purpose of the early prints and their accompanying descriptions would be echoed in Birch's *City of Philadelphia*, but another type of meaning in pre-Revolutionary views is equally, if not more significant for Birch's work. Charles Willson Peale's portrait backgrounds demonstrate the sort of meaningful association of images of American places with narrative that Birch would employ in the *Délices*. A view of the falls of the Schuylkill River just above Philadelphia, seen in Peale's 1770 *John Dickinson* (figure 52), is emblematic of Dickinson's role in the resistance to the Stamp Act: Dickinson's identity as the writer of *Letters from a Farmer in Pennsylvania*, protesting the Townshend Duties, was publicly revealed in a ceremony at the Fort St. David's fishing company at the falls of the Schuylkill.[10] The image of the falls in Peale's *John Dickinson* is thus emblematic of the communal consecration of colonial protest, a first step on the way to the creation of an American national identity. Dickinson's *Letters*, first published in 1767, were an important link in the chain of events that was to lead to open warfare within a decade.

The background landscape in Peale's *John Dickinson* marks a shift in the types of meaning communicated by American views and is an expression of a consolidated colonial identity—a nascent national consciousness. Peale's *John Dickinson* alludes to history, albeit a "contemporary history," as did *The Death of General Wolfe* by Benjamin West (Peale's teacher) of the same year. Peale was adapting the technique of associating a learned narrative with a landscape view that Birch was to use later in the *Délices*, but rather than only showing the setting for a significant site, he also included the main "actor" on the stage.[11]

Peale also produced views after the Revolution that bear directly on Birch's *City of Philadelphia* in both subject and manner of representation. Peale produced drawings for most of the plates published in the *Columbian Magazine* (the first such American publication) between 1786 and 1790; several

A N.W. VIEW OF THE STATE HOUSE IN PHILADELPHIA taken 1778

showed the settled part of the city.[12] The earliest and the last of these show the Pennsylvania State House (now called Independence Hall) at crucial political moments. *View of the State House in Philadelphia, taken 1778* (figure 53), showing the building as it appeared at the time of the Revolution, was published in July 1787, during the Constitutional Convention.[13] The print's accompanying text refers to the significance of current events, but also associates the building with earlier occurrences by noting the "August body which pronounced the freedom and sovereignty of the United States." Further, the site is also characterized as a memorial to the progress of

American civilization more generally: "The foundation was begun, within a century after the rude savages had quitted the soil on which it stands; and the [Continental Congress] was assembled beneath its roof within 150 years after the emigration from Europe under the venerable Penn."

Clearly, the association of learned narrative with an image of place is in full operation here, complete with reference to the earliest history of the colony. Further, it is apparent that this image and the association of a narrative with it are the stuff of nation-building, as the opening sentence of the description reveals: "the State-House of Pennsylvania [is] a building which

FIGURE 52. Charles Willson Peale, *John Dickinson*, oil on canvas, 1770. Courtesy the Historical Society of Pennsylvania Collection, the Atwater Kent Museum of Philadelphia.

FIGURE 53. Charles Willson Peale, *View of the State House in Philadelphia, taken 1778*, engraving, published in *Columbian Magazine*, July 1787.

will, perhaps, become more interesting in the history of the world, than any of the celebrated fabrics of Greece and Rome."

In the period after the Revolution, published views also played an important role in promoting the city to both domestic and foreign audiences. Two prints by James Pellor

Malcom published in the London *Universal Magazine* testify to the complex meanings associated with urban images before Birch's work, particularly after 1776. The first, of Christ Church, appeared in the July 1788 issue (figure 54).[14] Malcom's accompanying description suggests that the plate illustrates Philadelphia's—and by extension America's—prodigious progress, a theme later echoed by Birch.

> If we consider . . . how short a time it is since our ancestors landed in this state, and that many people still living recollect seeing bushes and briars, where the city now appears with the opulence of ages, we must be struck with astonishment. A member of our assembly having observed, . . . that, considering how lately the ground on which he then spoke was a land of savages, it was scarcely credible, that in the city were 15,000 houses. . . . But is it not still more extraordinary . . . that such an elegant structure as Christ Church should have been built so soon after the foundation of the city . . . ?

Malcom's hyperbole, addressed to a British audience, seeks to establish the place of the fledgling United States among the pantheon of great nations.

A second plate and description, *The Jail, Philad.*[a] (figure 55), appeared in the same London publication the following year.[15] Its description lauds the building as a sign of American civilization.

> As modern nations have advanced in knowledge, opulence, and power, the number of useful institutions has proportionably [*sic*] augmented; and the numer-

ous spires which adorn their cities, seem to remind the traveller of the majesty of the people whose capital he is approaching. If such then be the progress of society, how happy must it render every patriot bosom, to see our country advancing so fast, by similar establishments, to an equal degree of fame. I can scarce ever walk out without discovering some improvements in the appearance of our city.

It is not certain how many of the prints and paintings produced before 1800 William Birch and his son Thomas would have known when they created the *City of Philadelphia*. Birch was familiar with a significant body of Peale's work, and whether he knew all of the earlier views of the city is unknown and relatively unimportant. The vast majority of the conventions of formal composition and meaning that he used were shared by artists and audience in the young United States and in Britain, as already indicated. The key difference between Birch and his predecessors, however, is that with the appearance of the *City of Philadelphia*, the representation of American places was greatly enhanced in scope.

A CIRCUIT THROUGH THE CITY

Philadelphia was at a crucial moment when Birch's set of views was published. The federal government, whose temporary residence in the city had been established by the Compromise of 1790, was about to depart for Washington. Philadelphia's status as the leading port of the nation was also threatened. Birch

The Jail, Philad.ª Malcom del.t et fc

never fully explained the genesis of his first American set of views, but he clearly saw the opportunity to help the city redefine itself at this important juncture. The success of the *City of Philadelphia* indicates that its merchant patrons perceived the publication the same way.

Broadly speaking, Birch's message about the city is a dual one: he presents it as a modern, developed, national, civilized place with a strong, infinitely expandable commercial foundation. It also has another, perhaps covert meaning. Specifically because he did not explain the meaning of his images, several can be interpreted in different ways, depending on the viewer's knowledge of the events associated with the places he represents. He thus allows for two narratives,

FIGURE 55. James P. Malcom, *The Jail, Philad.ª*, engraving, 1789, originally published in *Universal Magazine*.

one primary and promotional, and one memorial, even mournful.

The *City of Philadelphia* differs from both the *Délices* and the *Country Seats* in several key ways. First of these is scale: both the *Délices* and the *Country Seats* are printed on quarto paper in horizontal (landscape) orientation, a common format for British sets of views. The prints are not truly miniature replicas like his enamels after Reynolds, but they do have a diminutive quality (as do his drawings for Springland). This is not true for the *City of Philadelphia*: the plates for this set were nearly twice as large (approximately 11 by 13⅜ inches versus approximately 7 by 6 inches).[16] This change in scale can be ascribed to the workshop arrangement Birch used, which he described in his autobiography: "I superintended it, chose the subjects, and instructed my son in the drawings and our friend Mr. [Samuel] Seymour in the engravings" (p. 204).[17] The father gave credit to son Thomas in describing the authorship of the work as "William Birch and son." (For the sake of convenience, and because the elder Birch was responsible for the primary decisions in the publication, I will refer to the work as his.)

Another discrepancy between the *City of Philadelphia* and both the *Délices* and the *Country Seats* is the binding order of the plates. No physical tour can be reconstructed logically from the sequence in the *Délices*; the same has also to be said of the *Country Seats*. Although not truly equivalent to a modern guidebook, the *City of Philadelphia* is organized as a conceptual circuit through the city. The sequence of the plates reflects an orderly progress through geographic zones, building types, and overarching themes; the set is thus both a physical and an ideological circuit through the city. The first and last plates bracket the city limits along the Delaware River waterfront. In the next group, Birch brings the viewer into the city as a visitor would have entered by water at the Arch Street Ferry, and then conducts the viewer along Arch Street, the principal east-west residential thoroughfare of the period. The tour then progresses to High, or Market, Street, another east-west street and the city's principal commercial axis. A thematic pair then follows showing two grand contemporary buildings near the end of the developed portion of Market Street. Groups showing sites on the principal north-south streets, Second and Third, then follow, succeeded by prints representing the cultural institutions around the State House, as well as the building and its garden. The next set of images shows charitable institutions, followed by the final pair, which depicts buildings designed by the architect Benjamin Henry Latrobe.

This organizational clarity is due to the didactic purpose the *City of Philadelphia* was to fulfill. Birch asserted that "no other work of the kind had ever been published by which an idea of the early improvements of the country could be conveyed to Europe, to promote and encourage settlers to the establishment of trade and commerce . . . [when] those with capital expected nothing but a forest" (p. 204).

Introduction to the Tour

The first three plates of the volume after the title page introduce the work as a whole.[18] The frontispiece, the *City and Port*

information that the set conveyed about its *civilized* resources was unprecedented.

Birch also describes his work as "a memorial of [the city's] progress for the first century" after William Penn's 1701 Charter as well as a record of things "all accurate as they now stand." The set is thus both promotional and elegiac: it bids to shape the city's future and celebrate its history (and, as will be discussed, mourn the glory of its past). Precisely because Birch eschewed lengthy accompanying description, virtually all of the plates can be interpreted either way (or sometimes both), depending on whether the viewer is acquainted fully with "local" history. The *City of Philadelphia* both records its

FIGURE 58. William Birch, *Arch Street Ferry*, engraving, 1800, from the *City of Philadelphia*.

FIGURE 59. William Birch, *Arch Street, with the Second Presbyterian Church*, engraving, 1799, from the *City of Philadelphia*.

Drawn Engraved & Published by W. Birch & Son. Sold by R. Campbell & Co. No. 50, Chesnut St. Philad.a 1799.

ARCH STREET, with the Second Presbyterian CHURCH.

PHILADELPHIA.

subject "as it appeared in the Year 1800," at the moment of the departure of the federal government, and responds to that act by asserting its place among the nation's, if not the world's, great centers.

Entrance and Arch Street, the Civilized City

The next plate, *Arch Street Ferry* (figure 58), brings the viewer into the city proper. The commerce referred to in the introduction is prominent here in the sailing vessel on the left with its stars and stripes flying astern. Two objects in the foreground are more symbolic than literal representations: a sheaf of wheat and an anchor, emblems of fertility and faith as well as of the seagoing and agricultural basis of the city's commerce.

The next three plates suggest progress by the viewer west on Arch Street, the heart of the residential area. In the first, *Arch Street, with the Second Presbyterian Church* (figure 59), the dense development of the city is seen in the uninterrupted brick façades that line the street down to the river. The buildings are shown in excellent repair, the streets are euphemistically clean, and many amenities of civilized urban life are prominent, including street lamps and the box of a night watchman at the northwest corner of Fourth Street. The whole is dominated by a sunny sky in which the steeple of the church sparkles. Birch presents the city as a compendium of modern civilities and as an ordered, hierarchical community of domesticity and religion.

Next seen are two nearby churches, the New, or Zion, Lutheran Church on Fourth Street just north of Arch Street and the Old Lutheran Church, or St. Michael's, on Fifth Street, also just north of Arch (figure 60). The bright south façade of New Lutheran Church, like the buildings in the preceding plates, is a well-polished, shining feature of a modern, literally enlightened Christian city. In the foreground walk a group of men; the three central figures are Indians. Above the heads of the pedestrians hangs a tavern sign on which a large tree can be made out, but not the name of the establishment. The Indians and their chaperones recall the figures in West's *Penn's Treaty* in their dress, and over them quite literally hangs a sign of a great tree. On the one hand, this seems almost an ironic commentary on the reduction of the Indians' place within the boundaries of the city of Philadelphia; on the other, it is a symbolic reduction of the emblems of West's painting. The figure at the right of this group, in a three-cornered hat, gestures toward the horse carts, piled high with lumber and barrels, perhaps filled with flour. The gesture of this man indicates that this plate is another story of progress, of the use of natural resources, and of the growth of commerce. The Indians are a mark of the starting point for that growth, as well as a foil for it.[23]

Market Street

After establishing the civilized nature of the city, Birch presents Market, or High, Street, the principal east-west axis of the city and its commercial core, shown in five plates. First

is *South East Corner of Third, and Market Streets* (figure 61). The activity and even the sheds of the market are visible in the frame, but the image is dominated by the radiant building at the corner, a combined residential and commercial structure in a contemporary, Adamesque style and scale that greatly exceeded the conventional scale of Philadelphia private buildings at the time. Birch therefore emphasizes the modernity of

the city's commercial facilities while also presenting the activities of the market.[24]

Another up-to-date building dominates the next plate, *High Street, with the First Presbyterian Church* (figure 62), which moves the viewer under the eaves of the market sheds. The gleaming white church stands in stark contrast to the older red brick houses to its left. Birch exaggerated its size by

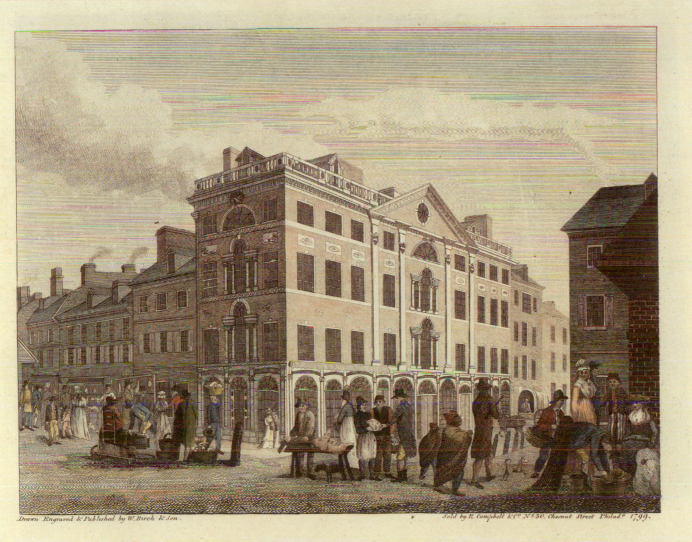

Drawn Engraved & Published by W. Birch & Son. Sold by R. Campbell &C° N° 30, Chesnut Street Philad° 1799.

South East CORNER of THIRD, and MARKET Streets.
PHILADELPHIA.

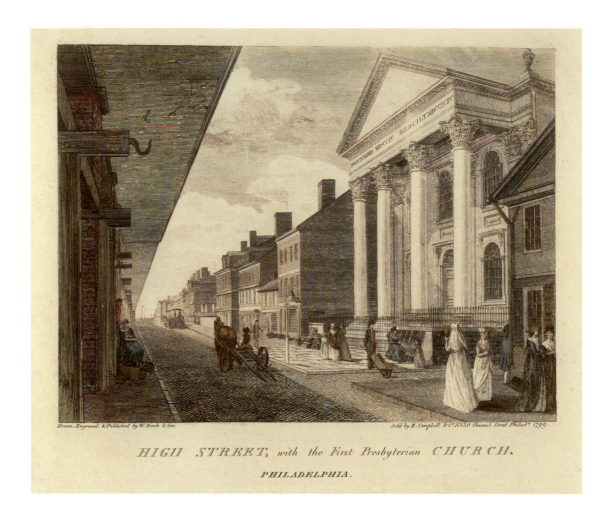

HIGH STREET, with the First Presbyterian CHURCH.

PHILADELPHIA.

FIGURE 62. William Birch, *High Street, with the First Presbyterian Church*, engraving, 1799, from the *City of Philadelphia*.

placing the peak of the gable at the top edge of the image. The design of this 1794 church has been attributed to the painter John Trumbull. Whether Birch was aware of this is unknown, but the church would serve regardless as a demonstration of fashionable classicizing taste.

Another key visual effect of this view is the exaggeration of the length of the market sheds, lending them a sense of great capacity. A woman at left mid-ground with baskets of vegetables in front of her presents an indication of the function of the structure, but the fact that they are largely unoccupied suggests their great potential, which is further developed in the next plate (figure 63). In it, the sheds are seen from the

inside, looking west. It may seem odd that Birch shows them empty, and in later editions he added figures to the plate, but the effect of great potentiality, of great possibility for the city's future, is the point.

The following *High Street, from the Country Market-place* (figure 64) also places the viewer inside the market sheds, looking west, as before, now at Fourth Street. This view, which originally showed a view of Market Street from the sheds, was reworked to show the memorial procession for George Washington of December 14, 1799. The empty, draped casket (Washington's body never left Mount Vernon) carried by uniformed officers is shown, as is a riderless white horse, also draped in black, followed by General Henry Lee, mounted, who rises above a throng of congressmen in black. Volunteer military companies in uniform precede the horse. Tearful onlookers can be seen beyond the procession.[25]

As Richard G. Miller has pointed out, the city's commemoration of Washington's death marked not only the passing of a revered public figure but the end of the Federalist era in Philadelphia. Miller remarks, "with Jefferson's election to the presidency, Philadelphia's Federalists could no longer rely on federal patronage or the prestige of having the nation's capital in Philadelphia. The federal government departed as scheduled in 1800."[26] Birch's representation of Washington's "sham" (because of the empty casket) funeral suggests not only the city's important role in the mourning of a great national figure but also Philadelphia's distress over the creation of the capital named after him.

The final plate of the Market Street group, *High Street, from Ninth Street*, takes the viewer to the western limit of the

developed city along that thoroughfare. The end of the Market Street group is further signaled by the (now empty) final appearance of a dray pulled by a chestnut horse. Its business is thus concluded, as is Birch's commercial theme.

Fabulous Fiascos of the Federal Era

The next group in Birch's tour consists of two thematically related plates. Both show grand, recently built dwellings that never fulfilled their original purpose. The first is *The House intended for the President of the United States* (figure 65), built

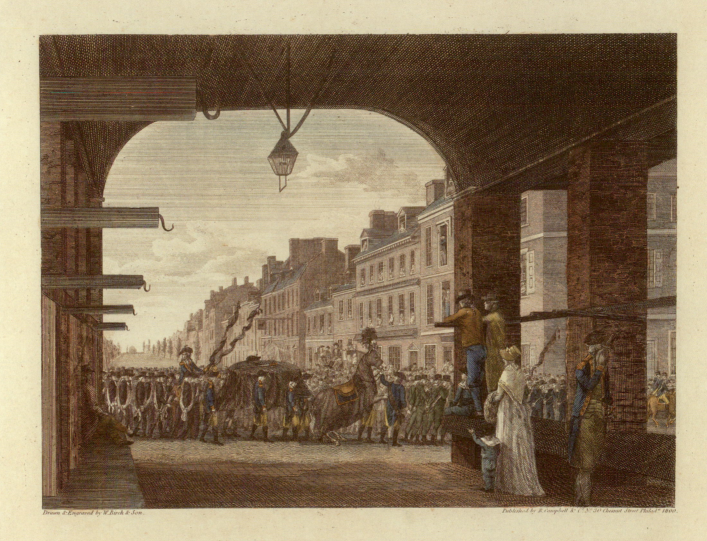

Drawn & Engraved by W. Birch & Son.

Published by R. Campbell & C° N° 30 Chesnut Street Philad.ª 1800.

HIGH STREET, *From the Country Market-place* PHILADELPHIA:

with the procession in commemoration of the Death of GENERAL GEORGE WASHINGTON, *December 26th 1799.*

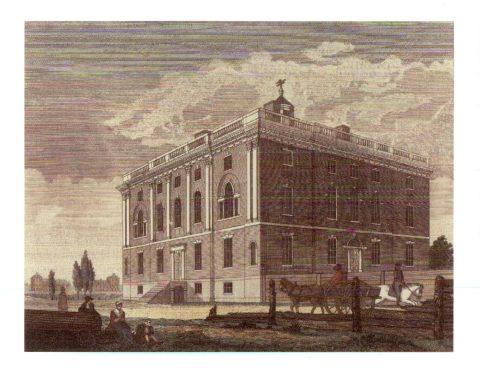

by the state of Pennsylvania in an effort to try to ensure that the federal government would remain in Philadelphia. When the building was completed in the spring of 1797, John Adams declined to occupy it. After the departure of the federal government, this great white elephant was sold at auction to become the first building of the second campus of the University of Pennsylvania.[27]

The complement to this plate, *An Unfinished House, in Chestnut Street* (figure 66), represents the extravagant mansion designed by Pierre Charles L'Enfant for financier Robert Morris on Chestnut Street near Eighth.[28] To contemporary Philadelphians, this house was the visible demonstration of the failure of this prominent Revolutionary figure whose vast fortune was lost speculating on western lands (and, because of its extravagance, even believed by some to be the cause of his financial collapse).[29]

For both images, however, there is little overt indication of the difficulties associated with these two buildings, with which contemporary Philadelphians would have been familiar. But subtle clues, such as the presence of the Almshouse and the House of Employment, clearly seen on the south, might allude to the extravagance of the president's house proj-

FIGURE 65. William Birch, *The House intended for the President of the United States*, from the *City of Philadelphia*.

FIGURE 66. William Birch, *An Unfinished House, in Chestnut Street*, from the *City of Philadelphia*.

ect and its futility. Birch's omission of accompanying text allowed these two plates to be viewed by the foreign audience for whom the set was intended without the prejudices of "local knowledge."

Second and Third Streets: Established and Wealthy City

The following group shows the city's principal north-south streets of the period, Second and Third streets. The Second Street group speaks to the settled nature of the city, the Third Street group to its prosperity. *Second Street North from Market St. with Christ Church* shows the city's other grand avenue (figure 67). In contrast to the examples of the latest architectural design notions seen before, the buildings, including the 1710 town hall/courthouse at left, show noticeable signs of age, both in style and condition. The established character of the city is shown by these; history is evident. The figures in the view, members of different social classes and races, are shown in a broad spectrum of urban activities and further this sense of establishment. The other Second Street view shows the "New Market" between Pine and Lombard streets. The presence of a second market in the city elaborates the sense of Philadelphia's scale and settledness.

The two Third Street views, *The Bank of the United States* and *View in Third Street, from Spruce Street* (figures 68 and 69), demonstrate the city's wealth and its ongoing place in the national economy. The Bank of the United States is presented in an entirely urban context.[30] The bank was the first such federal institution, created in 1791 to regulate the national currency, but as the frieze on the building's portico indicates, the bank's building on Third Street was begun in 1795 and opened in July 1797.[31] Birch gives the building the sense of a true colossus. As in his view of the First Presbyterian Church, Birch shows the bank's grand, Corinthian-order portico overwhelming its neighbors, particularly the small, early houses to its left.

The scene has several figures. One is probably symbolic: the man at right, standing in front of a pile of timber in the street, is sawing, his back turned to the viewer. At one level, this represents a common occurrence in the city: the selling of firewood. Given the prominence of this sawyer in the view, however, he probably represents the function of the bank as ordering and regulating America's resources if one extrapolates from the meaning of lumber in earlier plates.

The other Third Street view shows private wealth along the same thoroughfare. We see here the house of William Bingham, Birch's first American patron. This was arguably the grandest private residence in the city and a center of the de facto Federalist "court" in Philadelphia. Birch's view, which looks north toward the city's denser development, emphasizes the Bingham house and its surrounding grand property. The house was built in 1786 after the Binghams returned from a two-year tour abroad and was based on drawings by London pattern book author John Plaw. On the right is the Powel house, which survives to the present day.

SECOND STREET. *North from Market S.t w.th* CHRIST CHURCH.
PHILADELPHIA.

The State House and Surrounding Cultural Institutions

With the next group of prints, Birch takes his viewer to the heart of federal Philadelphia: the State House and surroundings. Like the group devoted to Market Street, this consists of five images—the two largest thematic groups in the set. The State House set does not begin with the building that had served as the national capital but with the cultural institutions nearby, thereby deemphasizing the significance of the departure of the federal government while retaining the importance of the recollection of Philadelphia's place in national history.

The first print of this group, *Library and Surgeons Hall, in Fifth Street* (figure 70), shows two buildings that represent

FIGURE 67. William Birch, *Second Street North from Market St. with Christ Church*, from the *City of Philadelphia*.

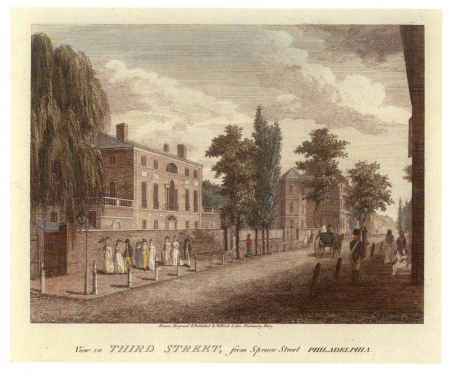

BANK OF THE UNITED STATES, in Third Street PHILADELPHIA.

View in THIRD STREET, from Spruce Street PHILADELPHIA.

both two important Philadelphia institutions and two different forms of knowledge. The main front of Library Hall, the home of the Library Company of Philadelphia completed in the fall of 1790, was ornamented with a large statue of Benjamin Franklin by François Lazzarini, placed there in 1792 by donation of William Bingham, then a U.S. senator. In addition to the main façade of Library Hall, light directs the viewer's attention to the large lantern on a house further to the south on Fifth Street, the "Surgeon's Hall" of the title. The cupola, which dominates a small and otherwise conventional, two-story Philadelphia brick house, indicates the presence of

an operating theater below. The two buildings shown here were probably intended to represent complementary types of knowledge. On the one hand, the Library Company represents the learning of the past: the collected wisdom of the ancients and the moderns. On the other hand, Surgeon's Hall represents knowledge based on scientific experimentation.

Congress Hall and the New Theatre, in Chesnut Street (figure 71) shows a different pair, here in opposition. Congress Hall looms on the left, in shadow, in contrast with the lit façade of the theater at right. This plate, one of the last prepared for the set, represents a vision of Philadelphia's past and its

FIGURE 70. William Birch,
*Library and Surgeons Hall, in
Fifth Street*, engraving, 1799,
from the *City of Philadelphia*.

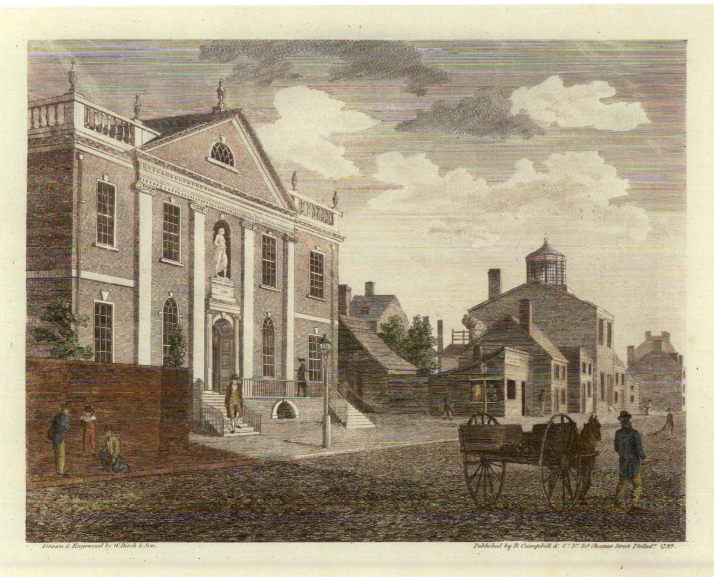

Drawn & Engraved by W. Birch & Son. Published by R. Campbell & C.º Nº 30 Chesnut Street Philadª 1799.

LIBRARY and SURGEONS HALL, in Fifth Street PHILADELPHIA.

FIGURE 71. William Birch,
*Congress Hall and the New
Theatre, in Chesnut Street*,
engraving, 1800, from the *City
of Philadelphia*.

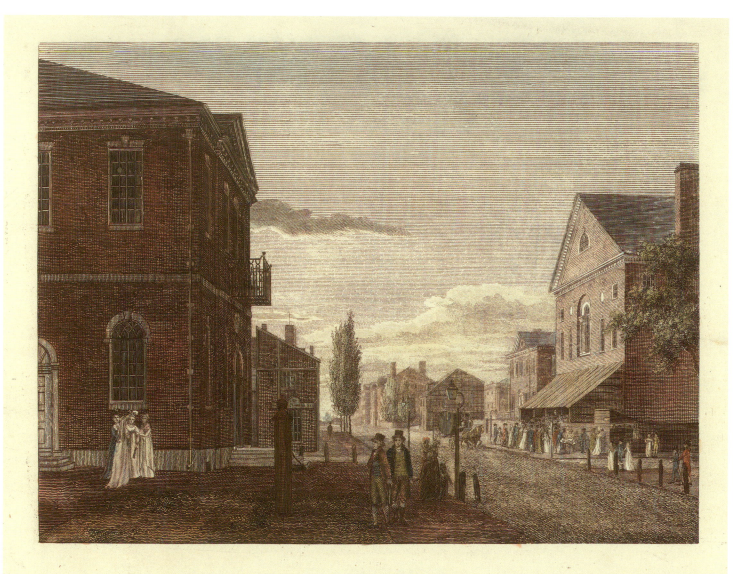

CONGRESS HALL and NEW THEATRE, in Chesnut Street PHILADELPHIA.

Drawn, Engraved &Published by W.Birch &Son Neshaminy Bridge. 1800.

future. The light is shown as it would have appeared on these two buildings at twilight, since Congress Hall faces north and the theater looked south, but in this depiction the sun also metaphorically sets on the city's federal era. If one "reads" the image with a movement toward the right (a commonplace in understanding the meaning of prints at the time), the city's future as a cultural center seems secure in the crowds flocking into the theater for an evening performance. Female theatergoers in fancy dress have supplanted U.S. senators and representatives.

The following plate, *State-house, with a View of Chesnut Street*, was among the first Birch made for the set and gets us to the center of the group. The environs of the former seat of the federal government are conveyed by the next two plates, *Back of the State House* and the *State-House Garden* (figures 41 and 72), both of which show the garden in the State House yard that encompassed the rest of the block bounded by Chestnut, Walnut, Fourth, and Fifth streets. In the first of these (one of the best known in the set), the building is balanced by the garden in the composition. These trees judiciously frame the buildings behind them: Library Hall, and roughly two-thirds of the façade of Philosophical Hall (the headquarters of the American Philosophical Society) with its door ajar. A sign for Charles Willson Peale's Museum, housed in the building, can easily be seen above the entry. In this image, Indians, who gesture toward the garden and the (again literally) enlightened institutions, are once more figures that indicate the progress of Philadelphia civilization and a kind of modern Eden: society in the garden.

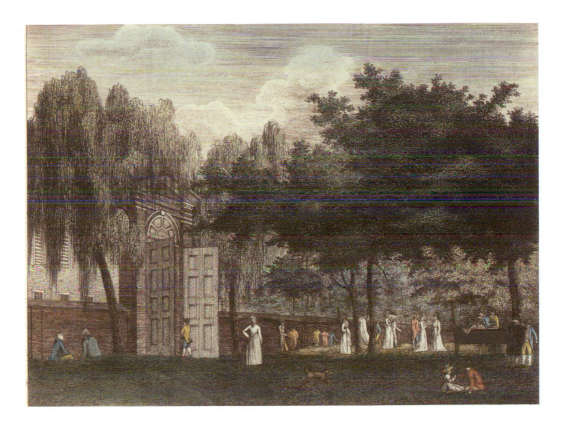

The final plate of this thematic group moves the viewer in the direction of the Indians' gesture and shows the southern end of the garden, including the great gate in the wall on Walnut Street. Birch's State House garden is this sort of social paradise, which is, however, threatened. The character of this scene is suggested by a prominent, angelic female figure at mid-ground who stands with her back to the viewer, left arm akimbo. At left the large Walnut Street gate looms, recalling many earlier depictions of the portal through which Adam

FIGURE 72. William Birch, *State-House Garden*, engraving, 1798, from the *City of Philadelphia.*

and Eve were expelled. This gate is flanked by weeping willows, symbols of mourning, which frame a well-lit fragment of the main façade of the Walnut Street Jail. Outside the walls of paradise is sin—and, as the next plate indicates, a sin against Philadelphia of a particularly egregious sort.

Public Institutions

The next group of prints shows a trio of large-scale institutions intended to solve societal problems mainly associated with the poor: the Walnut Street Jail, the Almshouse and House of Employment, and Pennsylvania Hospital. A cursory inspection might give the impression that these plates convey together yet another facet of the established and modern nature of the city: Philadelphia is sufficiently civilized to provide ample facilities for its poorest citizens and to regulate transgressors effectively, thus belonging among the ranks of world capitals.

First shown is the Walnut Street Jail (figure 73). The subject appears at right, its principal, light stone façade pristine and well lit, despite its northern exposure. The left half of the print and the foreground are dominated, however, by an entirely different subject. A frame building, placed on wheels, is being towed from left to right across the image by a large team of horses. Birch gives no clue about the foreground activities, but both the direction in which the moving building and its entourage are traveling and the starting point of the journey are suggestive. The horse train and its load move from the area of the State House toward the southwest, the direc-

tion that anyone leaving Philadelphia for points south by the normal land route would have taken. In the contemporary understanding of the term (and still the current British usage), what Birch shows is the "removal" of a house: this word encompassed not only its modern American sense of taking away but also the shifting of one domestic situation to another. This plate is thus an allegory of the removal of the federal government from Philadelphia to Washington, and the jail in the background (with its door ajar), together with the implications of the preceding plate, provide strong commentary on this event, although it is not clear whether the act or those responsible are criminal.[32]

Neither of the two remaining plates in this group, the *Alms House in Spruce Street* and *Pennsylvania Hospital in Pine Street*, appears to embody the same sort of pointed political commentary; instead their principal meaning is as an index of the civilized nature of Philadelphia society, as J. P. Malcom's text on the jail in 1788 had been. In both, the function of the institutions is suggested by the activities of foreground figures, where men control unruly animals, alluding to the work of controlling and correcting "animal" behavior in humans.[33]

Public Works of Benjamin Henry Latrobe

The last thematic set depicts the first commissions in Philadelphia of Benjamin Henry Latrobe, whose career marks a watershed not only in American design but also, as Birch's set indicates, in Philadelphia architecture.[34] The two images, the

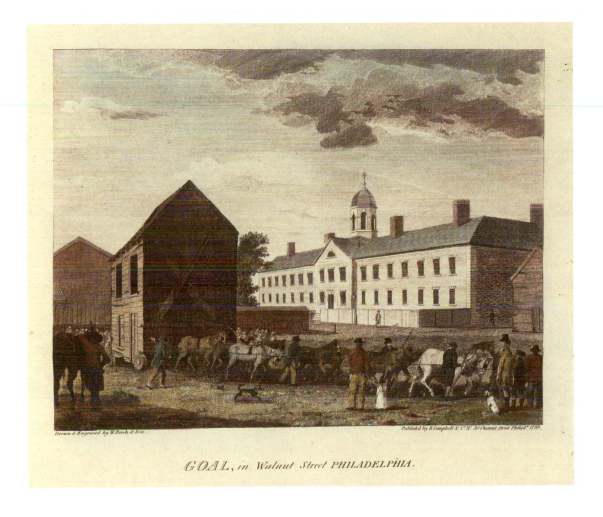

GOAL, in Walnut Street PHILADELPHIA.

Bank of Pennsylvania and the *Water Works in Centre Square* (figures 74 and 75), represent the final act in the drama of the *City of Philadelphia*—the culmination and the product of the two great themes presented to the viewer in earlier plates: prosperity and social cultivation. The construction of both buildings coincided with Birch's production of his views; both buildings were completed and in use by early 1801.

The view of the Bank of Pennsylvania terminates Birch's succession of depictions of temple-fronted buildings, which both herald the new taste and express the new national culture.[35] In his well-known "Anniversary Oration" delivered before the Pennsylvania Academy of Fine Arts in 1811, Latrobe alluded to the "spirit of the citizens who erected" the Bank of the United States. This relates to the meaning of both of these

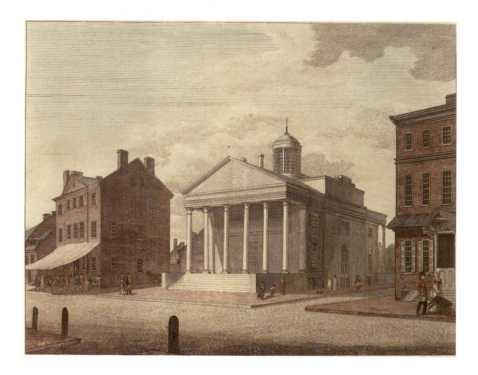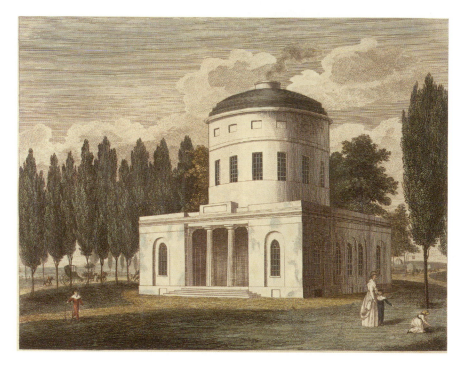

images of his buildings and their role at the end of the publication. The Bank of Pennsylvania and the waterworks were a demonstration not only of the wealth and taste of the city's elite but also of their progressive civic-mindedness.

The view of the Centre Square Waterworks carries this sense of public service to a high level. This building is progressive in both its style and purpose, which was to replace frequently contaminated city wells with a healthy water supply drawn from the Schuylkill River. As Birch shows it, though, the building is quite literally a machine in a garden, whose steam-powered pump is signaled by the smoke that rises from the chimney. This smoke is evidence of the transformation of the energy of the wood fueling the pump—lumber again serves as metaphor for American resources, arguably here put to the highest and best democratic use.

The waterworks is the westernmost subject addressed in the *City of Philadelphia*. Just as the *Arch Street Ferry* functions as an entrance to the city (from the east), the *Water Works* provides the viewer's exit (to the west). The primary cues for this come from several carriages and riders in the road in the background (technically part of Market Street). All of these move from left to right, or out Market Street toward the Schuylkill and westward. The *Water Works* is the end of the viewer's journey through the city of Philadelphia.

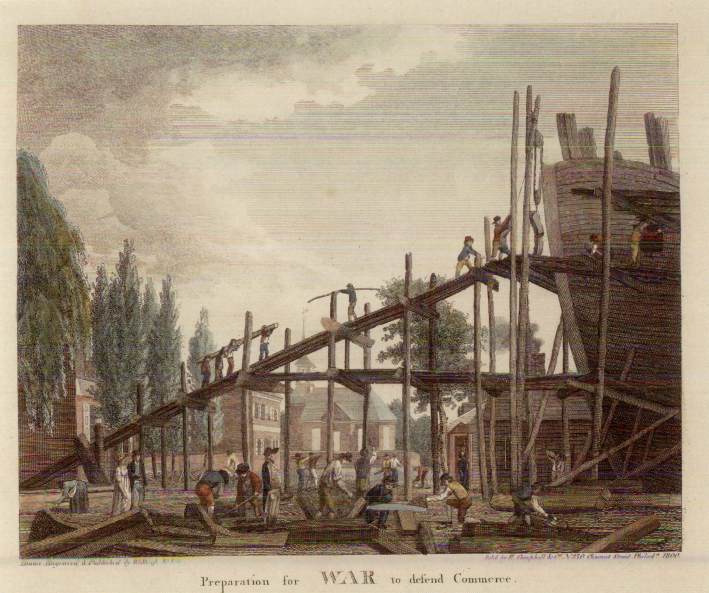

Preparation for WAR to defend Commerce.

The Swedish Church Southwark with the building of the FRIGATE PHILADELPHIA.

Epilogue

Birch's final Philadelphia view (figure 76) returns the viewer to the site of a shipyard (as in the frontispiece) and ends Birch's tour as it began, on the Delaware River. The plates function as pendants in subject matter as well as geography. While the frontispiece represents, as Birch says in his introduction, the "busy preparation for commerce," the final plate shows "the exertion of naval architecture to protect it." Words here reinforce the image, which is dominated by the frigate *Philadelphia* under construction. The bow of the uncompleted ship looms large and dark, emblematic of the city's might. As in the frontispiece, the continent's resources are rendered useful, here at an almost superhuman scale of accomplishment.

As for the plate that precedes it, the subject of this final print represents both the wealth of the city and the "spirit of its citizens," since the building of the vessel for federal use was largely financed by subscription.[36] The vessels of the "infant American navy" (including the *Philadelphia*) were all designed and built in this period by the depicted Humphreys naval yard.[37] While the *Water Works in Centre Square* represents the civic "spirit of its citizens," this final plate expands that generosity to national significance. The thrust of this final print is toward the future, expressed in the incomplete state of the frigate. Birch dated the plate 1800, emphasizing the unselfish, nationalist "spirit" of the city at the moment when the federal government was removed.

The plate also constitutes the final point of the *City of Philadelphia*: the depth of the resolve of its citizens to strive and even fight for their future prosperity. This resolve carried the city into the nineteenth century; it remained an important cultural center, the "Athens of America," until well after the War of 1812. But the federal government never returned, of course, and with the revocation of the charter of the Second Bank of the United States in 1834, the city receded from the national stage, despite its significant role as an industrial center in the latter part of the nineteenth century. New York and Washington increasingly took on national cultural leadership, but Birch's *City of Philadelphia* vividly represents (as no other visual document had before) a crucial turning point in the American early republic, as well as the place of its subject in it.

Chapter 5

"THE ONLY WORK OF THE KIND"

The Country Seats of the United States

BIRCH'S SPRINGLAND AND HIS VISION OF THE AMERICAN LANDSCAPE

Like his *City of Philadelphia*, William Birch's *Country Seats of the United States* relied on both American and British precedents, and on his education in the picturesque in England. Birch first learned to perceive and describe his surroundings according to the conventions of eighteenth-century British aesthetic theory in his travels with Nathaniel Chauncey in the English countryside and in the art world of London in the 1770s and 1780s. He brought these abilities with him when he emigrated to the New World. Birch was not alone among the citizens of the young nation in these abilities, but most others were not as adept as he in applying them and, more important, as much in the habit of using them to understand the American landscape.

Birch had acquired a very specific aesthetic vocabulary in Britain that he could use to categorize what he encountered in his travels. For example, he opens his description of a view of Annapolis by qualifying it as a "wild and picturesque scene" (p. 227). In using "wild" and "picturesque" together, Birch reveals his familiarity with the British aesthetic theories of the last decades of the eighteenth century, which are best known through the polemic writings of Richard Payne Knight and Uvedale Price. Birch intended by "picturesque" not only "like a picture" but also the "wilder," more "natural" aesthetic that is central to both Knight's *Landscape: A Didactic Poem* and Price's *Essay on the Picturesque* (both 1794). While these publications reached American libraries almost immediately, there is no known direct evidence about their immediate reception, and Birch was unusual in applying the new aesthetic theories in understanding the landscape and in landscape gardening.[1]

Birch's interests as a landscape artist—both image- and garden-maker—are reflected in the descriptions of scenery in his autobiography. Among these is his extensive account of the property that was to become Springland, his country seat on the Delaware, for which he also prepared his own designs. These documents are unusually detailed and lengthy examples of the application of the picturesque (both in the sense

of "framing the view" and as a set of aesthetic characteristics defining the territory between the sublime and the beautiful) in the United States. The results of this application, his garden at Springland and, ultimately, his *Country Seats*, were not as enthusiastically received as the *City of Philadelphia*. Many of Birch's ideas, however, became essential, among others, to the nineteenth-century landscape gardeners and painters who followed him.

Birch was, of course, not the first European to describe the New World landscape; a long tradition preceded him. A few general features were common to American descriptions in the eighteenth century: a reluctance or inability to provide more than a brief allusion to the aesthetic character of the countryside, and a tendency instead to quantify and catalogue its features and to privilege the potential economic or other utility of these.[2] Another commonplace was the notion that American wilderness was both "scaleless" and "unscaleable."[3] Given his absorption of late eighteenth-century British notions, Birch saw the undeveloped character of what surrounded him slightly differently than most of his American contemporaries. For Birch, the raw materials of the American countryside were more useful, for example, as the elements of a garden or a painted view than as the propelling force for a mill wheel.[4]

Birch's descriptions of American scenery are part of the accounts in his autobiography of his travels south of Philadelphia. The profits from the *City of Philadelphia* allowed him to "gratify [his] wishes in a knowledge of the country"—that is, to conduct picturesque tours, as he had in England with his patron Nathaniel Chauncey. There is an important difference between Birch's descriptions of these tours: he and Chauncey viewed and discussed scenery generally, while his American accounts concentrate on the surroundings of country seats. This was clearly related to his professional interests as a landscape designer, but it has implications for the representation of the scenery of the United States. Birch does not explicitly "place" houses within his verbal "views," but the wider landscape is explored and developed with the building and its immediate vicinity as a point of reference. In other words, Birch clearly saw and was able to represent the American landscape as the context of the country house, with all of its metaphoric implications for settlement and civilization in the wilderness. Both his "view" and those of many of his American contemporaries were picturesque, broadly speaking, in that their vision of the landscape was informed if not formed by its relationship to earlier images and established patterns of articulation.

Unlike many Americans of the period, however, Birch was able to place himself inside a landscape image, so to speak, and construct a representation (and a garden) out of New World materials by limiting the wilderness to what could be viewed from the front lawn. The American landscape was thus not merely seen with marks of civilization inserted into it but as the context for that civilization, and the "wilderness" was domesticated with minimal intervention. Further, the "artificial" insertion of settlement is thus transformed to a more "natural" process. This was a crucial step in adapting the picturesque convention of seeing the world as a (Claude) painting to American circumstances and would be more fully developed by later artists.

Discovery of Springland

Birch's account of his encounter with the place that was to become his own country seat provides an essential understanding of his experience of American landscape and his thinking in creating his second American view book. This part of his autobiography (pp. 205–215) stands apart from his general narrative in its verse form, undoubtedly inspired in part by Knight's *Landscape: A Didactic Poem*. The central part of the Springland description, "A lesson in Landscape gardening," is Birch's treatise on this subject.

Unlike most of his contemporaries, Birch addresses American native beauties in detail. He does share two principal features of landscape with other writers. Most important is his awe in the face of the site. Second, Birch both identifies and quantifies, although his principal interest is aesthetic and not economic. Birch's description of his "discovery of Springland" is overtly Edenic, an encounter with a "second Paradise."[5] He presents himself as a latter-day explorer, "discovering" a piece of America in which to make his home. This is ironic, as Springland was, in fact, surrounded by other country seats. His encounter with an Edenic Springland was necessary, however, to present the positive role of undeveloped nature in landscape gardening, even if his description seems at least partly disingenuous. The wildness that Birch describes at Springland was a necessary feature, as he saw it, of his design and of the context of the estate more generally.[6]

The opening sentences of Birch's description of Springland evoke a paradise that offers balm: rest and re-creation for weariness of body and soul ("Fatigued with care, with Worldly trouble frought; / A wandering spell I took: / To quiet oppressive and bewildering thoughts; / My weary way to the briery Covet led, / To trace in wild Nature some lonely seat to rest").

In an ancient trope, Birch emphasizes the hero's (that is, his) struggle to win entry to the hidden grove ("By bold attempt through thorney opposition / And the turfted flowering Shrubs I thrust my way"), "a second Paradise." There is also a sort of manifest destiny in Birch's description: he sees the site "as if intended by Nature for improvement."

Birch then catalogues the natural features he encounters in a way that is akin to a naturalist's expedition or a collecting trip to furnish an aristocrat's cabinet of curiosities (with, among other treasures, "rare botanic plants"). In this Birch adopts the contemporary American propensity to quantify, adapting convention to the service of aesthetic understanding. His orderly account progresses from large to small, beginning with geology ("the upper extremity of the bank, crowned with a Green Hill"), moving on to flora ("majestick Oake, the massy Chesnut, / The Seder, and the Pine, intwined with festoons of the / Luxuriant Grape"), and then to fauna ("the delicate race of turtles," "The gilt-eyed frog," "the flying squirrel with his / Harlequin tricks"). Finally, Birch addresses the bird life at Springland in similar terms ("The feathered race, in due season decorate with [their] / Rainbow plumage this ground") and concludes by naming this place ("Springland must be its name"), thereby completing his act of mental definition and possession.

After having staked his claim to this New World discov-

ery by defining and naming it, Birch then returns to Springland for "A Second Visit." In contrast to the hard-won access to his Eden with which he opens the account of his initial foray, his second entrance is easy ("more easy entrance found; / Through wild and oderous shrubs, with gentle / Steps"). It is clear that he has already begun to plan a landscape garden and has returned to refine his ideas ("where the new Magic is to rise, by Art, / To sporte with nature's charmes"). A change of mood then follows. While he had characterized specific features at Springland in the terms of the beautiful and the picturesque, new events evoke the sublime. A thunderstorm destroys a large tree ("over a horrable Cloud; / Fancy persuaded me I heard a voice, / Jupiter the angry mortal will revenge; / Crash went the Cloud; the god's vivid hand with firey dart, . . . / Choisest of the forest trees I cry'd of Springland's lost"), but Birch resolves to overcome the disaster and continue with his plans.

After the conclusion of the "Discovery of Springland," Birch addresses its transformation into a landscape garden. He titles this section "Springland Improved / as a Lesson on Landscape gardening," indicating that the project and his written account were intended to demonstrate both his specific abilities as a designer and his more general approach to the American landscape: his treatise on the subject. Springland was to be not merely the mark of Birch's social success in the land of opportunity but, more important, his professional advertising.

In this section, the Edenic character of Springland that dominates the account of his first foray is reversed: he now presents the literally deadly qualities of the site, using the obverse of the earlier topos of New World description—America as poisonous wasteland.[7] The enchantment he first located in the trees themselves is now his own and is used to purge his landscape of these dangerous traits. The "gen[i]us" Birch cites here is directly related to both the "genius of the place" and his own artistic powers—the aesthetic theory he brought with him to the United States and, more specifically, his ability to use this approach as a professional. The power he invests in this genius to "cleanse" the poisons of American nature is prodigious.

> Now gen[i]us let your wand be rais'd;
> Expell the Vipers, with their nesting brude,
> The poison Vine, that throws its deadly grasp,
> Around the Verdent Oke; the deadly shoemac,
> From disperseing its poisonous influance in the Aire.
>
> The cuting bryer, from the sweet bryer bush;
> So clens the Grove; invite the warbling songsters to
> your Shades;
> Let Nature be your god; she has charms with all her
> Falts that Art can never give; with cautious steps and
> Anxious care preserve her sweets.

He then continues by advocating a relatively minimal level of intervention (as the last line suggests), echoing Knight's and Price's plea for roughness. Birch approaches his most general in the next passage.

Trim not your bows away with wanton hand,
Let cautious taste reserve them for effect;
Spoil not your broken ground with too hasty leveling,
Study well what new charms by addition may
Be made, so parly with your fansy,

Till you find it's in your way, sport well your
Conception, seek not to undo what Nature well
Intends, advantage take from the roughest
Rudeness chance has given, so let the refinement
Of your taste work its way.

Birch's Landscape Collection

In a seemingly abrupt change, Birch turns in the next paragraph of his autobiography to discuss the state of the arts in the United States. This apparent shift comes logically, if cryptically, on the heels of his reference to the preparation of his Green Lodge at Springland, which he intended to equip as a sort of American academy of the picturesque. The gist of Birch's text (p. 215) is that, in a newly formed country in which a school of the arts with a nationalist consciousness had recently arisen, he felt that his superior knowledge—particularly his mastery of landscape representation—would assist in forging a new nation and its vision of itself. Birch saw art as a civilizing force in society: he comments elsewhere in his autobiography that the fine arts "are the last polish of a refined nation" (p. 230). Clearly, while he was also advertising

his own professional wares through his collection, his general themes are those that would resonate through the nineteenth century as Americans accepted landscape gardening as a profession and landscape representation as a means of defining national identity.

Birch sought to recapitulate the essence of Reynolds's lessons at the Royal Academy in his college, combined with notions of landscape painting garnered from his cohort of London artists and patrons; his principle didactic tool was his collection of prints and paintings. It is therefore logical that an "Introduction to the Fine Arts" follows his initial presentation of his collection at Springland in his autobiography. Here he describes the instruction his collection was to impart, and Reynolds and the academy haunt the first paragraph (p. 215).

It is the laudable ambition of European nations to excel in their collections of specimens of the fine arts, and to indulge in their pastime, a fond recreation with them.

It is with rapture the connoisseur views the fine feelings and sensibility of the mind of each painter, who by his great talents, he has transferred upon the canvas.

He views the great feats of history robed in their becoming dignity. He meets, in portraits of the great, the countenance of men marked with the character of their minds.

Birch then outlines English eighteenth-century notions about landscape "scenes of delight" from the climatic to the admiration of the "Flemish school in [its] simple [representation

of] nature" and the "sublime of the Italian and French schools" of painting.[8] He then advertises for engraving, calculated for a New World audience: by means of the "polygraphic art" of printed reproduction a collection of European paintings that "are most celebrated and which cannot be purchased" can be had by an American collector possessed of "any moderate fortune." Finally, he advocates the didactic purpose of the sort of portfolio he created in London for himself: "A well-chosen selection of prints will serve also to define the different schools of painting, where the collection of pictures may be deficient, and from [this] also may be pointed out the historical progress and perfection of engraving" (p. 216).

Birch's list of the contents of his collection follows his general description (see Appendix E). Although the medium of the images is not indicated, some could have been engravings, given Birch's emphasis in his introduction and his discussion of collecting prints in London. He discusses all of the works, however, as if they were original paintings. Several European history paintings are included on the list, but seventeenth-century Dutch and Flemish landscape paintings predominate. Birch describes his as "one of the finest collections of Flemish pictures in the country." Among these are several works of one or both of the van Ruisdaels, and of Jan van Goyen, along with genre scenes and still lifes. The painters idolized by British eighteenth-century landscape theorists are also represented: Guido Reni, Salvator Rosa, and Gaspar Dughet, although Claude's work is absent, presumably because it was beyond Birch's means to acquire an example of it.

Unfortunately, all evidence indicates that his collection

and the garden at Springland failed as a demonstration of Birch's knowledge, talent, and skills, although his efforts were appreciated by a few visitors he mentions in his autobiography.[9] A visit from his patron Charles Carnan Ridgely, owner of the estate Hampton outside Baltimore, seems to have produced the intended result. General Ridgely, who had come to nearby Bristol, Pennsylvania, to race some of his horses, arrived at Springland with an entourage; Birch, "seeing a company of horsemen at my gate, . . . ran down." Then "the gentlemen went with me to Green Lodge and amused themselves with my pictures. There was a fine light." The effect on Ridgely was substantial: "The general was fixed in the centre of the gallery; they had to shake him. He then exclaimed he had never been so struck with pictures before." Birch's landscape garden was also admired by Ridgely's friends, who, when conducted around the grounds, gave their "general approbation of them" (p. 231).

Birch also reports in his autobiography that William Hamilton, the owner of the Woodlands estate Birch would represent in the *Country Seats*, "having heard I had made [the] choice of [Springland for] a retreat hastened to see the spot. This, he declared, was what his place would not produce and what he so anxiously wished for" (p. 214).[10]

These seem, however, to have been the only high points for Birch at Springland. He bemoans its fate in his autobiography, saying that the "visit of General Ridgely's, with one I received from Mr. Bullock from Charleston (a man of taste who was highly gratified with a day's visit he paid me), was almost the only gratification or encouragement I received for

my labours to propagate taste in Springland as a sample to serve the country" (p. 231).

In addition to his written description of Springland and its didactic collection, Birch created at least ten drawings, apparently intended for publication, that provide more details of his plans for the estate.[11] It may be that this section of the autobiography was intended as accompanying text for this unpublished work. The date of the drawings is uncertain, although they probably were produced soon after he purchased the property in 1798 and would therefore be roughly concurrent with his work on the *City of Philadelphia*. It is equally uncertain how much of his design he was able to carry out before he lost Springland to creditors in 1805. One of the drawings, titled *The View from Springland Cot*, became the basis of the frontispiece for the *Country Seats*. A title page, *Views of and from the Country Residences of William Birch, Drawn by Himself*, indicates his intention to publish his designs for country estates. This never appeared, however, and instead he turned his efforts to publishing his second set of American views.

THE COUNTRY SEATS

The Country Seats of the United States of North America, published in 1808, was William Birch's third and last set of picturesque views. It was also only the second view book published in the United States after his *City of Philadelphia*. No other similar set would appear until 1820, with Joshua Shaw's *Picturesque Views of American Scenery*. Like Birch's first publication, the *Délices de la Grande Bretagne*, the *Country Seats* addresses a national theme, as its full title indicates. It is one of a group of American publications of this period that reflected and defined the culture of the fledgling nation.

In contrast to the *City of Philadelphia*, there is scant human presence in the images of the *Country Seats*; the people in them convey little or no sense of group effort, the nationalistic value so important in the early republic. This lack is partly because of the association of country life with *otium*. Birch shows the country estates as the province of retirement and calm, quite the opposite of scenes of activity.[12]

Precedents

The relevant earlier images for the *Country Seats*, like those for the *City of Philadelphia*, were few in comparison to the images of British landscape available to Birch before his emigration. Like the "Brobdingnagian" views of American port cities, the earliest sets of published views of North American scenery had been issued in London in the 1760s. While landscape backgrounds were important, meaningful elements of colonial portraits (including those by Charles Willson Peale), very few images of native landscape per se were either painted or printed expressly for a colonial audience on either side of the Atlantic.

Significant numbers of American landscape paintings and prints created for a domestic audience appeared only after the Revolution with the arrival of a group of British artists (Birch

among them) in the 1790s. This production was still minimal by contemporary British standards, and the immigrant artists were often disappointed in their attempts to find a New World market for landscape subjects. Birch alone overcame this obstacle to publish picturesque sets.

Unlike the paintings by the British immigrants, the landscape images that were published in national magazines reached a relatively wide American audience in the early republican period. Most of these prints are, however, technically crude.[13] The magazine engravings share a crucial attribute with Birch's *Country Seats*, however: most are accompanied by written description or other text. While the images tend

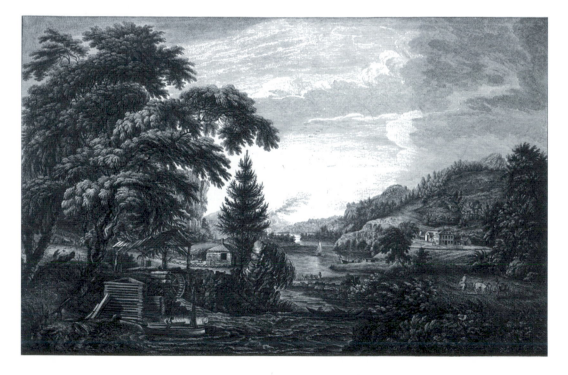

FIGURE 77. Paul Sandby, after Thomas Pownall, *A Design to Represent the Beginning and Completion of an American Settlement or Farm*, engraving, 1768. Library of Congress.

to the primitive, the prose is not; and it foreshadows many of the notions later expressed in the *Country Seats*. In their intention to address a wide public audience and in the joining of print and text to create an ensemble of meaning, illustrations in early national magazines are important precedents for Birch's *Country Seats*, as they are for the *City of Philadelphia*.

The earliest sets of views of American scenery were, like the majority of such British publications, the combined effort of several artists.[14] Among these was *Six Remarkable Views in the Provinces of New-York, New-Jersey, and Pennsylvania in North America* (1761), based on drawings by colonial governor Thomas Pownall (1722–?) and repainted for engraving by Paul Sandby (1725–1809).[15] The *Six Remarkable Views* anticipates Birch's *Country Seats* in geographic scope, ranging from lower New York State through east central Pennsylvania, and as in Birch's later work, the country estate is presented as an exemplar of American civilization: in *A Design to Represent the Beginning and Completion of an American Settlement or Farm* (figure 77), the finished farm is shown as a bright presence in the landscape.

While the general background of pre-Revolutionary views was somewhat distant, Birch's *Country Seats* had immediate predecessors: the paintings and prints of his fellow immigrant artists, and the views that appeared in early national magazines. The work of these immigrants reflects the aesthetic interests they shared with Birch but not with the greater American public. The relationship between the texts and landscape scenes published in early serials suggests different verbal and visual understandings of the countryside,

which also affected the reception of Birch's *Country Seats*.

The paintings and prints by 1790s immigrants (including George Parkyns, John James Barralet, William Groombridge, George Beck, and the brothers Archibald and Alexander Robertson) were the first American landscape images to be produced in significant numbers for the domestic market. This market, however, turned out to be limited and none was particularly successful; in fact, the stories of their American careers are largely tales of woe. The accounts of their American careers recall Birch's assessment of his own as a "profession dwindling into contempt." In his autobiography, Birch records that Parkyns, whom he knew and whose work was included in his collection at Springland, planned to publish a "tour of Schuylkill" (p. 203). Parkyns had attempted unsuccessfully to issue a series of twenty-four "American Landscapes" in 1796, but the proposed set attracted too few subscriptions. Both John James Barralet and William Groombridge, who were part of the Columbianum venture with Birch (as was Parkyns), similarly failed to find much of a market for their painted views. George Beck successfully published a series of six aquatint American views in London and Philadelphia. The first of these, *Philadelphia, from the Great Tree at Kensington* (1801), closely resembles the frontispiece of Birch's *City of Philadelphia*. Beck, however, later died in Lexington, Kentucky, "embittered by lack of recognition."[16]

Archibald and Alexander Robertson founded the Columbian Academy of Painting in New York; they were also involved in the American Academy of the Fine Arts.[17] Alexander Robertson is the artist of record for four aquatints issued around the turn of the century, although there is some evidence that his brother was the principal artist for at least one of these.[18] Like Beck's, the Robertson aquatints were issued in London.[19] The London publication of these views confirms a market stronger in Britain than in the United States for landscape scenery. The subjects of Beck's and of the Robertsons' views (including Mount Vernon and New York river scenery), however, link Birch's *Country Seats* to earlier British prints that had concentrated on country estates and waterways and indicate a continuing interest in certain subjects in Anglo-American landscape images.

Early National Magazine Landscape Views

Unlike the prints of the 1790s immigrants, the illustrations in early national magazines were unambiguously directed at a domestic audience, as was Birch's *Country Seats*. These landscape views have received scant scholarly attention, largely due to their amateurish technique. With rare exceptions, the American engravers were far less proficient than their London counterparts. As Karol Ann Peard Lawson has shown, despite their crudeness, they represent a consistent set of values and, like Birch's *City of Philadelphia*, were frequently didactic. She sees these views as "a sort of domestic, self-directed propaganda" and places them in the context of the early republican attempt "to engender a vital national identity."[20] They are thus akin to Peale's image of the Pennsylvania State House, which was associated with the bid to establish the importance of the

new nation. In these landscape views, nationalistic meaning could be invested as much in a representation of a natural feature as in a portrait of a revolutionary hero. In effect, the falls of the Schuylkill might convey a narrative independent of a portrait of John Dickinson. American-ness might thus be articulated, if not created, through a landscape image (and could thus be associated with American nature).

While the magazines may have aided in cultivating a general taste for American landscape, they did not do so sufficiently by 1808 to create more than a lukewarm reception for Birch's *Country Seats*.[21] Unlike Birch's landscape images, the magazine images cannot be separated from their original literary context—they were (often crude) *illustrations* for conceptions understood principally in verbal form. The work of the other immigrant landscape artists lacked two crucial factors: there was no accompanying text whereby a nationalist (or even personal) message could be associated with the image, and the formal conventions that they employed were not always appropriate in representing Americans' encounter with their surroundings.

Like the unclear relationship between earlier views of Philadelphia and Birch's first American publication, it is uncertain how many of these immediate predecessors directly affected the *Country Seats*. It is likely, however, that Birch knew many of them, including the work of his fellow immigrants and magazine views published in Philadelphia. In the emphasis in the *Country Seats* on aesthetics on the one hand and in its recapitulation of themes of "internal improvement" on the other, Birch's last set of engraved views seems to have been

an attempt to bring together the interests of his American audience with those he had brought with him from London. Unfortunately he found few subscribers for the education in aesthetics he was presenting, even if that education was joined with many of the interests of his contemporaries in the United States.

The National Scene

The national focus of Birch's *Country Seats* was a significant shift from the fierce localism of the *City of Philadelphia*, which, even while it addresses national subjects, presents them through the lens of Philadelphia's interests, fighting for its economic and cultural position. In contrast to this localism, the *Country Seats* was issued when a number of American publications relevant to his subject first appeared in Philadelphia. Bernard M'Mahon's 1806 *American Gardener's Calendar*, published in the city, had been the first English-language book on the subject produced in the United States. M'Mahon's work aimed at a national audience, as did the *Country Seats*, and uses the nationalist rhetoric of the period. In discussing horticulture, M'Mahon establishes a hierarchy in which an ornamental garden is both a reflection of and a means of achieving a national civilization. He identifies plants as the "materials for ornamenting the whole face of the country." His "ornamenting" is closely allied with settlement, but is presented as its highest form.

Birch's introduction to the *Country Seats* (published

two years later) begins with themes similar to M'Mahon's. With very few exceptions, the houses Birch selected for the *Country Seats* had all been created after the Revolution: they were products of the new nation. Unfortunately, as in his other writing on abstract matters, Birch does not articulate his thoughts clearly. He starts broadly, associating a group of concepts with emerging American culture rather than defining a single subject precisely: "The Fine Arts are, as to the American Nation at large, in their infancy; to promote them [by] propogating [*sic*] Taste with the habit of rural retirement, supported by the growing wealth of the Nation, will be to form the National character favourable to the civilization of this young country, and establish that respectability which will add to its strength." The specific role of the "Fine Arts" in forming the "civilization of this young country" was vigorously debated in the early years of the nineteenth century. The *Country Seats* appeared three years after the establishment of the Pennsylvania Academy of the Fine Arts in Philadelphia in 1805, which occasioned much printed discussion on the topic. Birch promoted the subject both in his own interest and as appropriate to the Philadelphia moment. As his discussion of the fine arts in his autobiography suggests, this embraced not only the professional practice of painting and sculpture but also architectural and landscape design. Birch's association of the development of the fine arts and the welfare of the nation and M'Mahon's notions of progress toward garden art are both related to the debates on the subject. As professionals, they both argued for a key role for the arts in national culture.

Birch's amalgam of the development of national culture, the "habit of rural retirement," and the "Fine Arts" emphasizes professional design at the country seat at the expense of agriculture. In essence, he promoted a tasteful suburban house divorced from the farm. In this, he was both ahead of his time and out of step with its values. Rather than presenting wealthy Americans as exemplary farmers, Birch defines the elite as cultural leaders in their propagation of "Taste," in much the same way that he had identified the aristocracy in the *Délices*.

Birch both chose and depicted estates that reflected his rejection of agriculture as a point of emphasis. While some of the country seats he selected provided their owners with a significant income, the vast majority of these landholders either practiced a profession other than agriculture or, like the members of the British upper class who had been Birch's patrons, disdained "practical" farming. So, for example, Richard Peters, the owner of Belmont at the time of Birch's depiction, *was* particularly interested in progressive agriculture, but he also was a justice of the U.S. district court; further, the image of the view from this house serves another purpose entirely in the *Country Seats*. On the other hand, William Hamilton of the Woodlands derived his income from his landholdings, but he preferred introducing exotic plant species from Asia (most notably the *Ginkgo biloba*) to breeding better grasses for cattle fodder.

The amalgam of the professional practice of arts, American culture, and rural life that opens Birch's introduction is followed by his clearest pronouncement of his approach to

landscape gardening and his vision of the aesthetic richness—the natural advantages—of the American countryside.

> The comforts and advantages of a Country Residence, after Domestic accommodations are consulted, consist more in the beauty of the situation, than in the massy magnitude of the edifice: the choice ornaments of Architecture are by no means intended to be disparaged, they are on the contrary, not simply desirable, but requisite. The man of taste will select his situation with skill, and add elegance and animation to the best choice. In the United States the face of nature is so variegated. Nature has been so sportive, and the means so easy of acquiring positions fit to gratify the most refined and rural enjoyment, that labour and expenditure of Art is not so great as in countries less favoured.

He then specifies some of the admirable features of American nature, using language derived from British aesthetic writing and, unlike the magazine descriptions of the previous decade, speaks in positive terms about what is "unimproved."

> It would be impossible to do justice in a work, such as this is intended to be, without appropriating some plates to the sports of wild unregulated nature: the woods, Lawns, broken Precipices and Crags: the curious and sublime of the Forest Trees: the Cataracts and Rivers: the blue Capt Mountains, and the deep, retired, and darksome Vallies.
> Such scenes which decorate the ground, and form the choicest Pictures of themselves, and which cannot be brought into the same Plate with the Villa, will be given separately, as highly necessary to form a full and correct idea of the American Country Residence.

What is implicit here, of course, is that the country seat is carved out of the wild.

Birch's suburban residences were all located in the region in which his fellow 1790s immigrants worked: the concentration of wealthy and politically powerful cities in the mid-Atlantic from New York to Washington. A polemic Philadelphia directory of 1804 described this region as a "pendulum of national activity, which must long vibrate (perhaps for ever) between Baltimore, Philadelphia, and New-York; a chain of commercial cities, unparalleled in history."[22]

While there is no clear geographic "tour" inherent in the *Country Seats* as there was in the *City of Philadelphia*, there is a clear thematic progress and the plates can be grouped by topics, as they can in the *City of Philadelphia*. The *Country Seats* opens, as did Birch's earlier views, with a "prologue" that lies outside the general subject of the publication: the title page shows a representation of the U.S. Capitol under construction (figure 78). The two wings of the building are shown incomplete, with a sawyer in the foreground in the midst of building materials. Two of the essential emblems of the *City of Philadelphia*—lumber and barrel-loads of goods—reappear, put to a new purpose: the creation of a seat of national government. This page places Birch's *Country Seats* in the context of this creation and suggests that it is another important aspect of nation-building.

As in both of his earlier publications, the first plate and

the last are subject pendants and bracket the work as a whole. Birch placed an image of Springland at the beginning and at the end of the *Country Seats*: the same position he assigned to Reynolds's two landscape views in the *Délices* and the location of the Delaware River images outside the geographic limits of the *City of Philadelphia*. The Springland prints have the same organizing, overarching function; while Reynolds's vision framed that of all the other British artists in the *Délices*, Birch's own country seat brackets the American estates he represents.

The frontispiece page, identified as a "View from Springland" (figure 79), shows the perspective from a position on a lawn east of the main house in Birch's plan for Springland, looking east toward Neshaminy Creek and the Delaware beyond. This print introduces (and places first) the view from the landscape garden to the wild context beyond. A classical figure suggests tradition (whether or not it represents Clio, the muse of history), and a potted citrus implies the presence of a conservatory greenhouse on a substantial estate.

FIGURE 78. William Birch, *Title Page*, engraving, 1808, from the *Country Seats*, Carson Collection.

The Country Seats of the United States of North America.

with some Scenes connected with them.

PART the FIRST

Containing Twenty Plates.

The View from Springland.

Designed and Published 1808. by W. Birch Enamel Painter Springland near Bristol Pennsyla.

FIGURE 79. William Birch, *Frontispiece*, engraving, 1808, from the *Country Seats*, Carson Collection.

This plate is unaccompanied by explanatory text, but it foreshadows and forms a pair with the final print (see figure 95), which also represents Springland, and which is described in the letterpress. It promotes Birch as both a landscape painter and garden-maker. The relationship between the two roles is implicit in his reference to his collection there: "This spot chosen by the artist for the exercise of his taste in retirement has peculiar beauties from nature. Art has added much to it, and the cottage is embellished with a small, but very fine collection of paintings by some of the first masters. This volume with his other works may be had at this place." The plate shows features of a different natural character than the frontispiece and establishes his preference for a "wild" aesthetic. The plate text—"View from the Elysian Bower"—specifically connects

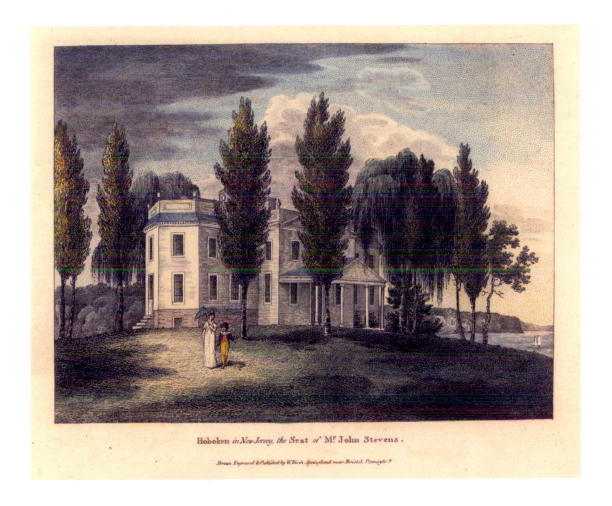

Hoboken *in New Jersey, the Seat of* M.ʳ John Stevens.

Drawn Engraved & Published by W. Birch. Springland near Bristol. Pennsylv.ᵃ

this aesthetic with the kind of paradise Birch evoked in his autobiography. It shows "wild unregulated nature": the viewer is placed under a rough and irregular canopy of trees.

After introducing his conjoined vision of the American landscape and landscape garden in the frontispiece, Birch's first two plates depict different types of scenery—a water view and an inland one—which he names in the letterpress descriptions. The first two plates also define the territory to the north and to the south of Philadelphia that interests Birch. Both of the images, unlike the Springland views, show the houses themselves and thus establish a crucial theme: the visual relationship between the heart of the property and its larger context. The first print represents Hoboken (figure 80), built in 1785 by John Stevens, who had subscribed to the

FIGURE 80. William Birch, *Hoboken in New Jersey, the Seat of Mr. John Stevens*, engraving, 1808, from the *Country Seats*, Carson Collection.

CHAPTER FIVE *"The Only Work of the Kind"* *143*

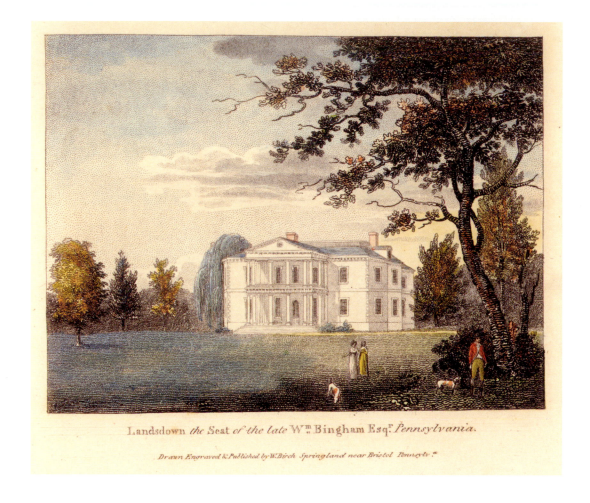

Landsdown *the Seat of the late* W^{m.} Bingham Esq^{r.} *Pennsylvania.*

Drawn Engraved & Published by W.Birch Springland near Bristol Pennsylv^a

City of Philadelphia. Birch's description alludes to the view, although not everything he names is represented: "[the house] is seated upon a prominent rock on the North [Hudson] River."

The print establishes a pattern of depiction shared by the vast majority of the following plates: the light-toned, smooth surfaces and rectilinear geometry of the house are juxtaposed against the relative darkness, roughness, and irregularity of the surrounding trees and bushes. The houses' visual perfection complements the surrounding complexity.

The next plate shows Hampton (see figure 129; 1783–90) north of Baltimore, where Birch had designed a part of the grounds. It represents another type of setting for the country house and identifies another category of American landscape scenery. The text is brief: "[the house] stands on a spherical

rise of ground, from whose valley emerges a wide amphitheatre of elegant inland country." Interestingly, Birch makes no mention of his design for the garden.

The next two engravings show Schuylkill estates, bringing the viewer to Birch's city and to the river where its most fashionable country retreats and the majority of his subjects were located. The print of Lansdowne (figure 81; 1773—burned 1854), which stood on the west bank of the Schuylkill, is accompanied by text that, like the Treaty Tree and the written introduction to the *City of Philadelphia*, recalls Pennsylvania's heritage by means of an allusion to the Penn family. It also introduces the first note of aesthetic assessment: "[Lansdowne] lies upon the bank of the Pastoral Schuylkill, a stream of peculiar beauty, deservedly the delight and boast of the shores it fertilizes. The house was built upon a handsome and correct plan by the former governor [John] Penn." Echo (figure 82), another Schuylkill property, continues the theme of the aesthetic character of the river and completes Birch's introduction of his essential notions.[23] Neither the river nor the house is shown; instead, Birch fulfills his introductory promise to represent "the sports of wild unregulated nature" and the "scenes which decorate the ground, and form the choicest Pictures of themselves" by a depiction of a wooded area.[24] The accompanying description explains his depiction of a small portion of the grounds at the expense of the house and the river view by recalling the site as a Revolutionary encampment of Washington and his troops, creating an equation of the significance of American nature with that of national heroes, a crucial point. Birch presents this wild scene as the raw materials out of which a landscape garden like Springland could be

The Sun reflecting on the Dew, a Garden scene.
Echo, Pennsylv.ª a place belonging to M.ʳ D. Bavarage.
Drawn Engraved & Published by W. Birch Springland near Bristol Pennsylvania.

fashioned, saying that it is "rich in every wild luxury which nature can afford to the plastic hand of art."

The contrast between this plate and the previous print showing Lansdowne is remarkable in its demonstration of the mental distance Birch had traveled from his work in England. In its composition and the representation of the house, the

FIGURE 82. William Birch, *The Sun reflecting on the Dew, a Garden scene*, engraving, 1808, from the *Country Seats*, Carson Collection.

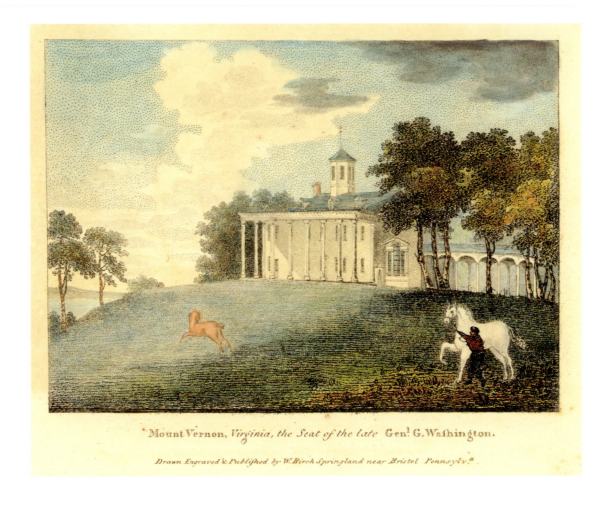

Mount Vernon, *Virginia, the Seat of the late* Genl. G. Washington.

Drawn Engraved & Published by W. Birch Springland near Bristol Pennsylv.ᵃ

FIGURE 83. William Birch,
Mount Vernon, Virginia,
the Seat of the late Genl. G.
Washington, engraving, 1808,
from the *Country Seats*, Carson
Collection.

Lansdowne image closely resembles the depictions of country houses in the British views with which Birch was familiar (including the view of Saltram, Devonshire, in the *Délices*). In contrast, the print of Echo, the "Sun reflecting on the Dew," is very much an experiment in depicting raw American nature itself.

Birch enunciates more conventional themes in the follow-ing two prints. In the first, Mount Vernon (figure 83), this "hallowed mansion," he further associates country life with national history, again using its most revered figure.[25] He associates Washington with English heritage, thereby legitimating the tradition from which many of the garden features sprang: "During the French war, Admiral Vernon, who commanded the British fleet on this station, frequently made visits to his

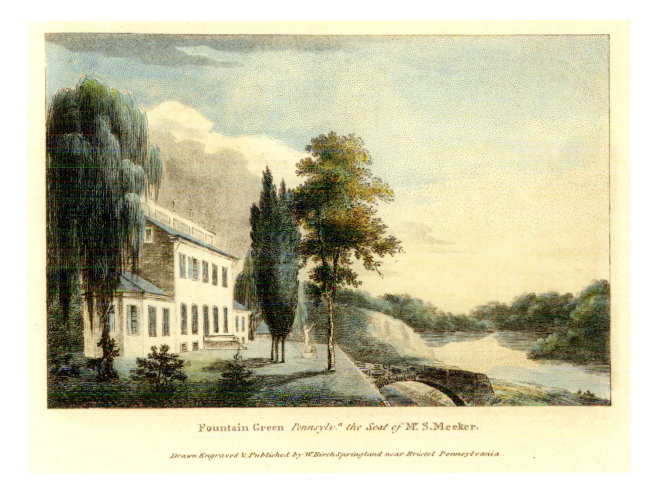

Fountain Green *Pennsylv.ᵃ the Seat of* Mᵣ. S. Meeker.

Drawn Engraved & Published by W.Birch Springland near Bristol Pennsylvania.

friend the father of Gen. W. and thence is derived its name. The additions of a piazza to the water front, and of a drawing room, are proofs of the legitimacy of the General's taste." The next plate (figure 84) and its description present an approach to the wild American landscape that differs slightly from that encountered in the print of the grounds of Echo. In Birch's image and account of Fountain Green, also on the Schuylkill,

the "internal improvement" of the new canal figures prominently, as the Centre Square Waterworks had in the *City of Philadelphia*. Birch's text characterizes the canal in aesthetic terms, however, predicting that "if ever finished, [it] will be a great ornament to the place," thus adding beauty to utility.[26]

Birch returns to the topic of undeveloped nature as the context of Solitude (figure 85), the 1784 estate of "poet" John

FIGURE 84. William Birch, *Fountain Green, Pennsylva. the Seat of Mr. S. Meeker*, engraving, 1808, from the *Country Seats*, Carson Collection.

Solitude in Pennsylv.ª belonging to Mr. Penn.

Drawn Engraved & Published by W. Birch Springland near Bristol Pennsylv.ª

FIGURE 85. William Birch, *Solitude in Pennsylva. Belonging to Mr. Penn*, engraving, 1808, from the *Country Seats*, Carson Collection.

Devon *in Pennsylvª. the* Seat *of* Mʳ. Dallas.

Painted by T. Birch, Engraved & Published by W. Birch Springland near Bristol Pennsylvania.

Penn.[27] The house is presented as a tranquil, even isolated retreat, whose circumstances are "solitary rocks, [where] the waters of the Schuylkill add sublimity to quietness," his first reference to the sublime since his introduction.

The next two images further earlier themes. *Devon, in Pennsylva. the Seat of Mr. Dallas* (figure 86) presents the Delaware as a region of rural estates similar to that of the Schuylkill and the Hudson. Like the text for Hoboken, the description for Devon—built around 1780 by another Philadelphia merchant, Joseph Anthony (another *City of Philadelphia* subscriber)—is brief, noting the estate's location as "an airy and pleasant situation on the Pennsylvania shore of the Delaware, fourteen miles from Philadelphia."

By including Mount Sidney, seen in the next engraving, Birch continues to reinforce the link between significant features of American history and his general subject. The view

FIGURE 86. William Birch, *Devon in Pennsylva. the Seat of Mr. Dallas*, engraving, 1808, from the *Country Seats*, Carson Collection.

FIGURE 87. William Birch,
*Mount Sidney, the Seat of Genl.
John Barker*, engraving, 1808,
from the *Country Seats*, Carson
Collection.

later plate) and suggests a kind of "borrowed" garden: "[Mt. Sidney's] sylvan scene mingle[s] with the romantic wilds of Sedgel[e]y."

Birch presents a new topic next with *The Seat of Mr. Duplantier* (figure 88), which shows a house built in New Orleans about 1765. The accompanying description documents the significance of the site for the national scope of the *Country Seats*: the property represents "our newly acquired territory"—the Louisiana Purchase. The plate text indicates the role of this particular property in that acquisition, recording that the house was "lately occupied as Head Quarters, by Gen[l]. J[ames] Wilkinson," the commissioner charged with receiving this territory from France.[28] The emphasis is on the import of the American moment.

Three engravings follow that share an association with the professional practice of the "Fine Arts," which is so important in Birch's introduction. Although his designs have been presented earlier (in the frontispiece showing the view from Springland and perhaps in the image of Hampton), the viewer is first explicitly informed of his work in the description for the print of Montebello (figure 89): "the house was built . . . from a plan and elevation by Mr. W. Birch." The letterpress also refers to its owner, Samuel Smith, by his Revolutionary military rank (general) rather than identifying Birch's patron as a U.S. senator, his principal public role when the *Country Seats* was published.[29] The now familiar topic of the Revolution joins others previously established in the text. He begins by noting the relationship both to a kind of wilderness and to urban settlement by locating Montebello "seated amid the woods, a few miles from Baltimore." He further characterizes

of the property, on the east bank of the Schuylkill (figure 87), is accompanied by a short description that associates the site with American politics and reiterates the aesthetic character of the river: "Mount Sidney [d]erives its honorable name from the patriot Algernon, who died in the reign of Charles II, a martyr to liberty." The estate belonged to Revolutionary general John Barker (one of Birch's enamel patrons), who named it after the English Whig hero Algernon Sidney (1622–83). Additionally, Birch alludes to a nearby property (seen in a

Drawn by G. Birch, Cornet of Light Dragoons, U.S. Army.

The Seat of M.ʳ Duplantier near New Orleans, & lately occupied as Head Quarters, by Gen.ˡ J. Wilkinson.

Engraved & Published by W.ᵐ Birch Springland near Bristol Pennsylv.ᵃ

FIGURE 88. William Birch, *The Seat of Mr. Duplantier, near New Orleans, & lately occupied as Head Quarters, by Genl. J. Wilkinson*, engraving, 1808, from the *Country Seats*, Carson Collection.

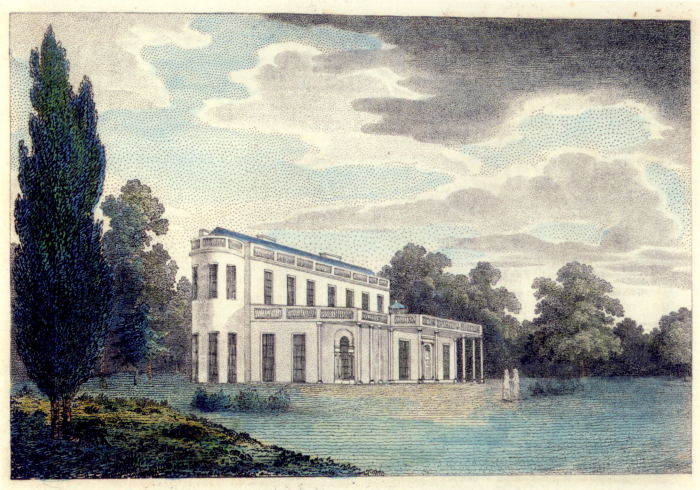

Montibello *the* Seat *of* Gen.ˡ S. Smith *Maryland*.

Drawn Engraved & Published by W.Birch Springland near Bristel Pennsylv.ᵃ

FIGURE 89. William Birch,
*Montibello, the Seat of Genl. S.
Smith in Maryland*, engraving,
1808, from the *Country Seats*,
Carson Collection.

the site by its relationship to the larger view, as he had previously, noting that the house "command[s] a prospect of the Chesapeake and Baltimore Bays." The house is another gleaming white structure in a frame of trees.

The virtuous place of art in mediating nature is most clearly articulated for the Woodlands (figure 90), which follows. This house, which was extensively remodeled in 1788 and 1789 by its owner, William Hamilton, was one of the few in the United States whose sophistication of design and art collection would have recalled the dwellings of Birch's London patrons.[30] Yet rather than emphasizing this British allegiance, Birch instead opens his account by asserting the property's place in regional history, remarking that "this noble demesne has long been the pride of Pennsylvania." The rest of his account links painting, garden art, and the landscapes that can be framed in the view, thus implicitly associating these with his own professional work. He concludes by complimenting the "taste" of the owner, which clearly is allied with his own, and by noting the estate's proximity to the city: "The beauties of nature and rarities of art, not more than the hospitality of the owner, attract to it many visitors. It is charmingly situated on the winding Schuylkill, and commands one of the most superb water scenes that can be imagined. The ground is laid out in good taste. There are here a hot house and green house containing a collection in the horticultural department, unequalled perhaps in the United States. Paintings & c. of the first master embellish the interior of the house, and do credit to Mr. Wm. Hamilton, as a man of refined taste. . . . It is about a mile from the city of Philadelphia" (ellipsis in original).

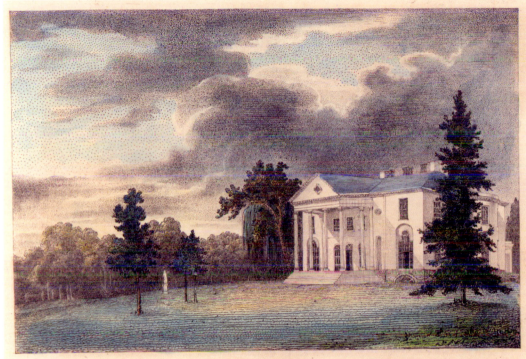

Woodlands *the Seat of* Mr Wm Hamilton *Pennsylvₐ*

Drawn, Engraved & Published by W. Birch, Springland near Bristol, Pennsylvanₐ

The final property of this "Fine Arts" triad is Sedgeley (figure 91), which Birch describes as a "beautiful gothic structure . . . erected [in 1799] by Mr. [William] Crammond, from a design by that able architect, Mr. J. H. Latrobe." Although Birch mistook the first name of his fellow professional, Latrobe is the only artist other than the author named in the *Country Seats*. This view completes, with the depictions of the Bank of Pennsylvania and the Centre Square Waterworks in the *City*

FIGURE 90. William Birch, *Woodlands, the Seat of Mr. Wm. Hamilton Pennsylva.*, engraving, 1808, from the *Country Seats*, Carson Collection.

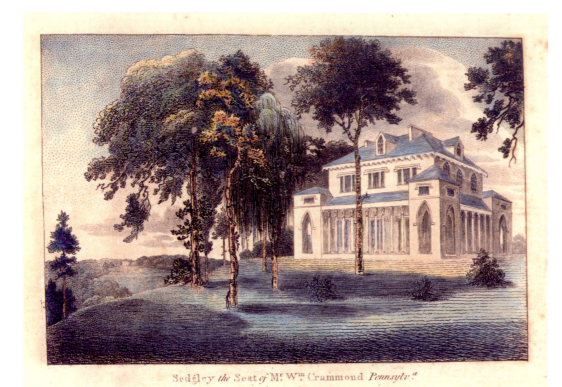

Sedgley the Seat of Mr Wm Crammond Pennsylva.

Drawn Engraved & Published by W. Birch Springland near Bristol Pennsylvania.

FIGURE 91. William Birch, *Sedgeley, the Seat of Mr. Wm. Crammond Pennsylva.*, engraving, 1808, from the *Country Seats*, Carson Collection.

humble, amidst romantic woods, gently descending lawns and caverned rocks." The larger landscape (and the view) is thus made up here by a succession of country estates.

This theme of the larger landscape is further developed in another trio of plates. These are the *View from Belmont* (figure 92), in which the vista from the west side of the Schuylkill to the north of Lansdowne is shown, *York Island* (upper Manhattan and the East River, figure 93), and *Mendenhall Ferry* (figure 94), in which an area north of Belmont on the river is represented. As in the plate representing Echo, the house is not seen in the *View from Belmont*; rather, the "prospect" from the high plateau in the front of the dwelling looking east toward a bend in the Schuylkill and Philadelphia is represented. The objects in the foreground (a line of short, obelisk-shaped bollards connected by a chain and interspersed with small plants) make it clear, however, as does the lawn descending before the viewer, that the house is not far from the vantage point. Birch begins by identifying this as *his* view: "it is impossible for the artist, who has fixed his attention upon the various beauties of the Schuylkill, to leave the study of its charms." It is, in fact, a landscape painter's vision of all the features that represent the United States, its culture, and its interaction with and exploitation of the land (and water). He recounts a physical progress from the scenery described in the previous plate to his current subject: "here you pass from the wild romantic scene; the rugged stone with wood and water bound to expand the sight from this high lifted lawn." He presents the reader with a literally global prospect, linked explicitly to economic supremacy: "to view in open space the world below,

of Philadelphia, Birch's representation of Latrobe's first Philadelphia works.

Both this plate and the description further the impression of the Schuylkill and its country estates as one great landscape garden. Birch's account presents the river itself—which is unseen in the view—as a docile, connecting thread and a natural ornament: "[Lansdowne] is seen in the distance on the opposite side of the river, whose gentle stream courses lowly and

FIGURE 92. William Birch, *View from Belmont Pennsyla. the Seat of Judge Peters*, engraving, 1808, from the *Country Seats*, Carson Collection.

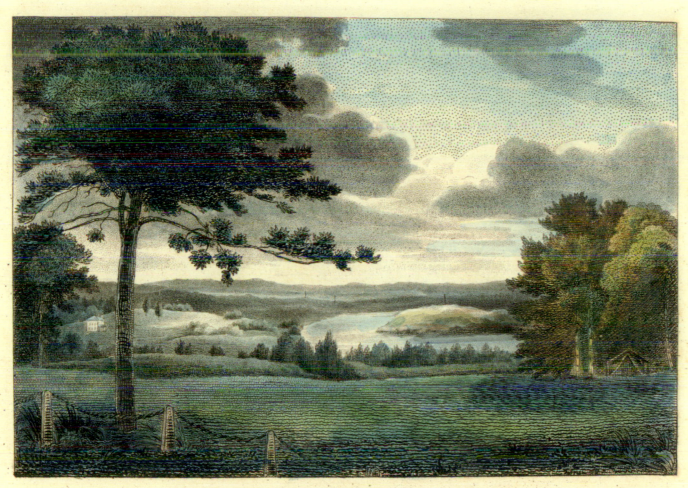

View *from Belmont Pennsyl.ª the Seat of* Judge Peters.

Drawn Engraved & Published by W. Birch Springland near Bristol Pennsyl.ª

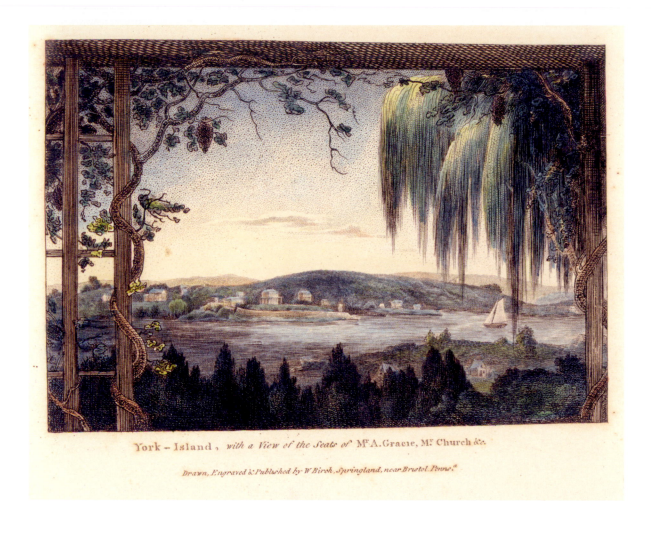

York – Island, *with a View of the Seats of* Mʳ A. Gracie, Mʳ. Church &c.

Drawn, Engraved & Published by W Birch, Springland, near Bristol Penna.

FIGURE 93. William Birch, *York Island with a view of the Seats of Mr. A. Gracie, Mr. Church & c.*, engraving, 1808, from the *Country Seats*, Carson Collection.

the riches of the richest state." He follows this hyperbolic assertion by bringing together wilderness and city, the twin economic forces of shipping and farming, land and water, and the countryside and the country seat, joining them in a harmonious whole: "the big metropolis in the woods, the chequered country with her merchants' seats; the bustle of agriculture,

and the verdant banks of the fluid mirror that reflects the sky. . . . The whole a soft and visionary scene." And a remarkable one, indeed.

A similar paradise is shown in the next plate, *York Island*, which represents the suburbs of the largest American city at the time of Birch's publication. The view is shown through a

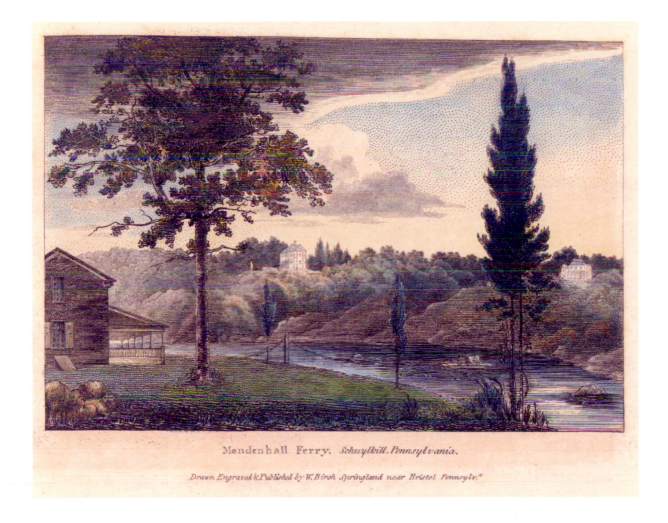

Mendenhall Ferry, *Schuylkill. Pennsylvania.*

Drawn Engraved & Published by W. Birch Springland near Bristol. Pennsylv.ª

physical and symbolic frame that combines the natural and the man-made: grape vines metaphorically laden with fruit climb trellises to the left and right and come together at the roof shown at the top edge of the image.[31] The final print of this thematic group shows the democratization of both this larger landscape and the vision of it in the form of Menden-hall Ferry, an inn and locus of public entertainment at another crossing point upstream on the Schuylkill. In his description, Birch introduces his subject as a "beautiful spot close upon the falls of [the] Schuylkill, and central to the neighboring seats of Philadelphia[; it] is one of nature's choicest retreats."

The penultimate engraving returns the viewer to the

FIGURE 94. William Birch, *Mendenhall Ferry, Schuylkill, Pennsylvania*, engraving, 1808, from the *Country Seats*, Carson Collection.

View from the Elysian Bower, *Springland Pennsylv.ª the residence of Mᴿ W.Birch.*

Drawn Engraved & Published by W.Birch Springland near Bristol Pennsyl.ª

FIGURE 95. William Birch,
*View from the Elysian Bower,
Springland, Pennsylva. the
residence of Mr. W. Birch,*
engraving, 1808, from the
*Country Seats of the United
States.*

Delaware River and thus forms a transition to the final plate, which shows Springland. Birch also goes back to the representation of a single house, China Retreat (see figure 115), and for the first time makes explicit the Old World (even the global) heritage of the "taste" he is promoting. He describes the 1796 dwelling, in terms similar to his account of Kenwood in the *Délices*: as a reflection of the intellectual accomplishments of its owner. He characterizes the property of his neighbor, the China merchant Andreas van Braam, thus: "[China Retreat occupies] an airy and pleasant situation on the Delaware, 17 miles from Philadelphia. The house was built by Mr. Van Braam, late ambassador from Holland to China. It was here he prepared for the press his account of that embassy together with the manners and characters of [t]he Chinese, and which was published at a great expense in London." This manifestation of the intellectual life (and business) of the owner in a rural residence logically leads to the final image of the set, the view of the "Elysian Bower" at Birch's own Springland (figure 95). Birch concludes his publication with a demonstration of his own "genius" in the creation of a garden that closely resembles, and blends with, the undeveloped countryside. All this, and a vision of that greater landscape, is accomplished through "art [that] has added much to [Springland]."

Unfortunately, Birch's notions of the relationship of the country house garden to the American wilderness and of the role of professional designers in the creation of the national culture went largely unrecognized by his contemporaries. His call for the leadership of the wealthy classes ran counter to the rhetoric of the period, and his conception of the positive value of the undeveloped landscape was of less interest than the communal accomplishments exemplified by "internal improvements" and advances in scientific agriculture. It would not be until nearly two subsequent generations of artists and designers had continued to promote these notions (and articulate them more clearly) that the citizens of the United States would take them to heart.

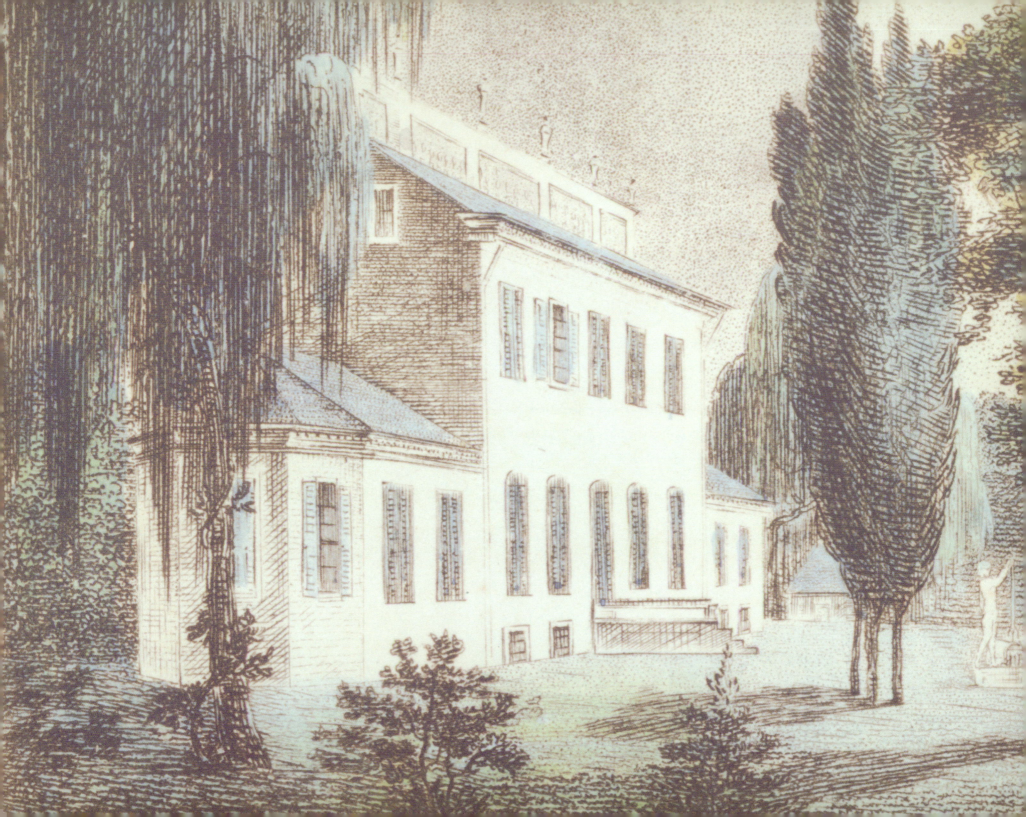

PART II

The Life and Anecdotes of
William Russell Birch, Enamel Painter

EDITOR'S NOTE

William Birch's "Life and Anecdotes" presents several interesting editing challenges. First and most important is that there are two complete copies, written in longhand, by Birch. Most of the material appears in both versions, although some passages are only in one. Many of the anecdotes are arranged in a different sequence in each text, further complicating the editorial process.

In order to present a complete text that organizes Birch's anecdotes in a format that is approachable for modern readers, we decided to present Birch's life in a single, inclusive version. For the purpose of clarity and continuity, some passages have been rearranged. In some instances, if a passage or a phrase appeared in both copies, although stated in different ways, the more clearly written text was chosen. Working from both copies also cleared up certain inconsistencies, especially in determining the correct name of a person or place.

In the early nineteenth century, there were no standards for spelling or grammar. Even so, Birch seems to have been less consistent in both than most of his contemporaries. In editing Birch's "Life," an attempt has been made to adhere to the rules of modern American English for spelling, grammar, and punctuation. To permit the twenty-first-century reader to have some insight into Birch's distinctive style, however, his "Introduction, upon Enamel Painting," and his poem on Springland in the beginning of Book II have been left largely unchanged, edited principally to modernize the spelling to aid comprehension. It is in these passages especially that readers can appreciate how keenly Birch observed nature and expressed it in his art.

No text has been omitted from the edited version, with the exception of the extensive material and correspondence relating to Birch's claim of family land in Maryland, which has been summarized and duly noted in the text. Passages that Birch crossed out have been restored, also with appropriate notation. A few passages, including one about Birch's childhood years in Birmingham, were repositioned to make the chronology of his life clearer. In addition, the numerous lists of paintings, subscribers to the *Délices de la Grande Bretagne* and the *City of Philadelphia*, and letters to and from Birch that he chose to include have been noted in the text and moved to

appendices. As an artist, Birch was not a linear thinker, and he did not have the formal education to express himself in a way that would have made his ideas clear to modern readers. The order of his anecdotes was associative, as can easily be seen by the way in which he made additions to the manuscript. Related stories are added by insertion in the Carson copy, and there are loose sheets of these anecdotes compiled in the Barra copy. The anecdotal nature of the work is acknowledged by Birch in his title: remembered stories and events of his life to be inserted in no particular order in his text.

Birch did not record why or when he began to write his autobiography. The anecdotes about his life in England clearly rise from cherished, if sometimes inaccurate, memories by the time he records them. It is probable that some sections were written as early as the turn of the nineteenth century. His Springland poem is contemporary with his time of residence there in the first decade, and his daughter Priscilla Barnes mentions in some later correspondence that her father journeyed southward in 1807 and 1808.

The bulk of Birch's manuscript, however, was probably compiled after the War of 1812. He refers to James Tilton's position as the surgeon general to the U.S. Army in the "last war" (p. 219) and remembers William Pinkney as the U.S. attorney general, a position that he accepted in 1811. Additions to the manuscript were made until the end of his life, as shown in his account of assembling decorations for Lafayette's visit in 1824 and several transcribed letters in the Barra copy about his Maryland land claim as late as about 1830.

Birch's motivation in writing his autobiographical manuscript is fairly clear from the contrast between his repeated emphasis on his relationships with the wealthy and important in England and in the United States in the first decade after his emigration and his lament of the state of the fine arts in America at the time of his drafting of the manuscript. Birch's "Life" is vindication for a career that ended in disappointment. His anecdotal approach was a conventional form of the period: James Northcote's early nineteenth-century biographical works on the life of Sir Joshua Reynolds were probably among Birch's most important models for his own account (see p. 174 for Birch's reference to Northcote's writing). Birch was certainly also familiar with Benjamin Franklin's autobiography (and is ambivalent at best about Franklin's bourgeois values). It is not known if Birch was familiar with the autobiographical writings of fellow artist Charles Willson Peale; in any event, Birch had begun his project before Peale communicated to Thomas Jefferson that he was working on such a literary endeavor in 1825.[1]

One of the copies of Birch's autobiography is owned by the heirs of Marian S. Carson. Mrs. Carson purchased it more than sixty years ago from a descendant of William Birch, Miss Louisa Birch of the Germantown section of Philadelphia. The Carson copy is part of a set of four board-bound volumes with "The Life and Anecdotes of William Russell Birch" copied into the first two volumes. The third volume contains an uncompleted transcription of most of Book I. In the fourth volume is a "Book of Profits: William Russell Birch," which records sales of Birch's published works, commissions, art supplies, and paintings from his own collection from 1813 to 1830. "The Book of Profits" is a poignant look at Birch's meager income in his last years when he was forced

to sell, both privately and at auction, his possessions for living expenses.

The Carson copy of Birch's autobiography appears choppy, both in format and appearance. Many pages have been pasted in, together with passages written on smaller pieces of paper, and inserted in the text at locations that Birch indicates with asterisks (figure 96). Some passages have been entirely crossed out and do not reappear in any form in the text. One interesting crossed-out passage concerns the discussion of a painted-glass window, designed for one of the chapels at Oxford by Sir Joshua Reynolds. A number of anecdotes that are retained in the other copy are in a different sequence than in the Carson version. Perhaps the Carson copy was read by Birch's fellow artists. In it there is a longhand note by John Neagle, commenting on Gilbert Stuart's Lansdowne portrait of George Washington. This note is glued into the text opposite Birch's anecdote on Stuart's Washington portrait.

The second manuscript copy that Birch wrote was part of the Barra Foundation Collection and was generously donated to The Athenæum of Philadelphia in 2009. The Barra Foundation copy was purchased in 1969 from Birch descendants along with a collection of family correspondence. This version of Birch's autobiography has no notes in it by others, and the text has been rearranged to produce a clearer, more readable narrative. It was probably copied later by Birch from the Carson manuscript. A more formal, finished copy, the Barra Foundation version has fewer crossed-out passages and not as

FIGURE 96. Page from Carson copy of Birch, "Life and Anecdotes," Carson Collection.

many changes in textual order indicated by asterisks. Books I and II of the Carson copy are combined into one paperbound volume with several lengthy passages appearing only in the Barra Foundation copy. In addition, the Barra Foundation version is illustrated with uncolored plates from the *Country Seats* and other small engravings by Birch. (There are no illustrations in the Carson copy.) The Barra Foundation copy also includes additional material in the form of transcribed letters pertaining to Birch's land claim in Maryland.

An accurate and complete transcription of Birch's "Life" accompanied the Barra Foundation copy. Other, less accurate typescripts, in the collection of the Free Library of Philadelphia, the Historical Society of Pennsylvania, and the New York Historical Society, had been made of the Carson copy in about 1927. These typed transcriptions proved useful in comparing and contrasting the two copies of Birch's "Life" and pointed out similarities and differences. Birch's handwriting was remarkably legible in most instances. The letters were well formed and regular, and one can be grateful that he used excellent quality rag paper and ink that has not faded.

As this is the first publication of the written work of William Russell Birch, it is possible to gain new insight into the unique and fascinating persona behind Birch the artist. As Birch himself said in his "Introduction, upon Enamel Painting," "Enamel painting is the unique art of heightening and preserving the beauty of tints to futurity." Our knowledge of Birch is similarly enhanced and preserved for generations to come.

LEA CARSON SHERK

THE
LIFE AND ANECDOTES *of*
WILLIAM RUSSELL BIRCH, *Enamel Painter*

or the *Unfortunate Traveller*

written by himself

With a list of his Copys in Enamel (by desire,)

From the Pencil of Sir Joshua Reynolds the Master

he studied under

A short detail upon Enamel Painting,

His discovery of a Claim in Maryland, North America

And Anecdotes of his Early Days

FIGURE 97. William Birch, *Self-Portrait*, cut paper silhouette, n.d. Carson Collection.

Contents

Introduction on Enamel Painting and Its Importance to the perpetuation of the Works of Sir Joshua Reynolds

Enamel painting is the Unique art of hightening and preserveing the beauty of tints to futurity, as given in the Works of the most celabrated Masters of Painting, without a possibility of there changing. The Colours are made of Metallic substances, soluted, calcined and composed with glassy substances, commonly called flux, and when layed on bodys of there own kind, and placed in a Strong heat, they will melt in one with them and become permanent; of this Art, there are many kinds and degrees in beauty, from the common potter's ware to China, or Porcelaine ware, the principle School or nursery of this Art has been at Geneva, where the most beautiful works of Art and labour have been given on Gold Boxes and other elagent articles. It still supplys the French Porcelaine Manufactory with Painters; the celebrated Petitot, with other painters of great merit might be mentioned as from that school.* The Art is not very new but rare where it excels; Raphael Painted dishes for the feasts of the Roman emperors at great cost, of three colours, gaudy and coarse, but spirited in design.

Moser, late Master of the Royal Academy in London, had one hundred Guineas for designing a Head, or a Figure, in two Colours upon a Watch Case;† it is now become a serious object in the Arts, more as mechinical imitation for the preservation of Colouring th[a]n the study of painting. The study of the Art now lays in the purity of the Fluxes for the reception of Colours; as the last Cote of the Enamel Plate; the refined tints of the Metallics, in expelling the corroding qualities of Metals, and forming a pure harmonious bloom on the Enamel, a word so often quoted by the Poet whoe wishes to express beauty and perfection in his poem.

There is no regular scientific principles laid down for this Art, its practice has hitherto depended upon chance, with its principal practitioners as to materials. The Metal or compound Enamels they have practiced upon by the different means found for beauty and effect, the qualities of substances painted upon, have been various; and the colours that are produced by one and the same compound will come from the fire very different in their seperate preparations; from the delicacy of chymical practice, which renders order impracticable for correct tints; but by study the tints are produced in a lasting stock, and the proper enamels attained by the same chymical

† George Moser (1706–83) was the first Keeper of the Royal Academy of Arts.

* French painter and enamelist Jean Petitot (1607–91).

FIGURE 98. William Birch, enamel palette, 1815. Private collection.

practice in melting. The beauty of Enamel Painting after this, depends upon the genius of the mind and the powers of the Painter.

A principal advantage I have had in most of my Enamels [has] originated from a thin layer of yellow Enamel under the last coat of white, before the flux for the reception of the Colours is laid on the plate; it gives warmth of colouring not otherwise to be obtained for the picture, a practice hitherto peculiar to myself and effects the beauty of Age seen in many of the old paintings in oil by the former masters.

In my immatations from this great master Sir Joshua Reynolds [figure 99] whose force of Colouring excelled all other masters while his pictures were fresh, I found a want of a deep brown to throw out the force of his effects in the bril-

FIGURE 99. William Birch after Joshua Reynolds, *Self-Portrait*, engraving, n.d. Carson Collection.

FIGURE 100. Henry Spicer (1743–1804), *Portrait of a Captain of the Grenadier Guards*, watercolor on ivory in jewelry mount. Victoria and Albert Museum, London, Alan Evans Bequest, given by the National Gallery.

liancy of his Colouring and Composition;[1] I applied myself to the Furnace with the deep and furm tints of the prepeared bodies of metallic substances, though the principal substance of this Colour is the calcined Terrovert*[2] compounded with the soft well-melted Fluxes from crucibles of the imitative Jewellers' manufactorys, which often ply to advantage in the study of colours for enamel painting. In the course of about a Month [I] fortunately produced an Enamel Colour pure and to the full tint of Vandike Brown which gave me infinitely the advantage of copying this master.[3] The Sociaty of Arts in the Adelphia, London gave me the Honorary Pallet for 1784 for this improvement in the Art.

Sir Joshua was understood to be the father of the English School of Painting. He brought forward the Old Masters of

*Terre verte ("green earth") is a naturally occurring compound used as an artist's pigment since at least ancient Rome.

*Engraver Francis Haward
(1759–1797) reproduced some of
Reynolds's best-known paintings,
including his famous portrait of
Mrs. Siddons.

†Gervase Spencer (d. 1763),
Christian Frederick Zincke
(1684?–1767), Jeremiah Meyer
(1735–1789), Henry Spicer
(1743?–1804), and Henry Bone
(1755–1834), respectively, all
miniature painters. See Chapter 1.

Painting which had been but little understood before in England, he lectured upon them, and with his own talents and the assistance of a few others, has brought the English School to a rivalship with the first of the Masters; his merit can never be forgot from the number of fine Plates engraved from his works by the hand of the Celebrated Haward and Others;*4 His colouring [was] a full portion of his merit, pride and delight in which he excelled, yet too much from the use of Meterials he knew himself would soon rob his Pictures of their beauty but could not leave his practice with them. There was no other Pencel in Enamel that reserved his tints before they had faded then that of my own. It has therefore been frequently hinted and requested of me to give a list of my Copys from Sir Joshua Reynolds. I have given them as stated in my Book of Delivery; the number is not great; they came in rotation with my other Works, as portraits from the life, etc. which is not an object here, excepting a few others of note, which I have introduced in the List. Among the late professors of the art were Spencer, Zincke, Meyer, Spicer [figure 100], Bone, etc., etc., not recollecting further to enumerate.†

List of Enamel Paintings by Wm. R. Birch from the Pencil of Sir Joshua Reynolds
With a few others of note from his Book of Delivery
[See Appendix A]

Having now finished my list of copies from Sir Joshua Reynolds, and given with it a few other specimens of my enamels, it is necessary to explain the cause of my irregularity in the dates of the pictures of my late friend and patron the Earl of Mansfield.* I was first engaged in his patronage in copying Mr. Copley's picture of him from the Death of Chatham, or a picture so nearly resembling one from it that I could not endure the idea of handing down to posterity anything like secondhand a character not short of the first of the age [figure 101].[5] Finding there were many wanting of this picture or portrait, I took the following opportunity of speaking my mind sitting at tea one evening with his lordship and the ladies. "Well, Birch," said [Lord Mansfield], "there is another picture to paint." "What, my lord, from Mr. Copley's picture?" I replied. "It appears to me too much like a copy from another picture [by which] to hand down your lordship to posterity. I cannot copy it, my lord." "What would you paint from?" he replied. "I cannot help thinking that in an age like this where two so great men have met as your lordship and Sir Joshua, it is your lordship's duty, to your friends and the public to sit to Sir Joshua Reynolds." He paused a while and came up to me. "Birch," said he, "the

Archbishop of York has for these ten years past been soliciting me to sit to Sir Joshua but I have always refused. But you shall go to Sir Joshua tomorrow and tell him I will sit to him whenever he will appoint me."[6]

Having thus succeeded in getting a fine portrait by my own master to copy, I sat down with pleasure to the orders, as from the first of the list. The picture being painted and much approved, his lordship said to me, "What is to be done with the Archbishop of York?" "A copy of the picture, my lord, should be ordered of Sir Joshua for his Grace." "Then go you and order it," he replied. He afterwards sent me to the bishop with a letter. What the contents of it were I know not, but I received much civility from him. While this picture was painting, the whole length of the Marquess of Rockingham was sent for from Town Hall in York by Lord Fitzwilliam to copy.†[7]

I had now with my enamel painting taken up the engraving tool in a style somewhat new—etching and dotting—a style which was afterwards taken up by my friend Haward, in which in his practice he so greatly excelled. Yet [he] was pleased so to honour me as to call his "Birch's style." In his practice in this style he received many useful lessons from

* *William Murray (1705–93), the first Earl of Mansfield.*

†*Charles Watson-Wentworth (1730–82), the second Marquess of Rockingham. William Wentworth Fitzwilliam (1748–1833), second Earl Fitzwilliam, was his nephew and heir.*

FIGURE 101. William Birch after John Singleton Copley, *William Murray, Earl of Mansfield*, enamel on copper, ca. 1785. Courtesy Special Collections Department, Harvard Law School Library.

Sir Joshua Reynolds (such as alluded to the distinction of colours in black and white) as Rubens assisted Bolswert in that part of the art of engraving so neglected by the most beautiful engravers of the French school.* This style being most adapted to the painter, I took it up to execute a small volume of British landscapes from the first landscape painters of the modern school. It being a compliment in England to France to adopt French titles to works of art and elegance, I entitled my volume *Délices de la Grande Bretagne*.

It was begun on a small size with the beautiful landscape by Sir Joshua Reynolds, the *View from Richmond Hill.*[†8] And though Mr. Northcote, in his life of Sir Joshua Reynolds, contradicts the authority of my last plate, I have in my own vindication to say that, at the close of the work, I called upon Sir Joshua and told him I had begun the work with him and wished to close with another plate of his.[9] He told me he did not think he had another. I said, "Think again, Sir Joshua." He then went up to his garret, willing to oblige as was always his disposition, and brought me down a small landscape. "That is my painting," said he, "but I do not know that it is a view. But you may take it and do what you will with it." I took it to my friend Mr. Robertson who was then about to publish the antiquities of Wales. He declared it to be a correct view of Snowden [figure 102]. "I have got a sketch of the castle," said he, "and can put it upon the bank of the hill." Perhaps a second thought would have induced me not to have published it.[10]

I have introduced the subscription list of the work which may in some measure serve to show its deserving merit from its having introduced in the list of the Royal Patronage, with the principal members of the Royal Academy and the amateurs of the age. The work consists of 36 plates with a de-

CONWAY CASTLE.

Painted by Sir Joshua Reynolds and engraved by W. Birch. Enamel Painter.

FIGURE 102. William Birch after Joshua Reynolds, *Conway Castle*, engraving, 1790. Published in the *Délices de la Grande Bretagne*, 1791. The Athenæum of Philadelphia.

The GREAT FIRE of LONDON in the Year 1666.

From the Original Picture in the Possession of

Robert Godin Esqr Painted by Old Griffier at the time of the Fire. The Scene is the Original Ludgate taken at the instant of time when the Walls of the Goal

adjoining it fell, and exhibited to the View Old St Pauls Church just taking fire, and Old Bow Church in the back ground.

FIGURE 103. William Birch after Jan Griffier, *Great Fire of London in the Year 1666*, engraving, n.d. Carson Collection.

scription of each plate, and an introduction upon the beauties of the British Isles. (Price three guineas in boards, proofs five guineas when published).

Subscription List to Delices de la Grand Bretagne
[See Appendix B]

The principal use of my engraving tool has been confined as yet to about five plates more. Upon the finish of this work, a very interesting subject in the history of England occurred for the use of my tool. Mr. Golding, a friend, brought me an old painting by Griffier, taken at the time of the Fire to know the subject. I discovered it by Hollar's Plates of Dugdale's Old St. Paul's. It was the Great Fire of London, with Inigo Jones's new front on fire in two places, Bow Church in the background and Ludgate in the front, surrounded in flames [figure 103]. Mr. Pennant was then publishing one of his late editions of London. I sent for him and, to his great surprise, he was struck with a view of Ludgate, a subject he had been ten years looking for. The print is coarse but interesting and correct. I have Mr. Pennant's letter in which he tells me he has inserted what he promised respecting it.[11] I had then to supply many of the members of the Antiquarian Society with it, at one guinea each.

The second print [see figure 14] was Mrs. Robertson [Robinson] by the seaside, from Sir Joshua Reynolds, highly finished. Sir Joshua Reynolds told me he would never wish his work better engraved. The third [was] a portrait of Sir Joshua Reynolds, very small, from his picture as Doctor of Laws without the cap [figure 99].[12] The fourth [was] the Nabob of

Surat from Kettle['s portrait] for, I think, Sir Acton Munro, which he took back to the Nabob to give to his friends at the time he presented the watch to the Nabob of Arcot from the Queen of my painting.[13] The fifth [was] from a drawing by H. Wieyx, small and beautiful.[14]

At this time I lost by death my three best friends, Nathaniel Chauncey, Esq., the Earl of Mansfield, and Sir Joshua

FIGURE 104. William Birch, *Nathaniel Chauncey*, enamel on copper, 1786. © The Trustees of the British Museum. All rights reserved.

Reynolds. The Devonshire family, my very valuable patrons, also went abroad. It was about the time of the French Revolution and things in England [were] very dull.*[15] Here let me pause a while and meditate my loss[es].

In Mr. Chauncey [figure 104], no more do I meet him, by his own appointment, at four o'clock every Wednesday in the year (after his amusing ramble in the morning), over a table, smoking, with luxuries prepared more for the indulgence of my appetite than his own, for often he would make his dinner of the liver of a fowl. The anecdotes of the day would whet the appetite during the repast. Dinner being over, the gratification of the bodily refreshment obtained [and] the wine cleared off, dessert consisted of the refreshment for the mind: the pleasures of perusing the works of great men in the fine arts and other picturesque beauties from painters stowed up in volumes of prints, etchings and drawings from his cabinet (which he possessed to the amount of thirty thousand pounds). Our researches continued 'til tea was served up when his friends of no small note would step in and join the conversation of the evening. It was here I had the pleasure of spending a long evening with the benevolent Howard, who amused us with the mode of his traveling; and seldom could I leave 'til near eleven o'clock.† Mr. Chauncey was very regular in all his conduct. He had other friends in the arts (as that was his principal enjoyment) on other days of the week and some days to himself. I knew him when his family was with him. His wife died and his two daughters left him by marriage. I had the pleasure of first introducing him to Sir Joshua Reynolds,[16] but the greatest advantage I derived from his friendship was in the summer season when he would wait my leisure to partake with him at

his own expense the pleasure of a journey in his handsome *vis à vis*,‡ which he had built for the purpose of travelling post. [There was] a seat for two in the back, and the whole front was one solid plate of polished glass, through which the enchanting scenery of Briton's Isle appeared as so many framed pictures. And knowing the country so well as he did, [he] took a pleasure in so directing the carriage as to surprise and astonish my delighted senses with everything new, beautiful, or picturesque, here and there driving up to the mansion or palace of some man of taste whose possessions were fraught with the finest specimens of the arts, in painting, sculpture and other objects of taste, [and] where I always found he was welcomed by a countenance of pleasure. It was thus travelling for a month, sometimes six weeks together, that stored my mind with a treasure well calculated for my profession. He had a small but very fine collection of pictures himself: two of Claude Lorrain's finest paintings—"The Angel in the Troubled Waters" and "The Enchanted Castle," [see figure 13] which George the second envied him of.[17]

The Earl of Mansfield; I have seen him on the Bench, robed with the King's authority, where his venerable person with his just decrees sat, infusing awe upon the vices of the British nation. I have traced him to his private life where his cheerful mind made happy his friends. The music of Murray's [Mansfield's] voice, which elevated the soul of our great poet Pope,§ in crossing his table to cheer the humblest of his guests, has delighted me also.[18] His pleasant humour and jocose tales never failed to banish care, when [he was] in health. For near eight years did I visit at Kenwood whenever my inclinations led me that way, and never was I sent from the gate [figures

105 and 106]. If his lordship was engaged, his order to the servant was to show Mr. Birch to the ladies, with whom I sat till he joined us. He promised to visit me at my neighbouring cottage on the heath but, alas, he was approaching his end. I called [and] was introduced to his sickroom. He was in his elbow chair, dozing. I sat alone with him for ten minutes; he did not speak. I rose to go; he lifted his hand from his knee and said in a low voice, "Don't go, Birch." I sat down till he slept. I rose gently, left the room and saw him no more. I visited the Miss[es] Murray a few days before I left England for America at Pope's villa at Twickenham.[19]

Sir Joshua Reynolds [was] the parent of the English school of painting whose merits are too well known for me to mention here, but as they allude to my own good fortune. His greatest pride in painting was the clearness of his tints and the brilliancy of his colouring, and this also is the first object in enamel painting. How fortunate was it then for me that I was in full practice in the height of his day, and so much favoured of him as to suppose that I might also be useful to him by handing down to futurity those clear tints and that brilliancy of colouring which he always suspected would leave his pictures but knew could never leave my enamels. He told me I might take his pictures even from the easel if dry or [in] any other part of the house I found them, for the purpose of copying without asking his leave and keep them as long as I would. The little applause the copyist will gain will serve him for handing down the merits of his master, after the original pictures have faded.

But he is gone. His funeral told the honours of his life; it was splendid. Mr. West had the arrangement of the pro-

FIGURE 105. Robert Freebairn (1764–1808), *Hampstead Heath*, watercolor on paper, ca. 1785. Carson Collection.

cession.* I called upon Mr. West and told him I must not be forgot in his arrangement. "I have thought of you, Mr. Birch. I know your standing with Sir Joshua and, as you are not a regular member of the Academy, I have ordered a black coach for you to join the family."

A few anecdotes which occurred with my friends in my happier days may be interesting. Lord Mansfield was very

* *Pennsylvania-born, Anglo-American painter Benjamin West (1738–1820) was the second president of the Royal Academy.*

FIGURE 106. William Birch, *Garden Front of Kenwood, the Seat of the Earl of Mansfield*, engraving, 1789, from the *Délices de la Grande Bretagne*.

partial to Pope. When at Kenwood he took me to his picture painted by Pope himself. "There, Birch," said he. "The greatest honour that ever was done to me in this world was that man's making me his executor." "A proof at once, my lord," said I, " of your lordship's friendship and humility." Humility is the first virtue of the human mind. It is only found with the great. The humble man feels the affections of his neighbour, and knows how to value his worth. The haughty feel not beyond themselves, and their disdain debars good fellowship. Lord Mansfield's judgment by humility became enlarged, and he supported his superiority by justice. It is pride that forms the tyrant, tyranny [and] avarice; and avarice that robs the poor. But friendship and humility [are] liberty and independence.

The key of his celebrated library was at my command. His beautiful and spacious gardens [were] often my morning's walk, sometimes with the celebrated antiquarian and member of the R[oyal]. S[ociety]., Dr. Combe, his physician, who had a room and medical apartment in the house.* I often took breakfast with him before I returned to my cottage.

I would often speak to his lordship of the improvements that might be made at Kenwood. He told me if he had been ten years younger he would submit to my taste in the entire new arrangement of his grounds. He told me to decorate my cottage from his greenhouse, which was splendid, saying there was enough for us both. Often did George the third and the Queen visit this happy retreat.

Being fine weather and unengaged on a Christmas Day, I thought I would walk from my cottage on the heath to Ken-wood and dine with my patron, as I had not seen him for some time. I was introduced to the Miss[es] Murray [and] told them my errand. They exclaimed, "Why, Mr. Birch, I thought you had known Lord Mansfield's movements better than that. He is now on his circuit, but we are going to dinner and shall be glad of your company." There were no visitors. The house at Kenwood was generally retired: few but elderly folks and lawyers visited there. Lord Mansfield was, of all the nobility, the most difficult of access. We sat down to dinner where the delicacies of the season were never wanting on the table. The ladies congratulated me upon the intimacy I had with the Earl of Mansfield, assuring me there were many of our first nobility [who] would be glad to stand in my shoes with Lord Mansfield. I told the ladies I was very sensible of the honour his lordship did me and was proud to bear it. After a very comfortable dinner and chat, [and] the dishes taken off, in comes the pride of my friend, Mr. French, his lordship's gardener, [with] a plate piled up with as rich-flavoured and fine-bloomed peaches as ever grew under the warm radiance of the summer's sun in a hot climate. This was not the only task Mr. French had to stick to. His fruits in general were fine (I never shall forget his currant tree), but his flowers were as much the object with Lord Mansfield. Every morning before he went to the hall at Westminster, Mr. French had to lay, by his cup of coffee, a nosegay of the finest odor and richest flowers, which he took with him to the bench. Thus did Lord Mansfield in the high refinements of his taste for life appropriate five hundred pounds *per annum* as Mr. French's salary to the gratification of three of the senses so essential in the

* Charles Combe (1743–1817), a fellow of the Royal Society, was both a physician and a classicist. He edited, with the Reverend Henry Homer, a publication of Roman poet Horace's works, which were inscribed to Lord Mansfield.

enjoyment of life with the pleasure of the garden. Dinner being over and a plate of peaches left, the ladies insisted upon my putting them in my pocket for Mrs. Birch and family at home.

It may be asked, as Lord Mansfield was so difficult of access, how I came by an introduction. As it will make a good anecdote, I will repeat it. As I was one morning looking at some pictures purchased by Lord Duncannon at his father's house* in Cavendish Square, he told me that Lord Mansfield wanted his picture in enamel, and advised me to go to him. I thanked him and said, "I suppose I may mention your lordship's name." He paused and said, "Why, Mr. Birch, there is a delicacy in that my father and Lord Mansfield are great friends and the two oldest peers of the realm and it might be thought a liberty in me." "Well, my lord," then I replied, "I will trust to my talents to introduce me." "And that is quite sufficient," he replied. The next morning, as his lordship was early at the Bench, I was at his house in Great Russell Street, Bloomsbury before eight o'clock with a proper specimen of my abilities. His carriage was waiting. I was shown in; his lordship was at breakfast. I presented the picture and told him I was informed he wanted an enamel picture painted. "Who sent you?" he replied sharply. "I am not authorized, my lord, to say. I depend on my talents, my lord, to introduce me." "Who have you painted for?" I mentioned several names he knew. "Did you ever do anything for Lord Bessborough?" "No, my lord, but I have done a great deal for Lord Duncannon." "Well," he said, "that is the same thing." "In fact, my lord, it was Lord Duncannon that told me of it. I asked if I might use his name. He told me he could not take that liberty: that your lordship and his father were great friends and the two oldest peers of the realm. [He] said he

* Frederic Ponsonby (1758–1844) was at the time of this meeting Viscount Duncannon, and his father, William Ponsonby (1704–93), was second Earl of Bessborough.

thought that my abilities would be sufficient."[20] He then asked me if I had breakfasted. I could not say yes; it was too early. I took a dish of coffee with him. He said he would send Mr. Copley's picture to copy [and] that he had been waiting near ten years for an enamel from Mr. Meyer, enamel painter to the King.[21] I thought by giving up my authority without opposing the confidence that Lord Duncannon had placed in me, it could be added to the lustre of the modest and delicate respect shown in that young nobleman to his friends.

The temper and mind of the Earl of Mansfield was mild and placid; he enjoyed retirement because it gave him leisure to form his judgment. His knowledge of the world was sufficient in his practice on the bench. His time for the recreation of life in the enjoyment of his friends was well chosen; and the whole arrangement of his system for life [was] enjoyed, as far as the evils of life, which no one is free from, could admit. [Lord Mansfield had] a former acquaintance with Pope, a man different from himself, peevish in a temper formed from his misfortunes in life. [Pope's mind was] apparent from his works, like that of [Mansfield's] own which he has left as lessons [in] moral virtues and wisdom to the following generations. It appears, from expressions I have often heard from his own lips, there must have been a great attachment between them. Pope must have received great consolation from Mansfield's endeavours to relieve the afflictions of his life.

It is said of Lord M. that he was fond of flattery. I should like to know who is not—no man that is human when it is given with decent respect it is the only mode in social life of conveying our ideas or feeling of affection to our friends which is the social happiness of life. His Lordship was as fond of

~~complimenting as being complimented. I remember sitting with him in his law library which was then in Lincoln's Inn Fields when some high character was ushered in. His lordship received him with marks of respect. He then introduced me: "this is Mr. Birch, the rising genius of the age." I blushed, if anybody could see it. It was impossible to know Lord Mansfield and not return such respect while his easy manners gave liberty to his friends to do so. I have received many kind marks of respect from him.~~

A singular mark of his respect to me may not be amiss to mention. After sitting at tea with the family, Lord Mansfield came up to me. "Birch," said he, "if any thing should happen to you, mind you send to me, directly, mind, directly" he replied. "I thank you, my lord, I will," but I could not conceive what he could mean, not being conscious of anything wrong. As he said no more, it was not my place to ask him more. About a week after, I recollected I had been in the Temple, in the chambers of my friend Robert Gray, Chamber Counsellor, spouting away upon *The Rights of Man*, just published by Thomas Paine.[22] A gentleman in the room, a stranger to me, fixed his eye upon me. When I had done, my friend Gray, who knew the gentleman to be one of those appointed by the Chief Magistrate to put down the work as seditious and dangerous to the peace of the government, very quietly argued the subject, saying, "these are dangerous times. Now, if anybody was to talk in the style Birch does now publicly, he would be taken up." A fierce and angry reply from the gentleman was uttered. "And serve him right, too. Such language as that is enough to inflame the public." "Yes," says my friend, "but in a private chamber it may be overlooked." No more passed at that time,

but this certainly must have been the case that was repeated to Lord Mansfield of me. He had but half [the] story, for at that very time I had 500 volumes of Thomas Paine's *The Rights of Man* consigned over to me to give away. I was not acquainted with Mr. Paine personally, though he was a subscriber for six volumes of my British views (at three guineas per volume), but [I] did not know then that he was the author of that work or had ever [ex]changed a word upon the subject with him.[23]

Lord Mansfield was well convinced that I should not oppose his endeavours to keep the peace as Chief Magistrate, nor do I believe that Lord Mansfield was more an enemy to the rights of man than Mr. Paine; but when I understood the hazard there was in circulating them to the public, I never touched one of the 500 volumes consigned over to me. Nothing convinced me more of the confidence that was placed in me in that house than the respectful letters from Buckingham House being read before me.

Lord Mansfield's renown was as early as at the trial of Lord Lovat at the Scotch Rebellion, where he was judge.* In my researches for scraps of drawings by the masters which were the delight of the modern painters, I found a lot of Hogarths, which had long been hoarded in a garret. Among [these] was a profile of Lord Mansfield (at that time, Counsellor Murray), with a fine likeness of Lord Lovat at the bar [figure 107]. [There were] other different designs [drawings], with two or three designs of the manoeuvre used by the Duke of Cumberland by which he gained the advantage of the battle.† Some of them I placed in the Buckingham House Library; others of them I sold to John Bull, Esq., who, finding

* *Simon Fraser, eleventh Lord Lovat (1667/8–1747), was one of three peers prosecuted by then solicitor general William Murray in the House of Lords for treason for their role in the 1745 Jacobite uprising.*

† *Prince William Augustus, Duke of Cumberland (1721–65), was the commander of the government forces in England that put down the rebellion at the battle of Culloden.*

FIGURE 107. William Birch after William Hogarth, *The Trial of Lord Lovat in the House of Lords*, engraving, n.d. Collection the Athenæum of Philadelphia.

* *"Lord Howe" could be either of the two brothers, William (1729–1814) or Richard (1726–99), who were commanders of the British army and navy, respectively, in the American Revolution. Lindsay (1737–88) was a rear admiral in the same war, and the nephew of the Earl of Mansfield.*

them valuable, presented them to Sir Horace Walpole for his superior collection of Hogarths.[24]

I was one day at dinner at Sir John (or Admiral) Lindsay's, in company with Lord Howe and Lady Lindsay (who had one of my enamels of Lord Mansfield in a locket).* [From] my being the artist in company Sir John was reminded of having in his possession a drawing of Lord Mansfield by

Hogarth, which he showed me after dinner and, and which I found must have been done at the time of the other sketches. It was a beautiful drawing and doubtless at the time a strong likeness. I requested of Sir John to lend it [to] me, promising to engrave it. It being not very large, I put it in my pocket book. The next day a note came from Lord Mansfield with compliments to Mr. Birch—[I] was persuaded not to engrave

that drawing, as Lord Mansfield conceived it to be a carica-ture. The word "caricature" has always been a stumbling block to me from the different ideas people in general have of it. Hogarth has certainly designed caricatures, as in his beautiful etching of the Italian opera dancer (where the nobility and gentry come in a string, kneeling as they approach—"pray ac-cept my five hundred pounds"—with different sums on labels to the end of the line), in his portrait of Churchill as a bear or English bulldog [figure 108]; and many others of note. But in his sketches from nature he is correct and spirited. His "Rake's Progress" and his "Harlot's Progress" are pure repre-sentations of nature, not defiled by caricature. Upon the same standing are his beautiful modern "Master Wilkin [Willes] in his Quarter Day" and "Reading the Will": works never to be excelled, [done] upon the principle of the Flemish School.[25] The head of Lord Mansfield by Hogarth I thought would make an additional amateur article to those by Cooper of Oliver Cromwell and Milton,* but it was not for me to ar-gue with Lord Mansfield. I returned the drawing to Sir John Lindsay.

I know of but one artist in the line of caricature of note as such, and he had both merit and wit and made them the object of his pursuit. It was Gillray [figure 109].† I collected about sixty of his prints for Judge Samuel Chase‡ when he was in London which he brought with him in a volume to Maryland as a proof of Gillray's merit in that line.[26] A set of his prints now sell for 100 pounds; [they were first] published at one shilling each. I cannot say how many there are of them.

Lord Mansfield was a great encourager and friend of the arts. [He] would often, from its being generally understood to

FIGURE 108. William Hogarth (1697–1764), *The Bruiser*, engraving, 1764. © The Trustees of the British Museum. All rights reserved.

be so, receive invitations to visit anything new exhibited, but would seldom go himself. [He] would frequently send me and wait my opinion. [He] was very cautious in giving his own opinion of the arts, though his judgment of them was natu-rally good. He would always refer any case at the bench that

* *Miniaturist Samuel Cooper's (1607/8–72) portraits of Cromwell and Milton are among his most important and best-known works.*

† *Caricaturist James Gillray (1756–1815).*

‡ *U.S. Supreme Court justice, Revolutionary leader, and Annapolis native Samuel Chase (1741–1811).*

referred to the arts (where it required knowledge of them) to a committee of the Royal Academy.

He had been a great friend to Mr. Copley before I knew him. He had taken a great deal of trouble upon himself (for him) for the picture of the death of Chatham. He told me he had procured all the sitters for that picture that Mr. Copley could not obtain himself. The picture is one of the best of that artist and the subject very interesting. It is a picture [made up] of portraits, well grouped [see figure 9]. The figure of Chatham is beautifully painted and hands down to posterity the history of that singular event to great advantage.

Mr. Copley must have enjoyed much good fellowship in the course of his patronage under the Earl of Mansfield. [He] need not have been offended with [Mansfield's] sitting to Sir Joshua Reynolds, or have thrown upon my back the ruin of his fortune from it, after having made one by his [own] means before. The inconsistent conduct of Mr. Copley was too clear. The dowager Lady Charlotte Wentworth, who witnessed the breaking out of his disappointment upon the subject at Kenwood, brought kind and tender caution for my safety.[27] [She] was absolutely agitated with fear for me, 'til I had persuaded her ladyship that my back was broad enough to bear all that Mr. Copley could lay upon it. Lord Mansfield, in his arrangement of the law, was the British lion, but in private society, [a] lamb. Mr. Copley had taken advantage of the latter; Lord Mansfield saw it [and] called me forward to test it. Then, like the lamb, let it drop in silent contempt.

The Earl of Mansfield has greatly honoured me in the social intercourse I have had at Kenwood, the seat of his retire-

FIGURE 109. James Gillray, *The Daily Advertiser*, engraving, n.d. Private collection.

ment. His unremitted application to the law for so many years required repose. Lady Charlotte Wentworth was one of that amiable society (with the Miss Murrays, some other dowager ladies, [and] some of the steady and stable pillars of the law as

Erskine Newman etc.) who soothed that venerable character in the decline of his days.[28] When I was copying the picture of her brother the Marquess of Rockingham from Sir Joshua Reynolds's [portrait], in enamel for Lady Charlotte Wentworth for her and her friends, she would attend me at the finish of each picture, to guide my pencil in the likeness. [These] instructions, [given] in an amiable manner, both delighted and informed me. They [were] attended with some sympathetic remarks of the virtues of the character of that great man and delivered with much tenderness and affection [as] the fond memory of a brother. [Her remarks] formed an addition to the picture from which I was painting, though [the original was] painted by Sir Joshua Reynolds. At the same time, [I] discovered the happy choice of society Lord Mansfield had formed for his retirement.

I must not neglect the honour intended me by Lord Mansfield. When Sir Joshua Reynolds had painted one of his finest pictures, the whole length of the Duc d'Orleans,* his lordship told me I should execute a fine enamel of that whole length, and [that I] should be paid one hundred guineas for it and be provided for to present it personally to the Queen of France from the Court of Britain.[29] [It was to be] a specimen of the advancement of the arts in the abilities of Sir Joshua Reynolds united with my own. The Duke was then in London and paid me a handsome compliment upon my talents. But near upon the same period of time, the French Revolution happened, which put a stop to the undertaking. Lord Mansfield had prompted me by encouragement to the purpose of the undertaking, saying, "Birch, you have the world before

you; you want for nothing." But soon after the Duke returned to France, and the Reign of Terror came on. No man can foresee the decrees of fate. The proud queen fell a sacrifice to her ambition and the monarch of France followed; and the false hopes of the Duke himself failed upon the block, where both vice and virtue suffered. The French long sustained the contest of vice and virtue, under the first Hero of the Earth, who by humility had gained the good fellowship and love of his country. Ambition to figure in the Venice Car led him to dare the elements in the Russian War where he grew weak. The Herald of England challenged him to the field of Waterloo where the noblest blood was selected and spilled. The Venice Car was the subject of the four colossal brazen horses formerly of the chariot of the sun in the Hippodromos of Constantinople. [They were] afterwards taken to Venice and placed at the Church of St. Marco. Napoleon in triumph brought them to France, intending at the close of his wars to place [them] in a triumphal car in Paris as the Venice Car.

N.B. The horses are supposed to [have been] executed by Lysippus in the reign of Alexander.[30]

Since I left England, I have had the pleasure of being informed that the monument of my friend and patron, the Earl of Mansfield, is erected in Westminster Abbey to commemorate his useful labours and virtuous life, ended in venerable old age. [It is carved] by one of the celebrated sculptors of the English school from the picture I had the pleasure of persuading him to sit for by the master I studied under myself, Sir Joshua Reynolds. Mr. Flaxman, the sculptor, was a great genius.† [He] chose that branch of the arts for his studies knowing that, if

* Louis-Philippe-Joseph, duc d'Orléans (1747–93), was the cousin of French king Louis XVI and a supporter of the democratic movement in France before the Revolution. Despite this, he was guillotined in 1793.

† Sculptor John Flaxman (1755–1826) was among the most prominent and successful practitioners of the specialty in the period.

he ever arrived at the perfection and deserved to be numbered with others as members of the fine arts, his works would be of duration. [They would] afford pleasure to future ages beyond the reach of our ideas. Such was his mind. I knew it by experience and will never forget the severity of his reproof. When I rendered him my subscription book for my British views (with specimens of prints for which I had received the highest applause and flattering gratifications), his answer was a reply with angry energy. "I subscribe to your plates. [You are] a man capable of enamel painting, an art so much required for the support and future pleasure of the arts." "No," he justly concluded, "one branch of the arts is enough for one man's life." I was acquainted with his friend Bacon, R.A.,[*] a man of equal merit and in the same line. [He was] I think a pupil of the renowned Roubiliac.[†] He brought me his picture to be copied, painted by Mr. Russell, R.A.[‡] in crayons (who was so celebrated in that line). Mr. Bacon wished it more durable. He was a handsome man and I thought I could please him better by taking it from life. I succeeded to his satisfaction, but a little to the displeasure of Mr. Russell who was a fine painter. Mr. Russell was of the same persuasion as George Whitefield and painted the finest full, whole length I ever saw of that reverend gentleman preaching on Tower Hill.[31] [It was] a picture of great merit in oil. Mr. Bacon was partial to my enamel painting and proposed to the Royal Academy [that I go] abroad under the King's patronage to copy some of the choicest subjects from the masters as studies for the Academy which, at that time were not known in England. The proposal was opposed by Mr. Cosway[§] and others.

The attention of Sir Joshua Reynolds was equally kind to me. There was a law in the Royal Academy that opposed the art of enamel painting, which was that all copies should be rejected in the exhibition. I reasoned with Sir Joshua upon its being a general law that there ought to be an exception: that good copies in enamel, from their superior durability and beauty, ought to be exhibited, as the art was principally calculated for copying and useful in preserving colouring that might be lost. I asked him whether, when he visited the cabinets of Europe, he did not find that they considered their enamels to be a choice part of their relics, and whether the best of them and most of them were not copies. He replied, "Yes, it was so," and before the next exhibition he sent me word that the law was in my favour. He told me [that] when Meyer died that he could procure me the situation of enamel painter to the King. I thanked him but [felt] that I would rather be without it, as I was not in a situation to receive it and should not be likely to benefit by it, and advised him to give it to his friend Collins. "He has more merit than myself, and is full as deserving." "But," said Sir Joshua, "he is no enamel painter." "He can soon acquire it with his abilities," I replied. "I will give him every assistance in my power if he will accept it." Sir Joshua seemed a little surprised, but the next week Mr. Collins came to me and said, "Mr. Birch, I am in a difficulty. I have accepted the situation you refused. The King has ordered six portraits of himself in enamel, and I cannot paint them." I told him if he would undertake them himself, I would engage he should get through the order handsomely, but he made me no answer

[*] *Sculptor John Bacon (1740–99) was elected a member of the Royal Academy in 1778.*

[†] *French-born sculptor Louis François Roubiliac (1702–62) worked in England from 1730.*

[‡] *Painter and portrait specialist John Russell (1745–1806). Birch engraved Russell's* Golder's Green *for the* Délices, *to which Russell subscribed.*

[§] *Miniature painting specialist Richard Cosway (bap. 1742, d. 1821).*

and I saw no more of him. He was in a state of ill health and I believe died soon after.[*]

Sir Joshua had been engaged to design the great window at Cambridge. He had planned for light to fall from the pointed Gothic of the window from the hovering angel, a bright glory, to descend in rays upon the nativity below, that the brilliancy of light might strike the beholder with awe. The power of his canvas was not in the execution of his design for the window. In spite of the transparency of glass, the half-calcined colours round the glory [were] too flat [and] the effect was lost. He feared the execution of his design would not be competent. He sent me to examine [it.] I was under the necessity to say, on my return, the window would not effect his force nor stand in its colouring.[32]

Another mark of his attention to me was the following. Sir Joshua had purchased the beautiful miniature of Oliver Cromwell by Cooper. Obracon, the engraver, had borrowed one of Milton by the same master of the Duke of Devonshire. The Duke had forgot[ten] whom he had lent it to. Obracon died before he had returned it. It was sold with the property he left [and] the broker who bought it sold it to Sir Joshua. These two celebrated pictures coming together soon raised the rumour of its being likely the one that was the Duke's. Sir Joshua sent word to the Duke to know if it was so. Sir Joshua had given the two pictures to me, saying, "They will make a great noise among the arts. All that come to me to see them I will send to you, which may be of use to you." In about a week, Lord Sandys came, with others.[†] "Mr. Birch, Sir Joshua Reynolds sent me to look at the picture of Milton by Cooper." I

showed it. "Ha, that's it, sure enough." I guessed his errand and replied, "What, my Lord, the Duke of Devonshire's?" "Yes," he replied. "I did expect so," I said, "but such a pair of pictures, I think, should never be divided. They are now in good hands. Sir Joshua will not for a moment dispute the rights of giving it up, but I do hope, my lord, you will plead in favour of Sir Joshua and say they ought to remain as they are." "I think so, too, Mr. Birch and I will do my endeavours to that purpose." When I saw Sir Joshua again he said the Duke had give[n] it up and he should like to have them framed as the handsomest pair of amateur articles ever put together for the pocket, to visit with, and that he would trust to my taste to do it for [him], as [he] never knew anyone who framed a miniature to so much advantage. He said, "We know what a picture is without a frame but we ourselves value them more when properly framed."[33]

Sir Joshua took every opportunity to serve me. My friend Mr. Chauncey told him I was poor, and that was nothing new. I never studied riches but independence and lost my way. Sir Joshua told my friend Chauncey that he "never knew a man that had more friends than Mr. Birch has, and such that would be happy to serve him. If Mr. Birch will intimate his wants on paper I will head a list myself and will collect as much money for him as he wants." When I saw him again I told him that Mr. Chauncey had told me [of his offer]. I thanked him for his kindness, but [said that] I had a great many rich relations, and if they would not help me, I could not think of troubling my friends. The fact was I wanted some of Franklin's economy, but could not submit to water gruel where better food was

[*] Richard Collins (1755–1831) was appointed enamel painter to the king in 1789 after the death of Jeremiah Meyer, whom Birch mentions above.

[†] Edwin Sandys, Lord Sandys of Ambersley (1726–97).

* Greenwood and Hutchins were contemporary London auctioneers. Hutchins conducted sales from an address in King Street, Covent Garden.

† Politician and author Edmund Burke (1729/30–97), who was a member of Reynolds's social and cultural circle.

waiting. I was as fond of the arts as he was of books, but instead of making water gruel serve me for breakfast in place of bread and cheese and beer (as he persuaded his pressmates to comply with though they needed nourishing food), I could not submit to such prudence. I used to go with my handful of guineas to Greenwood's and Hutchins'* evening sales and, on my return, sit up all night to separate my lots. [I would] retain such that suited the nature of my collecting and, instead of saving the residue (which was by far the greatest part) to sell again, I thoughtlessly committed them to the flames, by way of clearing them out of my way. And such has been my want of economy all my life. I have not been an idle man, but inattentive to my interest. For [this] I have sufficiently suffered, but I have not lost the credit of my collecting or the pleasure of having had the enjoyment of such a collection. I showed Mr. West my volume of painter's etchings.[34] Mr. West was a great collector himself, but he had more of Franklin in him (and, most likely, had the principal part of this volume); but when he observed the correct arrangement, the beauty of the impressions with the [rarity] and scarceness of some of the collection, he declared he had never seen such a volume before. ~~The general mode of collecting with the amateur is to book everything of the masters; mine was to retain only the fine ones of each master.~~ The volume I collected could not have cost me less than two thousand pounds.

Sir Joshua's hour for dinner, as usual, in high life, was four o'clock. The studies of the day were then over, the mind unbent and given up to the enjoyment of his friends in society, instead of hardening the heart by speculation 'til night. About

that hour his students would attend in his gallery (when he left his painting room) that they might have the pleasure of communicating a word to their advantage with him as he passed to dinner. It was at this time I called in and found Mr. Edward [sic] Burke making remarks upon a picture to one of the students.[†] I thought it nonsense, which every great man will, at times of unguarded moments, be guilty of. I cannot exactly recollect the subject, but I thought it too great a chance to neglect not to retaliate for [the] advantage he had taken of me some time before in a trifling incident of gallantry. I objected to the remark but could not apply it 'til I had twisted the matter into a question. While arguing I found Sir Joshua's head directly over my shoulder, his chin resting on me in a half laugh, I suppose to hear how far my impudence would take me in a contest with Mr. Burke. I plied the question. Sir Joshua burst out in a loud laugh [and] caught hold of Mr. Burke's coat, "Come along, come along," said he, "you will get no good here," and took him downstairs to dinner but not without Mr. Burke's angry looks being left behind him. But so long as I got off in bright colours with my master, I did not care for that. Sir Joshua was fond to see his scholars about him, and did not envy their success.

I often used to visit the King's Library at Buckingham House. It was famous for its collection of prints and drawing[s]. I knew Mr. Dalton when he was librarian, but more often attended in the time of Chamberlaine, Esq., R.A.[‡][35] I was looking one morning at a volume of drawings by Claude Lorrain when Mr. Chamberlaine came up to me, saying, "Mr. Birch, you collect, I understand, a great deal for yourself. I should

suppose you meet with things sometimes beyond your mark. If you will purchase them for this collection, we shall be very glad." "Sir, you do me honour," I replied. "I will try if I can suit you." I took him a lot a short time afterwards, and told him I had complied with his request, begged him to look at them and see if they would do. "Have you a bill, Mr. Birch?" he replied. "Here is a bill, sir, if they will suit you." He looked at the amount of the bill and laid down the money. "You pay me, sir, before you have seen the lot." "Mr. Birch, we know whom we employ." He then looked at the lot and said, "Yes, they are what I expected; and sir, whether you are at home or abroad, we will expect your attention to this collection, and your returns will meet with the same reception." Such returns as this for servitude defy infringement, and such confidence in those employed insures honour and honesty. It is such wisdom, O ye men of the northern forest, that holds Britain so high. Boast not of liberty if you have not wisdom to choose your officers.

When Judge Samuel Chase, of the Supreme Court of the U.S. of America, came over on the Maryland business, being related to me by his father's marriage to my sister as second wife, he frequented my house in London.[36] He persuaded me to go to America, but at that time I had no such view. But from the Revolution of France and the loss of my friends, the times grew dull in England. Meeting [with] my cousin William Russell in London, who was conveying Dr. Priestley* to America, I told him of my intentions to go too.[37] He said [that] he wished he had heard of it sooner, he would have taken us, but he was then ready to sail. [He] gave me directions for assistance when I got there if I should want. He had sent Dr. Priestley in another vessel before him (there being danger in his escape), but he himself was taken prisoner to France. The refugees were then leaving the country. One of them, hearing that [there was] a moneyed man in prison, came to him, and sold him an old monastery—a large building near Paris. Mr. Russell's connection with Dr. Priestley, then being favourable with Napoleon, soon got him released. He then made some stop in France, took the best apartment in the building for himself, and let out the residue to the annual amount of twenty-five hundred pounds.

Being now prepared for moving myself, I took passage in the *William Penn* for myself, wife, and four children in the year 1794.[38] Many letters of recommendation were offered [to] me, but I thought one from Mr. West, being an American and then president of the Royal Academy, would be sufficient. He offered me [one], directed to William Bingham,† Esq. of Philadelphia.[39] Being the only recommending letter I brought, I asked Mr. B. for it.[40] [See Appendix C]

Upon my leaving England, many articles in trade then were offered me upon speculation, but that was not my object. Mr. Godsell the coach maker, whose country seat was at Hampstead near my cottage, told me he had a beautiful article that would suit me well to take. A gentleman who had been to America, expecting great pleasure in sleighing, had ordered of him a rich and elegant sleigh for which he had paid him five hundred pounds. [He] was so disappointed with the country when he got there that he never took it from the vessel but returned with it himself. "It lays now packed up, and you may take it and make the best of it." But that timidity which has always attended me from a fear of getting into trouble by involving myself induced me to refuse his offer, though he assured me I should not be troubled for it.

* *Birch's first cousin (1740–1818) was a friend and patron of Unitarian clergyman Joseph Priestley (1733–1804).*

† *Merchant and U.S. senator William Bingham (1752–1804).*

My friend Mr. English, hearing of my intention, sent me the following letter. I was informed he sometime afterwards came over himself. But, not being able to find me and I suppose disappointed himself, returned back, and died by an accident in London.

Being a stranger in the country and depending upon my profession for support, [I] thought it necessary to have reference to some of my own private letters as recommendations. I here copy three of them. [See Appendix C]

Mr. Bingham was my first employer in America. [I was] to instruct his two daughters in drawing at his own house, attended with one of their friends[:] three scholars twice a week, at half a guinea per lesson each. I then built me a furnace [and] painted a full size picture in enamel of Mrs. Bingham and a smaller one from it for Miss Bingham, who afterwards married Sir Francis Baring.[41] Finding orders for portraits came in fluently, I gave up my scholars.

By this time my cousin William Russell, with his son and two daughters, came from France and met his friend Dr. Priestley. They took a house on Market Street and invited us to partake with them in social intercourse. Mr. Russell remained some time in America [to] see his friend Dr. Priestley settled on the banks of the Susquehanna with part of his family. [Here] it was intended to form a considerable settlement of English immigrants, but [they] did not succeed in their views, [although] Dr. P. was fixed upon his settlement there.[42]

It was Mr. R.'s intention to invite me to the plan and settle me as his father had done Mr. Onion* in Maryland.[43] Not willing to fall short of his intention to serve me, [he] came to me and made a general offer, saying, "Cousin William, I will give you five hundred acres of land in any part of the United States you will mention," finding he could not take up those tracts which were then his, the Wilderness & the Fishery, which he intended for me and which are now mine saying, "if you will only say you will settle upon them." Not understanding the case, I asked him how long he would give me to pay for them. He replied, "one hundred and fifty years." Not pleased, I suppose that I did not understand him. I answered [that] I could not settle in the woods. No more passed about it, but when he returned to Europe, he settled his son at Hanley Castle in Gloucestershire, and married his daughter.[44] He [later] reflected on the hard conclusion he had made [and] upon the hasty insensibility of my refusal of his offer to help me. [He heard] of Mr. John Coles' intention to come to America, brother in-law to Mr. Jefferys of London, with whom he had bound me apprentice.[45] [Mr. Jefferys] was in some shape related to us and [I had] served six years and odd months of my time with him. When he was taken ill and confined to his bed he sent for me, knowing I was disposed for the arts, and said to me, "Billy," (for such was then his mode of address to me) "I am now most likely on my death bed. I have no one I can trust but yourself. If you will turn your mind to my business I will give you a share of it and your cousin William Russell will find you everything else you want to set you up." This was Mr. Russell's first intention or wish in placing me there, but such was his reserve of manners he gave me no chance of calculating my advantages or forming my plan for life to his wishes. I had fixed upon the arts and Mr. Jefferys, seeing it was my plan, told me when he recovered he would not keep me an hour longer than I wished.

* *Stephen Onion married Deborah Russell, Birch's aunt.*

† William Jones (b. 1748) first formed a partnership with Jefferys in 1779.

I told him if he would give me the orders of his shop for enamel painting, I could support myself well. The smaller articles I could execute myself well enough. I fixed myself conditionally under Mr. Spicer,* the first enamel painter in London, that he should instruct me and share equally in the better jobs for his help in the execution of them. [The payment for these] was from twenty to thirty guineas for a plate or for subjects painted on such as watchcases, snuffboxes, etc., etc., then much in fashion. The thing took place as above. I did tolerably well.

He then engaged with Mr. Jones† who was a clerk he had got from the House of Deard in Piccadilly.[46] Wishing to be more at ease in his situation (having acquired a fortune) he agreed to give Mr. Jones a seventh of the profits of his business, which proved to be one thousand pounds a year. We were together in the house for a considerable time before I left it and acquainted a long time after, until I practiced enamel painting under the patronage of the Earl of Mansfield.

Here I must repeat an anecdote of my friend and patron Lord Mansfield as the only instance I ever knew of his expressing anger. Mr. Jones, though a religious man, was not without those evil qualities which a little mind is subject to imbibe. Lord Mansfield had ordered his portrait in enamel to be handsomely set in diamonds as a locket. [As I was] in the habit of doing business at Mr. Jefferys' shop, I took my picture to be set. I called at Lord Mansfield's some time after. "Well, Birch," said he "is that locket done?" "I saw Mr. Jones yesterday, my lord and I think he said it was." "Well, then go and fetch it." The family was then in town. I went to Mr. Jones. Mr. Jefferys was in the country. I told Mr. Jones that Lord Mansfield had sent for the locket. Mr. Jones, who now began to feel the effects of his elevated situation, thought it a fine opportunity of showing his integrity to his master. [He] looked at me, saying, "This is too heavy an article to let go without the money." "Lord Mansfield did not give me the money," I replied. No answer. Then Jones said, "Lord Mansfield must send another messenger for it." "Well, I'll go back and tell him you won't trust me with it."

I went back and told my lord that Mr. Jefferys was not at home and that Mr. Jones would not trust me with it and I had not the money to pay. Seeing me a little agitated with mortification, [and] from the tenderness of his mind [becoming] angry, he replied, "Go back and tell Jones to take the picture out of the setting and send it to me, and take the setting himself and go to the devil with it." But soon my lord, who was so little accustomed to anger, reflected on the harshness of his words. He replied, "No, no, Birch. We must not say so." But Lord Mansfield was not going to persuade me that he could commit himself. I replied, "I don't recall your words, my lord. There is no language in the English tongue that will do your lordship more honour on this occasion than what you have expressed." "Well, well, Birch, have your own way," he replied. "I will go back, my lord, and tell him to send it." "Do," he replied, "and we will wait tea for you." I returned to Mr. Jones and very quietly delivered my first message, saying that Lord Mansfield sent me to tell you to take the picture out of the locket, take the setting yourself and go to the devil with it. "What," said Jones, "did Lord Mansfield say 'go to the devil?'" "Yes, he did. He would have recalled his words but I would not let him." "Well," said Jones, "the locket is done. You say send Mr. Whiting with it." "I am going back and will be there to receive it."

I returned and told my lord it was coming. We sat down to tea, and the servant soon announced Mr. Whiting with the locket. Mr. Whiting came in and it was given to the ladies. Lord Mansfield said, "Show it to Mr. Birch. If he approves it, pay for it, not else." "No article, my lord, can be disputed from Mr. Jefferys' shop. He always superintends his own business." Seventy guineas were paid for the setting.

The next morning I called on Mr. Jones for my profit on the job, as Mr. Jefferys always allowed me a handsome profit for what I brought there. Mr. Jones gave me five guineas. Mr. Jefferys would have made it seven, but the subject of the locket is not over yet. In a few days after I had called upon Lord Mansfield, he made me his esquire to deliver the locket. He gave me a direction to Mrs. Knightly, charging me to deliver it myself to the lady. I found her a graceful figure, adorned with every elegance and affability of manners. After this, [she] had the honour to wear her father's picture.[47]

Here I [repeated with] the same emphasis on this occasion, his lordship's words as expressed to me when he took me to the picture of his friend Pope. From the exalted feelings of his mind, upon the reflections he had of his friends, [he had] superior knowledge of the human mind. The greatest honour that was ever done to me in this world was his lordship's making me the bearer of honour and parental affection without disguise to an affectionate child.

About this time Mr. Gilbert Stuart came from Europe. Congress was meeting in Philadelphia and Washington was President of the United States.[*48] It is to this distinguished artist that the people of the U.S. are obliged for that renowned portrait of their hero, but for which circumstance they would have fallen short of his just representation [figure 110].[49] When [Washington] was sitting to Stuart he told him he had heard there was another artist of merit from London, meaning myself, [and] that he would sit to me if I chose. Mr. Stuart brought me the message. I thanked Mr. Stuart and told him that, as he had painted his picture, it would be a mark of the

FIGURE 110. Gilbert Stuart (1755–1828), *George Washington (Gibbs-Channing-Avery Portrait)*, begun 1795, oil on canvas. The Metropolitan Museum of Art, New York; Rogers Fund, 1907 (07.160).

* *Stuart (1755–1828) came to Philadelphia from New York City a month after Birch's arrival in 1794.*

FIGURE 111. William Birch, *The View from the Springhouse at Echo*, watercolor, ink, and pencil on cream paper. Collection of the Corcoran Gallery of Art. Museum purchase through a gift of C. Thomas Claggett Jr.

highest imposition to trouble the general to sit to me, but that when I had copied his picture of him in enamel (which was my forte), I would show it to the general and thank him for his kind offer. When I had done [it], I waited upon the general with a note that an artist waited the honour of showing personally to the general a specimen of his talents. When I saw the general, I put the picture into his hand. He looked at it steadfastly, but from a peculiarity of solid habit in his manner, left me to look at him as solid. Feeling myself awkward, I began the history of enamel painting. By the time I got through, he complimented me upon the beauty of my work. I then told him how much we were beholden to Mr. Stuart for the correctness of his likeness. The anecdote of what Mr. Stuart calls his "Mount Vernon Head" is worthy of observation. It happened [as] the first picture near[ed] its finish. When Mr. Stuart turned his head to recruit his pallet, the general, knowing him to be a wit, took out his set of ivory teeth. The painter, on the turn of his head, [was] struck with the additional dignity of countenance. [He] told the President, in a tone of tranquil ease, that he had long been his subject, and with pleasure, "but you know, sir, now you are my subject and must to my pencil another tribute pay." A fresh picture was begun without the teeth, which is the one generally known. The first he called the "Mount Vernon Head." I copied one enamel from it which was purchased by Mr. McHenry.[*50] It was then painted over in water colours with a wig and put by as a legacy for his family and called the "Mount Vernon Head." A whole length of the last likeness was bespoke by Mr. Bingham and sent to the Marquess of Lansdowne.[51] From this portrait I made a cor-

rect drawing. The copying of it in enamel supplied me in work for a considerable time. I painted about sixty portraits of it, from thirty to one hundred dollars each.[52]

The summer season being very hot, Mrs. Birch proposed apartments out of town. We had fixed upon the house of Mr. Beveridge on Schuylkill which was then to let [figure 111].[53] His Excellency, Mr. Jaudenes, Minister from Spain,[†] was then in Philadelphia and sitting to me for his picture [figure 112].[54] He asked me if I knew of a place in the country to let. I told him we had been looking at a house in a beautiful situation we had some thoughts of taking. He asked if it were roomy. As our families were small, it might do for both. I told him I thought there was plenty of room. He then proposed [that] Mrs. Birch and Mrs. Jaudenes [figure 113] go with us to see it. We did so. We gave them the choice of apartments and plenty of room remained for ourselves. We spent the pleasantest summer I think I ever remember. Mr. Jaudenes was much the gentleman and a very pleasant man and his lady as agreeable. He was fond of the arts, very rich, and employed me the whole summer. The ladies agreed as well. We stood at but little expense as we were frequently invited to their table, and joined in amusements in the evening. We had little occasion to visit our town apartments. It was fortunate, perhaps, for us [because] in our absence a flash of lightning passed entirely through our apartments and tore its way to the kitchen we used, tore down the mantle and shutters, in [a] frightful wreck.

I was here put to the trial of recollection of my former knowledge of jewellery. A lady refugee from France had fled with her jewels as all she could bring away. [She] came to Mr.

[†]*Josef de Jaudenes y Nebot (1764–before 1819).*

[*]*James McHenry (1753–1816) was a physician and merchant who was a member of the Constitutional Convention and secretary of war under Washington.*

FIGURE 112. Gilbert Stuart, *Josef de Jaudenes y Nebot*, oil on canvas, 1794. The Metropolitan Museum of Art, New York; Rogers Fund, 1907 (07.75).

FIGURE 113. Gilbert Stuart, *Matilda Stoughton de Jaudenes y Nebot*, oil on canvas, 1794. The Metropolitan Museum of Art, New York; Rogers Fund, 1907 (07.76).

* As above, Birch here means "full-length."

Jaudenes to purchase [them]. He came to me to ask if I knew anybody [who] was a judge of diamonds, relating the case of the lady. He said he would wish to serve her, but was afraid to depend entirely upon his own judgment. He had a large stock of diamonds himself and was some judge. I told him the country was too new for that article; I knew of nobody, [but that] I had formerly been acquainted with that article myself. My cousin, Wm. Russell, had put me apprentice to Jefferys in London, jeweller and goldsmith to the King, but I knew

not if I could recollect now. He said that would do very well. He brought me the diamonds, told me to keep them 3 days, and make my estimate. I told him to do that himself first. He said he had, and put it on paper. I then made mine, taking off one 3rd on account of the French Revolution, as he had done. The amount was seven thousand, five hundred and odd dollars. We compared notes: the difference was twenty dollars only. Mr. Jaudenes then said, "I will take the lady the money directly."

The next day he brought me the lot of diamonds again and asked me if I knew anyone that could set a diamond. I told him a young man from London had shown me a very good specimen of setting. He told me to pick out the very best of the lot for the enamel I had painted from Stuart's picture of himself for a locket for Mrs. Jaudenes.[55] I marked them and asked the jeweller what he would take to set the locket. He said he could not do it for less than two hundred dollars. I told him not to fail in the execution, and Mr. Jaudenes would pay him. It was a full size* picture in a rich dress. The elegant brilliants for it amounted to two thousand dollars. It formed a beautiful locket. Mr. Jaudenes soon after returned to Spain. He told me if I would go with him he would pay the expenses of myself and family and find me plenty to do, but I excused myself.

We soon after moved to Burlington[, New Jersey]. It was about the year 1797. The mayor and aldermen of that city, wishing to have a plan of the city and island, called upon me and asked if I would undertake it. "Gentlemen," I replied, "you mistake my profession. I have never practiced in that line, and do not know if I could do it." "We do not ask you, Mr.

FIGURE 114. William Birch, *A Plan of the Island of Burlington, and a View of the City from the River Delaware*, engraving, 1797. Library of Congress.

FIGURE 115. William Birch, *China Retreat*, hand-colored engraving, 1808, from the *Country Seats*, Carson Collection.

Birch, what you can do; we ask you if you will undertake to do it." I said I had no objection to an order if I could execute it. They then asked my terms. Being unwilling to turn away an order, I told them one hundred subscribers at five dollars each, I thought, might enable me to deliver each one an impression of a plan; but that they must secure the subscription themselves. They agreed. I surveyed the island and town—

each town lot correct and each meadow distinct. [I] penciled it neat[ly] upon paper with a view of the city from the Delaware at the bottom of the plan. They approved the drawing. A plate was engraved from it and delivered [figure 114]. In about a week they (or some of them) called and said they thought there was something incorrect in the lines of Assicunk Creek. I told them I was glad to hear them complain, knowing that

FIGURE 116. William Birch, *Sweet Briar*, watercolor and pencil on paper, n.d. Collection of the Corcoran Gallery of Art. Museum purchase through a gift of Philip Alexius de Laszlo. Sweet Briar is one of the surviving country seats on the Schuylkill River in Philadelphia, now located in Fairmount Park.

most of them were men of science: [but] that they would only have to examine [them] again and acknowledge their mistake. They returned and soon after told me it was correct and that it should no longer be called "Assicunk Creek" but "Birch's Creek," by which name it now goes. This order assisted me and gained me credit.[56]

It was about the time when that ingenious and accomplished minister from Holland by the name of van Braam,* after spending much time with the Chinese, came to settle on the bank of the Delaware near the mouth of Neshaminy Creek within sight of Burlington [figure 115]. [His] active mind was busily engaged in pursuit of building him[self] an elegant house upon a splendid situation. It was often that our sight was enriched from the beautiful green bank on which our house was seated close upon the transparent flood over a clean, gravelly bottom. We [would] see him for a mile before, coming up with a rapid tide in his long boat, [with] his eight Chinese [servants] in white, trimming their oars to the water till he reached our bank giving me his first salute, then attending his orders in the city.

We spent a few summers upon that beautiful spot. It was a frame house we lived in; they moved it away from us. We then moved ourselves upon the bank of Neshaminy, nearer to Mr. van Braam, with whom I spent much time.[57] He employed me liberally: I painted four enamels of him for his friends. Being impatient to get his house finished, he thought a frame house would be soonest built. He took in timber of all sorts, good and bad, and composed one of the largest frame houses I ever remember [having] seen. His water floor to the frame was of white marble, well built. His property was extensive, but the

loss of a rich-laden vessel from China, with furniture for the house and elegant adoptions for his plan, threw a check upon his proceedings. The ungenerous and impatient inhabitants he employed, though there was plenty to secure them, threw him into a loathsome jail which (in a man of his fine feelings) broke the chain of his pursuit by disgust. He soon found means to settle his affairs and still possessed a font of wealth. I reasoned with him in hopes of composing his mind, but he told me he could never rest where he had been so ill treated. He moved to England and, I am told, died in Bath. The most beautiful China ornaments I ever saw in my life were a set of great value he had then with him, seven in number, as table furniture.[58]

In about June or July, 1798, understanding the arrival of two British commissioners from London upon the business of the Treaty, I attended as usual as to foreigners with my picture of Washington in enamel. [I] presented it to Mr. Guillemard† who, approving the picture, paid down his hundred dollars for it.[59] After seating me with him, he asked me if I recollected him. I told him I had not that pleasure. He said he remembered me very well: he had often stood at my knee, looking over portfolios with his uncle in the stable yard, [of] St. James [Palace]. "What, Sir, was Mr. Dalton, the King's librarian, your uncle? I remember well, sir, a young gentlemen attending us, but little expected to see him now." After a pleasing conversation, he invited me to go with him the next day to dine. He had taken Solitude upon Schuylkill, the house built by the son of Governor Penn‡ for his residence during his stay here [see figure 85].[60] The situation was retired and beautiful. There was a slight attack of the yellow fever at that

† John Lewis Guillemard (1764–1844) arrived in Philadelphia as a British commissioner in 1797.

‡ Solitude was constructed in 1784 by John Penn ("the poet," 1760–1834, the son of Thomas Penn, 1702–75), who, while never governor of Pennsylvania, was active in attempts to strengthen the Proprietorship. Birch may have confused him with his cousin John Penn (1729–95), who was governor in 1763–71 and 1773–76.

time in the city. He invited me to stop with him when I came to town on business. We spent some time together; we visited about Schuylkill [and] we dined by invitation with Governor Mifflin at his beautiful spot by the falls,* where we were entertained by feats of the revolution. We expected Dr. Smith,† but were disappointed [by] his indisposition. His son was their American consul, to whom they paid one hundred dollars per day during the transaction of business. Mr. Smith has since been to London, called upon him, and returned with his respects to me.[61]

I must not neglect to mention a very agreeable visit I paid to Fairy Hill on Schuylkill, and then held by Mr. F. de la Roche, aide-de-camp of General Washington.[62] I painted three enamels for him of General Washington. He invited me to spend a day with him and his family on this beautiful spot. Mrs. de la Roche and [their] daughter were ladies, trained in the highest accomplishments, free in conversation and affable in manners. The season was very fine and everything through the day appeared enchanting. Mr. de la Roche was fond of the arts and amused me with the sight of many fine drawings, some of his place, I think, in Switzerland.

The Schuylkill abounds with beautiful situations for retreats [figure 116]. Mr. Parkyns,† when he favoured this country with his celebrated talents, made a set of drawings of them, twenty miles up [the river], which he called the tour of Schuylkill. Mr. Rawle§ told me he had them in his possession.[63] The Woodlands near the city was the first of note. It has a beautiful water scene towards the Delaware. The

ground is spacious and elegant. Mr. William Hamilton was a man of taste and, at that time, first in botany. He had some good paintings. I spent some pleasant time at this place.[64] Mr. Greenleaf had a very engaging spot of much beauty laid out by Mr. Parkyns near Solitude. Lansdowne, the seat of the late Governor Penn, was a fine spot, had a good house upon it, but was placed too far back from the water.[65] When on one of my southern routes, I called at Annapolis where I found my niece, Miss Betsey Chase.[66] She had received an invitation from Mrs. Lenox, who had just returned from a tour of Europe with Miss Keene and the colonel.¶[67] [Mrs. Lenox] had requested her company for a month at this place and [she] asked me to take her there in my gig. I did so, and spent two days there myself. I discovered much beauty upon the spot, which had not been improved, which I attributed to the want of society. The beautiful channel or valley, through which this romantic stream glides, had on it (within the neighbourhood of a few miles) rocks and hills, gentle sweeps, and verdant changes of delight from seat to seat that soothed the weary citizen in his evening retreat to enchanting rest. I have visited the quiet retreat near the Falls of Schuylkill of old Judge Smith and his lady (who was connected to the Penn family) and have found in Mrs. Smith very agreeable company.** The judge was much my friend. I have published a set of Country Seats, the principal plates of which, so far as it continued, were the seats on the Schuylkill River. The work extended to twenty plates, the only work of the kind yet published, but want of encouragement stopped its progress.

*The property of former Pennsylvania governor and Revolutionary soldier Thomas Mifflin (1744–1800) stood on the east bank of the Schuylkill River.

† William Smith (1727–1803), Anglican clergyman and first provost of the University of Pennsylvania (then the College of Philadelphia).

‡ Painter and garden designer George Isham Parkyns (1749–1820).

§ Prominent Philadelphia lawyer William Rawle (1759–1836).

¶ Continental Army major David Lenox (1754–1828) married Tacy (d. 1834), the daughter of John Lukens, surveyor general of Pennsylvania.

** Thomas Smith (1745–1809), a member of the Continental Congress and the half brother of Dr. William Smith, served as president judge of the Pennsylvania Fourth Judicial Court and later as a member of the Pennsylvania Supreme Court. His wife, the former Letitia Van Deren, is not known to have been connected to the Penns.

Let me now return to my removal upon the bank of Neshaminy where I settled my family in a small tenement 'til I could form a plan for building and forward the work of my Philadelphia Views, which I had projected as a work of duration, to be published by subscription. No other work of the kind had ever been published by which an idea of the early improvements of the country could be conveyed to Europe, to promote and encourage settlers to the establishment of trade and commerce. [The nation's] early progress [led] the restless minds of those with capital to expect nothing but a forest. Seeing [instead] number after number of the elegant establishments of a city, [my publication] soon caused the full effect of its intention, by the arrival of funds, talents, projectors, and every other aid that a new country could wish. And to verify these suggestions, let me give the following list of subscribers to the work. To prove they must have had the same opinion of its utility, it will be found there is at this time scarcely one set of the work in Philadelphia that was not sent to Europe for that purpose.

It may easily be conceived what the opinion was of this work with our late friend and best-wisher to mankind [who] formed the Constitution of the country. It [should be] recollected that, during the whole of [Jefferson's] presidency, [the *City of Philadelphia*] lay on the sofa in his visiting room at Washington until it became ragged and dirty, but was not suffered to be taken away.[68] I boast no merit in the work, further than its answering the above purpose or intention. I superintended it, chose the subjects, and instructed my son in the drawings and our friend Mr. [Samuel] Seymour in the engravings.[69] It was with difficulty at that time I could get materials to publish it at any decent rate. There is reason to suppose that [from that] ardent attempt of the arts at so favourable a season when Europe was everywhere at war, that the present bustle in the solid improvement in our cities and internal projections in the country did originate.

Subscribers to Birch's Views of Philadelphia

[See Appendix D]

MY ATTEMPT TO SETTLE, OR SPRINGLAND LAID OUT*

During the execution of this work, I indulged myself after discovering a situation in laying out a plan for a settlement; the discovery of which situation I will give in a few lines (as it occurred to me).

THE DISCOVERY OF SPRINGLAND

Fatigued with care, with Worldly trouble frought;
A wandering spell I took:
To quiet oppressive and bewildering thoughts;
My weary way to the briery Covet led,
To trace in wild Nature some lonely seat to rest.

By bold attempt through thorney opposition
And the turfted flowering Shrubs I thrust my way,
To where cool inviting shades from spreading Okes,
Were darkly blended for retreat:
Chance favoured my pursuit.

A few steps within a spacious covert, awak'd my Soul;
My astonished Eyes beheld a second Paradise in View;
High groups of massy Chesnut grew;
Here and there, a lawn of Grass, uninterrupted grew;
Amidst a General Shade.

Which like a Wall inclosed the favour'd spot—
Except, what, like inchantment, broke the line;
To show some favourite object of the Seen.
The spot a gentle descending bank;
A half amphitheatre of high ground meeting the sky;
From North to East West Westward;
Inclosing broken ground in variegated shapes;
As if intended by Nature for improvement;
A bed of Lawn on its half assent invites to sitt;
The upper extremity of the bank, crowned with a Green
 Hill,
Appearing through a grouth of shrubs and Trees from a
 flat before it.
The opposite extremity at the foot of the bank, flows
A beautiful River, in a meandering direction of one mile
In direct desent towards you, sweeping in gentle flow
 beneath as it
Takes its passing turn to the right;

* This point marks the beginning of a new manuscript volume in the Carson copy

FIGURE 117. William Birch, *Plan of Springland*, watercolor, ink, and graphite on paper, ca. 1800. Carson Collection.

FIGURE 118. William Birch, *Entrance to Springland*, watercolor, ink, and graphite on paper, ca. 1800. Carson Collection. This view shows the entrance to Springland that appears at the upper left in the plan just to the right of the compass rose.

<center>* * *</center>

Its banks are clothed with the richest foliage;
At the foot of the green hill 100 feet above the stream that
 gently
Flows below, rises a Spring, imbosemed in virdent shade
The majestick Oake, the massy Chesnut,
The Seder, and the Pine, intwined with festoons of the
Luxuriant Grape, combine to expell the hot rediance
Of the Sun from its refreshing sweets.

Its gently descending streem from flat to flat,
On the easy decent of the Bank,
Unites with smaller Springs to fill the cavitys in its way,
As Ponds, and falls, with murmering sounds,
And nourish as it goes the Virdure of the luxurious spot;
Where 30 flowering(s) shrubs with innumarable
And rare botanic plants, are by Nature placed;
Some beds of Rock, on the channel of the Spring,
To stop the cutting of the soil too deep, as Nature placed,

FIGURE 119. William Birch, *Springland*, watercolor, ink, and graphite on paper, ca. 1800. Collection L. Alan Talley. Birch's house is at center, and his Green Lodge where he exhibited his art collection is at left.

While from there mossy heads the purling Water shows
The wash'd pebbles on their Gravely beds

Where the delicate race of turtles glide,
In their Rich variegated armour beneath the crystal surface
 play.
The gilt-eyed frog, in its beautious trim, its Zebra Streeks
In proud preamance show, where the Wild grass grows,
And botanic plants receive there succor.

The noble base of the bullfrog, from yon lower marsh is
 heard,
Nor does the land turtle with his rich-imbroydered shell
 neglect to join
Hear sports the gray squirrel, the timmed rabbet sits,
In a half-dryed turft of grass, the flying squirrel with his
Harlequin tricks is some times seen, while the playful
Ground squirrel nibbles his Nut.

How has Nature in this lovely spot fill'd up her measure of
 delight;
The feathered race, in due season decorate with there
Rainbow plumage this ground, inriching with minute
Masses of brilliant tints, the seen, as they face the Sun;
Hear, on a bow hangs the bright humming Birds Nest.

In all directions does this sympathetic bank throw
Out its weeping fountains, and its gentle Springs;
Which leaves no choice in the Poet's melody for its Name
Springland; must be its name; Five Acres long,

FIGURE 120. William Birch, *The Grove at Springland*, watercolor, ink, and graphite on paper, ca. 1800. The Athenæum of Philadelphia, gift of the McNeil Americana Collection. This watercolor shows the view toward the Neshaminy Creek along the path shown near the middle of the plan (figure 117).

These charms are spread, and breadth abundant,
To the purpose led; on the ancient River by the
Indians named, Nashaminy in Bucks;
Pennsylvania, claims, with pride the unrival'd
Preeminence of Springland for a Seat.

FIGURE 121. William Birch, *View of the Chapel/Smokehouse at Springland, with Steeple Detail and Plan*, watercolor, ink, and graphite on paper, ca. 1800. Carson Collection.

A SECOND VISIT

To Springland's cooling Shades I took;
In time of more ease, and more easy entrance found;
Through wild and oderous Shrubs, with gentle
Steps, to the half hight Lawn, on the flowery bank;
Where a mossey stone invites to sit:

Inthroned in flowers apt retreat; the churping Nestlings,
From each green bow their mother's grain to eat was hard;
And sporting Nature tells, her endless charmes;
Then to the little ants I rov'd to view the mottley sporters,
Of the Watery rills; the flowering blossoms of the christial
 beds,

The green turft lawn amidst the wilds of growth;
And where the new Magic is to rise, by Art,
To sporte with nature's charmes; from where among
The hights the most distant seens to view
And how to double the verdure of the seens.

But hark, a solemn murmering from the blue distance
Echos through the Air; a storm approaches;
The Birds seek retreet, the frog to his shelter in the mud
The Turtle disappears; but halt said I, all is gentle yet,
The Air serene and Sweet; a flash bespeaks
The hurried Clouds approach; no shelter yet,
On Springland's pleasant Spot;

The elements roughly demand a double space,
Are to my shelter I could reach, the Wind and the Rain
As Calaban to Ariel did complain, did beat me;

FIGURE 122. William Birch, *A Grub Found on the Virginia Spice Wood in Springland*, watercolor, ink, and graphite on paper, ca. 1800. Carson Collection.

Halt then with angry tone I cry'd, ye bellowing god;
And let me house me safe,

When from the window of my lodge look'd back to
 Springland,
Saw hovering over a horrable Cloud;
Fancy persuaded me I heard a voice,
Jupiter the angry mortal will revenge;
Crash went the Cloud; the god's vivid hand with firey
 dart,

The blue flued with roughful fury to the Chesnut led;
Choisest of the forest trees I cry'd of Springland's lost;
Five men alone could span its solid trunk,

FIGURE 123. William Birch, *The View from Springland*, watercolor on paper, ca. 1798–1805. Collection the Library Company of Philadelphia.

Each branch a powerful teem could scarcely hall;
Yet this wanton god rioting in his sport,

Hurl'd like a feather in the Wind, its largest mass,
Across the river's widest span, four hundred feet;
Other solid logers from hight they flew, fell bury'd deep
 in Earth.

Alass the Reck, one Pointed shaft alone was left to carve
 his bolt
To commemorate its fruitful bows.
~~Not withstanding this loss, the favourite spot had~~
 ~~objects enough to fix upon for my purpose.~~

FIGURE 124. William Birch. *The Elysian Bower*, watercolor, ink, and graphite on paper, ca. 1800. Collection L. Alan Talley. This view, toward the Neshaminy Creek, was engraved as the final plate for Birch's *Country Seats* and was pasted here between the sections of Birch's poem in the Carson copy of the manuscript as a divider, labeled by Birch "A View from Springland."

SPRINGLAND IMPROVED
AS A LESSON ON LANDSCAPE GARDENING

Now gen[i]us let your wand be rais'd;
Expell the Vipers, with there nestling brude,
The poison Vine, that throws its deadly grasp,
Around the Verdent Oke; the deadly shoemac,
From disperseing its poisonous influance in the Aire.

The cutting bryer, from the sweet bryer bush;
So clens the Grove; invite the warbling songsters to
 your Shades;
Let Nature be your god; she has charms with all her
Falts that Art can never give; with cautious steps and
Anxious care preserve her sweets.

FIGURE 125. William Birch, *Falls of the Potomac*, graphite and watercolor on paper, 1800–1810. Collection of the Corcoran Gallery of Art. Museum purchase through a bequest of Mr. and Mrs. Frank B. Kellogg, 1980.80.

Mark yon rich spot of sandy soil, from which
Drains moisture all the Year alike, wet or dry, its
Watery beds are one, flat lays its surface, high and
Secure its station on the bank, there chuse your botany
Plants to Place with ornaments of taste.

(William Hamilton, Esquire, of the Woodlands, to see the spot. This he declared
one of the most useful botanists of that time, was what his place
having heard I had made [the] choice of a retreat, would not produce and what
hastened he so anxiously wished for.)

Trim not your bows away with wanton hand,
Let cautious taste reserve them for effect;
Spoil not your broken ground with too hasty leveling,
Study well what new charms by addition may
Be made, so parly with your fansy,

Till you find it's in your way, sport well your
Conceptions, seek not to undo what Nature well
Intends, advantage take from the roughest
Rudeness chance has given, so let the refinement
Of your taste work its way;

Thus with wholsom caution was this place
Improved; tracts to varigate the seens, laid out for
Walks, shrubs to hide what suted not with taste,
Where placed, beds for flowers, where most were
Wish'd, nor was lawn neglected where 'ere the space
Allowed, the Ponds with fish where stock'd, a Green
Lodge for shelter was prepared, till the labours
Of delight were done.

~~In this early Country of the Arts, and as an American Cottage, it will be necessary to be particular in my introduction of those refinements which when united with the beauties of Nature add so much to cultivate Society, that I have for this purpose placed in the Cabenet of Green Lodge my pictures in a North light, a portofolio of printes selected from the choices Plates, and other valuable Works of Art; with Catalogue as follows~~

In order to render the enjoyment of an American Cottage agreeable, I decorated Green Lodge with my Collection of Paintings [figure 125], which I hung to a well adapted north light, and added to the Cabinet a portfolio of well chosen prints with an introductory catalogue to the arts as follows.

Introduction to the Fine Arts

It is the laudable ambition of European nations to excel in their collections of specimens of the fine arts, and to indulge, in their pastime, a fond recreation with them.

It is with rapture the connoisseur views the fine feelings and sensibility of the mind of each painter, who by his great talents, he has transferred upon the canvas.

He views the great feats of history robed in their becoming dignity. He meets, in portraits of the great, the countenance of men marked with the character of their minds. In landscape [he meets] various scenes of delight: the beauties of all climates; the serene morning; the storm; the glow of evening; the wild rocky precipice with darksome gloom; and all the softer scenes of ambrosial air. He views with wonder and delight the magic touch of the Flemish school, in simple nature and humorous drollery.

He reserves his finer feelings for the admiration of the sublime of the Italian and French schools.

As it is not in the power of any moderate fortune to select a collection of paintings sufficient to verify the full power of painting, the polygraphic art of engraving fortunately assists at small expense our attaining, in great part by prints, the very finest productions of the first Masters, by which we may judge of the composition, character and effect, as far as it is given by

light and shade, of those pictures which are most celebrated and which cannot be purchased.

A well-chosen selection of prints will serve also to define the different schools of painting, where the collection of pictures may be deficient, and from [this] also may be pointed out the historical progress and perfection of engraving.

Paintings at Green Lodge
[See Appendix D]

The Elysian Bower

This beautiful piece of water in the foreground was adapted to the natural scenery of the spot, upon the half-ascent of the bank, protected by its natural situation, with the botanical ground so highly approved by Mr. Hamilton. [It] was destroyed wantonly with two [in]appropriate bridges by its owner, from the advice of a tasteless artist in opposition to me, after I had bestowed the utmost pains upon it—too often the fate of beauty in bad hands.

A house is also built upon Springland, ill-calculated to its plan: the trees turned into sticks, and nature every way destroyed from the principle I had intended to establish [it in].

Having proceeded thus far in my settlement, and adding to Green Lodge a few outhouses, kitchen, stabling, etc., [we] made it our dwelling, leaving the spot for the principal building after providing timbers, sashes, etc., and purchasing two beautiful bas-reliefs of painting and sculpture from the ru-ins of the building erected by L'Enfant for the dwelling of Mr. Robert Morris in Philadelphia.[70] [These reliefs] were well-executed in Italy at great expense for the purpose, with which I intended to decorate the front of my cottage. The cottage [was to be built with] the profits of the Philadelphia

FIGURE 126. William Birch, *Bushkill Falls*, ink on paper, n.d. Private collection.

FIGURE 127. William Birch, *Design for a Garden for George Reed, New Castle, Delaware*, watercolor on paper, ca. 1805. Carson Collection. This watercolor shows an unexecuted design for a property in Delaware Birch visited during his travels through the state.

views, which, by this time, became forward enough for delivery in part.

I provided myself with a gig and a little black mare of the Canada breed, young and well-calculated for my service, which became a favourite. I then packed up my work and journeyed towards the south, calling on my route upon those characters most distinguished in my former connection [and] with those I wished to improve my knowledge of. [I sought] to gratify my wishes in a knowledge of the country [figures 125, 126] which my work, for a time, supported me in doing.

I made my first halt at Wilmington [figure 127]. Here I found a good friend in Dr. Tilton,* a pious and good man;

* James Tilton (1745–1822), a medical doctor and former member of the Continental Congress.

well-informed in taste and other matters of useful knowledge. I had occasion to stop some days; he made me stop with him at his house on the hill. It was a fine situation, but the ground[s] wanted a plan about the house. I made him a drawing, by his desire, for which he rewarded me handsomely, and [he] was well pleased with it. He introduced me to Mr. Rodney* who had a lot next to his more favourable for improvement. He was about to build upon it, [and] I made him a plan for the arrangement of it, which he approved, but I believe was not adopted. Dr. Tilton was a friend of Mr. T. Jefferson. The President appointed him Surgeon General to the Army in the last war.† I left Wilmington and slept at Head of Elk.‡ [The] next day [I] stopped at Green Hill, North East, with the family of my late cousin Thomas Russell,§ where I stopped three days.[71] My cousin Thomas Russell on his arrival in America married [Ann,] the sister of Mr. Chew Thomas of Chestertown who, after her husband died, married Mr. [Daniel] Sheredine. My cousin Thomas Russell came to this country from Birmingham. [He] was the [younger] brother to William and George Russell whose father Thomas settled Mr. [Stephen] Onion, who married my mother's sister [Deborah], [the younger Thomas's] aunt Russell, in Maryland. [72] The three brothers—Thomas, George and William—all older than myself, died, leaving me heir to my aunt [Deborah] Onion. My uncle Onion, dying first, made a will in favour of his nephew but left my aunt considerable property.

The family portraits (which I have never seen since the three brothers lived together in Digbath, Birmingham, at the house of my cousin William Russell, Esquire who put me to school near Birmingham and with whom I spent my Sundays in the house where they hung), struck me much. Some of them [were] painted by my friend Miller, an ingenious artist and a friend of Shenstone's;¶ [he] painted the best portrait of that poet.[73]

I could not but reflect upon the early days of my youth: my three cousins [were] stately men, dressed in the full costume of the day. From their amiable qualities, [they were] the pride of Birmingham [and] strictly attended their meeting house, generally on foot. [I accompanied them], a stripling half their height, clad by themselves in their own fashion, while the carriage conveyed the ladies before us.

My time [in Birmingham] was spent divided between the Russells and the Humphreys, the family of my mother's other sister, when [I was] not at school. My cousin, William Russell, seeing his aunt Birch's house full of children, took me under his own protection away from the rivalry of my brother Joseph Onion from his mother's partiality.

The country around Green Hill is wild and beautiful, well watered and [with] plenty of game. The amiable qualities of the family afforded me pleasant pastime. I left them and dined with Mr. Littleton Gale near Havre de Grace where I received much politeness, [I then] crossed the Susquehanna and slept at Colonel [Samuel] Hughes on Mount Pleasant.[74] Here it was impossible but to feel myself at home, being known by the colonel before and finding in Mrs. Hughes a lady of taste. [They were] surrounded with all the charms the luxurious hand of nature could form upon a spot.[75] After mounting a hill of winding turns through rugged rocks and overhanging shades of darksome gloom, rising by degrees to upland lights, to a level with the gods, [one was] launched at once upon an

¶ British author William Shenstone (1714–63).

* Probably Caesar Rodney (1772–1824), Delaware congressman.

† War of 1812.

‡ Elkton, Maryland.

§ Thomas Russell (1741–86), Birch's first cousin and younger brother of William, came to the Maryland colony in the 1760s as the managing director for the Principio Company, the earliest iron forge established in Maryland. The Thomas family estate, Green Hill, was located north of the town of North East, Maryland.

FIGURE 128. William Birch, *Gunpowder Falls*, watercolor on paper, ca. 1800–1810. Carson Collection.

Hampton *the Seat of* Gen.^l Cha.^s Ridgley, *Maryland*. —

Drawn Engraved & Published by W. Birch Springland near Bristol Penns.^a

FIGURE 129. William Birch, *Hampton*, engraving, 1808, from the *Country Seats*, Carson Collection.

extended flat of verdant green, enriched with cooling fountains and murmuring cataracts from neighbouring heights [which were] screened from sight by [the] woody foliage of the scene. From the uplifted dwelling on the lawn, [one] looked down upon the soft picture blended in air, over [the] tops of forest trees on the descending hill [and] a wide extended view of the Chesapeake Bay in its richest form and most splendid effect.

[This scene] completed at once the feeling of a student in the arts for the admiration of nature. Mrs. Hughes, perceiving my attachment to the place, requested me to stop until the next morning when, clad for a ramble, she showed me the beauties of the surrounding scenes. [The] gratification [of this plan] afforded the finest lessons in landscape gardening—seeing the wilds of nature so richly offering to the leading hand of art those beauties, which, in Europe, form the enchantment of every polished ground.

Here in my stop, I rose with the earliest dawn [and] took a sketch at the rising of the sun upon the opposite side of the Chesapeake. The open bay from this elevated spot, with a fountain playing upon the lawn before me, led my pencil to a fanciful design for a bath. I painted an enamel from it, with a bathing Venus. It was one of my best studies, and [I] burnt on the back of the picture the following lines.[76]

Colonel Hughes told me if I would stop three days longer he would show me a place he thought far more beautiful than his on the other side of the Susquehanna, but the plan of my route would not admit of the delay. I then paid my second visit to General Ridgely at Hampton, after my introduction to him by my friend Judge Samuel Chase. The general's at-

tention to me was very polite and marked with every appearance of respect. I stopped several days with him. The situation at Hampton [figure 129] is beautiful and richly deserves the embellishment of art in its improvement. I made several designs for that purpose which were approved. In the morning he found me a saddle for my mare and asked me to attend him in the recreation he had with his horses. He then had seven celebrated racers, each [with its own] jockey, which attended us in our morning's ride through beautiful country.[77]

While at Hampton, standing one morning at the door, "Look around, Mr. Birch," said he, "all the ground around this house for ten miles in almost every direction once belonged to your uncle and now [it] belongs to me. "Indeed," said I, "General, why then you must know something of our family." "I know something of your family," he replied, "I believe I do. I can tell you the day and the month you were born in." "And what, General, was it?" said I. "You were born in the year 1755 on the 9th of April and at 12 o'clock." So said my own records. He introduced me to his eldest son, Charles William Ridgely, and said, "I have named him after you." Charles was a mild and amiable young man. It was the wish and intention of the general to be friends with me, but Judge Chase was not candid in the introduction of him to me, as I knew nothing of the family before.

I left Hampton for Baltimore and put up at the Fountain Inn, which was kept by [James] Bryden. Judge Chase had kindly offered me a room in his house whenever I made a stop in Baltimore, but the nature of my route I thought might make it troublesome. I therefore preferred the inn, which was ad-

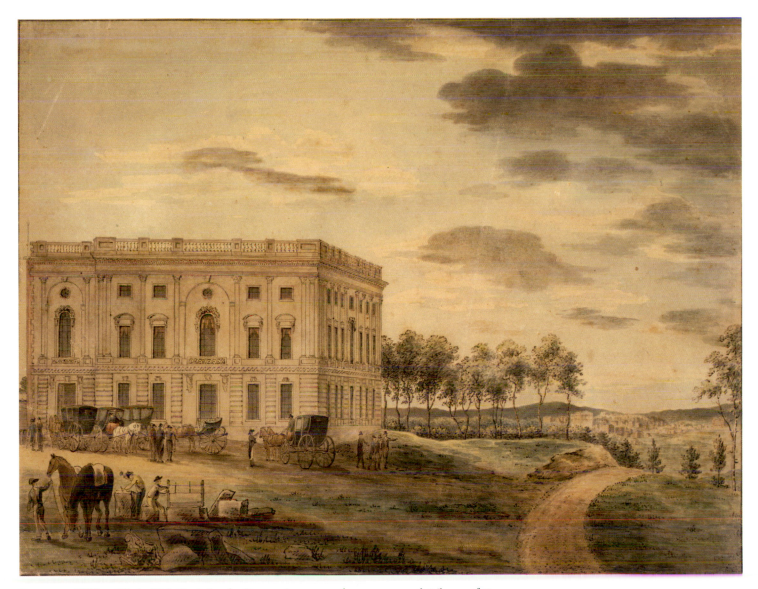

FIGURE 130. William Birch, *U.S. Capitol under Construction*, watercolor on paper, n.d. Library of Congress.

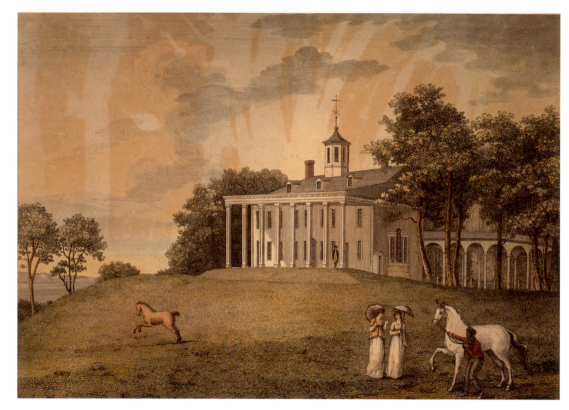

FIGURE 131. Samuel Seymour after William Birch, *Mount Vernon*, engraving, 1804. I. N. Phelps Stokes Collection, Miriam and Ira D. Wallach Division of Art, Prints and Photographs, New York Public Library, Astor, Lenox and Tilden Foundations.

* William Pinkney (1764–1822), Annapolis native, lawyer, and politician.

vantageous to my pursuit. I had but seldom visited Baltimore but found myself much better known there than in Philadelphia from my sister's connection by her marriage with the father of Judge Chase (as second wife), whom he married before the American Revolution [in] the house of my aunt Onion.[78] My subscription met with encouragement: Mr. [Charles] Carroll of Carrollton took great pains to secure a subscription for the Baltimore library and took one for himself also,

though I had not succeeded in securing one for the Philadelphia library.[79]

Finding my business upon a close in Baltimore, I called upon my friend Judge Chase. He asked me if my route led me on [to] the eastern shore.[80] I told him I meant to return that day. He told me I must not forget to call upon his friend Mr. Pinkney* who was then Attorney General of the United States to whom I could be of great service.[81] He was building a

splendid and elegant house. He gave me a letter to him, which I reserved, and made my way to Bladensburg to see Mr. Stier.*[82] I found him busily engaged in finishing a large and commodious house on a situation capable of great improvement, upon an extensive plan: an object he seemed to dwell upon and treated largely upon with me. It appeared he had intended to settle in this country but found he had to return back for his property, without hopes from his age of returning again here. He requested Mr. George Calvert to consult me in the arrangement of the grounds before he went.[83] He had with him the most splendid collection of pictures that ever came to this country. I understood [it] was the private collection of Rubens, which came into his possession from a connection with that family.

They had been unpacked once at Annapolis, I believe, but never opened afterwards here. Mr. [Gilbert] Stuart, I understand, saw them there. I saw the cases at Bladensburg. Mr. Stier indulged me by unpacking one of the small cases to show me. They went back to Holland [after] the French Revolution and were sold at great prices. Mr. Calvert sent for me upon the subject of a plan for the grounds but I believe very little was done.

I went to Washington where I spent some time [figure 130]. Mr. Law† was at that time engaged in the early improvements of that city.[84] He did me the favour of allowing me to attend him in his morning rambles upon that occasion. I succeeded here in my subscription to the Philadelphia views. I spent a very pleasant time at Mt. Vernon with Mr. and Mrs. Lewis‡ on that portion of Mt. Vernon left them by General Washington [figure 131]. It was a more beautiful situation

than that of the General's and a very healthy spot. Mr. Lewis was then building a house upon a very extensive plan. He had built two wings, which were handsome elevations, but was at a stand whether to go on with the mansion or not, [due to] a defect in the plan. The architect had placed the building too much on the precipice of the bank, an error often committed in this country. The builder, in his choice for a spot to build on, places himself upon the point most beautiful for the scene, saying "there shall be the seat or the door of the house," forgetting the advantage of lawn, or that too much familiarity with beauty wears to indifference. A more domestic adoption of beauty by art from the house would reserve the principal beauty of the situation to more proper seasons for enjoying it. But fortunately in this case, from the rocky basis of the situation and the advantage to be taken in the descent before it, we found a remedy against the wash it would have been subject to. Mr. Lewis continued the building, but the want of society in that neighbourhood rendered it lonesome.[85]

I returned to Alexandria [and] spent a few days with my son-in-law, Mr. Guy Atkinson,§ and his family who were very happily situated in that place [figure 132].[86] Before I left Alexandria, I could not help but repeat my visit to Mr. Custis¶ who seemed anxious to proceed upon his plan at Arlington** which I had dissuaded him from, [because of] the difficulty of attaining comforts upon its spot. The scene around it was splendid and elegant. [It] overlooked the principal property left him by General Washington [and] took in a complete view of the city of Washington with the arm of the Potomac, the surrounding hills of Georgetown, the rich decoration of Mason's Island with a full bird's-eye view of his own farm at

*Henri Joseph Stier (1743–1821).

†Thomas Law (1756–1834).

‡Lawrence Lewis (1767–1839) was George Washington's nephew.

§Guy Atkinson (1758–1835), an Alexandria merchant, married Birch's daughter Albina (1786–1818), in 1803.

¶George Washington Parke Custis (1781–1857).

**Arlington House, now also known as the Robert E. Lee Memorial located in Arlington National Cemetery.

FIGURE 132. William Birch, *Albina Birch Atkinson*, watercolor, ink, and graphite on paper, ca. 1800–1815. Carson Collection.

the foot of Arlington. He had built the two wings of his house, which, with the hill they stood upon, were an ornament to every elegant situation within the city limits of Washington.[87] If anybody's taste and perseverance can surmount the difficulties of rendering its spot comfortable, it must be his own. I spent a pleasant afternoon with him. [I then] returned to Washington, finished my business there, and made my best way to Annapolis.

Here I found many friends and was successful in the purpose of my route. Judge Jerry Chase,* hearing of my arrival there, sent me word that my niece Miss Betsey Chase was at his house where he [said] he hoped I should not be a stranger. I soon got an interview with my niece, being the first time I had ever seen my sister's daughter. I had seen her younger sister Nancy in Baltimore before. I found that the accomplishments of Miss Betsey Chase rendered her one amongst the first class of the elegants of that popular city.[88] I was introduced by one of my friends to Governor Mercer[†] of whose virtues and affability too much cannot be said.[89] He invited me to an evening party which, when I attended, he assured me was intended for the pleasure he should have in introducing me to my niece. I found [her] placed at the harpsichord in a large assembly of both sexes, where female rivalry could not be distinguished from a universal affability among the sexes, but where gentlemen of the law and literature had cautiously to guard against the repartees of superior wit.

The next morning I received an invitation to ride with the judge Jerry Chase out to his country seat. I borrowed a saddle and rode with him on horseback. He told me Mrs. Chase wished to know what improvements could be made there. It was a very pleasant morning. In passing through the shady thickets on the border of the woods, the gentle breezes of the air seemed to refresh the mind for our rural pursuit. When we arrived at the retreat, I felt a pleasing surprise at the appearance of a wild and picturesque scene upon an elevated

* *Jeremiah Townley Chase (1748–1828).*

† *Maryland governor John Francis Mercer (1759–1821).*

FIGURE 133. William Birch, after Gilbert Stuart, *Thomas Jefferson*, watercolor on paper, ca. 1805. The American Philosophical Society, gift of the McNeil Americana Collection.

flat of beautiful retirement enriched by a water scene below, with a high and verdant bank leading to the city. [The view] terminat[ed] with a narrow distance, [and was] crowned with the splendid dome of the Capitol, which was so fortunate in [this] point of sight as to take off the elephant appearance of the building and effect more of the Roman structure which greatly improved the scene. But a more unfortunate instance of a misplaced house was never seen. It rendered every attempt for improvement useless [and] it blocked out every advantage of scenery and beauty of situation. When Mrs. Chase asked what improvement could be made, I was under the necessity of saying none could be attempted until the house was taken away. I spent a day by desire of the governor at his elegant farm near Annapolis. Mrs. Mercer was indisposed, but his sister (a lady of great taste) favoured us with her company at dinner. She had late returned from London, and when the [table] cloth was removed she produced for me a volume of British views. I found [it] to be my own work, under the title of *Délices de la Grande Bretagne* (but without the letterpress), which she purchased in London from seeing my name to it. The situation provides a fine view over the country with an extensive prospect of the ripening harvest.

I took leave of my niece and the judge's family, crossed the Chesapeake Bay and landed on [the] eastern shore. [I] took my route over the level roads under the towering pines of the gloomy forest, inhabited by the turkey buzzards, the bald eagle and the deer among the thickets. [I] call[ed] at the neighbouring seats with my work until I heard of Mr. Pinkney's place, which I found was ten miles out of my way. [But I] found it [was] situated on a beautiful island, [with] a splendid

and extensive building in the most modern style worthy of an Attorney General.[90] I looked out my letter, got ferried over and delivered it to Mr. Pinkney, whom I found in an angry humour. Finding I was an artist, [he] began complaining of the one he had engaged in the house to paint five miniatures, whom he said had worked one hour in the day and spent all the rest of his time in gunning, which did not suit him. It was near the time of dinner and the ladies, hearing my name mentioned, took me under their wing. [They] made great inquiries after my two nieces, [and] sat me down to a comfortable dinner with them. [After dinner] I returned across the water as soon as I could. I now took my route to Easton, where I stopped several days. I made good use of my time, set off for Middletown [, Delaware], finished my business there and started for home between ten and eleven o'clock. [I] reached Neshaminy by two the next morning, [driving] by moonlight with my little black Canadian in good order and full of spirits.

I made several other routes on or near the same road upon the completion of my work. On one of my turns to Washington, I had the pleasure of meeting with a party upon the road [that] was going to Georgia: Mr. Forsyth,* Mr. Morris Miller, and another gentleman whose name I have forgot[ten].[91] We rode fifty or sixty miles together. Fourteen of them between Havre de Grace and Baltimore, I was told, once belonged to my uncle Onion. As I have generally some specimens of the arts with me, I amused them as well as I could. I had a design of my own for a small Gothic house with which Mr. Forsyth was much pleased. He told me he was about [to] build a house for his mother, and he did me the favour of accepting [my] design. I am told since it is built. Mr. Forsyth left us in

* *John Forsyth (1780–1841) was a U.S. representative and later senator from Georgia.*

Baltimore. Mr. Morris Miller was then in a state of ill health. As he was unable to go on, I thought it my duty to stop a few days on his account, after which he started for Washington where we stopped some time together. I had then to leave him, and some time after, I received the following letter from him. From its kind and affectionate mode of expression, I cannot but record it. I understand he is since dead.[92]

In another of my turns to Washington on the route of business, I visited the President Jefferson [figure 133] about October 1805. It was rather early in the day; I found him alone and had an opportunity of talking with him. He took pains to show me the house and the nature of its situation. Our conversation turned upon the arts, which induced him to show and present to me his portrait in a small print which I accepted graciously. But, disapproving the execution of it, [I] told him (as I had so far ingratiated myself in his favour) I should request one more favour of him and that was not to give away another of those prints. "Why, Mr. Birch?" said he. "Why sir," I replied, "you are giving away your own caricature." He smiled and said he really always thought so. I told him, if he would lend me Stuart's profile of him (which he had just showed me) and which I thought the best that ever was done of him I would take a drawing from it and send him a plate that should answer a better purpose. I got the picture. It was a levee morning and the people were thronging in. He asked me to stop but I saw no further chance of talking with him. I took the picture, made a correct drawing of it, and returned it two days after. I thought of engraving it myself, but found I could not equal Mr. [David] Edwin* in it.[93] [I] got him to do it, took off a few impressions, and sent [it to] him intending to

rebite the plate to make it more lasting, but spoiled the plate in attempting it. The following letter was his answer.[94]

[While] on another of my journeys to Washington, I was travelling on the road I think passing through Elkton, [when] a shower of rain drove me in my gig and another gentleman in a phaeton into an inn yard for shelter. The hostler took charge of the horses [and] we turned into the house [and] took a little refreshment. The conversation turned upon some remarks on the country. He observed he was from London, [and] I told him that that had been my residence: I had served my time in Cockspur Street, Charing Cross, but since that had practised the arts. "What, is it possible I am speaking to Mr. Birch?" he replied. "My name is Coles," he said.[95] We then recollected each other personally. He told me he had the strictest orders that could be given to find me out if possible, from Mr. Jefferys and Mr. Russell, to tell me that Mr. Rawle the attorney has orders to supply me with whatever I wanted and place it to their account. Mr. John Coles was Brother-in-law to Mr. Jefferys with whom I served my time. I called upon Mr. Rawle some time after. He congratulated me upon having such friends. I told him I was in hopes of doing without their help, but that if I should find it otherwise I should call again. I soon after found the expenses of travelling and the produce of my work was not competent to supply my expenses, and proposed assistance from my friends, when security was talked of by which I could obtain it from any broker as well. I wished him good morning and retired. Mr. Coles had gone back. I wrote to England but found soon after they were both dead: Mr. Rawle I found had been agent for Russell many years back.

I took many turns to New York where I met with friendly

* Engraver David Edwin (1776–1841) was also an English emigrant who arrived in Philadelphia in the 1790s.

reception and politeness. [I] visited Mr. Gouverneur Morris near Hell Gate [and] was honoured with his attendance at breakfast, with the rich furniture of the late king of France on the table, purchased at his sale. He had a splendid situation intended for improvement.[96] At another time [I] breakfasted with Lord Courtenay, a man of fine taste but extravagant in high life, on the road to Harlem.[97] [I] paid a visit at the seat of Mr. A[rchibald] Gracie,* and viewed several elegant retreats on the North River.[98]

I had nearly completed a set of drawings of that city which I meant to publish as a companion volume to the Philadelphia views, but found that the profits of the undertaking were not equal to the expense of travelling and the support of my family. Also, the foreign visitors to this country upon whom I chiefly depended [were] greatly falling off, and the art of enamel painting here [was] not understood, [nor] encourage[d] enough to excel. I found my profession dwindling into contempt.

This country is new and flourishing. The mechanical arts are at their highest pitch, but the fine arts are of another complexion. They are the last polish of a refined nation. The mistaken principles of liberty indulged by the majority of the people [are] much against them; which, if they were well understood, would be their support. But time in this new establishment must bring on its own remedy. The distinction between the arts and the fine arts is not generally understood, and nowhere more mistaken than among the professors of painting in so early a school as this. From an insignificant conceit of merit we have generally no knowledge of or feeling for,

our imitations of nature, however beautiful, are mechanical altogether. But [these imitations] may be considered as the first lesson necessary for the fine arts, and useful [in their progress] as furniture, as a watch or lock, etc., may be. The poet i[s] general[ly] more sensible of what the fine arts are, being free from [this] first lesson [of imitation] or [this] first lesson being more easily attained for the Poet, as sublime ideas are more easily penned than painted. [But] the basis of the fine arts is [the] superiority of ideas expressed from the superior senses of the mind, as sublime, or beautiful beyond the common course of nature, but [these ideas must be] naturally expressed. Inspiration, or expanded ideas of beauty or virtue, [are] confined to nature's laws, either in history or allegory supported by the wisdom of our forefathers (whom we call heathens among the ancient Greeks) and men of taste, who have excelled us in virtue and merit. A little mind cannot be a member of the fine arts whatever is his practice, nor can a society of professional men and unmeaning amateurs ever nourish the fine arts. Men who study the fine arts should be independent in their circumstances. Portrait painting will make a trade, and furniture painting (as copyists[' work]) another, but they must not be depended upon for the fine arts.[99] You may point to a painter of merit, to the prints of the great masters, to the copies of the divine Raphael, [or to] the beauties of the Poussins, with the excellences of all the first masters.[100] They will appear as the diamond among the dust to the fowls that seek their grain. They can see no merit beyond their own talents. The fine arts are above the common capacity of man. An intimacy with the paintings themselves of the schools as

established, with the elevation of the mind by nature, leads to the fine arts. They rise by degrees from the special studies of the schools, void of wrangling for wealth or support by scandal. There is no example here [in the United States] or taste to encourage. Another fifty years may lay a foundation for the fine arts, but the opinion of the people universally is that a mechanical portrait of a citizen, [along] with other imitations of nature, are the highest power requisite for the fine arts. [This is] a low basis for a temple of the powers of the human mind. I do not profess myself a member of the fine arts; I am a copyist only, but from my knowledge of them [I] have been allowed judgment and taste, which is competent to give me a relish for them, having studied the schools.

Having had the occasion to cross the bridge of Neshaminy, I was informed that General Ridgely was at [the] Bristol Races with one or two of his horses upon his usual excursion of amusement. I saddled my horse and rode the three miles to Bristol to invite him to breakfast with me the next morning. The next morning as the horses were preparing to start the general was preparing to visit me. His friends, seeing him differently disposed [than] to the turf, exclaimed, "Why, General, you are not going to leave us?" [He] answered, "I cannot disappoint Mr. Birch." His friends, seeing him fixed upon going, declared they would go with him if he did. The general, who was never so happy as to see his friends about him, from his natural affability was never without a retinue of them around him. Fourteen of them on horseback attended him to Springland. Seeing a company of horsemen at my gate, I ran down. "Surely," said I, "General, you have not brought all these folks

to breakfast? They will fare badly, I fear, if you have." "No, no," said he, "we have all breakfasted." My lawn never was so handsomely furnished before with so many fine horses in a group.

The gentlemen went with me to Green Lodge and amused themselves with my pictures. There was a fine light, and at that time [I had] one of the finest collections of Flemish pictures in the country, many of them from Mr. Hycana's collection, with others well chosen. The general was fixed in the centre of the gallery; they had to shake him. He then exclaimed he had never been so struck with pictures before. The gentlemen then expressed a desire to see my spring. The brandy and glasses were taken up to it and the water pronounced equal to any they had ever tasted before. It was then in full flow one hundred feet above the level of the river. We took a walk round the grounds while I had the pleasure of listening to a general approbation of them. They then returned to the racecourse.

I again applied myself to my studies but with little prospect of success. Instead of projecting the building of the cottage, I had to throw up my plan of settling and think of returning to England. I had sold the property and before I could return my finances were too short for my purpose.

This visit of General Ridgely's, with one I received from Mr. Bullock from Charlestown (a man of taste who was highly gratified with a day's visit he paid me), was almost the only gratification or encouragement I received for my labours to propagate taste in Springland as a sample to serve the country.[101] And, I had not the means of enjoying it myself before it was torn to pieces by its whimsical purchaser. After losing near twelve months' time on superintending and continuing

the improvements for him, I was rewarded only by a disgraceful suit at the court of Doylestown which cost me three hundred dollars.[102]

During my moving from Springland I purchased a small house and lot on the Bristol Road which I called "Roadside Cot," not far from Springland. While at this cottage, hearing [that] the national visitor Lafayette was shortly to pass on this road, I formed a complimentary vignette on the lawn of the cottage as a congratulative of welcome out of articles I fortunately happened to have in my gallery. General _____, as he was passing, told him it was the house of an artist. He halted to observe it and was much pleased with it. In the centre of the lawn was placed (surrounded with trees, flowers and shrubs) a beautiful piece of tapestry with a rich border of the Gobelin manufactury. The piece was six feet high by nine feet broad. Upon the centre of the top of the frame was fixed the Pennsylvania [coat of] arms carved by the late Dickerson of New York, gilt in matte and burnished gold with the inscription on one side "Welcome to Pennsylvania."[103] "Lafayette" [was inscribed] on the other [side]. On top of the arms were the U.S. colours with the cap of liberty. A pedestal bearing the name of Washington was placed before it, and on the top of the pedestal [there was] a real Tuscan vase in beautiful polished marble and of fine workmanship. The cap of liberty was a cap worn by an officer in the late war against the British whose company gave the first blow at Canada. Upon the whole, a rich trophy. General Lafayette in the open carriage rose upon his feet. I collected what of my family I had with me and bowed from the bank of the cottage. I afterwards met with his son in Philadelphia. [He] assured me his father hoped he should

meet me in Washington where he should have an opportunity of speaking to his friends.

I found now the country engaging in new speculation so much that the arts of painting and publishing in that line were altogether neglected and forgot. The overstock of cheap prints and lithography coming into the country with the overplus of spoils: paintings and gleanings of the European collections with which the market of the arts was so cheapened and glutted that, for want of judgment and finding their value was gone for the market, the arts fell altogether. The endeavours I had made to establish the means of an easy existence in the country became opposed and fearful. I had from necessity to apply to a recourse I thought laudable and easy, which was to request General Ridgely to supply me with enough to land me safe in England. Conceiving he was sensible of a claim I thought I had upon Hampton, [I] doubted not of his assistance.

[The last portion of Birch's "Life and Anecdotes" corresponds to the section "Discovery of a Claim in Maryland, from the Recorded Will of My Uncle Onion, Dated—1745" of his table of contents. It begins with his correspondence with Charles Ridgely of Hampton in 1821, initially for the purpose of raising enough money for Birch's return to England. Birch's account continues with visits there between 1821 and 1830 and other efforts to pursue his claim to part of the land of the Hampton estate, which he believed he was entitled to by virtue of the fact that a portion of it belonged to his uncle Thomas Russell. While this may seem an ill-informed pursuit, it was not at all uncommon in the period, given the widespread nature of land speculation. The pursuit of a claim on two pieces of property that had been owned by Russell

near the Susquehanna River in Maryland and Pennsylvania involved many members of Birch's family, including his older cousin William Russell, who eventually prevailed, his nieces Elizabeth and Ann Chase, and members of the family in Birmingham. This struggle is detailed in Bundle XXVIII ("Onion's land") of the Russell Papers at the Historical Society of Pennsylvania. Because Birch's family did not know of Russell's successful suit for the properties, his daughter Priscilla Birch Barnes continued the claim to properties formerly owned by her great-uncle after Birch's death, as is documented in correspondence that accompanied the Barra Foundation copy of Birch's manuscript, collection the Athanæum of Philadelphia.

Birch's initial letter to Ridgely of 1821 inventories a group of drawings that he sent to him for Hampton in the hope the Ridgely would purchase them. These are:

the ground plan about the house, the double tower or granary [which] is intended to enrich by contrasting and softening the beautiful amphitheatre of nature around it, [and] the gate in the sham wall. The extremities [of the wall are] to be concealed by a group of trees for some space before you enter. The house, being seen through it, denotes its being the entrance of the pleasure ground on the inside. The porter's lodge or a small tenement to part of the farm may be placed convenient to the spot. The appearance [of] the mansion should be cautiously avoided, but in a few instances, in the approach to it from the main road. The above three designs appear to be the first objects of the improvement. There are seven other designs which may be adopted as seems fit.]

Anecdotes of My Early Days

I have fortunately in the early days of my time escaped bad example.* In the cottage of my nurse there was no interruption to peace and comfort the first five years of my life. I must not forget here to describe her cottage. It was one of two small tenements at the bottom of West Street, Warwick [figure 134], enclosing a small garden in front. It consisted of three rooms [and the] front was covered with roses, honeysuckle and jasmine to the roof, admitting, through the green foliage and flowery group, the gentle rays of the morning sun to the lattice casement of our chamber. A strip of ground sufficient for vegetables and fruit [lay] at the back [and] at the end of the lot a beautiful run of water [took] its course to the Avon. Crossing the bottom of West Street [there was] a wide and open space with country scenery. Nor must I forget the large growth of a spreading codlin tree† in the centre of the lot at the back of the cottage whose choice fruit was carefully preserved for my comfort. From this easy existence I was fetched home to my father's house to the society of strangers where the guardian care of my mamma was my greatest dread, though she was a lady of the strictest order in her family duty and a complete tutoress in the instruction of her daughters.[104] At early sunset her little flock was laid to repose but never dared I sleep till the night watch had passed. At ten, before she slept herself, she passed the rounds. Her unwelcome countenance, with a blaze of light in her hand like a ghostly vision, terminated my troubles of the day when her absence and the thoughts of my cottage lulled me to sleep. But soon I crept from under the twig of Mamma Birch [figure 135] and was put to school to old Mrs. Dodd to learn my letters. She was a very corpulent lady and had a large apron as a recourse of punishment to those who would not learn. In [that] case they [were] placed close to her under that protecting veil, as chickens, to prompt them to better attention to their book. But my father, who had the appointment to attend the scholarship of the boys, was determined I should be a great man. And, before I could read English, I was placed under the care of the Rev. Dr. Roberts of the College at Warwick, a school fitted up under the patronage of the Earl of Warwick for the use of that city where no English was taught.[105] I was supplied with my arrangement of Latin books, but for want of a knowledge of my mother tongue, [they were] useless. Finding I had no chance of im-

*Book III marks the beginning of a new manuscript volume in the Carson copy.

† A tree that produces small, poor-quality apples.

FIGURE 134. William Russell Birch, *The Town and Castle of Warwick from Emscote*, engraving, 1789, from the *Délices de la Grande Bretagne*, 1791. The Athenæum of Philadelphia.

provement and had a very easy master and that Latin would be of no use to me, [I] had recourse to manoeuvre for my quiet. Six o'clock in the morning was the precise hour of receiving our classical lessons. Before I left the house for school I had recourse to my mother's pantry, which was always fraught with good things. I supplied myself with a good lunch of bread and cheese, which I shared with my friend and schoolmate. [He] was a good Latin scholar and fond of a bite in the morning and got my lessons construed which made me easy for the day. My father did not trouble himself much how I came on. He was a very easy man and I took example from him. But it was not so with my sisters. They became accomplished and good scholars under their mother. My brother [Joseph] Onion had the attention of both sides and was a better scholar than myself.[106]

I made myself happy with the beauties that surrounded Warwick. [It was] the most regular built city in England and the centre of the island, founded on a rock of freestone [and] watered at its foot by the Avon's stream where the goddess of Shakespeare's genius is said with its pure waters to flow.* In the summer mornings at 5 o'clock I followed a path through a rich flowery pasture of a vast extended meadow chequered with primrose and violets, leaving the town and castle in [a] beautiful picture upon the hill to a choice spot in the Avon for bathing. Mounting a cut willow on the bank, [I] marked a white stone among the gravel twelve feet below the crystal surface. In the flood, darting with my eyes open to the mark, [I] disturbed the finny inhabitants of the pure water. Throwing up their silvery scales to the light to avoid me, [they] re-

*A reference to Shakespeare's Stratford-upon-Avon.

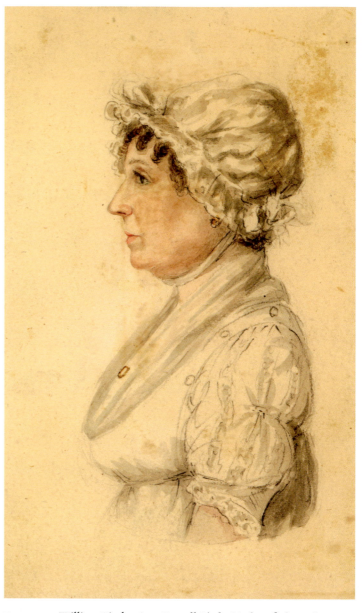

FIGURE 135. William Birch, *Anne Russell Birch*, *Mother of the Artist*, watercolor and graphite on paper, n.d. Carson Collection.

SHAKESPEAR

Sketch of Stratford Jubilee Booth or Amphitheatre.

FIGURE 136. Shakespeare Jubilee, engraving. Carson Collection.

flected brightness in my eyes while in playful shoals [they] darted from their intruder while I recovered my mark. Then [I] swam to the bed of rushes to improve my early lesson in swimming. After winding through a verdant path in the bank of the river, [I] returned to the ancient city, [looking at] St. Mary's Gothic Church with the tomb of bold Beauchamp in the brazen chapel and the priory at one end [leading] on to the ancient towers of the kingmaker at the other.[107] The two arched chapels at the extremity of its cross-line, east and west, terminated its beautiful plan.

I remember the bustle for the coronation of George the 3rd and droves of carriages coming into town from Stratford, with company for beds in the evening of Shakespeare's Jubilee by Garrick which was seven miles from that spot [figure 136].*

*David Garrick (1717–79) was arguably the most renowned actor of his day. The 1769 Jubilee he organized in Stratford played a crucial role in Shakespeare's rising reputation in the eighteenth century as Britain's greatest playwright.

Here was my beloved and eldest brother Thomas, who first pinned my attachment to the arts, until [he was] sent as a surgeon on board of an East Indiaman. My brother George to the West Indies did my mother decree, where my brother John soon after died.

Now the town was lively and well I remember, with the ripening fruit, came on the races, balls and the Sessions which told unhappy men their doom. The first sight of near my last friend occurred when I was but a stripling in my father's house. The King's trumpet was heard in the street denoting his authority in the approach of the judge to the Sessions. We ran to the sight. A troop of sheriff's officers on horseback (to the number of about thirty) in double lines with their long staffs headed with a blue ribbon resting on their stirrups followed the trumpeter. At the end of the line [came] a handsome chariot with the venerable figure of the judge in his long wig. "Who is that?" said I. "That is Lord Mansfield," said my neighbour. I little thought at that time of the honour I should have in his friendship afterwards, or the pleasure of being carried home from a late enjoyment of his society with his friends from Kenwood in that very same chariot. He never altered the fashion of his chariot for his family use to his death.[108]

I had but little more to do with my college instructions but to enjoy the pleasure of a visit from the patron of the college, Lord Warwick, about once in a fortnight, when he entered the gate with his rich embroidered clothes (then the fashion of the day). [He was] received by the boys with loud acclamations of joy, enquiring for the Rev. Dr. Roberts that he might beg a holiday for the boys, which ceremony he seemed to pass through with much pleasure. Soon after this,

my friend and cousin William Russell fetched me away to Birmingham and attended my education, which was scanty. But my mother contrived, unknown to him, to put me to a Birmingham button-maker. When he discovered it, he sent me to his friend Mr. Thomas Jefferys, goldsmith and jeweller to the King.[109]

My cousin Wm. Russell was a very extraordinary character. Firm and cautious with a friendly attention to his connection, he followed his father's steps. His feelings [were] strong and deep, rather than hasty and vehement (as Sir Walter Scott says of Bridgenorth) and is, as I understand, of direct descent from the Roundheads in the time of Charles the 1st (who had many virtues and some vices).[110] Dr. Priestley says of him that he had a public spirit and zeal in every good cause that could hardly be exceeded.[111] He was fond of hereditary honours but from the unhappy catastrophe in the family at the time of Charles was deprived of his titles.[112] I believe that the principal motive in his father's compliance with the union of my father and mother was from historical connections in my father's house with the conquest of Britain. A singular instance in the reserved character of my cousin Wm. Russell was as follows.

About the year 1786, being just entered myself into the practice of the arts and wanting money, [I] proposed to sell my entailed estate (which came to me at the death of my father). I applied to my friend Mr. R. Gray, Chamber Councillor in the Temple, to prepare it for sale. He found it necessary that a single question should be answered which no one could answer but my cousin Wm. Russell. Mr. Gray wrote to him for information. Letter after letter, all answered evasive[ly] un-

til thirty letters had been sent from London to Birmingham and as many answers from Birmingham but no one to any purpose. Being tired out, we made an excursion on horseback to Birmingham. When we arrived there Mr. Gray sent me to battle it out with him. He was then at his elegant retreat on Showell Green, three miles from Birmingham where I had formerly spent much of my time. He was a man of genuine taste. It was a handsome house upon an extensive flat of lawn; decorated with wide groups of shrubbery in the front, well-disposed. The kitchen garden [was] hid[den] from the eye in the general view within these groups of shrubbery. At the back of the house on the same extended lawn [there was] a large sheet of water embellished with gravel walks, lofty trees and shrubs, white seats, aviaries of American birds, &c. The whole [was] composed by himself in one general effect of harmony and beauty. On one side of the house, at a proper distance hid[den] with shrubs and trees, stood his well-stocked extended farm yard with a brick wall around it twelve feet high. His splendid farm [was] adjoining. About a mile from the front of the house, on a hill, stood the seat of my cousin George Russell. My cousin Thomas Russell was settled at North East in Maryland, N.A.[113]

I now entered the house angrily [and] saw my cousin in the parlour. [I] moderated my feelings as much as I could [and] told him I thought it very hard that I should have to journey so far at heavy expense for what might have been sent by post. Finding no immediate reply to my purpose, [I] flew out in a loud exclamation of anger, charging him with a want of feeling. This brought the amiable Mrs. Russell,* a lady for whom I had always the highest esteem and respect, down

from the chamber above. [She] entered the room with terror, exclaiming, "What is the matter?" Never was an unfortunate fellow so abashed. I dropped like a wounded butterfly. Cousin William, taking the advantage of it, laughed at me saying he did not know, it was cousin William, something is the matter with him, he could not tell. I got out of the room as soon as I could but not without having done my business. Mr. Gray got his answer.

The business was then prepared. My mother, with some other part of the family, raised the money. The business being about to be settled, Mr. Gray told me Mr. Russell had offered one hundred pounds more for the property. Not understanding his motive but conceiving he was taking the advantage of his aunt (my mother) in the bargain, [I] refused his offer. But after the business was settled, [I] found his motive to be only to preserve the property wholly for myself as eldest son till I was more settled, [and] that the honour that attended the property might be handed down to posterity with the family in the order it had stood from the conquest of Britain.[114]

My father's ancestor, having been a captain under William the Conqueror, after the conquest was presented a tract of land by the Conqueror. He or his heirs reduced [it] to the seventy acres I sold to my mother and which are still in the family. The situation is called Oat Hill, from which is an extensive prospect of the country near Birmingham. The reservoir of the canal before the house forms a beautiful effect. There are six locks on each side upon the descent of the hill with two steam engines to return the water to its summit. About two or three miles [away] on one side is the celebrated manufactory of Soho, known by Boulton's Works, near the

* Martha Russell, née Twamley (1741–90), married William Russell in September 1762.

foot of the hill.[115] At some distance [is] the Crossway Farm of Smithwick,[116] which was settled on my mother as pin money with other property near. On this spot my great grandfather lived one hundred ten years, and my grandfather upwards of ninety. ~~Near this time [he] would indulge himself with a walk of three miles to West Bromage to drink his pint of ale with his neighbours.~~

My father [figure 137] was an ingenious man. He received his instruction(s) as a surgeon in France [at] the School of Surgery.[117] On his return, he performed the only instance of the Caesarean operation in England in which both mother and child lived. It was noticed by Dr. Wm. Hunter.* The case was afterwards differently effected and that practice became void. My father had a valuable collection of surgical preparations. He was fond of the arts and a great friend to Worlidge† who practiced in portraits in a finished style in black lead on vellum. [He was] so called in the costume of his dresses[118] as to attract the notice of Sir Horace Walpole for whom after he drew much. But the finest of his works I ever saw was a set of portraits of the Russell family which he drew for my father in kitcat.[119] My father was a churchman and had a seat in St. Mary's Gothic Church and sometimes sat in it, but alone. My mother took her flock of both sex[es] to the Presbyterian Meeting and attended under Parson Kettle,‡ a good-tempered old gentleman and a favourite of my father's.[120] [He] would sup and smoke his pipe every Sunday evening with him at my mother's house and assist my mother in family arrangements. [During the week on] pleasant summer evenings, my father would attend Parson Kettle not in the meeting house

FIGURE 137. Thomas Worlidge, *Thomas Birch*, graphite on paper, 1742. Carson Collection.

but at the back of it where one of the most beautiful bowling greens I ever remember seeing was laid out. The gentlemen of the town with their pipes and glasses met [there] in social amusement.

[There was] a low wall upon the opposite side from the

*Scottish anatomist and physician Dr. William Hunter (1718-83) was the author of An anatomical description of the human gravid uterus, and its contents. By the late William Hunter, M.D. . . . (London, 1794), the authoritative text on the subject at the time. Hunter was, like Thomas Birch, a "man-midwife."

† Thomas Worlidge (1700–1766), a painter and engraver who was in nearby Birmingham in 1736 and whose best-known work included heads drawn in pencil.

‡ The Reverend James Kettle (d. 1806) became the Presbyterian minister in Warwick in 1746 and continued to serve in that role for forty years. He remained in Warwick until his death.

meeting house (which stood high on a rock of freestone) overlooking, from a considerable descent, the park and gardens of the castle. [They] were divided by the silver stream of the Avon running between them, with rich embellishments of art and large groups of deer sporting in the park with an extended scene of verdure for miles. Near this place, upon the descent of the hill winding between two verdant banks, was a favourite walk of mine. A gloomy shade over a descending path led to a romantic arch overhung with trees. Through its shadow a confined light with picturesque beauty was seen, exhibiting a dam of water confined by a half-circled wall ten feet high reflecting its foliage from above. A murmuring fall of the spring, with an echo from the rock, [fell] into a cistern carved in stone. Overflowing water supplied the dam, while the surplus was carried off through a hole (or cavity) in the wall of rock. An echo from the arch, shrill and rapid to your ear, vibrated a whisper from the enclosed wall and water. This enchanting spot was wrought by the Warwick family, so distinguished for taste, for the use of watering the town horses. It was called, I think, Low Ladsom. Here, early in the morning at the rising of the sun, from the rich verdure around have I listened to the concert of the feathered tribe: the blackbird and the thrush with the rising lark in sweet harmony swelled their notes in welcoming the day.

This with many enchanting scenes in the early days of my life have I spent my past hours, but as I approached to man's estate, the storms of life arose, when as my countryman Shakespeare observes the wind and the rain, and rain it rained every day. Fast fled my pleasures, yet some social hours in life's gay comforts with the wise and the great, the rich & virtuous, can I yet boast I had enjoyed. Oh! Bangham, my friend, where thou sittest at the seat of tribute at Whitehall with a liberal hand discharging the undisputed demands upon thy country's wealth, how didst thou caution me against my unhappy purpose of leaving my country for America.[121] But when the destined Philadelphia was mentioned—forbid it heaven—I should use thy words in answer, but how has thirty years woeful experience verified the misfortunes you feared I should suffer under. Yet there are many men here who are good citizens, advocates for liberty (not imprudence) who would do as they would be done by. They are overpowered by the greedy speculator as those who feel not for their neighbour but scorn as they grow rich and grasp at others' rights. They publish their intentions to assist the needy but if the needy call upon them they do not know them. They serve them they know and if they are foreigners or not born here they get them dubbed with scandal to stop others from helping them. It is but little use pleading for right; wrong will be predominant till men take more pains to educate their children or lead them [by] better example. I have laboured to succeed in comfort and repose but my days of sorrow are come upon me in my age.

Appendix A

"List of Enamel Paintings by Wm. R. Birch from the Pencil of Sir Joshua Reynolds With a few others of note from his Book of Delivery"

1783	[Subject]	Purchased by or Painted for
March 3d	Lord Lucan	Lady Althorp[1]
10	D[itt]o.	Miss Poyntz[2]
June 13	Duke of Devonshire in a blue coat buttoned up to the collar, an interesting picture.	The Duchess of Devonshire[3]
Sep. 11	Hon'ble. Mrs. Stanhope—From an unfinished Picture—an Oval[4]	Nat.'l Chauncey Esq.
Oct.	Mrs. Robertson [Robinson] with black hat. This was the first portrait of that Lady by Sir Joshua, replete in effect, beauty and colouring, the pride of the Exhibition of that year.[5] Size 3 inches by 2½	Nath'l Chauncey

[1] Sir Charles Bingham, Lord Lucan (1735–99), was painted by Reynolds in 1780 (Mannings, Sir Joshua Reynolds, cat. 174). Birch's patron for this enamel, Lavinia (1762–1831), Viscountess Althorp, was his daughter, whom Reynolds also painted in 1782. She was the sister-in-law of Georgiana, Duchess of Devonshire.

[2] An unidentified member of the Poyntz family, probably a first cousin of the Duchess of Devonshire through her mother, Margaret, Lady Spencer (1737–1814, née Poyntz).

[3] William Cavendish (1748–1811), fifth Duke of Devonshire, married Georgiana (1757–1806), the oldest daughter of John, first Earl of Spencer. Reynolds painted two portraits of Cavendish, one in 1766/67 and one in 1776. Birch's description corresponds to the earlier version (Mannings, Sir Joshua Reynolds, cat. 336). Reynolds also painted the Duchess of Devonshire several times. See Chapter 1.

[4] The former Eliza Falconer, married (ca. 1783) to Henry Fitzroy Stanhope (1754–1828). Reynolds painted several portraits of the sitter; the source for this enamel is uncertain. See Mannings, Sir Joshua Reynolds, cats. 1699–1701, and Hamilton, The Engraved Works, 135.

[5] Mrs. Robinson (1758–1800), née Mary Darby, was "tutored for the stage by Garrick" (Penny, Reynolds, 299) and came to be known as "Perdita" after an early stage part. She was the mistress of the Prince of Wales. The Duchess of Devonshire played an important role in establishing her career. On this painting, which was finished in 1782, see Mannings, Sir Joshua Reynolds, cat. 1529.

Dec. 12	Madam Bacelli with a Tabour, Landscape background, and yellow Drapery; a pleasing and beautiful picture. Size 3 inches by 2½	Duke of Dorset[6]
26	The Hon'ble Mrs. Stanhope by Moonlight,[7] one of the most beautiful of Sir Joshua's Portraits. Intending this picture for his own private collection he bestowed the utmost of his powers upon it, but having given me an unlimited commission to procure him the celebrated Teniers in the possession of my friend Mr. Chauncey saying as money was not an object with Mr. Chauncey that I should be more likely to succeed in getting it than himself, that he would willingly give up any picture in his possession for it. Mr. Chauncey came in at my House while I was copying this picture; he was enraptured with the Picture. I told him he should have it if he would give up to Sir Joshua Reynolds his Teniers; finally the bargain was struck, and this lady in the prime of her beauty with the cool radiance of the Moon in the background was given up for the old woman returning with her basket of trinkets, had passed the dog Cerberus and the infernal regions behind her. Mr. Chauncey took both copy and original. (The Teniers was afterwards engraved by Earlom.)[8] Size 3 inches by 2½	Nat'l Chauncey, Esq.

1784

Jan. 15	Mrs. Robertson [Robinson] by Sea Side.[9] This picture, though never finished in the ground and drapery, was the best specimen of Sir Joshua's flesh tints. I took the greatest pains with it, and was most successful in it of any of my works. I showed it to Mrs.	Nat'l Chauncey, Esq.

[6] The subject was Giovanna Bacelli (d. 1801), mistress of John Sackville (1745–99), third Duke of Dorset. Mannings describes him as "one of Reynolds's most imaginative patrons" (Penny, Reynolds, 265). The duke was also one of the lovers of the Duchess of Devonshire. For the painting, see Mannings, Sir Joshua Reynolds, cat. 90.

[7] The original was painted in 1782, exhibited at the Royal Academy in 1783 (Mannings, Sir Joshua Reynolds, cat. 1699), and engraved by J. R. Smith in the same year (see Hamilton, The Engraved Works, 135).

[8] Of the Teniers family of Flemish painters, this was probably David (1638–85). Engraver Richard Earlom (1743–1822) is particularly known for his prints after Claude Lorrain.

[9] John Ingamells, in The Wallace Collection, Catalogue of Pictures (London: Trustees of the Wallace Collection, 1985), 155–57, notes the publication of the completion of this painting in January 1784. See also Mannings, Sir Joshua Reynolds, cat. 1532. Birch also engraved this painting as Contemplation. See Chapter 1.

	Robertson [Robinson] who requested the favour of me to show it to her friend Col'n. Tarleton,[10] whose thumb was cut off when he was pursued by General Washington in the Revolution of America. I showed it to him, and afterwards to the Prince of Wales, late George the 4th, who expressed a wish to have it, but it was then sold. Size 3 inches by 2½	
April	A second of Mrs. Stanhope unfinished Size 3 inches by 2½	Nat'l Chauncey, Esq.
July	The Seducer or Snake in the Grass. The bewitching effect with the colouring of this picture so excelled the Print from it that I did not recollect the picture by it.[11] I copied it when fresh and thought it the finest of his Works. Size 3 inches by 2½	Nat'l Chauncey, Esq.
Aug. 11	A Portrait of Sir Joshua Reynolds[12]	Nat'l Chauncey, Esq.
1785		
April 9th	The Marquess of Rockingham	Lady Charlotte Wentworth[13]
Aug't.	The Marquess of Rockingham whole length in the full dress of the rich robes of his title.[14] Extra size	Lord Fitzwilliam
Oct.	Lord & Lady Duncannon.[15] Two Plates.	Lady Duncannon

[10] Cavalry officer Sir Banastre Tarleton (1754–1833) was injured at the battle of Guilford Court House in 1781. See Stephen Conway, "Tarleton, Sir Banastre, baronet (1754–1833)," *Oxford Dictionary of National Biography*, Oxford University Press, 2004, http://www.oxforddnb.com/view/article/26970 (accessed August 13, 2006).

[11] The original was exhibited at the Royal Academy in 1784. The print Birch scorns here may have been the version by J. R. Smith, published in 1787 (Hamilton, *The Engraved Works*, 158). See also Mannings, *Sir Joshua Reynolds*, cat. 2125.

[12] The identification of this among Reynolds's many self-portraits is uncertain.

[13] Charles Watson-Wentworth (1730–82), second Marquess of Rockingham, was the brother of Lady Charlotte and the leader of the Whig opposition to Lord Bute. He died without children and his estates went to his nephew, the second Earl Fitzwilliam, William Wentworth Fitzwilliam (1748–1833), the patron in the following entry.

Reynolds painted portraits of Watson-Wentworth in two formats: full length and oval bust. He also began but did not complete a portrait of Watson-Wentworth with Edmund Burke, whom he employed. As Birch notes, Lord Fitzwilliam ordered a replica of the full-length portrait. See Mannings, *Sir Joshua Reynolds*, cats. 1858–63.

[14] Reynolds first painted a full-length portrait of the Marquess in 1766–68. A full-length studio replica of this image was commissioned by Lord Fitzwilliam in 1781–83. See Mannings, *Sir Joshua Reynolds*, cats. 1858, 1860.

[15] Frederic Ponsonby (1758–1844), Viscount Duncannon, later third Earl of Bessborough, and Henrietta Francis Spencer (1761–1821). Lady Duncannon was the younger sister of the Duchess of Devonshire. See Mannings, Sir Joshua Reynolds, cat. 1459, for the 1785 portraits in kit-cat.

Nov.	Marquess of Rockingham for Lady Rockingham	Lady Charlotte Wentworth
Dec. 15	Marquess of Rockingham	Mrs. Weddell [16]
1786		
June 31	Marquess of Rockingham, large oval [17]	Lord Fitzwilliam
Feby.	Marquess of Rockingham, a second for	Lady Rockingham
	The Earl of Mansfield Lord Chief Justice of the King's Bench in the rich order of his station, very fine. [18]	Lady Charlotte Wentworth
April 21	The Earl of Mansfield, as above	Sir John Lindsay [19]
	The Earl of Mansfield, a second	Sir J. Lindsay
May	The Earl of Mansfield	Miss Murray
	The Earl of Mansfield	Miss E. Murray [20]
May 20	The Earl of Mansfield, for Mrs. Johnson [21]	Earl of Mansfield
27	Marquess of Rockingham, a 3rd	Lady Rockingham
	Earl of Mansfield	Counsellor Newman [22]
Sept.	Earl of Mansfield set in Diamonds for Mrs. Knightly [23]	Earl Mansfield
Oct.	Earl of Mansfield	Sir Tho's Mills [24]

[16] Mrs. William Weddell (d. 1831), an amateur painter, sat for a Reynolds portrait in 1775 (Mannings, *Sir Joshua Reynolds*, cat. 1848) and subscribed to Birch's *Délices de la Grande Bretagne*.

[17] See Mannings, *Sir Joshua Reynolds*, cat. 1863.

[18] Reynolds painted Mansfield's portrait in 1785. See Mannings, *Sir Joshua Reynolds*, cat. 1318. See Chapter 1.

[19] Sir John Lindsay (1737–88), rear admiral and the son of Mansfield's sister Emilia. See Chapter 1.

[20] Mansfield's niece Anne Murray and his grand-niece Elizabeth Murray (ca. 1763–1823), both of whom the earl had adopted. See Chapter 1.

[21] Mansfield commissioned this enamel as a gift, perhaps for Mrs. Samuel Johnson.

[22] In the main text of his autobiography, Birch describes Erskine Newman as a "steady and stable pillar of the law" (p. 186).

[23] For an anecdote relating to this enamel and its jewelry setting, see p. 194. In this, Birch asserts that she was the earl's daughter, thereby identifying her as illegitimate, since the earl and his wife had no children.

[24] Reynolds painted a sitter by this name who died in 1793. See Mannings, *Sir Joshua Reynolds*, cats. 1256–59.

Dec. 9	Lord Spencer for Lady Spencer	Sir J. Reynolds
1793 [26]		
	A second of Mrs. Robertson [Robinson] by Sea Side, with The Hon'ble Mrs. Stanhope by moonlight bought at the late Mr. Chauncey's sale by Mr. Davenport, for	Catherine, Empress of Russia
June	The late Earl of Mansfield, large Oval for	Lord Fitzwilliam
July	The late Earl of Mansfield, large Oval	Duke of Newcastle [27]
13	The late Earl of Mansfield, large Oval	Sir Wm. Burrell [28]
	The late Earl of Mansfield, large Oval	Mr. Udny [29]
Sept. 7	The head of King Lear in fine caricature and beautiful colouring [30]	Mr. Gosling
29	A wood scene with a child and lamb, beauty and innocence combined, very fine, large Oval	Mr. Gosling [31]
1794		
Jan. 15	The late Earl of Mansfield, large Oval	Mr. Baron Thompson [32]
	Reserved on my own account the following: Sir Jos. Reynolds as Dr. of Laws, without cap, the Earl of Mansfield, large Oval with a flaw, Lady Inchinguin, formerly Miss Palmer, Sir Joshua's Niece with a Bologne hat. Nathaniel Chauncey, Esq., from nearly the	

[25] George John Spencer (1758–1834), second Earl Spencer, was the only brother of the Duchess of Devonshire. He married Lavinia Bingham in 1781. Reynolds painted a full-length portrait of Lord Spencer in 1774/76. See Mannings, *Sir Joshua Reynolds*, cat. 1675.

[26] The missing years, 1787–92, are unaccounted for, although it was in this period that Birch produced the *Délices de la Grande Bretagne*.

[27] Henry Pelham-Clinton (1720–94), who also subscribed to the *Délices de la Grande Bretagne*.

[28] Sir William Burrell (1732–96), LL. D., was a member of the Society of Antiquaries. John H. Farrant, "Burrell, Sir William, second baronet (1732–1796)," *Oxford Dictionary of National Biography*, Oxford University Press, Sept 2004; online edn, Jan 2008 (http://www.oxforddnb.com/view/article/4102, accessed 24 Jan 2010)

[29] Udny (first name not given) also subscribed to the *Délices de la Grande Bretagne*. This may be the merchant and collector Robert Udny, patron of painter Edward Edwards. See Martin Postle, "Edwards, Edward (1738–1806)," *Oxford Dictionary of National Biography*, Oxford University Press, 2004, http://www.oxforddnb.com/view/article/8533 (accessed August 12, 2006).

[30] See Mannings, *Sir Joshua Reynolds*, cat. 2100.

[31] George Gosling, presumably the same patron, subscribed to the *Délices*. The Reynolds painting is unidentified.

[32] Subscriber to the *Délices*; otherwise unidentified.

last of Sir Joshua's Portraits, beautifully painted and very fine. This portrait was engraved by Miss Caroline Watson in her best style. 30 impressions were taken for his friends and the plate then gilt. I was presented with the third choice of the impressions. [33]

End of the list of copies from Sir Joshua Reynolds. The following in addition to the list will take another arrangement of dates on account of Mr. Copley's picture being first copied from. [34]

1784

Aug.	A large enamel of the Ouse Bridge of York, took from Farington, the artist that added to Northcote's Life of Sir Joshua Reynolds. A picture in the bold and correct style of Canaletto, clear and bright in effect. It was one of the most beautiful or perfect Enamels I ever painted. The size of my plate was that which I engraved for my Délices de la Grande Bretagne, and which was the principal cause of my undertaking that work. [35]	Nat'l Chauncey, Esq.

1785

Feb.	The Head of the Nabob of Arcot from Kettle on the inside of a watch got up as the return of present from the large diamond brought over for her Majesty by Sir Acton Munro [36]	Queen Charlotte [37]

[33] Reynolds painted himself in doctoral robes "without cap" twice ca. 1773–74; he was made an honorary Doctor of Civil Laws at the University of Oxford in July 1773. The self-portrait that Birch copied, painted in an oval format, was created to hang in the Royal Academy of Arts (see Mannings, Sir Joshua Reynolds, cat. 12). Reynolds's portrait of his niece Mary Palmer (1750–1820) in a "Bologne hat" was painted around 1785. See Mannings, Sir Joshua Reynolds, cat. 1464. His portrait of Nathaniel Chauncey (1784; Mannings, Sir Joshua Reynolds, cat. 352) is lost. Caroline Watson's (1760–1814) engraving was completed in 1790.

[34] The reference here is to John Singleton Copley's Death of the Earl of Chatham (1779–81), which shows the collapse of William Pitt in the House of Lords in 1778. Copley used the sketches created in the preparation of the painting as the basis of portraits, including one of Lord Mansfield (1783), who is represented in the later painting in a slightly different pose. Birch is referring to this portrait here. See Chapter 1.

[35] Joseph Farington's (1747–1821) Ouse Bridge at York was exhibited at the Royal Academy in 1784. See Chapter 2. James Northcote's Memoirs of Sir Joshua Reynolds and Life of Sir Joshua Reynolds were the first published biographies of the artist (in 1813 and 1818/19, respectively). Venetian native and landscape painter Antonio Canal, known as Canaletto (1697–1768), lived in London in 1746–56, creating paintings of British scenery. On representations of the Ouse Bridge, see Barbara Wilson and Frances Mee, "The Fairest Arch in England": Old Ouse Bridge, York, and Its Buildings: The Pictorial Evidence (York: York Archaeological Council, 2002).

[36] English portrait painter Tilly Kettle (1735–86) was in India between 1769 and 1777, where "his clientele . . . consisted of nabobs, merchants, and army officers." Martin Postle, "Kettle, Tilly [1735–1786]," Oxford Dictionary of National Biography, Oxford University Press, 2005, http://www.oxforddnb.com/view/article/15490 (accessed August 11, 2006). Arcot in the state of Tamil Nadu. The identification of "Acton Munro" is uncertain: it is either Sir Hector Munro (1726–1805), or his brother Sir Alexander Munro, both of whom were in India. See Chapter 2.

[37] Charlotte (1744–1818), consort of George III.

	Three Portraits of the Earl of Mansfield from Copley's picture of the Death of Chatham.	Earl of Mansfield
April	A large whole length enamel of the Earl of Mansfield—From Mr. Copley's. Pronounced by the Duke of Orleans when I showed it to him, to be the very perfection of the Arts. [38]	Lady Stormont [39]
1786		
Dec. 22	Two portraits of Lord A. Hambleton [Hamilton], father to Lady Stormont from one of the finest paintings by Sir Godfrey Kneller. [40]	Lady Stormont

[38] Louis-Philippe-Joseph, duc d'Orleans (1752–85), was the cousin of French king Louis XVI and a supporter of the democratic movement in France before the Revolution. Despite this, he was executed in the Reign of Terror. The duke also subscribed to the *Délices*.

[39] Presumably Louisa, née Cathcart, second wife of David Murray (1727–96), sixth Viscount Stormont and nephew of the Earl of Mansfield. The younger Murray inherited Kenwood and became second Earl of Mansfield after his uncle's death.

[40] Birch confused generations in his reference to Lord Archibald Hamilton (bap. 1673, d. 1754), who was Lady Stormont's maternal grandfather, not her father. Kneller (1646–1723), born in Germany, was one of the most prominent painters in England at the end of the seventeenth century and the beginning of the eighteenth, and is particularly known for his portraits.

Appendix B

Subscription List to DELICES DE LA GRANDE BRETAGNE

His Majesty's Library

Her Majesty's Library

His Royal Highness the Prince of Wales[1]

His Serene Highness the Duke of Orleans[2]

Mr. [F]. Abbot [Artist, Caroline Street][3]	James Bindley, Esq., F.A.S. [Somerset Place][4]
Mr. Robert Adams [sic], Arch't[5]	Joseph Onion Birch, Warwick [6]
John Bacon, Esq. [Temple]	Mr. Booth [Artist, Strand] [7]
Th. Bangham, Esq. [Pay Office][8]	Mr. Blamire [Book Seller, Strand]
Mr. Baldwin [Book Seller, Paternoster Row]	Rev. Mr. Boucher
G. Hollington Barker, Esq.	The Hon. Tho. Bowes
Frederic Barnard, Esq. [St. James]	Robert Bow[y]er, Esq. [Miniature Painter to his Majesty][9]

[1] George IV (1762–1830), who would not ascend to the throne until the last decade of his life.

[2] Louis-Philippe-Joseph, duc d'Orléans (1752–1785).

[3] Unless otherwise noted, information in brackets comes from a broadside Birch published to advertise the *Délices de Grande Bretagne*, June 1, 1798. This broadside not only called out geographic information not included later in his subscription list that was a part of the *Délices* but also identified a number of his supports as artists, print sellers, and booksellers. Unless otherwise noted, identifications and/or life dates are from either the *Oxford Dictionary of National Biography* (Oxford: Oxford University Press, 2004) or the Union List of Artists Names Online, Getty Research Institute (http://www.getty.edu/).

[4] Book collector James Bindley (1739–1818), a fellow of the Antiquarian Society.

[5] The work of architect Robert Adam (1728–92) is featured in Birch's own view of the Earl of Mansfield's Kenwood, which Adam extensively altered along with his brother James and is included in the *Délices*.

[6] William Birch's younger brother, a physician.

[7] Perhaps William Booth (active 1780–1817).

[8] See p. 241.

[9] Bowyer (1758–1834) also published engraved sets. See Deborah Graham-Vernon, "Bowyer, Robert (1758–1834)," *Oxford Dictionary of National Biography*, Oxford University Press, 2004, http://www.oxforddnb.com/view/article/3091 (accessed August 12, 2006).

Mr. W. Barnett [Seal Engraver to his Royal Highness the Prince of Wales]

Mr. [J.] Barrett [Artist, Paddington][10]

J. Bastard, Esq., M.P. [11]

Rev. Mr. Bastock, Windsor

Mr. Beechy [Artist, Hill Street][13]

—— Beedsley, Esq., Carnarvonshire

Mr. T. Beck

W. Beckford, Esq., M.P. [Fonthill][16]

Mr. Bell [Book Seller, Strand][17]

Mr. Billington [Print Seller, Temple Bar]

[page break]

John Bull, Esq.

Mr. Burgess [Artist, Piccadilly]

Mr. E. F. Burney [Artist, Titchfield Street][20]

Sir Wm. Burrell, Bart., M.P. [21]

Sir Peter Burrell, Bart. M.P. [23]

---- Braddyll, Esq.

Mr. Bradshaw [Print Seller, Coventry Street]

Rev. Mr. Brand

Mr. Baxter [Furnival's Inn][12]

Mr. Brewin Leicester

Mr. Brotherton [Print Seller, Bond Street][14]

Mr. T. Beach [Artist, Wigmore Street][15]

Mr. Brown [Book Seller, Strand, two sets]

Her Grace the Duchess of Buccleuch[18]

Mr. J. Davis

Mr. Debrett—2 copies [Book Seller, Piccadilly][19]

Mr. Dickerson—2 copies [Dickenson, Print Seller]

Mr. Dilly—24 copies [Poultry][22]

[10] Birch engraved George Barret's (1732?–84) *Llanberis Lake, North Wales* for the *Délices*. The subscriber may have been one of his sons, James or Joseph, who were also painters. The family lived in Paddington. See W. C. Monkhouse, "Barret, George (1732?–1784)," rev. Anne Crookshank, *Oxford Dictionary of National Biography*, Oxford University Press, May 2006, http://www.oxforddnb.com/view/article/1512 (accessed August 20, 2006).

[11] John P. Bastard (1756–1816).

[12] Furnival's was one of the Inns of Court, no longer extant, indicating that Baxter was a lawyer by profession.

[13] Presumably portraitist William Beechey (1753–1839).

[14] Probably print seller and engraver James Bretherton (ca. 1730–1806).

[15] Probably portraitist Thomas Beach, who studied with Reynolds.

[16] William Thomas Beckford (1760–1844), writer and art collector, lived at Fonthill,

his family property. He built an enormous "abbey" there from designs by James Wyatt (also a *Délices* subscriber), which eventually collapsed under its own weight.

[17] Perhaps Andrew Bell (1725/6–1809), engraver and publisher.

[18] Lady Elizabeth Montagu (1743–1827), wife of Henry Scott, third Duke of Buccleuch and fifth Duke of Queensberry (1746–1812).

[19] John Debrett (d. 1822), publisher and bookseller.

[20] Edward Francisco Burney (1760–1848).

[21] Burrell, second baronet (1732–96), was an antiquary who was also purchased an enamel from Birch. See Appendix A.

[22] Charles Dilly acted as publisher for works by Boswell, Dr. Johnson, Thomas Paine, and Philadelphia physician Benjamin Rush. Birch's title page indicates that both Dilly and James Edwards (twelve copies) were the primary outlets for his work. See Chapter 2.

[23] Politician Peter Burrell (1754–1820).

Mr. Michael Bush

Mr. Cadell [Book Seller, Strand, two sets][25]

John Camden, Esq. [Wapping]

—— Campbell, Esq. [Berkeley Square]

The Right Hon. The Earl of Carlisle[28]

Mr. Caulfield [Print Seller, Castle Street, two sets][30]

Miss Caulfield

His Grace, the Earl of Chandos[33]

Right Hon. The Earl of Chesterfield[34]

Mr. John Child [Golden Square]

Rev. Mr. Clare

Mr. Clark [Engraver & Print Seller, Strand][37]

—— Coffin, Esq.

Dr. Combe, F.R.S.[38]

Mr. Cooke [Book Seller, Paternoster Row][40]

Captain Wm. Dowdeswell[24]

Mr. Drue Drury[26]

The Right Hon. Lord Dudley Ward[27]

James Dugdale, Esq. [Somerset Place]

The Right Hon. Lord Duncannon[29]

Mr. Edwards—12 copies [Pall Mall][31]

Mr. Egerton—2 copies [Book Seller, Charing Cross]

Mr. G. Engleheart, [artist, Hertford Street][32]

Hugh Evelyn, Esq., Surrey

B. B. Evans, [Print Seller, Old Jewry], two copies

The Right Hon. The Earl Exeter

Mr. Faden [Book Seller, Charing Cross][35]

Joseph Farington, Esq., R.A.[36]

Mr. Faulder [Book Seller, Bond Street]

Mr. V. Feary [Artist]

Rt. Hon. The Earl of Fife, F. N. & A.S.[39]

J. Fittler, Esq. [Engraver][41]

[24] William Dowdeswell (1760–1828), army officer and art collector.

[25] Thomas Cadell (1742–1802).

[26] Probably silversmith and naturalist Dru Drury (1725–1804).

[27] William Ward (1750–1823), later third Viscount Dudley and Ward.

[28] Frederick Howard, fifth Earl of Carlisle (1748–1825).

[29] Birch included his patron's *View of Portsmouth and the Masts of the Royal George* in the *Délices*. See Chapters 1 and 2 and Appendix A.

[30] James Caulfield (1764–1826) was both an author and a print seller.

[31] See note 22 above.

[32] Miniature painter George Engleheart (1750–1829).

[33] Richard Temple-Nugent-Brydges-Chandos-Grenville (1776–1839), first Duke of Buckingham and Chandos.

[34] Philip Stanhope, fifth Earl of Chesterfield (1755–1815).

[35] Perhaps William Faden (1749–1836), engraver and cartographer.

[36] Four paintings by Farington (1747–1821), a member of the Royal Academy of Arts ("R.A."), were engraved for the *Délices: Ouse Bridge at York* (1784), *Remains of the Seagate at Winchelsea* (1785), *View at Nunnery in Cumberland* (1787), and *Bishop's Gate Norwich* (n.d.). Birch reports that his copy of *Ouse Bridge* in enamel gave him the idea of creating the *Délices*. See Appendix A and Chapter 2.

[37] Probably John Clark (active 1775–1825).

[38] Birch knew Dr. Charles Combe (1743–1817), a fellow of the Royal Society, through their relationship with Lord Mansfield.

[39] James Duff, second Earl Fife (1729–1809).

[40] William Bernard Cooke (1778–1855), the head of a family of engravers, publishers, and booksellers. Cooke had apprenticed with William Angus, who engraved of *The Seats of the Nobility and Gentry in Great Britain and Wales* (1787–[1800]).

[41] James Fittler (1758–1835).

Richard Cooper, Esq.[42]

J. S. Copley, Esq., R.A.

Mr. R. Corbould[46]

Rev. Mr. Cracherode[48]

Richard Cosway, Esq., R.A.[50]

Richard Dalton, Esq. [Librarian to the King, and F.R.S. two sets][51]

Sir Henry Dashwood, M.P.

Mr. Daulby, Liverpool

Mr. J. Davenport [Salvadore House]

[page break]

Mr. Golding

George Gosling, Esq. [Doctor's Commons]

Richard Gough, Esq.[55]

His Grace the Duke of Grafton[56]

Mr. Robert Gray [Temple]

The Right Hon. Earl Fitzwilliam[43]

The Right Hon. Lord Fortescue[45]

Chas. Fox, Esq., Northamptonshire[47]

Henry J. Fuseli, Esq., R.A.[49]

Mr. Gains

Right Hon. Earl of Gainsborough[52]

Mr. Robert Gibson [Hampstead]

Mrs. Gibson

Mr. T. Lawrence [Artist, Jermyn Street][53]

Dr. Lettsom [F.R.S.][54]

Mr. Lewis [Gower Street]

Mr. Lewis, three copies [bookseller, Russell Street]

Francis Longe, Esq.[57]

The Right Hon. Lord Lucan[58]

[42] Artist Richard Cooper's (b. 1740?, d. after 1817) *View of Saltram in Devonshire* was included in the volume.

[43] William Wentworth Fitzwilliam, second Earl Fitzwilliam (1748–1833), was also a patron of Birch's enamels. See Appendix A.

[44] Anglo-American painter John Singleton Copley was connected to Birch primarily through Birch's copies after his portrait of the Earl of Mansfield. See Appendix A and Chapter 1.

[45] Hugh Fortescue, third Baron and first Earl Fortescue (1753–1841).

[46] Richard Courbould's (1740–1814) *Landguard Fort* (n.d.) was one of the paintings engraved for the volume.

[47] Charles Fox (1737–1810), of Chacombe Priory, Northamptonshire, was the owner of Philip Reinagle's *Llanrwst Bridge, North Wales* (1788), which Birch engraved for the volume.

[48] Book and print collector Clayton Mordaunt Cracherode (1730–99).

[49] Swiss-born artist (1747–1825).

[50] Prominent miniature specialist Richard Cosway's (1742–1821) wife, Maria (1759–1838), an artist in her own right, is represented in their apartments in William Hodge's (1744–97) *View from Mr. Cosway's Breakfast Room, Pall-Mall* (1787). Cosway loaned Birch the painting to engrave for the *Délices*, as well as de Loutherbourg's *View of Lake Wynandermeer, Westmoreland*.

[51] On Birch's relationship with Dalton, see Chapter 1.

[52] Henry Noel (1743–98), sixth Earl of Gainsborough.

[53] Painter Sir Thomas Lawrence (1769–1830), living at the time at 41 Jermyn Street.

[54] John Coakley Lettsom (1744–1815), physician, naturalist, and philanthropist.

[55] Probably the antiquarian of this name (1735–1809).

[56] Augustus Henry FitzRoy, third Duke of Grafton (1735–1811).

[57] Presumably the owner of Spixworth, in Norfolk.

[58] Sir Charles Bingham, Lord Lucan (1735–99). Birch produced an enamel of his portrait by Reynolds. See Appendix A.

The Right Hon. Charles Greville, M.P.[59]

The Hon. Coln. Greville

The Right Hon. The Earl of Grosvenor[61]

Col. Hamilton[62]

Mr. Harding[63]

Mrs. Harlow, two copies [Book Seller, St. James St.]

James Haseltine, Esq.

Francis Haward, Esq. R.A.[64]

The Right Hon. Lord Hawke[65]

Mr. Hayes [Book Seller, Oxford Street]

Mr. T. Hearne [Landscape Painter][67]

Mr. [H] Hemsley [Architect]

Mr. Holland [Architect][68]

Rev. Mr. H. Homer[69]

The Right Hon. Earl of Hopetoun[71]

James Houston, Esq. of Swansea

Mr. Huckhum

The Right Hon. The Earl of Mansfield[60]

Mr. Manson, two copies [Book Seller, Covent Garden]

Mr. Morris [Artist, Margaret Street]

—— Mason, Esq.

Mr. Masters [Hampstead]

The Right Hon. the Lord Mayor [of London]

—— Merrick, Esq.

James Merrick, Esq. [with above "Agents"]

Paul Mathuen, Esq. [Paul Methuen][66]

Mr. Middleton

J. Milbank, Esq.

Miss Milbank

Mr. James Miller, Birmingham[70]

—— Mitchell, Esq. [Banker]

Messrs. Molton & Co., 12 copies [Print Sellers, Pall Mall]

His Grace the Duke of Montagu, F.R.S.[72]

[59] Charles Francis Greville (1749–1809), younger brother to George, the second Earl of Warwick, who also subscribed. Presumably also the older brother of the next listed subscriber.

[60] William Murray (1705–93), the first Earl of Mansfield, was Birch's most important British patron.

[61] Richard, first Earl Grosvenor (1731–1802).

[62] Hamilton owned the Gainsborough painting engraved by Birch for his publication. Possibly the uncle of William Beckford (see above).

[63] Perhaps either Silvester Harding (1745–1809), artist and publisher, or his brother Edward Harding (1755–1840), engraver and publisher.

[64] Birch praises engraver Francis Haward (1759–97) in the main text of his autobiography.

[65] Martin Hawke, son and successor of Edward Hawke, naval officer and first Baron Hawke (1705–81).

[66] Presumably Paul Methuen (1723–95), who lived at Corsham Court and inherited an important art collection from his uncle and godfather of the same name. On Reynolds's portrait of the subscriber, see Mannings, *Sir Joshua Reynolds*, cat. 1242 (p. 331).

[67] Thomas Hearne's (1744–1817) *Appleby Castle, Yorkshire* (n.d.) was engraved for the volume.

[68] Presumably Henry Holland (1745–1806).

[69] Henry Homer (bap. 1752, d. 1791), classical scholar. Homer edited a publication of Roman poet Horace's works, which was completed by Dr. Charles Combe, who also subscribed, after his death. See Thompson Cooper, "Homer, Henry (bap. 1752, d. 1791)," rev. Philip Carter, *Oxford Dictionary of National Biography*, Oxford University Press, 2004, http://www.oxforddnb.com/view/article/13652 (accessed August 20, 2006).

[70] Probably a Russell family associate.

[71] James Hope-Johnstone, third Earl of Hopetoun (1741–1816).

[72] George Brudenell Montagu, Duke of Montagu (1712–90), elected a fellow of the Royal Society in 1749.

Mr. Humphry

Mr. W. Humphreys, Birmingham[74]

Mr. George Humphreys, do.

Mr. Jefferys, 4 copies [Book Seller, Pall Mall]

Dr. Johnstone, Birmingham

Mr. Jones, six copies [Engraver][77]

The Marchioness of Lansdowne

[page break]

George Nicol, Esq. [Bookseller to his Majesty, two sets][79]

—— North, Esq.

Mr. Nunes

William Osley, Esq.[82]

Right Hon. Earl of Upper Ossory[84]

Mr. Pars [Artist, Strand][86]

Mr. Payne, six copies [Book Seller, Mews Gate]

John Peachy, Esq., F.R.S.

Mr. Pearson, Birmingham

Right Hon. Lord Pelham[88]

Mr. John Munro[73]

Mr. [E. G.] Mountstephen [Berner's Street]

Right Hon. Lord Mountstuart[75]

Mr. C. Nattes [Artist][76]

Joseph Neale, Esq.

His Grace the Duke of Newcastle[78]

Mr. Deputy [John] Nichols

Mr. William Robson[80]

Mr. G. Romney [Artist, Cavendish Square][81]

Mr. Rumsey [Hampstead]

John Russell, Esq., R.A.[83]

William Russell, Esq., Birmingham[85]

Mr. G. Russell, do.

Her Grace the Duchess of Rutland[87]

Mr. Ryder

Mrs. Ryland [Print Seller, Bond Street, two sets]

[73] Physician (1715–91).

[74] The Humphreys were members of Birch's mother's family.

[75] John Stuart, first Marquess of Bute (1744–1814). At the time of Birch's publication, he was known as Lord Mountstuart.

[76] Presumably John Claude Nattes (ca. 1765–1839), topographical draughtsman and watercolorist. See Aidan Flood, "Nattes, John Claude (c. 1765–1839)," *Oxford Dictionary of National Biography*, Oxford University Press, 2004, http://www.oxforddnb.com/view/article/19810 (accessed August 13, 2006).

[77] William Jones (b. 1748), partner of Thomas Jefferys with whom Birch apprenticed from 1779.

[78] Henry Pelham-Clinton (1720–94) was also an enamel patron of Birch's.

[79] George Nicol (1740?–1828), bookseller and publisher.

[80] The artist of *Meadow Scene, at Hampstead, Middlesex*, which Birch engraved for the volume. Presumably Robson and Birch knew each other; Robson may be the drawing master who authored *Grammigraphia; the Grammar of Drawing*, published in London in 1799.

[81] Painter George Romney (1734–1802).

[82] William Osley owned Joseph Farington's *Ouse Bridge at York*. Birch's enamel of this painting prompted his first landscape engraving. See Appendix A and Chapter 2.

[83] Birch engraved painter John Russell's (1745–1806) *Golder's Green* for the *Délices*.

[84] John Fitzpatrick (1745–1818).

[85] Birch's first cousin, along with his brother George, the next listed subscriber.

[86] One of two brothers: Henry (1734–1806), draughtsman and drawing-master, or William Edmund (1742–82), painter.

[87] Mary Isabella Manners (née Somerset), Duchess of Rutland (1756–1831).

[88] Thomas Pelham, first Earl of Chichester (1728–1805), named earl in 1801.

Mrs. Pennent

Right Hon. Lord Petre[90]

Mr. Pilkington [Architect][92]

Mr. A. Plimer [Artist, Golden Square][93]

Mr. Pocock[95]

Mr. B. J. Pouncy[96]

Mr. M'Queen [Bookseller, Strand]

Mr. Read—three copies

Mr. Reid

Mr. P. Reinagle[97]

Sir Joshua Reynolds, president of the R.A & F.R.S.

—— Richards, Esq.

Mr. Richards

Mr. Richardson—five copies [Print Seller, Strand]

His Grace the Duke of Richmond[101]

Right Hon. Lord Rivers [103]

Mr. Samuel [Artist, George Street][89]

Paul Sandby, Esq., R.A.[91]

Colonel Sharp

The Right Hon. Lord Sheffield[94]

Rev. Mr. Shields

Mr. Shute

Mr. Silvester [Artist, at the Lyceum, Strand]

Mr. Simco [Bookseller, Great Queen Street]

Mr. John Smith, Bart.

Mr. J. R. Smith—two copies[98]

Mr. J. Smith—five copies

Mr. Smith

Right Hon. Lord Southampton[99]

Right Hon. Lady Spencer[100]

Sir John St. Aubyn, Bart., M.P.[102]

Mr. Stevely, York[104]

George Steevens, Esq.[105]

[89] Painter George Samuel's (active 1785–1823) *View on the Thames from Rotherhithe during the Frost*, January, 1789 was engraved for the *Délices*.

[90] Robert Edward Petre, ninth Baron Petre (1742–1801).

[91] Sandby (1725–1809) was particularly known for his landscapes and his talent for watercolor painting.

[92] William Pilkington (1758–1848).

[93] Andrew Plimer (1763–1837), miniature painter.

[94] John Baker Holroyd, first Earl of Sheffield (1741–1821), politician.

[95] Birch engraved two images by Nicholas Pocock (1740–1821) for the *Délices*: *View in Monmouthshire* and *View of Kilway Towards Britton Ferry* (both paintings undated).

[96] Benjamin Thomas Pouncy, painter and printmaker (d. 1799), whose *St. Augustine's Monastery & Cathedral at Canterbury* Birch engraved for the *Délices*.

[97] Birch engraved Philip Reinagle's (1749–1833) *Llanrwst Bridge, North Wales* for the volume.

[98] John Raphael Smith (1752–1812) engraved a number of Reynolds's paintings, including two reproduced by Birch in enamel. See Chapter 2.

[99] Charles FitzRoy, first Baron Southampton (1737–97), army officer and politician.

[100] Margaret Georgiana Spencer (1737–1814, née Poyntz), mother of the Duchess of Devonshire.

[101] Charles Lennox, third Duke of Richmond, third Duke of Lennox, and Duke of Aubigny in the French nobility (1735–1806), was a founder of the Society of Arts. He was elected a fellow of the Royal Society in 1756.

[102] Fifth baronet (1758–1839) and patron of painter John Opie, whose *St. Michael's Mount, Cornwall* Birch included in the *Délices*. See Chapter 2.

[103] George Pitt, first Baron Rivers (1721–1803), politician.

[104] Perhaps W. Staveley (active 1785–1805), painter.

[105] George Steevens (1736–1800), literary editor and scholar.

Mr. Roberts

Mr. Robson [Bookseller, Bond Street][107]

[page break]

Mr. Tassie [Artist, Leicester Square][110]

Mr. Baron Thompson[112]

Mr. Thornton—eighteen copies [Bookseller, Southampton Street][113]

Mr. Tudor, Monmouth [Bookseller]

Mr. Towne [Artist, Hampstead][115]

---- Udny, Esq.[117]

Mr. Venner [Surgeon]

Gen'l Vernon[119]

Mr. Viller

Mr. Vittall [Tower]

Mr. Wales [Artist, Hampstead][122]

Mr. Stockdale [Bookseller, Piccadilly][106]

Mrs. Stothard[108]

Sir Robert Strange[109] [Engraver]

Mr. George Stubbs, A.[111]

Mr. Watson

John Way, Esq.

Mrs. Weddell[114]

Hon. Lady Charlotte Wentworth[116]

Mr. Wells

Benjamin West, Esq., R.A.[118]

Mr. F. Wheatley [Artist][120]

Mr. White [Surgeon][121]

Mr. White—2 copies [Bookseller, Fleet Street]

Caleb Whit[e]ford [Whitefoord], Esq.[123]

[106] John Stockdale (ca. 1749–1814), publisher and bookseller.

[107] Printer and bookseller James Robson (1733–1806).

[108] Perhaps Thomas Stothard (1755–1834), painter and book illustrator.

[109] Scottish-born Strange (1721–92) had been enmeshed with the Jacobite uprising of 1745 and spent many years on the European continent before coming to London in 1765.

[110] James Tassie (1735–99), modeler and portrait medallionist, whom Birch may have known from his apprenticeship with Thomas Jefferys.

[111] Stubbs (1724–1806) is perhaps best known for his paintings of horses. As Birch's "A" after his name indicates, Stubbs had a problematic relationship with the Royal Academy: elected to membership in 1781, he refused to deposit his required diploma painting and his membership was annulled.

[112] Probably Sir Alexander Thompson (1745–1817), judge.

[113] According to the inscriptions in the plates first engraved by Birch for the *Délices*, T. Thornton was to be the primary outlet for the sale of Birch's work. In later plates, Thornton was supplanted by Molton & Co., for unknown reasons. See Chapter 2.

[114] Mrs. William Weddell (d. 1831) also purchased an enamel of the Marquess of Rockingham from Birch.

[115] Perhaps landscape painter Francis Towne (bap. 1739, d. 1816).

[116] Lady Charlotte Wentworth provided one of the paintings engraved for the volume.

[117] This may be merchant and collector Robert Udny, who also ordered an enamel from Birch.

[118] Birch engraved West's (1738–1820) *Bathing Place at Ramsgate* for the *Délices*. See Chapter 2.

[119] Charles Vernon (1721–1810).

[120] Painter Francis Wheatley (1747–1801).

[121] Perhaps Charles White (1728–1813), surgeon.

[122] James Wales (1747–95), portrait painter and archaeological draughtsman.

[123] Caleb Whitefoord (1734–1810), diplomat and connoisseur, was a friend of Reynolds. See Mannings, *Sir Joshua Reynolds*, cat. 1876.

Mr. Walker [Artist, Queen Ann Street East][124]

Mr. Walker—two copies [Print Seller, Cornhill]

The Hon. Horatio Walpole[126]

Mr. Walton—four copies [Bookseller, Charing Cross]

Mr. Warner [Seal Engraver][127]

The Right Hon. the Earl of Warwick—five copies[129]

His Grace the Archbishop of York[130]

Mr. Wigstead [Artist, Soho][125]

Mr. Wilkinson—two copies [Print Seller, Cornhill]

Mr. Wilson, Esq. [Banker]

Mr. Wirgman

James Wyatt, Esq., R.A.[128]

The Hon. Miss York

[124] Perhaps engraver John Walker (fl. 1784–1802).

[125] Perhaps caricaturist, painter, and etcher Henry Wigstead (ca. 1745–ca. 1800).

[126] Walpole owned J. C. Barrow's view of his property Strawberry Hill included in the *Délices*.

[127] Perhaps Thomas Warner, who exhibited his work at the Royal Academy of Arts.

[128] Architect James Wyatt (1746–1813).

[129] George Greville (1746–1816), second Earl of Warwick, who owned the view of Warwick Castle by Abraham Pether included in the *Délices*. Two of his brothers also subscribed.

[130] William Markham (bap. 1719, d. 1807), a close friend of the Earl of Mansfield, was appointed Archbishop of York in 1776.

Letters of Reference and Recommendation

Dear Sir,

Mr. William Birch, who will have the honour to present this letter to you, is an ingenious artist. He goes out of this country with character and a high reputation in his profession to practice that profession in America.

I have not the knowledge of anyone whose situation and disposition for the fine arts are more calculated to befriend Mr. Birch, than that of your own. And I am persuaded that when you know his abilities you will have the same gratification in rendering him friendship that I have in making him known to you in the city of Philadelphia.

I am with the greatest respect, dear sir,
Your obedient humble servt.,
Benjamin West

London July 14, 1794
William Bingham, Esq.

Dear Sir,

I am happy to hear that you are preparing to embark for America, a land wherein I hope you will enjoy an agreeable tranquillity. I should have been still more happy had it been in my power to accompany you in the voyage, but this I must postpone till an uncertain hereafter. I shall however beg of you the favour to inform one in what repute the mathematical and philosophical sciences are held in any part of the United States where you may have the good fortune to reside. For such information may perhaps be to me of the greatest utility since I have so long wished to visit that glorious land of liberty. By an early attachment and unwearied application to the study of those sciences (I hope I may say without vanity) that I have not only acquired an extensive knowledge of the abstract branches, namely arithmetic, geometry, algebra and fluxions; but also their application to the various physics/mathematical subjects which constitute mathematical philosophy. For indeed, by being instructed as an engineer teacher in the Royal Navy and public lecturer in those sciences, I have had the greater opportunity to cultivate my natural talents.

As I deem no place more eligible for residence than the land to which you are bound nor inhabitants more worthy of instruction than those with whom you are about to be acquainted, you have my leave to show these lines to any of your friends. In the meantime, wishing you a pleasant and prosperous voyage, I am with proper compliments to Mrs. Birch and family,

Dear Sir, yours most sincerely,

John George English
London, July 22, 1794

[certification letter from Lord Buchan]

Dryburgh Abbey October the 26th 1791[?]

John George English the bearer of this applied to me at this place in consequence of my known attachment to mathematical and arithmetical studies, as his countryman, and one desirous of promoting the success of such as having had a better education than usual have fallen into distress, without having been guilty of any breach of society.

He produced to me certain certificates of a very late date, from persons known to me, which induces me to endeavour to require for him some honest settlement in which he may be useful to society and his family. I do therefore address these lines to such persons as knowing my character and considering the grounds upon which I have proceeded, which Mr. English himself will communicate, may be disposed to employ him, or further his employment of settlement with others.

The right honourable Earl Buchan's recommendatory letter

 (signed) Buchan

———

"Letter containing an order on Childs the Banker for 60 Guineas."

Lord Fitzwilliam desires Mr. Birch to send him a receipt for the picture; it is very like and very well done.

Mr. Birch will direct to Ld. F[or T. or J.?] at Wentworth near Sheffield.

———

Lady Stormont's compliments to Mr. Birch and, if he chooses to dispose of Lord Mansfield's picture for thirty guineas, Lady Stormont has left the money with her which she will pay him when it is convenient for him to call for it. She will be at home between six and seven this evening or tomorrow morning between ten and eleven.

Portland Place, Wednesday

———

Lady Charlotte Wentworth's compliments to Mr. Birch. [She] is much obliged to him for the print he has procured for her and must beg to know what she is indebted to him for it. If he could conveniently call upon her about six this evening, he would be certain of finding her at home. His last picture has been much admired by everybody who has seen it.

Monday morning

———

Off of Savannah Bar, December 8th 1801
Mr. Birch

Sir,

You will find by the date of my letter that I have been unable to perform my journey by land and that I succeeded in disposing of my horses. It is true I sold them at a sacrifice and upon credit but the unfortunate are not to look for favours. My inclination to convince that I number you with regard is not less, I assure you sir, than the obligation which my promise to do so lays me under. I missed you very much at Washington where, after you left me, I was much worse than before your departure. I am now, thank God, much better and the sea air has been of infinite advantage to me. But I am still feeble, weak and much

indisposed. I write a bad hand at best but the motion of the vessel makes it worse than it would be. Excuse that, while you also excuse the shortness of a letter which goes from a sick but respectful friend.

Morris Miller

⁓

Monticello, August 3rd
Sir,

I received some days ago your favour of July 8 and with it the prints you were so kind to address to me. For these be pleased to accept my thanks. They are an elegant specimen of Mr. Edwin's talent in this line and prove also that the design has well conformed to the original. I am very sensible of this mark of your attention and of the kind expressions of your letter towards myself personally. Be pleased to accept my best wishes and the assurance of my esteem and respect.

Thomas Jefferson
Mr. Birch*

*The correspondence between Birch and Jefferson on this subject is preserved in the Library of Congress archives and is dated 1812.

Appendix D

Subscribers to Birch's Views of Philadelphia

Consisting in Its First Edition[1]

29 Plates, 13 by 11 inches

Mr. James Abeen[2]	[New] Brunswick, New Jersey
Mr. John Allen [Merchant]	Philadelphia
Mr. Samuel Anderson [Merchant]	Do.
Mr. Joseph Anthony [Goldsmith & jeweller][3]	Do.
Mr. Josiah Hewes Anthony [Merchant]	Do.
Mr. James Ash [Revenue collector]	Do.
Mr. John Ashley [Merchant]	Do.
Mr. Bela Badger [Cabinet maker]	Do.
Mr. Jacob Baker [Merchant]	Do.
Mr. Charles N. Banckor [Merchant]	Do.

[1] Biographical information for subscribers generally comes from standard sources, including *American National Biography Online* (http://www.anb.org/) and *Appleton's Cyclopaedia of American Biography*. When not available through these or similar sources, information on the profession of the subscribers is primarily derived from city directories of the period. In addition to the list in this Appendix, manuscript subscription information for the City of Philadelphia is included in Birch's "Book of Profits" (see Appendix G) and in a bound volume labeled "Subscribers to Philadelphia, Second Edition" in the collection of the Historical Society of Pennsylvania (hereafter cited as HSP list). Despite this title, this volume contains subscription lists for both the original edition and later ones. For further information on Philadelphia's merchants, who comprise the largest group of subscribers, see Abraham Ritter, *Philadelphia and Her Merchants, as Constituted Fifty & Seventy Years Ago, Illustrated by Diagrams of the River Front, and Portraits of Some of its Prominent Occupants, together with Sketches of Character, and Incidents and Anecdotes of the Day* (Philadelphia, 1860). Information about the profession of the subscribers included in brackets comes from these sources.

[2] Captain James Abeel (1733–1825) served as quartermaster-general for New Jersey in the American Revolution.

[3] Gold- and silversmith Joseph Anthony (Jr.) was the son of the merchant Joseph Hewes Anthony. See Ritter, *Philadelphia and Her Merchants*, 65.

Mr. William Barker [Engraver][4]	Do.
Mr. William Barrol	Chestertown, Maryland
Mr. John H. Behn, 3 sets [Merchant]	Baltimore
Mr. Edward Bennett	Eddington, North Carolina
Mr. Peter Blight [Merchant]	Philadelphia
Mr. Joseph Bolding[5]	on Neshaminy, Pennsylvania
Mr. P[hineas]. Bond[6]	British Consul
Mr. J[oseph]. B. Bond [merchant]	Philadelphia
Mr. J[ohn]. B[eale]. Bordley [Gentleman][7]	Do.
Dr. Samuel Borrowe [Physician]	New York
Mr. Francis Bourgeois [Engraver, enameler]	Philadelphia
Mr. Daniel Bowly [Merchant][8]	Baltimore
H. H. Brackenridge[9]	Judge
Mr. Francis Breuil [Merchant]	Philadelphia
Dr. Joseph Brown[e] [Physician]	New York
Mr. A[lexander]. Brown, Jun. [Merchant]	Baltimore
Mr. E. Brush [Merchant]	New York
Mr. Frederick Bossler[10]	Richmond, Virginia
Mr. John Buchanan [Merchant]	New York

[4] Barker engraved the plan of Philadelphia included in the *City of Philadelphia* and presumably received a copy of the volume in exchange for his work.

[5] Birch's HSP list indicates that the name of this subscriber may have been Boldwin or Baldwin.

[6] Bond (1749–1815) was a native Philadelphian and son of the physician of the same name. A loyalist, he practiced law in London before returning to his native city in 1786 as British consul. He served as the consul for the middle and southern states until the War of 1812, when he returned to England.

[7] Wealthy landowner John Beale Bordley (1727/26–1804) trained as an attorney; he moved to Philadelphia from Maryland in 1791.

[8] Prominent Baltimore merchant (1745–1807).

[9] Scots-born Hugh Henry Brackenridge (1748–1816) studied law under Birch's relative Samuel Chase. Governor Thomas McKean appointed Brackenridge to the Pennsylvania Supreme Court in 1799.

[10] Bossler's name appears in no other subscription list. A native of Berne, Switzerland, Bossler worked as an engraver and drawing instructor.

Mr. Thomas J. Bullitt	Easton, Maryland
Baltimore Library[11]	
Mr. Matthew [*sic*] Carey [Publisher, Bookseller][12]	Philadelphia
Mr. Charles Carroll of Carrolton[13]	Annapolis
Mr. Charles Carroll, Jun.	Baltimore
Mr. John Carvill	Chestertown, Maryland
Mr. H[enry]. J[ames]. Carroll, Kingston Hall[14]	Eastern Shore, Maryland
Mr. Lynde Catlin [Cashier, U.S. Bank][15]	New York
Mr. Theophile Cazenove[16]	Philadelphia
Judge J. T. Chase [Attorney, Judge][17]	Annapolis
Mr. S. Chaudron—2 sets [Watchmaker and jeweler]	Philadelphia
Mr. John Clifford [Merchant]	Do.
Mr. William Clifton, Jun. [Blacksmith]	Do.
Mr. Daniel C. Clymer[18]	Morgantown, Pennsylvania
Mr. William Cobbett [Newspaper proprietor][19]	Philadelphia
Mr. John Coles	New London, Connecticut
Mr. Anthony Coste	Philadelphia
Mr. J. Coulton, on Neshaminy, [publ. as Coulon]	Pennsylvania

[11] Birch records that Charles Carroll of Carrollton obtained a subscription for his work from the Baltimore Library Company. See Chapter 3.

[12] Mathew Carey (1760–1839), born in Dublin, Ireland, was one of the most important publishers in Philadelphia in the early national period.

[13] Charles Carroll of Carrollton (1737–1832), a wealthy Maryland landholder and signer of the Declaration of Independence. The next subscriber was his son, Charles Carroll "of Homewood," whose property survives on the campus of Johns Hopkins University in Baltimore.

[14] Kingston Hall, located in Somerset County near Kingston, Maryland, was placed on the National Register of Historic Places in 1974. Carroll was the father of Thomas King Carroll, later governor of Maryland.

[15] Catlin (1768–1820) was trained in the law at Yale and was the first cashier of the Merchant's Bank of New York. He was persuaded to join the New York branch of the Bank of the United States by John Jacob Astor and later served as president of the Merchant's Bank.

[16] Cazenove (1740–1811) was a speculator who arrived in Philadelphia in 1790 and was a notable figure in Federalist social circles.

[17] Jeremiah Townley Chase was related to Birch by marriage. Birch spent time with Judge Chase in Annapolis. See Chapter 3.

[18] Philadelphia native and attorney (1748–1819).

[19] Cobbett (1763–1835), an Englishman who arrived in the United States in 1792, published *Porcupine's Gazette*, a pro-Federalist newspaper, beginning in 1797.

Mr. Edward Courey[20]	Easton, Maryland
Mr. John R. Cozine [Attorney]	New York
Mr. L[ouis Martial Jacques]. Crousillat [Merchant][21]	Philadelphia
Mr. J. N. Cumming	Newark, New Jersey
Mr. Richard Dale [Commodore, U.S. Navy][22]	Philadelphia
Mr. Benjamin F. A. C. Dashiell[23]	Eastern Shore, Maryland
Mr. George Davis [Merchant]	Philadelphia
Mr. John Davis [Merchant]	Do.
Mr. William Dean	Charleston, South Carolina
Mr. Henry Dearborn[24]	Washington
Mr. Charles Deamling[25]	Philadelphia
Mr. Daniel Delany	Do. [New York][26]
Mr. Robert Denison [Merchant]	Do.
Mr. Ashby Dickens [Bookseller and stationer][27]	Do.
Mr. George Dobson—2 sets [Merchant]	Do.
Mr. Joseph Driver[28]	Eastern Shore, Maryland
Mr. Edward Duffield[29]	Benfield, Pennsylvania
Mr. Anthony Dugain [Dugan, merchant]	Philadelphia
Mr. W. T. Dunderda[le]	New York

[20] This subscriber does not appear in any other of Birch's lists.

[21] For further information on Crousillat, see Scharf and Westcott, *History of Philadelphia*, 3:2205–26.

[22] Dale (1756–1826) commanded a squadron of frigates in 1801 that included the *Philadelphia*, which Birch shows under construction in the last plate of the first edition of his publication.

[23] Benjamin Frederick Augustus Caesar Dashiell (1763–1820) served in the Maryland legislature and lived in Somerset County.

[24] Dearborn (1751–1829) rose to the rank of lieutenant colonel in the Revolution. An ally of Jefferson, he was named secretary of war in 1801.

[25] This subscriber does not appear in any of Birch's other lists.

[26] Birch's original published subscription list locates Delaney in New York City.

[27] According to the subscription list published with the first edition, the name of this subscriber was "Asbury Dickins." "Ashbury" Dickins is listed in Cornelius Stafford's *Philadelphia Directory, for 1800*, at a corresponding address to that in Birch's manuscript subscription list.

[28] Birch's HSP list indicates that this subscriber lived in Caroline County, near Easton, and that he was in fact Joshua Driver, who served in the Maryland House as a representative from Caroline County in the 1790s.

[29] Perhaps the clock and watchmaker of the same name (1720–1801). See Scharf and Westcott, *History of Philadelphia*.

Mr. James Earle, Jun.	Easton, Maryland
Mr. A[dam]. Eckfeldt [coiner to the U.S. Mint][30]	Philadelphia
Mr. Ralph Eddowes [Merchant]	Do.
Mr. Alexander Ewing [Merchant]	New York
Mr. Eylerger	Holland
Mr. Robert Ferguson [Merchant]	Philadelphia
Mr. Thomas Filldston[31]	Dutchess County, New York
Mr. James C. Fisher [Merchant][32]	Philadelphia
Mr. William Fitzhugh[33]	Alexandria
Mr. John Forsyth [Attorney][34]	Augusta, Georgia
Mr. Richard Frisby	Chester[town], Maryland
Mr. Robert Fulton[35]	Maryland
Mr. Li[y]ttleton [W.] Gale[36]	Havre de Grace, Maryland
Mr. John Gale[37]	Eastern Shore, Maryland
Mr. John Galloway, Tulip Hill[38]	Annapolis
Mr. Samuel Ga[t]liff [Merchant]	Philadelphia
Mr. Samuel Gibbs, near	Bristol, Pennsylvania
Mr. William Gibson [Clerk of Baltimore City]	Baltimore

[30] Adam Eckfeldt (1769–1852) constructed the U.S. Mint's first screw-coining press. See Jean Gordon Lee, *Philadelphians and the China Trade, 1784–1844* (Philadelphia: Philadelphia Museum of Art, 1984), 139.

[31] Birch's HSP list correctly gives this subscriber's name as "Tillotson." Tillotson (1750–1832) was a politician and elected U.S. representative from New York. He held various other state positions as well.

[32] James Cowles Fisher, a merchant and director of the Bank of the United States. Fisher purchased Sedgeley, which Birch depicted in the *Country Seats*, from fellow merchant William Cramond after his financial failure.

[33] Presumably the landowner and planter (1741–1809) who built Chatham Manor near Fredericksburg, Virginia, and who moved to Alexandria in 1799. His daughter Mary married George Washington Parke Custis, whom Birch visited at their property, Arlington.

[34] Forsyth (1780–1841).

[35] Birch's HSP list locates Fulton in New York, thus suggesting that this was in fact the Robert Fulton (1765–1815) best known for his advances in steamboats. It might be noted, however, that Fulton began his career as a miniaturist, like Birch.

[36] Birch dined with Gale during one of his trips south.

[37] Birch's HSP list indicates that this subscriber lived in Somerset County.

[38] Tulip Hill was the name of a property located in Anne Arundel County, Maryland, near Annapolis.

Mr. James Gibson [Attorney]	Philadelphia
Mr. Aquila Giles [Colonel][39]	New York
Mr. Stephen Girard[40]	Philadelphia
Mr. Robert E. Griffith [Merchant][41]	Do.
Mr. Archibald Grac[i]e[42]	New York
Mr. Gray	Philadelphia
Mr. John Grant	Do.
Mr. J. Guillemard, British Commissioner[43]	Philadelphia
Mr. John Brown Hackett[44]	Eastern Shore, Maryland
Mr. W. Hamilton, Woodlands near[45]	Philadelphia
Mr. N. L. Hammond	Easton, Maryland
Mr. John V. Hampton	Columbia, South Carolina
Mr. Thomas Harper	Philadelphia
Mr. Harper[46]	Annapolis
Mr. David Harris [Merchant]	Do.
Mr. Thomas Harris, Jun. [Gentleman]	Do.
Mr. John Hart [Druggist and apothecary]	Philadelphia
Mr. Pattison Hartshorn [Merchant]	Do.
Mr. E. Haskell[47]	South Carolina

[39] A Revolutionary War and War of 1812 officer (1758–1822) who rose to the rank of general. His ca. 1794 portrait by Gilbert Stuart is in the collection of the Wadsworth Athenaeum, Hartford, Connecticut.

[40] French-born Stephen Girard (1750–1831) was the most successful merchant and private banker in Philadelphia of the time.

[41] Merchant Robert Eaglesfield Griffith was the owner of Eaglesfield, a country house property on the Schuylkill depicted by Thomas Birch in 1808.

[42] Scots-born merchant Archibald Gracie (1755–1829) built the house that has survived as the residence of the mayor of New York. The area of Gracie's house was depicted by Birch in the *Country Seats* as *York-Island*.

[43] John Lewis Guillemard (1764–1844) was the nephew of Richard Dalton, whom Birch knew in London and who subscribed to his *Délices* (see Appendix B).

[44] The HSP list locates this subscriber further as being in Queen Anne's County, Maryland.

[45] William Hamilton's (1745–1813) Woodlands was depicted by Birch in his *Country Seats*. Hamilton also visited Birch's Springland and gave his approval.

[46] This subscriber appears in no other list Birch made of the supporters of this work.

[47] Although Birch gave the residence of this subscriber as being in the south, his name appears with a group of New York subscribers, indicating that Birch met him in that city.

Mr. William Hayward	Easton, Maryland
Mr. George R. Hayward, near	Easton, Maryland
Mr. Ebenezer Hazard [U.S. Postmaster General]	Philadelphia
Mr. William Henderson [Merchant]	New York
Mr. Joseph Higbee [Merchant]	Philadelphia
Mr. Joseph Horn [Carpenter]	New York
Mr. Henry Hollyday, near	Easton, Maryland
Mr. James Hollyday	Queen Anne's County, Maryland
Mr. J. G. [E] Howard, near[48]	Baltimore
Mr. Samuel Hughes, Mount Pleasant[49]	Havre de Grace
Mr. Francis Ing[ra]ham [Merchant]	Philadelphia
Mr. John Johns	West River, Maryland
Mr. James Irvine[50]	Philadelphia
Mr. Robert H.[I.C.] Jackson[51]	Eastern Shore, Maryland
Thomas Jefferson[52]	President of the United States
Mr. Edward Johnson	Richmond, Virginia
Mr. John Kaighn [Merchant]	Philadelphia
Mr. Robert T. Kemble, [Merchant] near	New York
Mr. Owen Kennar[d]t	Easton, Maryland
Mr. Hector Kennedy	Philadelphia
Mr. David Kennedy [Carver and gilder]	Do.

[48] Birch's reference to politician John Eager Howard's (1752–1827) location "near Baltimore" indicates his estate Belvedere, which was to the north of the contemporary city boundaries.

[49] Birch spent time with ironmaster Hughes and his wife at their property near Havre de Grace, Maryland, and described both its situation and view in some detail.

[50] Irvine (1784–91), a general in the Pennsylvania Militia, was active in politics as a member of the Constitutionalist Party.

[51] Birch's HSP list indicates this subscriber lived in Somerset County, Maryland.

[52] Jefferson was a subscriber to the first edition of the volume. Birch recounts that his publication was on display in the White House during Jefferson's presidency. Birch also describes a visit to Jefferson there in 1805.

Mr. Abner Kintzing, Jun. [Merchant][53]	Do.
Mr. J. Latimer[54]	Do.
Mr. B. Henry Latrobe[55]	Richmond, Virginia
Mr. Thomas Law[56]	Washington
Mr. J[onathan]. B. [H.] Lawrence [Merchant][57]	New York
Mr. David Lenox, Landsdowne, near	Philadelphia
Mr. Herman LeRoy [Merchant]	New York
Mr. Moses Levy [Attorney]	Philadelphia
Mr. Mordecai Lewis [Merchant]	Do.
Mr. Lawrence Lewis[58]	Woodland, Virginia
Mr. Robert Liston[59]	British Minister
Mr. Edward Lloyd[60]	Talbot County, Maryland
Mr. P. G. Lorinerie, 4 sets	Philadelphia
Mr. Turman Lowes	Eastern Shore, Maryland
Mr. William Lynch [Merchant]	Philadelphia
Mr. Joseph Lyon, Jun.	Elizabethtown, New Jersey

[53] The entry in Birch's HSP list confirms that this subscriber was Abraham Kintzing. Kintzing was a prominent merchant in the city at the time and the business partner of Henry Pratt, who subscribed to a later edition and who also appears in this list. Pratt is also remembered as the builder of Lemon Hill on the Schuylkill River.

[54] Correlation of the address given in Birch's HSP list and contemporary city directories indicates that this was George Latimer, the former collector of the port of Philadelphia.

[55] British immigrant architect Benjamin Henry Latrobe (1764–1820) was among the first to subscribe to the volume, probably in 1798 before he had taken up residence in Philadelphia, as his Richmond address indicates. In the HSP list, Latrobe's name appears next to that of Samuel Mickle Fox, director of the Bank of Pennsylvania. A total of three of Latrobe's commissions were included in the first edition of the *City of Philadelphia*: the bank on Second Street, the Center Square Waterworks, and the Chestnut Street Theater (shown under construction in the first edition and complete in later editions). Birch also depicted Sedgeley, a Schuylkill estate after Latrobe's design for William Cramond,

which was subsequently owned by James C. Fisher, who also subscribed to the *City of Philadelphia*.

[56] The English immigrant husband (1756–1834) of George Washington's step-granddaughter Elizabeth Parke Custis (1779–1832). On Law, see Ainslie T. Embree, "Law, Thomas (1756–1834)," *Oxford Dictionary of National Biography*, Oxford University Press, 2004, http://www.oxforddnb.com/view/article/16153 (accessed September 9, 2006).

[57] Correlation of period city directories and the HSP list indicates the correct first name, middle initial, and occupation of this subscriber.

[58] Lawrence Lewis (1767–1839), George Washington's nephew.

[59] Sir Robert Liston (1742–1836) was the British minister to the United States between 1796 and 1800.

[60] Presumably the Edward Lloyd (1779–1834) who occupied the family estate on Wye Island and who served as a U.S. representative and senator from Maryland.

Mr. Alexander Maxcomb [Merchant]	New York
Rev. Samuel Magaw[61]	Philadelphia
Mr. Luther Martin, 2 sets[62]	Maryland
Mr. James [Thomas] McEwin [McEuen, Broker]	Philadelphia
Mr. James McHenry[63]	Do. [Baltimore]
Mr. J[oseph]. B. [Mc]Kean [Attorney]	Do.
Mr. William M[a]cPherson[64]	Do.
Governor Mercer[65]	Annapolis
Mr. Archibald Mercer	Newark, New Jersey
Mrs. Merry[66]	Philadelphia
Mr. Peter Miercken [Sugar refiner]	Do.
T. Mifflin[67]	late Governor of Pennsylvania
Mr. Morris Miller[68]	Savannah, Georgia
Mr. James Milner [Milnor?][69]	Philadelphia
Mr. James Molan	Philadelphia
Mr. William Mooney [Upholsterer]	New York
Rev. Benjamin Moore [Clergy]	Do.
Messrs. Morgan and Douglas [Sugar refiners]	Philadelphia
Mr. John Morriam	New York

[61] Magaw (1735–1812) was an Episcopal clergyman who was involved with a number of charitable and educational institutions in the city, including Episcopal Academy.

[62] Lawyer and politician (1748–1826) who was counsel for the defense in the 1804 impeachment trial of Justice Samuel Chase, Birch's associate.

[63] On McHenry's (1753–1816) purchase from Birch of an enamel after one of Gilbert Stuart's portraits of Washington, see p. 197.

[64] MacPherson (1751–1813), Naval Officer for the District and Port of Philadelphia, served as an aide-de-camp for Lafayette during the Revolution.

[65] Birch describes an evening spent with Maryland governor John Francis Mercer (1759–1821). See Chapter 3.

[66] Ann Merry (1769–1808, née Brunton) was one of two women to subscribe to Birch's views. After 1798, she married Thomas Wignell, the manager of the Chestnut Street Theater. He also subscribed to the *City of Philadelphia* in 1803.

[67] Thomas Mifflin (1744–1800) served as Pennsylvania's Supreme Executive Council, the equivalent of governor, in 1788–90.

[68] Birch encountered Miller and John Forsyth while traveling near Washington, D.C., probably in the first decade of the nineteenth century.

[69] This subscriber, to Birch's "Second Edition with Supplement" of the views, issued in 1809, was probably politician and clergyman James Milnor (1773–1844), who served as a deacon under Bishop William White (1748–1836). Birch created a number of portraits of White in enamel.

Mr. Gouveneur Morris, near[70]	New York
Mr. R[ichard]. H[ill]. Morris [Merchant]	Do.
Mr. Moses L. Moses [Auctioneer]	New York
Mr. W. P. [V.] Murray[71]	Cambridge, Eastern Shore, Maryland
Mr. Samuel Murgatroyd [Merchant]	Philadelphia
Mr. Joseph Musgro[a]ve [Merchant]	Do.
Mr. Robert Nelson	New York
Mr. Lewis Neth [Merchant]	Annapolis
Mr. George Newman	Philadelphia
Mr. Robert Lloyd Nicols, near[72]	Eastern Shore, Maryland
Mr. William Nichols[73]	Philadelphia
Mr. Joseph Norris[74]	Do.
Messrs. Nottnagle and Montmolling [Merchants]	Do.
Mr. Henry Nurls [Nicols, Jr.; Birch misreading]	Eastern Shore, Maryland
Mr. Jesse Oat[75]	Philadelphia
Mr. N. Olcott, for Theodore [Fowler], Eastchester[76]	New York
Mr. S. Page, on Neshaminy, 2 sets	Pennsylvania
Mr. Matthew Pearce [Merchant]	Philadelphia
Mr. Parris	Do.
Mr. Peter Pederson [Diplomat][77]	Do.

[70] The location Birch gives for lawyer, politician, and diplomat Morris (1752–1816) indicates the subscriber's estate, Morrisiana (where Birch visited), which is now part of New York City.

[71] William Vans Murray (1760–1803) was trained as a lawyer in London and served both in the U.S. House of Representatives and as a diplomat.

[72] Birch's HSP list locates this subscriber in Talbot County.

[73] Nichols held a variety of city and state positions in Philadelphia, including inspector of the revenue and Pennsylvania marshal.

[74] Joseph Parker Norris (1763–1841) was one of the presidents of the Bank of Pennsylvania, among other associations.

[75] Oat, a coppersmith, may have supplied the plates for the engravings for the publication.

[76] Olcott was a merchant.

[77] Pederson was the Danish consul and chargé d'affaires. He remained in the United States for some time, marrying Charleston native Ann Caroline Smith in 1820.

Mr. Edward Pennington [Sugar refiner]	Do.
Dr. P. S. Physick[78]	Philadelphia
Mr. Henry Pratt [Merchant][79]	Do.
Mr. Peter Price	Do.
Mr. William Priestman [Gentleman]	Do.
Mr. Matthew Randall [Merchant]	Do.
Mr. R. T. Rawle [Bookseller & stationer]	Do.
Mr. George Read [Attorney][80]	New Castle
Mr. George Reinholdt [Merchant]	Philadelphia
Mr. C. Ridgeley, Hampton near[81]	Baltimore
Mr. Edward Ross	Harrisburg
Messrs. George Rossier and Roulet [Merchants]	New York
Mr. C. F. Rousset [Merchant]	Philadelphia
Mr. Richard Rundle [Merchant][82]	Do.
Mr. John Rutherfo[u]rd[83]	New Jersey
Mr. William Sansom [Merchant]	Philadelphia
Mr. E. Savage [Painter]	Do.
Mr. Thomas Satterthwaite [Merchant]	New York
Mr. James Scott	Chestertown, Maryland
Mr. Paul Seaman [Sieman] [Merchant]	Philadelphia
Mr. William Sergeant [Attorney]	Do.

[78] Prominent physician Philip Syng Physick (1768–1837).

[79] Prominent merchant Pratt (1761–1838) was the partner of Abraham Kintzing, who subscribed to the first edition. Pratt was the builder of Lemon Hill, which survives in Fairmount Park, Philadelphia.

[80] George Read (1765–1836), son of the signer of the Declaration of Independence of the same name, served as the U.S. attorney for Delaware in the early nineteenth century. Birch completed a drawing for his garden (figure 127) on the Delaware River.

[81] Charles Carnan Ridgely (born Charles Ridgely Carnan, 1760–1829) inherited the Hampton estate from his uncle.

[82] On English-born Rundle (1747–1826), see Foster, *Captain Watson's Travels in America*, 31.

[83] Birch's HSP list indicates that U.S. senator Rutherfurd (1760–1840) subscribed while in Philadelphia, presumably at the end of his service in the Senate in 1798.

Mr. James Seton [Insurance broker]	New York
Mr. Arthur Shaaff [Attorney]	Annapolis
Mr. Daniel Sheredine[84]	Cecil County, Maryland
Dr. W[illiam]. Shippen[85]	Philadelphia
Mr. Walter Sims, on Neshaminy,	Pennsylvania
Mr. John Simson [Merchant]	Philadelphia
Mr. Lawrence Sink [Cabinet maker]	Philadelphia
Mr. Andrew Smith [Merchant]	New York
Mr. John Smith [Artist]	Philadelphia
Mr. John Smith, Jun. [Merchant]	Do.
Mr. S. Smith[86]	Baltimore
Mr. Willet Smith [Merchant]	Philadelphia
Mr. John Smith, near	Vienna, Maryland
Mr. W. Smith[87]	Bristol Township, Pennsylvania
Rev. Dr. Samuel S. Smith[88]	Princeton College
Mr. Thomas Snowden, Jun.[89]	Maryland
Mr. John M. Soullier [Merchant]	Philadelphia
Mr. Stier[90]	Bladensburg

[84] Sheredine was connected to Birch by marriage: Sheredine's wife, Ann (née Thomas), was the widow of Thomas Russell, Birch's first cousin.

[85] Shippen (1736–1808), a physician, was an important figure in the establishment of the medical school of the College of Philadelphia, later the University of Pennsylvania.

[86] Samuel Smith (1752–1839) was a U.S. representative and senator. Birch designed his house, Montebello, just north of Baltimore and included an image of it in his *Country Seats*. Birch's plan for the house and the watercolor original for his engraving survive in the collection of the Baltimore Museum of Art.

[87] Birch's HSP list indicates that this was William Moore Smith (1759–1821), an attorney and the son of William Smith (1727–1803), an Anglican clergyman and the first provost of the University of Pennsylvania (then the College of Philadelphia). Birch visited the elder Smith's country estate on the Schuylkill.

[88] Samuel Stanhope Smith (1751–1819) was president of the College of New Jersey, later Princeton University. It is interesting that Birch refers to the school as "Princeton College," which was not its correct name.

[89] Birch's HSP list locates this subscriber in Prince George's County, thereby indicating that this may be "Major" Thomas Snowden, the builder of Montpelier, which survives to the present in Laurel.

[90] Henri Joseph Stier (1743–1821), an aristocratic Belgian refugee who lived with his family in the United States for slightly less than a decade. See Chapter 3.

Mr. Watson Scott[91]	Philadelphia
Mr. James Steele	Cambridge [Maryland]
Mr. Isaac Steele	Do.
Mr. Samuel Sterett [Merchant][92]	Baltimore
Mr. John Stevens[93]	New York
Mr. Ebenezer Stevens[94]	Do.
Mr. Thomas Stockton[95]	Wilmington
Mr. G. G. Stuart[96]	Germantown
Mr. Joshua Sutcliff [Merchant]	Philadelphia
Mr. Clement Sullivan	Eastern Shore, Maryland
Mr. L. D. Teackle, 3 sets[97]	Do.
Mr. James Thackara[98]	Philadelphia
Mrs. Rachel Thomee	Do.
Mr. Richard B. Thompson [Attorney]	Baltimore
Mr. Henry J. Thompson	Baltimore
Mr. Rodolphe Tellier	New York
Mr. Peter Tilly	Philadelphia
Mr. Richard Tootle, near Middletown,	Eastern Shore, Maryland
Mr. Daniel N. Train [Carver]	New York
Mr. J[ohn]. C[ornelius]. Van den Heuvel	New York

[91] Birch's HSP list indicates that Scott was to receive his set care of the mercantile firm of Walker and Kennedy on South Front Street.

[92] Sterett (1758–1833) served as a U.S. representative in the Second Congress.

[93] Inventor and landowner Stevens (1749–1838) owned Hoboken, which Birch depicted in his *Country Seats*. Stevens competed with Robert Fulton, who also subscribed, in the establishment of a steamboat to travel from Manhattan to Albany.

[94] Stevens (1751–1823) distinguished himself in military service during the Revolutionary War.

[95] Perhaps the later governor of Delaware (1781–1846).

[96] Birch copied a number of painter Gilbert Stuart's (1755–1828) portraits in enamel, most notably his portraits of Washington. See Chapter 3.

[97] Littleton Dennis Teackle (1777–1848) was a resident of Princess Anne, in Somerset County. His residence, built beginning in 1802, survives as a museum there.

[98] Engraver Thackara worked in partnership with John Vallance in Philadelphia. Thackara engraved some of the earliest published views of street scenes in Philadelphia; these appeared in the *Columbian Magazine* in the 1780s.

Mr. James Vanuxem [Merchant]	Philadelphia
Mr. Ambrose Vasse [Merchant]	Do.
Mr. Richard Varick[99]	New York
Mr. Jacob Vogdes	Philadelphia
Mr. Joseph Viar, Spanish Consul[100]	Do.
Mr. J. [Y.] Wachsmuth	Do.
Mr. H. L. Waddell	Do.
Mr. Philip Wager, 2 sets—one for himself and one for Mr. Adam Reigart of Lancaster	Do.
Mr. Onslow Wakeford [Coach maker]	Do.
Mr. Alexander Walker [Merchant]	Do.
Mr. George Walker [Silversmith & goldsmith]	Do.
Mr. Robert Waln [Merchant][101]	Do.
Mr. Peter P. Walter [Merchant]	Do.
Mr. Jeremiah Warder [Merchant]	Do.
Mr. John Watts [Physician]	Do.
Mr. Samuel Wheeler [Blacksmith]	
Judge William Whittington, Snow Hill	Maryland
Mr. Thomas Wignell[102]	Philadelphia
Mr. David Williamson [Nurseryman]	New York

[99] Varick (1753–1831) was mayor of New York City at the time of his subscribing to Birch's views.

[100] José Ignacio de Viar arrived in New York in 1785 as one of two assistants to the Spanish minister. He and the other, Josef de Jaudenes y Nebot, became joint consul in Philadelphia in 1790. Birch shared summer lodgings with Jaudenes in the 1790s. See Chapter 3.

[101] Waln (1765–1836) was a merchant prominent in the China trade, among other activities.

[102] Wignell was the manager of the Chestnut Street Theater, which was represented in the volume. Wignell married actress Ann Merry (who also subscribed) in 1803. The Chestnut Street Theater, while its façade was still in construction from designs by Benjamin Henry Latrobe, was shown in the first edition. Birch depicted the finished building in later editions.

Mr. Martin S. Wilkins [Attorney]	New York
Mr. J[ohn]. Wilson [Merchant]	Philadelphia
Mr. E[phraim]. K. Wilson, Snow Hill[103]	Maryland
Mr. John C. Wilson, near Princess Anne	Maryland
Mr. Samuel Wilson	Do.
Mr. J[oseph]. Winter [Attorney]	New York
Mr. Notley Young[104]	Washington
Marquis Casa de Yrujo[105]	Philadelphia

[103] Politician Wilson (1771–1834) was a member of the Maryland House of Delegates and a U.S. representative.

[104] Young (d. 1802) was related to the Carroll family of Maryland and owned a large property that became part of the District of Columbia.

[105] Don Carlos María Martínez de Yrujo y Tacón, Marqués de Casa Yrujo (1763–1824), came to Philadelphia as the Spanish envoy in 1796.

Appendix E

List of Paintings Exhibited by William Birch at Green Lodge

Paintings	Names of the Painters
A fountain under a ruin arch, with the glow of sunset, in fine tints	Both [Probably Both, Jan (Flemish, ca. 1615-52)]
A study, a bright sunset with ruins, and robbers, by	S. Rosa [Rosa, Salvator (Italian, 1615-73)]
A Dutch church on fire by night. An uncommonly brilliant picture, by	P. P. Brueghel, called also hellish Brueghel [Brueghel, Pieter (Flemish, ca. 1564-1637 or 8)]
A landscape wood and water, a serene morning	Waterlow [Waterloo, Anthonie (Dutch, ca. 1610-90)]
A landscape, a warm summer's evening, by	Van Blom [Probably Blom, Jan (Dutch, ca. 1622-85)]
A garden scene with a beautiful female dancing	Laura [Lauri, Filippo (Italian, 1623-94)]
A wood scene with figures, a picture of uncommon merit and beauty	A. Verboom [Verboom, Andreas Hendricksz (Dutch, 1628-70)]
A winter scene with figures skating, very fine	Van Goen [Goyen, Jan van (Dutch, 1596-1656)]
Flowers in a glass. [It] was called in Paris "the breakfast piece," from its being begun and finished before breakfast, by	Madm Lavier [unidentified]

A pair of drolls. 1st picture a lover presenting to the mother of his intended a plate of mushrooms, as an addition to her stock. She sits in her vegetable and fruit shop. 2nd picture his visit to his intended. He sits in a chair with a happy face and a jug in his hand. In the background the mother [is] recommending the lover to the daughter, by

Van Osass
[Probably Ostade, Adriaen van (Dutch, 1610-85) or Ostade, Isack van (Dutch painter, 1621-49)]

This painter is one of those so famous in the Flemish school that happily tells by the touch of his pencil what others have to labour hard to represent. The touch of the fruit and vegetables is exquisite; but above all the countenance of pleasure or happy attention in the daughter, and the well-told marks of approbation in the countenance of the mother is equal to anything ever produced by the Flemish masters.

A pair—a battle; and after a battle, by

Napoletano
[Napoletano, Filippo (Italian, ca. 1587–ca. 1629)]

This master for spirit and animation is inferior to no one, and is possessed of the magic art of touching in his subjects to a wonderful degree. He effects, upon a well-prepared ground, the confusion of a battle with very little labour. The battle [scene] is fine and spirited, and [the scene] after the battle excels in the harmony of bright tints.

The vision of the cross, by

Bon Boullogne
[Boullogne, Louis de (the elder) (French, 1609-74)]

Seems to be intended for a small altarpiece. The figure of Christ is a beautiful child, exquisitely painted, seated upon a cushion in the clouds, with cherubs round Him. The faces . . . are sublime and beautiful, and highly finished.

A landscape Name not known

The scene [is] a rich valley with lofty trees. [Their] spreading
boughs reflect their soft shades in a gentle stream that flows
through an extended vale. Through the foliage of the trees a
convent appears, spiring above a distant forest. At the foot of
a mountain glowing with the evening sun, under the cooling
shade upon the verdant bank of the stream, are two hooded
friars on an evening walk. In the distant thicket a sober
domestic is seen driving a hampered mule with provision[s]
to the convent. The quiet serenity of the scene fixes attention
upon the purpose of the evening walk and leads us to imagine
it prepares the holy fathers for devotion, and that they walk
until the tinkling of the knell from the distant convent shall
call them back. They return [and] chant their pious ejacula-
tions to the God of nature and rest retired, far from the busy
tumult of the world.

After a battle at single combat. The scene before Jerusalem: Paracell
the slain and his horse dying in the field, the antagonist [Parrocel, Joseph (French,
riding off towards the city. The dying warrior, unmantled 1646-1704)]
of his helmet, is attended by two robed priests: the one
tendering hold admonition to his departed spirit, the other
on his knee recommending his soul to God while his companion
laments his loss. The scene is grand. The smoke passing off after
the general battle, the conqueror descends a hill with his animated
steed. [He is] being directed [on] his way by the glittering arm
of a coat of mail on a warrior on foot, pointing towards the city
which, now the smoke's expelled, appears in the dark horizon among
the hills. The colouring is brilliant and the composition sublime.
The subject appears to be taken from the ancient crusades.
 I showed this picture to Sir Joshua Reynolds, as a titan, his
opinion. He pronounced it to be a Paracell, a rival of Titian,
observing that he thought Paracell a far greater master than
Titian, and that this picture [was] the finest Paracell he had
ever seen.
 The picture is much damaged.

Lucretia, the wife of Collatinus, a general in the Roman army, by	Guido Reni [Reni, Guido (Italian, 1575-1642)]

She was a Roman beauty of great birth, who, being forced by Sextus the son of the Tarquin king of Rome, to the injury of her virtue, called her friends around her. . . . After relating the event, [she] slew herself before them, from which originated the republic of Rome. This picture is one of those so celebrated (of which Guido has painted several). The picture has been damaged—whether it has ever intended as more than a bust does not appear, but it contains the most beautiful part of the subject: the bosom unmantled to receive the wound, the bloom of life fading in the countenance, death stealing in the eye, yet enough of departing charms to irritate revenge on the cause of the evil.

The death of the stag, by	Ross[1] [unidentified]

It will be enough to say of this beautiful picture that it is much in the style and by no means inferior to [Frans] Snyder[s]. The fiery animation of the dogs, the expression of fear in the countenance of the stag, the grouping of the subject in the water, with a fine landscape, marks its excellence.

Still life with a mouse, very fine, by	A. A. Flen. [unidentified]
A landscape and figures upright. A soft and spirited pencil of the Dutch school	Name not known
A pair of landscapes from the Dusseldorf Gallery by	Ruysdell [Ruisdael, Jacob van (Dutch, 1628/29-82)]

I am indebted to the research[es] of Napoleon for these pictures. [As] he [was] expected to seize upon that (continued)

[1] An enamel copy of this painting by Birch is in the collection of the Philadelphia Museum of Art (1993-31-2).

celebrated collection, was taken down and dispersed. In the confusion of the times, several of them were sent to this country. These fortunately fell into my hands. One of them is a well-known picture called "Ruysdael's Stump," mentioned in several of the travels through Europe as one of the choicest pictures of that master. Its companion is very fine. A quiet rich scene with two swans floating on a clear surface of water.

A Landscape and figures, by	Mosseron [Probably Moucheron, Frédéric de (Dutch, 1633-86)]

A warm summer's evening—a soft and brilliant picture.

A fishery, with distant vessels melting in the soft air of a bright sunset, by	Van Goen [Goyen, Jan van (Dutch, 1596-1656)]
A landscape. The gray morning, finely pictured, with cattle and figures, very fine	Vandermulling [Probably Meulen, Adam Frans van der (Flemish, 1632-90)]
A landscape. The corner of an orchard	Van Ossas [Probably Ostade, Adriaen van (Dutch, 1610-85) or Ostade, Isack van (Dutch painter, 1621-49)]

A strong clear painting, a beautiful effect of air playing between the boughs, with two figures finely painted.

A pair of figures. Bandits upon the lookout, by	DeLoutherberg [Loutherbourg, Philip James de (British, born Alsace, 1740-1812)]
A landscape, by	(Gasper) Poussin [Dughet, Gaspard (French, 1615-75)]

The usual subject of this great master. Wild and sublime, with a fine effect of still water. A small picture, an unusual size for Gasper Poussin.

Christ casting out devils, by	Brueghel and Old Franks [Flemish, possibly one of the Breughels and Sebastian Vrancx (1573-1647)]

This picture is one of an extensive set from the scriptures which [has] celebrated the characters of Brueghel and Old Franks (who generally painted the figures in Brueghel's landscapes). The figures are very fine. The troubled waters Before Jerusalem, with the stormy sky, are very appropriate to the subject, and form a beautiful picture.

A landscape; a sunset, by	Vandermuling [Probably Meulen, Adam Frans van der (Flemish, 1632-90)]

An uncommonly fine effect of the evening glow of sunset throughout the picture.

The head of a female with a thin veil, by	Titian [Vecellio, Tiziano (Titian) (Italian, ca. 1480/85-1576)]

Part of a picture preserved as a relic of the pencil of Titian.

A group of Italian beggars with an ass finely foreshortened, by	T. Barker [Perhaps Barker, Thomas "of Bath" (British 1769-1847)]

The portrait of Gabrielle d'Etrees, by	Pourbus [One of several Flemish artists by this name: Frans (the elder, 1545-81); Frans (the younger, 1569-1622); Peiter Jansz (1523/24-84); or Pieter (the younger, 1543-83)]

A lady celebrated in the reign of Henry the 4th of France.

The great falls of the Potomac, by	J. G. Parkyns [Parkyns, George I. (British, 1749-1820, active in the United States)]

The scene sublime and finely painted.

A flower piece, by	Baptiste [French, active 1683]
This is the principal group of a wreath of flowers which embellished an altar piece of the holy trinity from one of the churches in Holland. [As] the entire picture was too large, [this piece] was carefully separated from it, which is a brilliant and bold specimen of this celebrated master.	
A pastoral scene with two lovers, the female figure very fine, by	Morelli [Probably Morelli, Bartolomeo (Italian, ca. 1674–ca. 1703)]
A landscape, by	William R. Birch
The effect of sun upon dew from nature.	
A pair of landscapes with figures, by	Barker [Perhaps Barker, Thomas "of Bath" (British, 1769-1847)]
The most beautiful of the modern school have the tint of Tenniers. One, the lake scene, [with] the prison tower of Mary Queen of Scots; the other a close scene famous for its still reflecting water among the rocks.	
A beautiful study, by	Gainsborough [Gainsborough, Thomas (British, 1727-88)]
And some others, all genuine pictures calculated for the study of the arts, as well as for the amusement of the cottage. [They are] principally landscapes.	

Appendix F

Birch's Birmingham Relatives

[*Note*: Birch compiled a list of his relatives connected to the government of the city of Birmingham based on those included in the section on "Government" in William Hutton's *An History of Birmingham*, which was first published in 1781.]

The following is a statement from Hutton's *Birmingham*, showing the connection of our family with the government of that town within the years 1733 to 1782, as adopted to the time of the riots.

Low Bailiffs

J. Kettle	in 1733	connected by marriage with the Russells
J. Russell	1735	I believe an uncle
Tho⁵ Russell	1740	brother to Mrs. Onion & my uncle
Wm. Kettle	1742	as above
John Humphrys Junᵉ.	1744	my uncle
T. Kettle Esq.	1756	as above connected by marriage
Able Humphrys	1760	brother to my uncle I believe
Wm. Russell Esq. rejecting his title	1768	my cousin and nephew to Mrs. Onion
Tho⁵ Russell cousin	1770	died at North East, Maryland, No. America

Wm. Humphrys cousin	1779	I was at his feast & slept at his house where he told me he could get 10,000 pounds for the next _____ of Low Bailiff; but there was honour in that house, & peace in the government of that town under them.
Geo. Humphrys cousin	1782	

Constables

J. Russell	1743	
Saml Birch	1753	of my father's family from Oat Hill Staffordshire
Geo. Birch	1762	

all of our family connection

The Low Bailiff appoints the Jury & is at the Head of the Constable, but the Constable alone corrects the enormities of the 50,000 inhabitants of that Town of Birmingham

The Riots of Birmingham [were] also ruinous to our family with the incident of the death of Lord William Russell.

Book of Profits
William Russell Birch

[*Note:* This account book, in Birch's hand, was purchased by Marian S. Carson at the same time that she purchased her copy of the autobiography, and is titled "Book of Profits" in ink on the cover in Birch's hand. It remains essentially as he wrote it, edited only for consistency in spelling. Proper names have been changed to their modern spelling, if known.]

1813	Delivery of Philadelphia 2nd Edition[1]
Mr. [James] Molan 1 set coloured returned	~~D 2~~
Mr. [Thomas M.] Souder 1 set coloured	D 20 pd.
Mr. [Pat.] Lyon Do[2]	D 20 pd.
Mr. [John] Livezey Do[3]	D 14 pd.
Mr. Duncan plain	D 14 pd.
Mr. Stiles—plain	D 14 pd.

[1] This edition was actually the "second addition with supplement," which Martin Snyder erroneously dated to 1809. See "Philadelphia Views." A more complete version of this list is found in the unpaginated volume of subscription lists in the collection of the Historical Society of Pennsylvania (HSP). Additional information in brackets from this list.

[2] Locksmith and mechanic Patrick Lyon is best known for having been falsely accused of robbing the Bank of the United States.

[3] The HSP subscription list indicates that Livezey ordered his copy to be bound in leather.

	Mr. R. D. Brown, Swedish Cons.	D 16 pd.
	Mr. Ridgway[4]	D 14 pd.
	Mr. H. J. Hodskinson [Hotchkinson or Hodgkinson]	D 20 pd.
	Mr. Waddle of Lancaster	D 16 pd.
	Mr. Tod [Todd] of Washington	D 15 pd.
	Mr. T. E. Schwarz plain	D 5 pd.
1813		
	Continuation of miscellaneous profits Enamel paintings &c delivered	D. C.
	By order of the Corporation of N. York, an Enamel Painting of the Victory gained between the Constitution and Guerrière for a gold snuffbox presented to Capt Hull[5]	100. 0
1814 March		
	By order of the Corporation of N. York, an enamel painting of America taking the trident from Neptune, for a gold snuffbox presented to Commodore Perry for his victory on Lake Erie[6]	100
Dec[r]		
	Sold by lottery[7] 16 enamels various	160

[4] Probably merchant Jacob Ridgway (1768-1843).

[5] Thomas Birch painted the *Constitution and the Guerrière*, which represented an American victory in the first significant naval engagement of the War of 1812, the same year as his father's enamel, 1813. In this image, the battle, which took place off the coast of Nova Scotia on August 19, 1812, shows the dismasted British frigate *Guerrière* at right. The U.S.S. *Constitution* had been built in Joshua Humphreys's naval yard, which Birch depicted in his *City of Philadelphia*, and was under the command of Captain Isaac Hull (1773-1843).

[6] In another American victory in the War of 1812, Commodore Oliver Hazard Perry (1785-1819) defeated a British squadron in the Battle of Lake Erie on September 10, 1813.

[7] Artists regularly sold their work by lottery during this period.

1815
April 11

Mr. Stewart of Baltimore[8] 3 enamels: sea shells, Broadway, N.Y., & rose and oranges	50
Sold to Mr. Stewart my picture by Ruisdael, and 5 others, the	350
Moucheron evening scene, van der Muelen morning scene, Brueghel casting out devils, van Ostade small landscape & two figures orchard scene, & an upright landscape, 3 figures old man and 2 lovers[9] Captain Clark a small Venus, enamel	10
Mr. Stiles 2 drawings of C[ountry] Seats	60

1816
Jan 7

2 volm of the Philaa and N. York large plates	12.50
Odd print	1.50

March

2 paintings to Thos.[10] Cash 5 dollars. Chaff[11] 10 dollars	15
Odd prints	5

April

Venus in enamel &c. lottery	135

[8] Stewart's collecting activities are known in part through his interactions with Robert Gilmor Jr. (1774-1848), who purchased works from Stewart in 1815. Lance Humphries hypothesizes that Stewart may have been pianoforte manufacturers Adam or James of Baltimore. See Humphries, "Robert Gilmor, Jr. (1774-1848): Baltimore Collector and American Art Patron" (Ph.D. diss., University of Virginia, 1998), 1:184n, 2:428.

[9] All of these paintings were included in Birch's catalogue of his collection. The last most closely matches his "pastoral scene with two lovers" by Morelli (see Appendix E).

At this point in his list of profits, Birch is likely listing the original paintings, given the price at which he sold them. At other points in the entries that follow, it is unclear in some cases whether he is selling or bartering the originals or enamel copies. In most cases it is the latter.

[10] Birch's son, the artist, who appears regularly in this list of profits, and was presumably acting as an agent for his father.

[11] Birch here abbreviates the archaic verb "to chaffer" meaning to barter or trade.

May 27

	Nine small enamels, gems &c. &c. to Mr. J. Lewis	110
	Mr. T. Masden Philaa & N.Y. &c. &c.	10
	Mr. Warren Prints D° & c. for bedstead	14
	Mr._____ Prints for Gen.	10

1816

	September Sold an old frame to Mr. Dunlap	15

1817

	D° to Thomas a landscape	5
Jan 27	Mr. Fearman an enamel of Lucretia and a copy from Sully of his son	
	Wm.[12] for a horse valued 200D sold it for	150
April		
	an enamel of shells to Mr. Samuel Coates[13] valued 50 for 12 Sea Shells	
	Mr. Delaplaine an enamel of his son Brockhurst for prints to the	
	amount of[14]	132
	presents family	10
	Odd prints	4
	The small enamel of Washington by raffle	35

[12] The original work by Thomas Sully (1783-1872) referred to here is not certainly identified, although it may be that Birch copied the portrait of George (not William) Fairman, completed in September 1816 for his father, Gideon Fairman. See Edward Biddle and Mantle Fielding, *The Life and Work of Thomas Sully* (Philadelphia: Wickersham Press, 1921), 148. The "Lucretia" was presumably an enamel of the work by Guido Reni from Birch's collection, which he sold to Robert Gilmor Jr. in 1822.

[13] Most likely the prominent Philadelphia merchant (1748-1830) of this name.
[14] The enamel of *Brock Livingston Delaplaine*, after a portrait of Thomas Sully, is in the collection of the Metropolitan Museum of Art (Maria DeWitt Jesup Fund, 1985 [1985.141.12]).

A drawing of Mr. Goodwin's house	5
The Danae enamel by raffle	38

1817
May 22 Mr. ~~Westcoat~~ Masschoat plain — D 14 pd.

Mr. Masschoat a second set plain — D 10 pd.

Oct[r] 1

by Thomas a set[15] — D 12 pd.

1818
March 8

sheets of ivory — 4

18th

Mr. Richard Burr, an enamel crucifix — 60

Mr. Shaw, the oval Lucretia & small crucifix for flowers by
Bapt & 2 others[16]

Mr. Dunlap a pair of candlesticks — 10

Aug

Thomas a Heath Washington — 5

Do a pr of Phila & N York coloured — 5

Mr. Earl 2 Irish Seats by Mideman[17] — 5

A Painters Room Mr. Deln. for Londn., a Washingn., a Start
[perhaps Stuart] and Stag Hunt[18] — 50

[15] These entries refer to prints.

[16] Again, it is not clear whether Birch was trading the originals or enamel copies of works in his collection. The first was probably another enamel of Birch's Guido Reni. "Shaw" is perhaps the British immigrant landscape artist Joshua Shaw (1776-1860), who published *Picturesque Views of American Scenery* in Philadelphia in 1820, the first set of engraved views issued in the United States after Birch's *Country Seats*. Shaw and Birch knew each other by 1819, when both were involved in the Association of American Artists formed in the city that year. The "flower piece" and "small crucifix" may be the same paintings by Jan de Heem that Thomas Birch sold to Baltimore collector Robert Gilmor in 1822 or enamel copies of these. See Humphries, "Robert Gilmor, Jr.," 2:418.

[17] Engravings of country seats in Ireland.

[18] Painting by "Ross" in Birch's collection. See Appendix E.

	The Grand Aloe Mr. Sansom[19]	15
1820		
	Large Flower Piece Oval to Kennedy[20]	50
	A Lottery of various enamels	400
March 25		
	A raffle of Washington	30
	A Do. of Do. about	40
	A Do. of Genl. Barker[21]	50
	A Do. of Luna[22]	30
	A Do. of the crucifix	50
1821		
	A Do. of a rich snuff box	45
	Dr. Duews a tablet	5
	Mr. Strickland a van Goyen[23]	6
	Mr. First a Gainsborough	10
1822		
	Mr. Wetherill a Lucretia	40
	Mr. Sanders NY a Lucretia & 2 pictures	40
	Sir James Wright a Lucretia	80

[19] Probably Philadelphia merchant William Sansom, who subscribed to the *City of Philadelphia*. Whether this was a copy enamel or an original is not known.

[20] Presumably an enamel after the work by Baptiste in Birch's collection (see Appendix E).

[21] Birch depicted John Barker's (d. 1818) property, Mount Sidney, in the Country Seats. Enamels of Barker, a popular Philadelphia politician, and his wife survive in the collection of the Walters Art Museum, Baltimore.

[22] No copies of this enamel are known in public collections. It was illustrated, however, in Jean Lambert Brockway, "William Birch: His American Enamel Portraits," *Antiques* 24, no. 3 (1933): 96 and captioned as "Mrs. John Penn as 'Luna.'"

[23] Also presumed to be an enamel after a work in Birch's collection (see Appendix E).

	Mr. G. Catlin the Head of an Ass[24]	7
	Mr. Robt. Gilmor the Head of an L. by Guido[25]	100
	Mr. Bell 2 Gainsborough's for Franklin Plate[26]	
	Sundry Prints at sales &c. C[ountry]. S[eats]. & P[hiladelphia]. V[iews]. & c.	50
	Plans of Burlington[27]	25
	Dr. Ealy a set of C[ountry]. Seats	10
	Mr. Tenner 4 or 5 small plates for jew[illeg.]	
	A Design for a card Mr. Eliot	2
	Mr. Jennings a pin	7
1823		
	Capt. B.	20
	Hay to Mr.	20
	3 Prints	3
	Mr. Fielding for Phila. [views]	10
New York 1823		
Febry. 18		
	Mr. Fras. Graham Sir Joshua Reynolds[28]	50
	Mr. Paff Prints	10

[24] The identity of this image and whether it was an original or enamel are not known. It is possible that the purchaser was the famous artist George Catlin (1796–1872), who had come to Philadelphia in 1821 to establish his career in art after abandoning the practice of law.

[25] On the collecting activities of Robert Gilmor Jr., see Humphries, "Robert Gilmor, Jr." Birch indicated to Gilmor that he had purchased the painting originally from James McMurtrie of Philadelphia (Humphries, "Robert Gilmor, Jr.," 2:204).

[26] A plate for engraving—references to Franklin that follow indicate that he was selling prints. There are no known enamels of Franklin by Birch.

[27] See Chapter 1.

[28] Presumably one of Birch's enamels of Reynolds's self-portrait (see Appendix A).

	Capt. Webb Lucretia	45
	Capt. Webb a Washington flawed	15
	Mr. Fras. Graham the Danae, Luna, & 1 V. 2	25
	Mr. D°. the gem in case	2
	Mr. Mayer drawings of Van Goyen flawed	33
Philaa.		
	Mr. [John] Neagle[29] a flower piece	15
	Mr. Catlin a Venus	30
1823		
Sept		
	Mr. Wm Morgen [Morgan] a Plate of Phila	50
	Pd Mr. Jannins [Jennings?] by Prints &c.	14
	A Print by T.	1
	A Set of Prints &c. by Auction	8
	Mr. Polson a Bathing figure	20
Oct 28th		
	a Raffle for a Danae	28
	D°. two damaged, small	8
Novr		
	D°. a Musadora[30]	20
Dec 30	D° D° 20	

[29] John Neagle (1796-1865) painted portraits of both William Birch and his son Thomas. Neagle's portrait of William was sold at auction in the summer of 2007 by Alderfer Auctions of Hatfield, Pennsylvania. Neagle's portrait of Thomas Birch is in the collection of the Pennsylvania Academy of the Fine Arts, Philadelphia.

[30] The fictional maiden Musidora appears in Thomson's *The Seasons* and was painted by both British and American artists. Birch probably refers here to the sale of an enamel.

1824
N. York

Jan 5th

a Raffle of the two bathing figures	51
Mr. Henry Cary[31] 2 Enamels the Ruisdael Stump & Battle after Philip	60
Neopolitan[32]	
Mr. Myers, a lot of Drawings	15
A small sea piece on board & small tablet Enamel	5
Mr. Smith square Shells and Chasapeek [Chesapeake]	13

22nd

Sale by Auction N. York	
Mr. Gerard Danae	11.50
Cash small Corrigio [Correggio][33]	8
Mr. Hone small Springland[34]	7

1824

Mr. Rogers Virgin Mary from Guido	4.50
Mr. Montrie Spring Large S.	8.25
Mr. H. Cary Flowers from Baptist[35] and Plate	12
Mr. Mitchel [Mitchell] Washington	8.50

[31] Perhaps Henry C. Carey (1793-1879), economist and son of Philadelphia publisher and bookseller Mathew Carey.

[32] Enamels after objects in Birch's collection. See Appendix E.

[33] Birch did not note any works by Correggio (ca. 1489-1534) in his collection at Springland.

[34] Presumably a small enamel of a view of Springland.

[35] Another work in Birch's collection. See Appendix E.

	Mr. P. Hone Point Breeze[36]	7
	Mr. Curb Lucretia	10.50
	Mr. Baker small van Goyen	4
	Mr. Pemury a Danae	4
	Mr. Cary 2 tablets fruit and shells	5
	Mr. Hone an Onyx with design	9
	Mr. Fiongo pr. Delight. &c.	1.75
	Mr. Mitchell Dance of Death	2.50
	Mr. Bell 2 sets of C[ountry]. Seats c[oloure]d.	4.63
NY		
	Mr. Salmon a Franklin for lot of Pictures &c.	16
	a Raffle won the Musadora and Pd. Costs	
	Mr. Negle [prob. Neagle] a small Danae and Case	4.25
1825 Mar 7		
	Raffled a Lafayette	40
	A Franklin Cd. Size Mr. Saint	11
April N. York		
	Mr. Geo. Oakley from London purchased in a lot. The small	
	Parasell [Parrocel][37] & Ruysdell [Ruisdael], the Bath Piece Chesapeake	

[36] Perhaps an enamel after Thomas Birch's view of Point Breeze, the country seat of Joseph Bonaparte (Napoleon's brother) on the Delaware River near Bordentown, New Jersey.

[37] See Appendix E.

and

small Musadora, Detreasy Mother & 2 Daughters, or Danae upright
damaged, a Corragio [Correggio] & Lucretia, C[ountry]. S[eats].,

2 small Danaes, the box

from Thomson's Seasons,[38] a card with 7 Landscapes, a small
Washington & a Lafayette, & a Luna & the Damaged Lafayette,
22 in number good & bad 600

May 20
N. York stopped 13 days

Sold to Mr. Franks from Engd. from Portfolio 4

Mr. F. Graham very small tablet 2

Chafft with Mr. Smith B.Way the small spoilt Box and the other
very small for his shell piece, sold it to Coln Pilkney for his purse
and 5 D 10

Coln Pilkney the small spoilt Danae 10

Coln Pilkney the small Lafayette 5

Coln Pilkney the large Flower Piece 40

paid 5 short

Capt Webb a Lafayette 11

Nov 25
1826
N. York

Dr. Osick [Hosack] a Parasell [Parrocel][39] 50

Apr 10

D° Mr. Sansum [Sansom] Niagara and Natural Bridge[40] 80

[38] English author James Thomson's (1700-1748) *The Seasons* (1730) was an important and influential nature poem. Birch is presumably selling his own copy here.

[39] Presumably physician and botanist Dr. David Hosack (1769-1835).
[40] Enamels of views of Niagara by Birch survive in several collections, including those of the Pennsylvania Academy of the Fine Arts and the Smithsonian.

May

Mr. C. Whethrell [Wetherill] a Rose	5

June 9

Dº a Frinklen [Franklin]	20

14
N. York

Mr. John Allen collector of Models &c. for Prints	3
Mr. Martin, Detrusa, Venus of the Grotto, Ruysdell [Ruisdael] & the Falls of Principio, 400 for	26.50
Dº 4 cases	3
Mr. Richard Jewn. Broadway the Box Triumph of Independence of U.S. for a piece of Frisks[?][41]	3

1826
Aug 9

The Water in Fleens boat a lot of Prints	8
Mr. Shufflebottom a lot of flowers	1.25
A lot of Prints & Painting &c.	15
A Press for Printing	13
A Diamond	4
A Plate of Franklin and Dolphin	5

Decr

Thomas for sundries	8

[41] This is presumably the enamel *Triumph of Independence of the United States*, or a copy of it, found in the collection of the Philadelphia Museum of Art (1912-104).

	John Palethrop for Drawing	10
	Prints from Red Book	18.50
	A Gun	6
1827		
Jan 18		
	Mr. C. Wathreal [Wetherill] a head with flowers	18
	Oval and a box size flower Piece	
19		
	Dr. E. M. Blaine City Hotel small Danae	10
	Mr. Van Pelt for practical instructions	5
Feb 27		
	Mr. Goodwin a Washing[ton]	10
Mar 14		
	Mr. Birkley [Berkeley?] a Luna from Boydel pd.	20
	Mr. Van Pelt a red colour	8
May		
	Mr. Mondry Luna and shell from frame	15
June		
	Dº for Landscape by Martin	7
	Dº for Flower Piece Baptist	15

1827

June

	Mr. Neagle[42] Infant Academy	2

July 1

	Mr. Charles Wothrell [Wetherill] sm. Ruysdell [Ruisdael]	10
	Mr. Neal Luna	7.50
	Mr. Chase the Gainsborough	10

Augt

	British Capt of Ny. small Ms. & shell	5

22nd

	Mr. Pike the falls by Parkyns[43]	10
	Mr. Smith for Gold Colour	8

Sept

	Mr. Truefoot the Lafayette C. Size	30

1828

Jan

Mr. C. E. Chevallier upright Danae C. Sts, a diamond brooch and ring

Feb 7

Mr. Baker the Venus in water colours 10
(5 of it for interest)

[42] Artist John Neagle.
[43] Either a copy or the original of George Parkyns's *Falls of the Potomac* (see Appendix E).

Mr. Neal—Ass's Head	2
Mr. Smith a Vise &c.	5
Mr. Baker for the interest of 2 Notes the small Danae Box size	10
Mr. Rockhill a Rose for a breast pin	10
Mr. Rap view on Schuylkill with Stag	40
Mr. Apple the Lemon Piece 9 12½	
A Philaa on Penns Tree	50
Miss M. J. Phillips a Miniature	5
Mr. McAran Grand Aloe	5
Mrs. Fleming 2 C[ountry] S[eats] Woodlands	50
Mr. Hummons likeness of Dead Brother	10

1829

To Mr. Baker

Feb

the Enamel of Sir Joshua Reynolds and Case	15
Ten Dollars & a pr. of Spacks [spectacles?]	
Mr. Denness [Dennis?] 2 Portraits and Frames	17

Apl

Mr. Hagerden an Enamel Shells	30
Mr. Lavett a flower Piece by P. B.	10
Mr. Pike Enam. flowers for Parkyns fall[44]	10

[44] Birch here recovers Parkyns's *Falls of the Potomac*.

	Mr. Baker frame with Grand Aloe & Autumn &	80
	on Blue, the Holy family Gainsborough,	
	the Lemon, Springland, Witch and his Portrait	
	Mr. Baker frame with Niagara and Peacock	25
	Mr. T. Birch junr Genl Jackson	7.50
	Mr. Apple 3 Prints Phila	1.50
	D°	.50
	Mr. Lovett a pr. of small landscapes	10
	Mr. Natt a head by Sedlen [?] for 4 Prints	
	Mr. Cook a Phila & C. Seats pn. for 4 Drawings	
	Mr. Stringer a Port. of himself	8
	Mr. Harding mending a Picture	2
1829		
July 10		
	Mr. C. T. Ferrist of N.Y. Enamel of Ruysdeel [Ruisdael]	200
	Mr. Lovett 2nd a flower Piece	14
	Mr. Lovett putting figures to a Landscape	10
	Mr. Gobson a pr. of Portraits	21
Octr		
	Mr. Lovett varnishing a Poussin and [re]touching a Bandit Scene	5
	Mr. Apple a flower Piece	3.50

	2 small enamels for 8 Prints of Mr. Hawood's son George	40
	Mr. Hawood 6 fine Prints for 2 other Enamels a Picture & frame	1.25
	at Auction the nut & c.	
Nov 30		
	Mr. Torr the Ruysdeel [Ruisdael] & the Niagara & Bridge	60
Decr		
	Mr. Monday the Holy Family framed	15
	Mr. Lovett a copy from Mallet	30
1830		
	Borrowed of Mr. Lovett, to be taken out	20
	pd. by flower Piece	
	Mending & varnishing 2 Pictures, not pd.	2
Feb 17		
	Sold at Auction 2 Phila. 2 C. S. [Country Seats], 6 drawings	
	13 prints, 2 drawings in black frames	7.30
	Mr. [no name given] a pr. of flowers for frames	
March		
	Mr. Monday a pr. of Heny. 4th of France	20
	Mr. Dº 2 pr. of fruit for frames and	10
1828	Subscribers to a Sale of the 12 Plates of the Country Seats[45]	

[45] See Snyder, "William Birch: His 'Country Seats of the United States' [sic]," 241.

Aug 8

 Left with Mr. Tiller one plain

 Left with Mr. Hobson 2 plain returned

 ~~D° Mr. Stewart 2 plain and 4 doz odd prints & 1 doz coloured~~ D 1.25 pd.

 (sold, returned the rest)

 Mr. Childs 1 set in return for his Phila[a].[46]

 ~~Left with Mr. Stuart 1 set coloured & two enamels returned~~

 Mr. Baker a pres[t] p.

 Mr. Tilden Esq. on account 1 plain D 3

 Mr. Jobson for Hat D 3

 Mr. Jos[a] Longsheth plain D 3

Oct 31

 Mr. Jacob Harnmum 1 PH[Philadelphia views] 1 C[ountry Seats]
 to take to New Orleans with an enamel of

 The witch at 30 on sale or return

 Mr. Tho[s] P. Clay N. Orleans C.

 Mr. B. Davis City Hotel paid by St. D 3

 Dr. Clark pd. D 5

 Paid by Mr. Dearborough[47] by a set cd. D 5

[46] This transaction indicates that Birch traded a copy of this later edition of the *Country Seats* with Cephas Grier Childs for his *Views in Philadelphia and its Environs, from original Drawings taken in 1827-30.*

[47] Probably Henry Dearborn, who subscribed to the *City of Philadelphia*.

1829

	Mr. [blank] Front St. a set	D 3
	Mr. Blake Comn	D 3

April

	Mr. Casemaker a set cd. for Bill	D 5
	Mr. C. J. Ferrest N.Y. coloured	D 5
	Pettis[?] a defno[illeg]d 1 set coloured	
	Mr. Wilson a fee 1 set plain	
	Mr. Van Pelt 1 Do	D 2
	Mr. J. Flint 1 Do P. Presented	

Notes

Chapter 1. Friends and Relations

1 Significant portions of the research into Birch's early life and his family's history are the work of Glenn Curry, whose interest in Birch was first inspired by his mother-in-law and Philadelphia historian and collector Marian S. Carson. I am also indebted to Mr. Curry for a number of ideas in this chapter, which are included in an untitled draft manuscript on Birch and his life. If otherwise undocumented, facts about Birch's family are from Mr. Curry's manuscript.

2 Portions of St. Mary's Church are twelfth through fifteenth century. Most of the structure as it stood in Birch's childhood (and today) is the result of post-fire rebuilding of the late seventeenth century done by Sir William Wilson, in a typical blend of Gothic and Renaissance forms. See Nikolaus Pevsner and Alexandra Wedgwood, *Warwickshire* (London: Penguin, 1966), 443ff., and plate 35a.

3 Parish church records compiled by the Church of Jesus Christ of Latter-day Saints, available through http://www.familysearch.org, indicate that Anne, the daughter of William, was baptized on June 13, 1713, at Saint Martin's in Birmingham. Anne Russell married Thomas Birch in Aston Juxta in Birmingham on February 21, 1736. Birch's autobiography names older brothers Thomas, George, and John and younger brother Joseph Onion, as well as "sisters," one of whom was Ann, who married Thomas Chase, and another, Sarah, who appears in the records of William Russell. See note 21 below. Joseph Onion Birch remained in Warwick, following his father into the medical profession. William West, *History, Topography and Directory of Warwickshire* (Birmingham: R. Wrightson, 1830), 671. Joseph also subscribed to his older brother's *Délices de la Grande Bretagne* (see Appendix B).

4 See James Haw et al., *Stormy Patriot: The Life of Samuel Chase* (Baltimore: Maryland Historical Society, 1980), 12. Parish church records compiled by the Church of Jesus Christ of Latter-day Saints, avail-able through http://www.familysearch.org, indicate that Ann was baptized at the New Unitarian Meeting in Birmingham in 1743.

5 Rate Book for 1771, St. Mary's Parish, Warwickshire offices, Warwick. The four-shilling pew rent for "Thos Birch MD" is among the highest listed.

6 Neil Harris, *The Artist in American Society: The Formative Years, 1790–1860*, 2nd ed. (Chicago: University of Chicago Press, 1982), 11.

7 It should be noted that the honing of technique through practice is presented as crucial in the *Discourses*, particularly in the third.

8 See Dell Upton, "Pattern Books and Professionalism: Aspects of the Transformation of Domestic Architecture in America, 1800–1860," *Winterthur Portfolio* 19 (1984): 107–50. Upton cites Magali Sarfatti Larson, *The Rise of Professionalism: A Sociological Analysis* (Berkeley: University of California Press, 1977), in the use of the term "market professionals" (112).

9 "Kit-cat" refers to the general size of the painting and the (relatively large) scale of the sitter within the overall image. On the Kit-Cat portraits, see David H. Solkin, *Painting for Money* (New Haven, Conn.: Yale University Press, 1992), 32–36.

10 *An Historical and Descriptive Account of the Town & Castle of Warwick . . .* (Warwick: H. Sharpe, 1815), 135–36, indicates that Kettle became the parson of the High Street Chapel in 1746, served in that position for forty years, and died in 1806 at the age of ninety. See also John Sibree and M. Caston, *Independency in Warwickshire . . .* (Coventry: G. and F. King, 1855), 131. The assumption that he may have been related to Kettle comes from the appearance of several individuals by this name among Birch's mother's relatives on a list of Low Bailiffs included in his autobiography. See notes 12 and 13 below.

11 For a concise account of the multitude of factors in Birmingham's economic growth in the eighteenth century, see Eric Hopkins, *The Rise of the Manufacturing Town: Birmingham and the Industrial Revolution* (Gloucestershire: Sutton Publishing, 1998), 4–5.

12 William Hutton, *An History of Birmingham*, 2nd ed. (Birmingham, 1783), 86–87.

13 See Hopkins, *The Rise of the Manufacturing Town*, 137. The list included in Birch's autobiography was derived from a more comprehensive version in Hutton, *History of Birmingham*, 94–98.

14 R. B. Rose, "The Priestley Riots of 1791," *Past and Present* 18 (November 1960): 83, and Hopkins, *The Rise of the Manufacturing Town*.

15 Jacob M. Price, "Russell, William (1740–1818)," in *Oxford Dictionary of National Biography*, ed. H. C. G. Matthew and Brian Harrison (Oxford: Oxford University Press, 2004), available at http://www.oxforddnb.com/view/article/24349 (accessed November 20, 2004).

16 A. F. Leach, *History of the Warwick School with Notices of the Collegiate Church, Guilds and Borough of Warwick* (London: Archibald Constable & Company, 1906).

17 Thomas Russell (1743–86) emigrated to North East, Maryland, near the Pennsylvania border, to look after his interest in the Principio Iron Works, which had been left to him by his father, one of its founders. Russell married Ann Thomas of Chestertown, Maryland, and became an American citizen, while George remained in Birmingham as his brother William's partner in his mercantile business. See Price, "Russell, William (1740–1818)," and S. H. Jeyes, *The Russells of Birmingham in the French Revolution and in America, 1791–1814* (London: George Allen & Company, 1911), 305.

18 The "unhappy catastrophe" most likely refers to the beheading of William, Lord Russell (1639–83), the third son of the duke, who was executed for his alleged participation in the Rye House plot to kill Charles II. Russell was taken up as a martyr by the Whigs, as was Algernon Sidney, his supposed coconspirator.

19 On Jefferys, see Arthur G. Grimwade, *London Goldsmiths, 1697–1837, Their Marks and Lives* (New York: Faber and Faber, 1976, 1982), 560–61. Jefferys took on William Jones as a partner in 1779; Birch attributes this to his having declined Jefferys's offer of partnership; see "Life," p. 194.

20 William Russell's personal account book (fol. 55, Russell Papers, vol. VI, MS. 44997, Manuscripts Collection, British Library [hereafter Russell Papers]) records that on a trip to London he gave Birch 5 shillings and 3 pence while there. Russell's account book notes two other expenses for Birch: one in June 1772 in which he gave Birch 10 shillings and 6 pence (fol. 58), and one, perhaps more important, that he "gave Wm. Birch to pay a writing master" 1 pound and 1 shilling in April 1774 (fol. 69).

21 William Russell's personal account book (fol. 45, Russell Papers) records that he gave "Cousin Sally Birch" the relatively large sum of 1 pound and 1 shilling "for London," in April 1770. In October 1773 (fol. 66), Russell "Pd. Miss Birch for Capp's for the Children"; in April 1774, while in London, Russell records having paid 2 pounds and 5 shillings to "Sarah Birch for Millinery as pr. bill" in an entry that appears immediately before that for the payment for her brother's writing master (fol. 69).

22 Grimwade, *London Goldsmiths*, 560–61.

23 Multiple purchases from Jefferys are recorded in William Russell's personal account book for dress fabrics for his wife and daughters.

24 Among the skills he may have acquired was die cutting. The design of some early U.S. coins have been attributed to him, although Carl Carlson implausibly suggests that Birch came to the United States in 1793, returned to London, and then emigrated permanently in 1794. See Carlson, "Birch and the Patterns of '92," *Numismatist* 3 (1982): 628–45.

25 For further biographical information, see Daphne Foskett, *A Dictionary of British Miniature Painters* (New York: Praeger, 1972), and Basil S. Long, *British Miniaturists* (London: Geoffrey Bles, 1929).

26 Horace Walpole, *Anecdotes of Painting in England; With Some Account of the Principal Artists; and Incidental Notes on Other Arts . . .* (Twickenham, 1765–71), vol. 4, chapter 5, 90ff.

27 Walpole also singles out Zincke as one of the miniaturists of note in his Anecdotes, 91–92.

28 On the Vaughan-type portraits, see Carrie Rebora Barratt and Ellen G. Miles, *Gilbert Stuart* (New Haven, Conn.: Yale University Press, 2004), 129–44.

29 Algernon Graves, *The Society of Artists of Great Britain, 1760–1791, the Free Society of Artists, 1761–1783, a Complete Dictionary of Contributors and their Work from the Foundation of the Societies to 1791* (1907; reprint, Bath: Kingsmead Reprints, 1969), 34; Foskett, *Dictionary of British Miniature Painters*, 166.

30 Grimwade, *London Goldsmiths*. See "Life," p. 194, for an anecdote about a business dealing with Jones.

31 Marriage, birth, and baptism date records are from the parish church records compiled by the Church of Jesus Christ of Latter-day Saints, available through http://www.familysearch.org/. These indicate that Thomas and Deborah Birch were baptized at Saint Anne's Soho,

and George Birch at St. Paul's Covent Garden. There was no record in this source associated with either Albina Birch's birth date or that of her mother. These dates courtesy Glenn Curry.

32 See John Summerson, *The Iveagh Bequest: Kenwood, A Short Account of Its History and Architecture* (London: Greater London Council, 1974), 7–8.

33 Martin Snyder apparently takes the term at face value, describing Murray, Reynolds, and Chauncey as "three of his closest friends" in "William Birch: His Philadelphia Views," *Pennsylvania Magazine of History and Biography* 73 (1949): 271. Stefanie Munsing paraphrases Birch without analysis: "finding life in London sluggish following the deaths of his two close friends Sir Joshua Reynolds and the Earl of Mansfield (also a good patron), Birch decided to immigrate [sic] to America," in "William Birch," in *Philadelphia: Three Centuries of American Art* (Philadelphia: Philadelphia Museum of Art, 1976), 181.

34 David Mannings, *Sir Joshua Reynolds: A Complete Catalogue of His Paintings* (New Haven, Conn.: Yale University Press, 2000), 130. Chauncey's older brother Charles (1700–1777), a fellow of the College of Physicians, had appointments with Reynolds in 1770 and 1771, but no painting is known to have resulted from these.

35 Quoted in M. Kirby Talley Jr., "'All Good Pictures Crack': Sir Joshua Reynolds's Practice and Studio," in *Reynolds*, ed. Nicholas Penny (New York: Harry N. Abrams, 1986), 55. Talley describes Reynolds as "the most eclectic of technicians."

36 Glenn Curry ms., n.p., citing Minutes of the Committee on Polite Arts, December 3, 1784, Royal Society for the Encouragement of Arts, Manufactures and Commerce, London. Van Dyck brown (a term still in use) is a "soft black" named in honor of painter Antony van Dyck (1599–1641), the Flemish-born painter who achieved renown as a portrait painter in the highest levels of English society in the early seventeenth century.

37 Algernon Graves, *The Royal Academy of Arts: A Complete Dictionary of Contributors and Their Work from Its Foundation in 1769 to 1904* (1905–6; reprint: Wakefield, Yorkshire: S. R. Publishers and Kingsmead Reprints, 1970), 1:199.

38 James Northcote, *The Life of Sir Joshua Reynolds* (London, 1819; facsimile reprint, London: Cornmarket Press, 1971), 180.

39 Ibid., 174–76.

40 Stipple engraver Francis Haward (1759–97) may be best known for his 1787 print of Reynolds's 1782 portrait of the famous actress Mrs. Siddons. The portrait of Mrs. Robinson and Birch's print are documented by Mannings, *Sir Joshua Reynolds*, 394. John Ingamells also records Birch's print in *The Wallace Collection, Catalogue of Pictures 1 (British, German, Italian, Spanish)* (London: Trustees of the Wallace Collection, 1985), 155–57. Ingamells records four versions of this portrait. On *View from Richmond Hill*, see David Mannings, "View from Sir Joshua Reynolds's House, Richmond Hill," in Penny, *Reynolds*, 270–71. See also Mannings, *Sir Joshua Reynolds*, cat. 2189.

41 Northcote's only direct reference to Birch is regarding this engraving (*Life of Sir Joshua Reynolds*, 184).

42 See David Mannings's discussion of the painting in Nicholas Penny, "View from Sir Joshua Reynolds's House, Richmond Hill," *Reynolds*, 270–71. He characterizes it as an "experiment in the fashionable mode of the Picturesque."

43 A principal (and important) difference between Birch and Reynolds is that the latter preferred to spend his social time with writers and intellectuals rather than with wealthy patrons. Richard Wendorf, *Sir Joshua Reynolds: The Painter in Society* (Cambridge, Mass.: Harvard University Press, 1996), chapter 1.

44 Ibid., 15.

45 The "Lord Howe" in question could be either of two brothers, William (1729–1814) or Richard (1726–99), commanders of the British army and navy, respectively, in the American Revolution. Lindsay (1737–88) was a rear admiral in the same war, and the son of Mansfield's sister Emilia.

46 Some of these paintings were acquired in the United States.

47 Jules David Prown, *John Singleton Copley in England, 1774–1815* (Cambridge, Mass.: Harvard University Press, 1966), 285.

48 Ibid.

49 For more information on the portrait, see Emily Ballew Neff, *John Singleton Copley in England* (Houston: Museum of Fine Arts, 1996), 36–39, 51–52, and Ellen G. Miles, *American Paintings of the Eighteenth Century* (Washington, D.C.: National Gallery of Art, 1995), 71–76.

50 Mannings, *Sir Joshua Reynolds*, cat. 1318. Mannings also documents a replica of this portrait (cat. 1320) made for the archbishop in 1788.

51 See "Life," p. 186, for Birch's report of Copley's violent response to Reynolds's portrait. Despite this reported incident, Copley went on to subscribe to Birch's *Délices* only a few years later.

52 See Summerson, *The Iveagh Bequest*.

53 Amanda Foreman, *Georgiana, Duchess of Devonshire* (New York: Random House, 1998), 79.

54 Lindsay, who served in the Royal Navy, had brought back Dido's mother as a prisoner from the West Indies. Gene Adams, "Dido Elizabeth Belle: A Black Girl at Kenwood," *Camden History Review* 12 (1984): 10–14. Elizabeth Murray left Kenwood in 1785 to marry.

55 See Graves, *The Royal Academy of Arts*, 199.

56 Charles Combe (1743–1817), a fellow of the Royal Society, was both a physician and a classicist.

57 Gray also subscribed to the *Délices de la Grande Bretagne*. See Appendix B.

58 Jenny Uglow, *The Lunar Men* (New York: Farrar, Straus and Giroux, 2002), 437.

59 See Rose, "The Priestley Riots of 1791," 71, which discusses those probably responsible. It should be noted that the mob were perhaps a bit misguided on the motives for their violence—shouting "no popery!" for example, at the Dissenters.

60 Russell's daughter later recalled the incidents in detail. See Martha Russell Skey, *Journal Relating to the Birmingham Riots*, by a Young Lady of one of the Persecuted Families (originally published in the Christian Reformer, May 1835; republished 1872).

61 The house of G. Humphreys, probably Birch's uncle (the husband of Birch's mother's sister), was also damaged in the riots. Jeyes, *Russells of Birmingham*, 38. On the riots and their impact on Russell and his family generally see chapters 2–7.

62 Eliza Falconer married (ca. 1783) Henry Fitzroy Stanhope (1754–1828). Watson-Wentworth is arguably best remembered as Edmund Burke's employer. He married Mary Bright (1752–1804) and died without children. See Foreman, *Georgiana, Duchess of Devonshire*.

CHAPTER 2. "ENCHANTING SCENERY OF BRITON'S ISLE"

1 Much work has been published on the aesthetic theory of the eighteenth century, providing essential background for this chapter. John Dixon Hunt's work is foremost, including the essay collection *Gardens and the Picturesque: Studies in the History of Landscape Architecture* (Cambridge, Mass.: MIT Press, 1992), *Greater Perfections: The Practice of Garden Theory* (Philadelphia: University of Pennsylvania Press, 2000), and *The Picturesque Garden in Europe* (London: Thames & Hudson, 2002). Malcolm Andrews, *In Search of the Picturesque: Landscape, Aesthetics, and Tourism in Britain, 1760–1800* (Stanford, Calif.: Stanford University Press, 1989) is also key, as is Christopher Hussey, *The Picturesque: Studies in a Point of View* (1927; London: Frank Cass, 1983). Other useful works include Walter J. Hipple, Jr., *The Beautiful, the Sublime and the Picturesque in Eighteenth-Century British Aesthetic Theory* (Carbondale: Southern Illinois University Press, 1957), and Samuel H. Monk, *The Sublime: A Study of Critical Theories in XVIII-Century England* (Ann Arbor: University of Michigan Press, 1960). Aspects of Ann Bermingham, *Landscape and Ideology: The English Rustic Tradition, 1740–1860* (Berkeley: University of California Press, 1986), and John Barrell, *The Dark Side of Landscape: The Rural Poor in English Painting, 1730–1840* (Cambridge: Cambridge University Press, 1980), have also informed parts of this chapter.

2 The use of viewing devices was not unique to Chauncey, although the glass front of a carriage was probably less common than Claude glass and mirrors. On these, see Andrews, *In Search of the Picturesque*, 67–73, and Deborah Jean Warner, "The Landscape Mirror and Glass," *Antiques* 105 (1974): 158–59. Warner suggests (159) that these devices first came into widespread use in Britain in the mid-eighteenth century. Andrews (68–69) also includes camerae obscurae in his account of these "idealizing," mediating devices; it should be noted that the common, "wide angle" perspective that can be remarked in Birch's prints suggests that he used a camera obscura for his preparatory drawings.

3 Birch's own collection included works by Dughet and Rosa. See Appendix E.

4 A lucid discussion of the importance of Claudean formulae can be found in Andrews, *In Search of the Picturesque*, 26–29.

5 See Andrews, *In Search of the Picturesque*, 29; John Dixon Hunt, "Theaters, Gardens, and Garden Theaters," in *Gardens and the Picturesque*, 49–73; and Hunt, "What, How and When Was the Picturesque Garden?" in *The Picturesque Garden in Europe*, 8–25. See also Stephen Daniels, "Joseph Wright and the Spectacle of Power," in *Fields of Vision:*

Landscape Imagery and National Identity in England and the United States (Princeton, N.J.: Princeton University Press, 1993), 43–79.

6 It should be noted that Birch knew Burke (1729/30–97) through Reynolds and includes an anecdote of an encounter with him at Reynolds's house wherein he disputes Burke's opinion of a painting. See "Life," p. 190.

7 William Gilpin, *Three Essays: On Picturesque Beauty; on Picturesque Travel, and on Sketching Landscape* (1792; London: Printed for T. Cadell and M. Davies, Strand, 1808), 49. On the earlier codification of the picturesque, see Hunt, "What, How, and When."

8 *Délices*, iii–iv.

9 William Gilpin, *Observations on the River Wye, and Several Parts of South Wales, &c., Relative Chiefly to Picturesque Beauty, made in the Summer of the Year 1770* (London, 1782). This followed two earlier publications pertinent to the picturesque: his *Dialogue upon the Gardens . . . at Stow* (1748) and *Essay upon Prints: Containing Remarks upon the Principles of Picturesque Beauty . . .* (1768).

10 Gilpin, *Observations on the River Wye*, 38–39. The original portion of the castle was built in the fourteenth century, when it belonged to father and son earls of Warwick, both named Thomas Beauchamp. Birch's reference to the "tomb of bold Beauchamp" is to fifteenth-century descendant Richard, whose will provided for the construction of the chapel for St. Mary's. On the castle, see Nikolaus Pevsner and Alexandra Wedgwood, Warwickshire (London: Penguin, 1966), 452–56. The authors date the design of the garden by "Capability" Brown to 1753, during the occupancy of the first Earl of Warwick (1727–73), whom Birch recalls bestowing a school holiday while he was at the Warwick College ("Life," p. 234). For the church, see Pevsner and Wedgwood, *Warwickshire*, 443–51. Birch's father was a member of the congregation there; see Chapter 1.

11 See Mannings, *Sir Joshua Reynolds*, cat. 1532. Mannings notes that this portrait, not Reynolds's first of this sitter, reflected her mental state after her legs had become paralyzed through illness.

12 The enamel of Bacelli was for the duke and that of Mrs. Stanhope for Nathaniel Chauncey. Edward Hamilton, *The Engraved Works, 1755–1822, of Sir Joshua Reynolds* (Amsterdam: G. W. Hissink & Company, 1973), 65, 135. On the original paintings, see Mannings, *Sir Joshua Reynolds*, cats. 90, 1699. It is interesting to note that Birch never men-

tions the work of Smith (who subscribed to the *Délices*), although he does refer to engraver Francis Haward.

13 Jones's front for St. Paul's was destroyed in the fire, as was most of the church.

14 Thomas Pennant (1726–98) first published *Of London* in 1790. Subsequent editions, with the title *Some account of London, Westminster, and Southwark*, followed in 1791, 1793, 1805, and 1813. In his discussion of Ludgate in the third edition (1793, p. 240), Pennant notes "Old *Greffier* [sic] gives a view of the antient gate in a good picture of his of the great fire of London in 1666, which is engraved by Mr. *Birch*" (emphasis original).

15 This entrance through the London wall was originally a Roman structure but came to be understood as the first-century work of King Lud. Rebuilt in the thirteenth and sixteenth centuries, Ludgate was demolished in the eighteenth.

16 Arcot is in the state of Tamil Nadu, Surat in the state of Gujarat, both of which are in India. Portrait specialist Tilly Kettle was the first British professional painter to make a career in India. "Acton" Munro is most likely Sir Hector (1726–1805) but could also be his brother Sir Alexander Munro, as both were in India.

17 See Penny, *Reynolds*, 256–57. The identification of this artist is uncertain but may be one of the members of the Wierix family of Flemish artists active in the sixteenth and seventeenth centuries.

18 See "Life," p. 185, for Birch's discussion of Hogarth (1697–1764), in which he properly makes a distinction between satirical images done in a "natural" style and the work of such artists as James Gillray, which he describes as caricature.

19 Graves, *The Royal Academy of Arts*, 2:87.

20 All of the plates carry the first day of the month as the publication date. As would be the case later with Birch's *City of Philadelphia*, there was some sort of rupture with the initial seller for the *Délices*.

21 View painter Giovanni Antonio Canal (1697–1768), best known for his depiction of Venetian scenes, worked in England during the middle of the eighteenth century.

22 Birch's remarks about Joseph Farington in connection to *Ouse Bridge* are the only instance in which any other artist connected to the *Délices* is mentioned.

23 See Chapter 1 for Birch's mixed feelings about West. This painting was never exhibited at the Royal Academy.

24 Graves, *The Royal Academy of Arts*, 1:301, 2:87, 1:166.

25 Ibid., 1:127, 4:10. In addition, Joseph Charles Barrow's *North View of Strawberry Hill, the Seat of the Honorable Horace Walpole, Twickenham* was shown at the Society of Artists in 1790. Graves, *The Society of Artists of Great Britain*, 23. The titles of Birch's engravings often differ slightly from those of the original paintings.

26 In addition to the sources for the engravings after Reynolds, the paintings Birch notes as owned by their creators are John Russell's *Golder's Green* (Birch plate 27), George Samuel's *View of the Thames . . .* (plate 24), and West's *Bathing Place at Ramsgate* (plate 26). In addition, fellow miniaturist and academy member Richard Cosway provided *View from Mr. Cosway's Breakfast Room, Pall-Mall,* on which he collaborated with William Hodges and which was shown at the academy in 1787 (Graves, *The Royal Academy of Arts*, 2:118), and de Loutherbourg's *View on Wynander Meer.*

27 George Greville, the Earl of Warwick, also subscribed to the *Délices,* as did his two younger brothers.

28 A drawing of Duncannon's of Blenheim was the source for an engraving (plate V) included in William Angus's *The Seats of the Nobility and Gentry in Great Britain and Wales* (London, 1787; reprint, 1982).

29 *The Royal George* was a British navy vessel lost in a disastrous dry-dock accident in 1782. The ship was heeled over for repairs, and simultaneous cargo loading led to its listing too far, taking on water, and sinking. Because shore leave had been canceled for the crew to prevent desertion, many visitors were on board in addition to the ship's regular complement. While some were saved, hundreds of lives were lost when the ship sank.

30 See Appendix A. Mary Hartley (active 1761–75) is listed as an amateur landscape painter in standard biographical sources. Quotation from the *Délices* appears in the description for plate 5.

31 All of the plates produced in 1788 and 1789 are inscribed "sold by T. Thornton, Southhampton Strt. Covt. Garden." "Messrs. Molton & Co." also ordered a substantial number of copies (twelve) for sale.

32 James Beeverell, *Les délices de la Grand' Bretagne et d'Irlande . . .* (Leiden: P. van der Aa, 1707), introduction, 3 recto.

33 Ibid., main text, 2 recto.

34 *Délices,* vi.

35 Ibid., vii–viii. The roots of the connection of the peasant to the land and the assertion of rural circumstances as the locus and source of his/her freedom was one that ultimately had its roots, for eighteenth-century Britons, in Virgilian poetry. For a concise and lucid summary of these notions, see James S. Ackerman, *The Villa: Form and Ideology of Country Houses* (Princeton, N.J.: Princeton University Press, 1990), 39–42. For a discussion of the rural poor as the subject of picturesque objectification, see Barrell, *The Dark Side of Landscape.*

36 *Délices,* x.

37 There are a total of five seascapes included in the set: plates 9 and 10, John Opie's (1761–1807) *St. Michael's Mount, Cornwall* and Edmund Garvey's (d. 1813) *View of Plymouth Dock,* plate 16, Duncannon's *View of Portsmouth,* plate 26, West's *Bathing Place at Ramsgate,* and plates 31 and 32, Richard Corbould's (1740–1814) *Landguard Fort* and Birch's *Cave Near Margate.*

38 Barret's view includes figures, according to Birch, "by Gilpin"; that is, either Sawrey Gilpin (1733–1807) or William Sawrey Gilpin (1762–1843), the brother and nephew, respectively, of the Reverend William. Whether the figures were added to Barret's painting or Birch's plate is uncertain.

39 Unless otherwise noted, all plate descriptions are bound to appear opposite the appropriate plate in the *Délices.* Only the introduction is paginated. It should be noted that in the eighteenth century "curious" did not always have the present meaning of "quizzical." Here Birch intended that the image was well worked, or worthy of interest or curiosity.

40 It may be that there was some connection between the inclusion of this painting and Birch's patron, William Murray, the first Earl of Mansfield. Mansfield's family seat is at Scone Palace just north of Perth.

41 Monk, *The Sublime,* 92.

42 This is *Rumbling Brig,* plate 33.

43 As noted previously, Birch published the *Délices* from his "cottage" on Hampstead Heath near Kenwood, the estate of his patron the Earl of Mansfield.

44 It should be noted that this metaphoric elision of the separation of vessel and ocean reinforces the proper connection (and balance) between these elements.

45 In this recording vein, Birch often also notes the dimensions of the source (plates 1, 2, 3, 4, 7, 9, 10, 24, and 27). The date of the originals is cited for plates 2, 3, 9, 11, 12, 13, 14, 15, 18, 21, and 23, and is one

of the points of emphasis in the text for plate 24, the frozen *Thames* view description. The use of the term "taken" for the act of recording a landscape is a reminder of the persistence of the fundamental operations of picturesque modes of perception into the early twenty-first century in the United States; however, much the technology of the "taking" may have changed and the activities have become popularized. Birch's use of the term is, of course, also a reminder of the connection between picturesque touring and the hunting of game, which has been noted by numerous authors. The language of "hunting" of views is particularly noticeable in Gilpin's *Three Essays*.

46 The plates of the *City of Philadelphia* note only the year.

47 The proper relationship of the artist to nature and copying it is, as noted in Chapter 1, one of the principal subjects of Reynolds's earlier discourses.

48 John Hayes asserts that Birch's identification of Wolverstone (or any specific site) is inaccurate and gives the original title as *Wood River Landscape with Peasants Resting and Church Tour.* See Hayes, *The Landscape Paintings of Thomas Gainsborough: A Critical Text and Catalogue Raisonné* (Ithaca, N.Y.: Cornell University Press, 1982) 2:331 (catalogue #5). Hayes dates the painting to ca. 1745–46.

49 The difference in tone can clearly be accounted for by Birch's temporal distance from the events.

50 A particularly striking example of this sort of operation can be found in John Collinson's *History and Antiquities of the Country of Somerset*, published in 1791. This four-volume work is principally organized by land ownership, and is introduced by appropriate passages from the Domesday Book. There are only a handful of plates of antiquities per se. These most often show a group of medieval churches in side elevation (four per page) as if they were scientific specimens, without any of the context in which they would have been found. In contrast, the majority of the full-page plates show the country houses (some quite vast) of the upper-class patrons of the publication, who are frequently celebrated in the conjoined notes on local history in great and radiant detail.

51 Angus concludes his description of Saltram (plate xxi, from another drawing by Lord Duncannon) by also noting the visit of "their Majesties, with the Princesses in the summer of 1789 [while traveling] into the West of *England*" (emphasis original).

52 *Délices*, x.

53 By the time of the publication of the *Délices* some of these "stories" had been told so often Birch felt proscribed from even repeating them. The briefest plate description in the *Délices* accompanies the print of J. C. Barrow's *Strawberry Hill*. He addresses his subject, saying that "it must be thought entirely useless to describe this so much admired place." Just as he had a community of artists from which to "borrow" images to create his first set of views, so the body of description of places, including Strawberry Hill, had already become such common knowledge that it had descended into the realm of cliché.

CHAPTER 3. SUCCESS IN THE NEW WORLD

1 Richard G. Miller, "The Federal City, 1783–1800," in *Philadelphia: A 300-Year History*, ed. Russell F. Weigley (New York: W. W. Norton, 1982), 177.

2 Julian Ursyn Niemcewicz, *Under Their Vine and Fig Tree: Travels Through America in 1797–1799, 1805 and Some Further Account of Life in New Jersey*, ed. and trans. Metchie J. E. Budka (Elizabeth, N.J.: Grassmann Publishing, 1965), 37.

3 On Smith, see John S. Pancake, *Samuel Smith and the Politics of Business* (Montgomery: University of Alabama Press, 1972), and Frank A. Cassell, *Merchant Congressman in the Young Republic: Samuel Smith of Maryland, 1752–1839* (Madison: University of Wisconsin Press, 1971). On the subject of earlier illicit trade by Philadelphians, see Theodore Thayer, "Town into City," in Weigley, *Philadelphia*, 73.

4 See Daniel M. Friedenberg, "The Strange Case of Robert Morris," in *Life, Liberty and the Pursuit of Land: The Plunder of Early America* (Buffalo, N.Y.: Prometheus Books, 1992), 338–47. On Cramond's connection to Morris, see correspondence and business papers of Philips, Cramond and Co., Claude W. Unger Collection; and Philips, Cramond and Co. Papers, Society Collection, Historical Society of Pennsylvania, Philadelphia.

5 Many saltwater parasites that attack wood hulls will not survive in freshwater.

6 On van Braam, who added Hoockgeest to his name in later life, see Jean Gordon Lee, *Philadelphians and the China Trade, 1784–1844* (Philadelphia: Philadelphia Museum of Art, 1984), 81–91. For a detailed contemporary description of the house, see Niemcewicz, *Under*

Their Vine and Fig Tree, 62–63. Clay Lancaster traces the inspiration of van Braam's pagoda-form cupola to Chinese-motif dwellings in Baarn, Holland. Lancaster, "Oriental Forms in American Architecture, 1800–1870," *Art Bulletin* 29 (1947): 192. It should be noted that Lancaster incorrectly notes Birch's engraving of China Retreat as part of the *City of Philadelphia*.

7 Miller, "The Federal City," 177.

8 Niemcewicz, *Under Their Vine and Fig Tree*, 37. As Miller notes ("The Federal City," 177), while Thomas Jefferson was a friend of Anne Bingham, he did not frequent her house because of the undemocratic values it expressed.

9 Miller, "The Federal City," 177–78.

10 His republican sympathies are confirmed by his role the same year in the Columbianum group, which will be discussed later in the chapter.

11 By "full size" Birch meant full-length, rather than life-size.

12 See Chapter 1 concerning the relationship between printmaking and the technique for creating multiple images of Stuart's portraits.

13 Although he refers here to a single source, his surviving enamels show that he copied all different versions of Washington's portrait. These enamels can be found in several American public collections, including the Walters Art Gallery and the Maryland Historical Society, both in Baltimore, the Cleveland Museum of Art, Middleton Place in Charleston, South Carolina, and the R. W. Norton Gallery in Shreveport, Louisiana. On the Washington portraits, see Carrie Rebora Barratt and Ellen G. Miles, *Gilbert Stuart* (New York: Metropolitan Museum of Art, 2004), 129–83. Birch discusses both the "Athenæum" and the "Lansdowne" portraits in his autobiography.

14 Charles Merrill Mount, *Gilbert Stuart: A Biography* (New York: W. W. Norton, 1964), 189. See also Barratt and Miles, *Gilbert Stuart*, 133.

15 Stuart later subscribed to the *City of Philadelphia*. Washington may have been informed of Birch's existence by his cousin William Russell, who was in Philadelphia in the winter of 1795–96 and who came to know the president on intimate terms. See Jeyes, *Russells of Birmingham*, 203.

16 Stuart had painted de Jáudenes and his wife in his New York studio in 1794 and could have made the introduction to Birch. On the Stuart portraits, see John Caldwell et al., *American Paintings in the Metro-politan Museum of Art* (New York: Metropolitan Museum of Art, 1994), 1:168–72, and Barratt and Miles, *Gilbert Stuart*, 124–27. According to Jean Lambert Brockway, "William Birch: His American Enamel Portraits," *Antiques* 24, no. 3 (1933): 96, the enamels Birch painted were copies after Stuart's portraits.

17 Among the immigrants was George I. Parkyns (1749–1820), whose work was included in Birch's collection at Springland. See Appendix E. The Columbianum is documented most completely in scholarship relating to Charles Willson Peale, since Peale is the best-known participant and was one of the main organizers.

18 Lillian B. Miller, ed., *The Selected Papers of Charles Willson Peale and His Family* 2 (New Haven, Conn.: Yale University Press, 1983), part 1, p. 102. Documents and commentary on the Columbianum appear on pp. 102–13.

19 Miller, *Selected Papers of Charles Willson Peale*, 110–11. The final act of the drama was played out in the press.

20 *The Constitution of the Columbianum, or American Academy of the Fine Arts . . .* (Philadelphia: Francis and Robert Bailey, 1795).

21 Ibid., 7.

22 Ibid., 14.

23 *The Exhibition of the Columbianum or American Academy of Painting, Sculpture, Architecture, & c. . . .* (Philadelphia, 1795). Birch's entries (p. 2) are followed by one each from "Miss Birch" (unidentified, although Birch does refer to his daughter's family in Alexandria in his autobiography) and "Master [Thomas] Birch." The latter's entries include "Views near Philadelphia (drawings)" (p. 4).

24 Peter Hasting Falk, ed., *The Annual Exhibition Record of the Pennsylvania Academy of the Fine Arts, 1807–1870* (Philadelphia: Sound View Press, 1988), 28.

25 Whether this was a summer or full-time residence is not clear. Birch's first reference to Burlington is "we . . . moved to Burlington. It was about the year 1797." See "Life," p. 195, where he says that "we spent a few summers upon that beautiful spot."

26 It should be noted that the Assicunk Creek did not retain Birch's name, if in fact it was ever renamed in his honor. A copy of the survey, "A plan of the island of Burlington: And a view of the city from the River Delaware" (Philadelphia: Sold at M[athew]. Carey's, 1797), is in the Library of Congress Collection.

27 See Martin Snyder, "William Birch: His Philadelphia Views," *Pennsylvania Magazine of History and Biography* (hereafter PMHB) 73 (1949): 271, 274.

28 Seymour was an engraver and fellow English emigrant. For a brief biography, see Edward J. Nygren, ed., *Views and Visions: American Landscape Before 1830* (Washington, D.C.: Corcoran Gallery of Art, 1986), 288–89.

29 As Snyder notes ("Philadelphia Views," 274), Thomas must have worked as his father's apprentice. By the end of the first decade of the nineteenth century, Thomas had begun his successful career as a painter of landscape and marine subjects.

30 Martin Snyder, "William Birch: His 'Country Seats of the United States,' [sic]" *PMHB* 81 (1957): 230n.

31 Accession number Am336, vol. 1, Historical Society of Pennsylvania, Philadelphia. A full chronology of these editions and a collation of the plates for each is given in Snyder, "Philadelphia Views," 271–315, and Snyder, "Birch's Philadelphia Views: New Discoveries," *PMHB* 88 (1964): 164–73. It should be noted that Birch delivered the "Second Edition with Supplement" of 1809 several years later, in 1813 and 1817. See Appendix G.

32 The manuscript volume is unpaginated. Page numbers have been assigned based on binding sequence. The 1800 edition list appears on 2, the 1804 edition on 17, the 1809 on 20, the 1827–28 on 21. The list for the 1804 edition is titled "Subscribers to Birch's Views of Philadelphia. Second Edition. With Alterations, New Plates, & C. To consist of Twenty Views"; the third (1809) is called "Second Edition with Supplement containing Fourteen Plates"; and the final list, for the 1827–28 edition, appears under "Subscribers to Eleven of the Principle [sic] Views of Birch's Philadelphia."

33 See Snyder, "Philadelphia Views," 276, and Snyder, *City of Independence: Views of Philadelphia Before 1800* (New York: Praeger, 1975), 226–38.

34 This is suggested by an entry on the fourth page of the manuscript list. Benjamin Henry Latrobe's name appears with his address as Richmond, Virginia. He did not move to Philadelphia until 1799.

35 Birch's notice dated January 29, 1799 appeared in the *Philadelphia Gazette* multiple times beginning February 2, 1799 and continuing through that month. He announced the publication of the first two plates in the Pennsylvania Gazette, February 9, 1799: the *Library and Surgeons Hall* and *Goal* [sic], *in Walnut Street*, plates 19 and 24, respectively, in the first edition. He re-published the announcement of their publication on April 4 1799 in *Porcupine's Gazette*.

36 See Snyder, "Philadelphia Views," 276.

37 Transcribed in Snyder, "Philadelphia Views," 304–5.

38 I. N. Phelps Stokes, *The Iconography of Manhattan Island, 1498–1909* (New York: Robert H. Dodd, 1915–28), 1:468, plates 76, 77.

39 Subscription list, 14–15. Page 15 is also partially devoted to subscriptions for a print of Mount Vernon issued in 1804. See Susan R. Stein, *The Worlds of Thomas Jefferson at Monticello* (New York: Harry N. Abrams, 1993), 184. For the "large Plates," see Nygren, *Views and Visions*, plates 107, 110. See also Margaret Sloane Patterson, *Views of Old New York: Catalogue of the William Sloane Collection* (New York: Privately printed, 1968), 23.

40 Although the headings for the editions are bound in chronological order, a comparison of the subscribers' list published with the first edition of the views with the version in the manuscript volume indicates that the sheets have lost their original sequence (the pages have been cut down and are attached to the binding with tape). Pages 10–14, bound before the second edition heading on page 17, include names that appear in the subscribers' list for the second edition.

41 Both Thomas Jefferson, then vice president, and Samuel Smith, a Baltimore merchant and congressional representative, subscribed while in Philadelphia. "E. Haskell" (unidentified) appears among a group of New York subscribers, with his home residence in South Carolina. The subscribers' list is bound at the end of the volume.

42 The second edition begins on page 17. The southern subscribers' names begin on page 10.

43 Most of this scrapbook was sold at auction in June 1980 by C. G. Sloan & Company in Rockville, Maryland. The drawings were purchased by the Baltimore Museum of Art, by the Corcoran Gallery of Art in Washington, D.C., and by private collectors.

44 Samuel Chase's mother, Matilda, had died in childbirth. Birch notes that Thomas Chase's marriage to his sister "took place before the Revolution of America." Birch was eight at the time. Thomas (1703–79) was an English emigrant who served as rector of St. Paul's (Anglican) church in Baltimore for over three decades. See J. Thomas Scharf, *Chron-*

icles of Baltimore (1874; reprint, Port Washington, N.Y.: Kennikat Press, 1972), 29, and James Haw et al., *Stormy Patriot: The Life of Samuel Chase* (Baltimore: Maryland Historical Society, 1980), 3, 12.

45 Thomas and Ann Birch Chase had five children, including George Russel Birch Chase, a son presumably named for Ann's dead brother (see Chapter 1). Ann died seven years before her older husband. After Thomas died in 1779, these children, who were roughly the same age as Samuel's own four children, were taken into Samuel's household in Annapolis. His niece Ann, whom Birch calls "Nancy," was approximately thirty-five and Elizabeth ("Betsey") in her early thirties at the turn of the century when Birch first met them. See Haw et al., *Stormy Patriot*, 102–3. Birch was about ten years older than they were.

46 Chase's influence reached into Pennsylvania as well: Hugh Henry Breckenridge, one of his law students, subscribed to a late edition of the *City of Philadelphia*.

47 Birch notes that he "found many friends [in Annapolis] and was successful in the purpose of my route" (p. 227). See also the manuscript subscription list (Appendix D).

48 Jeremiah was Samuel Chase's first cousin once removed (the son of Richard, Samuel's older cousin). They had a close relationship, however: Jeremiah had been raised by Thomas, Samuel's father, after the death of Jeremiah's own father in 1757. See Haw et al., *Stormy Patriot*, 6. Jeremiah and his better-known relative were also allied by politics and career: both were jurists and anti-federalists. See Haw et al., *Stormy Patriot*, passim.

49 In the letterpress, which is unpaginated, the house is described as "from a plan and elevation by Mr. W. Birch." The surviving plan and an accompanying watercolor that became the basis of the plate in the *Country Seats* are in the collection of the Baltimore Museum of Art. The latter, although a perspective drawing, could be the elevation to which he refers. Since Birch was not a trained architect, it is most likely that the house was a cooperative project with Smith and that Smith and his builders supplied most of the construction details. The house itself was demolished in 1909. It stood near what is now 33rd Street east of Memorial Stadium, on part of the site occupied today by Baltimore's City College. The house, built circa 1799, is documented by two articles: J. Gilman Paul, "Montebello, Home of General Samuel Smith," *Maryland Historical Magazine* 42 (1947): 253–60, and Lawrence Hall Fowler, "Monte-

bello, Maryland," *Architectural Review* 16 (1909): 145–49. The house is also recorded in several late nineteenth- and early twentieth-century photographs in the collection of the Maryland Historical Society.

50 On Latrobe's drawings from this period, see Jeffrey A. Cohen and Charles E. Brownell, *The Architectural Drawings of Benjamin Henry Latrobe* (New Haven, Conn.: Yale University Press, 1994), 1:180–258.

51 I am indebted to Lynne Dakins Hastings, former curator of Hampton National Historic Site, for the information that no plan is known to survive. A portion of Birch's autobiography (p. 232) is devoted to Birch's dispute with Ridgely's family over the ownership of land relating to Birch's relatives' former holdings.

52 I am grateful to Edward Day, Riversdale Museum manager, for assistance in my research there.

53 See Margaret Law Callcott, ed., *Mistress of Riversdale: The Plantation Letters of Rosalie Stier Calvert, 1795–1821* (Baltimore: Johns Hopkins University Press, 1991).

54 For a discussion of Latrobe's designs for the house, see Cohen and Brownell, *Architectural Drawings of Benjamin Henry Latrobe*, 1:291–95. See also Callcott, *Mistress of Riversdale*, 28–29.

55 Callcott, *Mistress of Riversdale*, 53–54.

56 Cohen and Brownell, *Architectural Drawings of Benjamin Henry Latrobe*, 1:181.

57 Henri J. Stier to Rosalie Stier Calvert, August 26, 1803, Henri J. Stier Papers, Maryland Historical Society, transcribed by Margaret Law Callcott, Landscape Chronology File, Riversdale Museum, Riverdale, Maryland. Birch had already been in touch with Rosalie. Callcott, *Mistress of Riversdale*, 53–54.

58 Callcott, *Mistress of Riversdale*, 134.

59 Ibid., 148.

60 See ibid., 180–81. Birch was probably not responsible for one of the features of the garden: a series of falls on the south side of the house. Falls were a nearly ubiquitous element in Tidewater gardens, and the Calverts probably directed their construction. See C. Allan Brown, "Eighteenth-Century Virginia Plantation Gardens: Translating an Ancient Idyll," in Therese O'Malley and Marc Treib, eds., *Regional Garden Design in the United States* (Washington, D.C.: Dumbarton Oaks Research Library and Collection, 1995), 142–45.

61 "Mr. Rodney" was perhaps Caesar Rodney (1772–1824), Dela-

ware congressman. Like Tilton, he was appointed to a government post (attorney general) by Jefferson. These Jeffersonian connections further support Birch's political allegiances.

62 I am grateful to Timothy Mullin, Delaware Historical Society and former curator, the George Read Jr. House, New Castle, for this information. Read had demolished an earlier house that belonged to the family just to the south and created his main garden there. Read's name appears on the manuscript subscription list (Appendix D).

63 Snyder, "Philadelphia Views," 281, concludes that the decision to publish the second edition in color "indicates Birch's own opinion of the extent to which color enhanced his plates." I would argue that Birch's decision was primarily economic, not artistic.

64 See Snyder, "Philadelphia Views," 305–8, for his collation of the second edition plates. On Latrobe's work at the Chestnut Street Theater, see Cohen and Brownell, *Architectural Drawings of Benjamin Henry Latrobe*, 1:183.

65 See Snyder, "Country Seats," 234.

66 Ibid., 235.

67 Carson Collection, Philadelphia.

68 *Notes on the State of Virginia* (1787; reprint, New York: W. W. Norton, 1972), 164–65.

69 The last entries in his "Book of Profits" (Appendix G) occurred that year.

70 Subscription list, 21. Several of Strickland's works were featured in Birch's final edition, including the Second Bank of the United States.

71 See Snyder, "Country Seats," 252–53.

72 See Appendix G.

73 Several copies of the Lafayette enamel survive in public collections, including that of the Mead Art Gallery, Amherst College, Amherst, Massachusetts, and that of the Yale University Art Gallery, New Haven, Connecticut. Birch resorted to selling some of his work by lottery, a relatively common tactic of the period, as well as by auction. See Appendix G.

74 A signed and dated landscape (1832), oil on canvas, was offered for sale by the Bucholz Galleries in Philadelphia in 1960. A reproduction of this painting appears in an advertisement in *Antiques* (1960): 508. For Birch's exhibition record at the academy, see Falk, *Annual Exhibition Record*, 28.

75 Since Chase died in 1811, the same year that Pinkney became U.S. attorney general, it seems likely that Chase sent Birch to Pinkney in 1805, when he was Maryland attorney general, and that Birch misremembered his position. Pinkney had been Chase's protégé and law student. See Haw et al., *Stormy Patriot*, 120–21.

76 This debate has been most thoroughly studied by Lillian B. Miller, *Patrons and Patriotism: The Encouragement of the Fine Arts in the United States, 1790–1860* (Chicago: University of Chicago Press, 1966), and Harris, *The Artist in American Society*.

77 Published in *Port Folio* 3 (1807): 278–82.

78 The foreign ambassadors who purchased the *City of Philadelphia* included Robert Liston, the British minister, Guillemard, as previously noted, and Spanish dignitaries Joseph Viar and Don Carlos d'Yrujo.

79 John Penn (1760–1834), "the Poet," was the first cousin of John Penn (1725–95), "the Governor," while the younger Penn was in Philadelphia in a futile attempt to secure family landholdings in Pennsylvania. On this struggle, see Lorett Treese, *The Storm Gathering: The Penn Family and the American Revolution* (University Park: Penn State University Press, 1992).

80 De Jaudenes and his family left the United States in July 1796, and Birch arrived in the fall of 1794.

81 Little is known about Echo or its owner, whom Birch identifies in the *Country Seats* as "D. Bavarage." An unpublished drawing by J. P. Malcom labeled with this name (Snyder, "Country Seats," figure 97) and showing a small, cubic house is the only other known image that can be connected with the property. "Beveridge" also appears on the western shore of the river just above the upper ferry on the 1796 Varlé map (Snyder, *City of Independence*, 198), indicating the site of the property.

82 James Robinson, *Philadelphia Directory, City and County Register for 1804* (Philadelphia, 1804), 3.

83 On this period in the city's history, see Edgar P. Richardson, "The Athens of America, 1800–1825," in Weigley, *Philadelphia*, 208–57.

84 Latrobe gave his address as Richmond, Virginia, which indicates that this portion of the subscription list was most likely completed in 1798 before the architect moved to Philadelphia in December of that year. See Jeffrey A. Cohen, "Bank of Pennsylvania," in James F. O'Gorman, Jeffrey A. Cohen, George E. Thomas, and G. Holmes Perkins, *Drawing*

Toward Building: Philadelphia Architectural Graphics, 1732–1986 (Philadelphia: University of Pennsylvania Press, 1986), 47–48.

85 These included Joseph Parker Norris, William Sansom, Godfry Haga, and James Smith, Jr.

86 Ann Merry (1769–1808, née Brunton) was born in Bristol, England. Brunton had a successful career on the London stage before marrying a spendthrift. According to an article in the *Philadelphia Monthly Magazine* (April 1798): 185–88, she was a friend and London contemporary of Mrs. Siddons, and thus conceivably could have known Birch before their emigration. After accepting an offer from Thomas Wignell, the manager of the Chestnut Street Theater, to return to the stage in Philadelphia, the Merrys emigrated in 1796. After Merry's death in 1798, Ann married Wignell, who also subscribed to the *City of Philadelphia* in 1803. See Appendix D. The Chestnut Street Theater, while its façade was still in construction from designs by Benjamin Henry Latrobe, was shown in the first edition. Birch depicted the finished building in later editions. A total of five diplomats were subscribers.

87 See Snyder, "Philadelphia Views," 278.

88 Manuscript subscription list, 22, 19.

89 Ibid., 19.

90 On Bordley's support of Peale, see Edgar P. Richardson, "Charles Willson Peale and His World," in Richardson, Brooke Hindle, and Lillian B. Miller, *Charles Willson Peale and His World* (New York: Harry N. Abrams, 1982), 24, 28, 29, 40.

91 See J. Thomas Scharf, *History of Maryland* 2 (1879; facsimile reprint, Hatboro, Pa.: Tradition Press, 1967), 613, and Frederic Emory, *Queen Anne's County, Maryland: Its Early History and Development* (Baltimore: Maryland Historical Society, 1950), 301.

92 David R. Brigham, *Public Culture in the Early Republic: Peale's Museum and Its Audience* (Washington, D.C.: Smithsonian Institution Press, 1995). Regarding subscribers, see chapter 5 and the appendix.

93 For example, museum subscriber Robert Morris had gone to debtor's prison in 1798.

94 James McHenry (1753–1816), a physician and merchant who was a member of the Constitutional Convention and secretary of war under Washington, also subscribed to the *City of Philadelphia*. Both Rutherfurd (1760–1840) and Smith (Birch's client for the design of his Baltimore house, see above) were museum subscribers. Philadelphia at-

torney William Rawle (1759–1836) figures in Birch's autobiography as his legal representative.

Chapter 4. Full Effect of Intention

1 For an interesting parallel from New Zealand regarding the importing of similar notions, see Jacky Bowring, "Pidgin Picturesque," *Landscape Review* (New Zealand) 2 (1995): 56–64.

2 See Sinclair Hitchings, "London's Images of Colonial America," in *Eighteenth-Century Prints in Colonial America: To Educate and Decorate*, ed. Joan D. Dolmetsch (Williamsburg, Va.: Colonial Williamsburg Foundation, 1979), 11–31.

3 See Snyder, *City of Independence.*

4 See ibid., 42–47, and Ellen S. Jacobowitz and Beatrice B. Garvan, "An East Prospect of the City of Philadelphia," in *Philadelphia: Three Centuries of American Art* (Philadelphia: Philadelphia Museum of Art, 1976), 56–59. The *East Prospect* is also discussed in Nicholas B. Wainwright, "Scull and Heap's East Prospect of Philadelphia," *PMHB* 73 (1949): 16–17.

5 The *East Prospect* was published in four separate half-folio sheets, for a total width of just over seven feet. Hitchings, "London's Images of Colonial America," 15–16. "Brobdingnagian" refers to the country of giants of Gulliver's Travels, book 2. Views of the other cities, Boston and New York, were published by William Burgis. A smaller version of the East Prospect was produced by Thomas Jefferys in London, also at Thomas Penn's behest. See Snyder, *City of Independence*, 45.

6 *London Magazine*, October 1761, 515–16.

7 Hospitals were primarily for those unable to pay a physician to visit the home of patients with physical and mental illnesses.

8 See J. Thomas Scharf and Thompson Westcott, *History of Philadelphia, 1609–1884* (Philadelphia: L. H. Everts & Company, 1884), 2:1449ff. The Almshouse and House of Employment closely resembled the plans for the complete hospital (not finished until the end of the century) and was probably based on the drawings done by master carpenter Samuel Rhoads.

9 See Ellen S. Jacobowitz, "A South-East Prospect of Pennsylvania Hospital," in *Three Centuries*, 77–78, and Snyder, *City of Independence*, 53–57.

10 Karol Ann Peard Lawson, "Charles Willson Peale's *John Dickinson*: An American Landscape as Political Allegory," *Proceedings of the American Philosophical Society* 136 (December 1992): 455–86.

11 Peale was to use the same device repeatedly in his full-length portraits of Revolutionary War figures. The best known of these is his *Washington at the Battle of Princeton* (1779; collection Pennsylvania Academy of the Fine Arts). In the case of *John Dickinson*, the inclusion of the falls was arguably the only effective way to demonstrate the public acknowledgment of the act of writing the *Letters*.

12 Three of five views were published in the *Columbian Magazine* in its second year, 1787, one was included in the May 1789 issue, and the last was issued in January 1790. The engraver was James Trenchard, one of the magazine's editors and an acquaintance of Peale's. See Richardson, "Charles Willson Peale and His World," 91–95. The prints are also discussed in Snyder, *City of Independence*, 146–59. On the general subject, see Peter J. Parker and Stefanie Munsing Winkelbauer, "Embellishments for Practical Repositories: Eighteenth-Century American Magazine Illustration," in Dolmetsch, *Eighteenth-Century Prints in Colonial America*.

13 Richardson, "Charles Willson Peale and His World," 58, 92. The *Columbian Magazine* 1 (1787): 512 print was probably based on a drawing made for the background of his 1779 *Conrad-Alexandre Gérard* (collection Independence National Historical Park, Philadelphia) in which the building appears, although some details of the painting and print differ. The print includes a more complete description of the surroundings to the north of Chestnut Street, and some details of the foreground are different.

14 *Universal Magazine* 85 (July 1788): 33–34.

15 *Universal Magazine* 85 (July 1789): 16–18.

16 See Snyder, "Philadelphia Views," 271–315, and Snyder, "Country Seats," 224–54, for specific dimensions.

17 For a brief biography of engraver Samuel Seymour, see Nygren, *Views and Visions*, 288–89. Thomas Birch would, of course, go on to a career painting full-size oils.

18 The introductory text page lists the plates in binding order below the text. These three plates are separate and described before this list with an explanation: "The Plates in this Work are arranged as is most convenient to review the City; after the Title, the General view of the City, River, and Port; this page [introduction] next, then the Plan of the City, and the Dissections as follow."

19 In his broadside prospectus for the set, Birch explicitly associates the Treaty Tree with the event that purportedly took place under its branches: "the view is taken from the great elm at Kensington, called Penn's Tree, on account of the treaty for lands formed under it by William Penn with the Indians, respecting the settlement of the State of Pennsylvania." Snyder, "Philadelphia Views," 304. Penn gave payments to Delaware Indians on several occasions between 1682 and 1684. No original documentation confirms a single treaty meeting under the elm on the Delaware River. See Mary Maples Dunn and Richard S. Dunn, "The Founding, 1681–1701," in Weigley, *Philadelphia*, 5.

20 Ann Abrams, "Benjamin West's Documentation of Colonial History: *William Penn's Treaty with the Indians*," *Art Bulletin* 44 (1982): 59–75.

21 It should be noted that the sole figural element of the title page is a rather fanciful version of the coat of arms, or seal, of the state of Pennsylvania.

22 See Graham Clarke, "Taking Possession: The Cartouche as Cultural Text in Eighteenth-Century American Maps," *Word & Image* 4 (1988): 455–74.

23 As Snyder notes in "Philadelphia Views," 375, this plate is in part based on a watercolor by Birch in the collection of the Library Company of Philadelphia, *Hon. Frederick Muhlenberg pointing out to visiting Indians the German Zion Church*. Gary Nash amplifies this as a delegation of "Senecas, Oneidas, Onondagas, Stockbridges, and Tuscaroras who were received at the State House by Governor Thomas Mifflin" (Nash, *First City: Philadelphia and the Forging of Historical Memory* [Philadelphia: University of Pennsylvania Press, 2002], 125). While Birch's print was certainly based on a factual observation recorded in watercolor, both authors fail to take into account the tradition of symbolic and emblematic representation upon which Birch drew and which was shared by his American contemporaries.

24 The building was constructed by jeweler and goldsmith Joseph Cooke, who was probably associated with Birch in some way. The project that came to be known as "Cooke's Folly" was described enthusiastically by Thomas Porter in 1831: "[This building] was finished in 1794 . . .

[and] was intended for three Dwellings and Stores, and was finished in the very best manner, even to the lower cellar, in which were the kitchens, finished with pumps, sinks, and every convenience; . . . the stores were first occupied by Jewellers, and when first opened, presented a scene of magnificence not surpassed by any place of business on the globe." Thomas Porter, *Picture of Philadelphia from 1811 to 1831* (Philadelphia: Robert Desilver, 1931), 92. Cooke's building was one of many speculative schemes of the period. It was to be financed by a lottery, a common contemporary method of capitalization, but, despite its gleaming appearance in Birch's view, the building was ultimately not a success and caused the builder's ruin. See Scharf and Westcott, *History of Philadelphia*, and Joseph Jackson, *Encyclopedia of Philadelphia* (Harrisburg, Pa.: National Historical Association Telegraph Building, 1931), 2:528–29. Scharf and Westcott give the details of the lottery scheme but do not identify their source. Porter describes the dilapidated condition of the building in 1831. An advertisement for Cooke's wares that appeared in the May 7, 1789, edition of the *Pennsylvania Gazette* includes not only "Tea-setts and Side-Boards of Plate" (i.e., serving pieces made of sterling silver) but also notice of his ability to set "miniature pictures" in gold and "a Most Brilliant Assortment of every article in his line of business." Cooke is described by Scharf and Westcott as a "fashionable and flourishing goldsmith and jeweler" (1:487n).

25 See Scharf and Westcott, *History of Philadelphia*, 1:501–2.

26 Miller, "The Federal City," 202.

27 See Scharf and Westcott, *History of Philadelphia*, 1:462, 463, 488, 501, 503, and Joseph Jackson, *Market Street: Philadelphia* (Philadelphia: Privately published, 1918), 148–50.

28 Birch reports in his autobiography that he purchased two bas-relief sculptures created for the building. See "Life," p. 217.

29 One of the best-known contemporary critiques of the grandiose aspirations of this American *hôtel particulier* is found in the writing of Benjamin Henry Latrobe. See Edward C. Carter II et al., eds., *The Journals of Benjamin Henry Latrobe* (New Haven, Conn.: Yale University Press, 1977), 2:376, and Beatrice B. Garvan, *Federal Philadelphia, 1785–1825: The Athens of the Western World* (Philadelphia: University of Pennsylvania Press, 1987), 58. Latrobe termed it "violently ugly." On Morris's failure, see Friedenberg, "The Strange Case of Robert Morris,"

338–47. In "The Federal City," Richard G. Miller aptly calls Morris "ubiquitous," since not only did he play a key role in financing the Revolution itself but was later a U.S. senator. In that position he was one of the key figures in the Compromise of 1790, which brought the national capital temporarily back to Philadelphia from New York. See Jacob E. Cooke, "The Compromise of 1790," *William and Mary Quarterly* 27 (1970): 523–45.

30 Snyder documents an earlier version of this plate with the view looking southwest, down Third Street (*City of Independence*, figure 153).

31 The design is conventionally ascribed to Samuel Blodget, a wealthy amateur, who relied heavily on Thomas Cooley's design for the Dublin Royal Exchange. The Royal Exchange, later Dublin City Hall, was designed and built between 1769 and 1779. See John Summerson, *Architecture in Britain, 1530–1830*, 9th ed. (1953; New Haven, Conn.: Yale University Press, 1993), 412–13, and Beatrice B. Garvan, "Bank of the United States," in *Three Centuries*, 172–73. In sources on Philadelphia, the design has sometimes been mistakenly attributed to James Gandon, who took over much of Cooley's work in Dublin after the latter's death in 1784. On the attribution to Blodget and other details regarding the construction of the building, see James O. Wettereau, "The Oldest Bank Building in the United States," in Eisenhart, ed., 70–79; Scharf and Westcott, *History of Philadelphia*, 2:1068. Blodget was, inter alia, a director of the Insurance Company of North America.

32 Gary Nash has asserted that this image represents the moving of a blacksmith's shop to establish the first building for Mother Bethel A.M.E. Church. There is no evidence in Birch's records that this was the artist's intention. See Nash, *Forging Freedom: The Formation of Philadelphia's Black Community, 1720–1840* (Cambridge, Mass.: Harvard University Press, 1988), 1–7, 130, and Nash, *First City*, 148.

33 Given what the viewer has just seen, one wonders if the implication is that the removal of the house of government springs from baser instincts as well.

34 In addition to these public works, Birch would go on to represent two other Latrobe Philadelphia commissions from the turn of the century: a new plate of the renovated Chestnut Street Theater was added to the 1804 edition of the *City of Philadelphia*, and a view of Sedgeley, merchant William Cramond's house on the Schuylkill, was included in

the *Country Seats*. The introductory description to that plate suggests that Birch did not know the architect particularly well, since he mistakes his first name, calling him "that able architect, Mr. J. H. Latrobe."

35 Birch's view of the bank suggests that he had seen Latrobe's perspective presentation drawing. See Cohen and Brownell, *The Architectural Drawings of Benjamin Henry Latrobe*, 1:201, for illustration, and 1:203–4 for a discussion of the relationship between the drawing and Birch's view.

36 In a way, the frigate *Philadelphia* here also represents Birch's *Philadelphia*, in the sense of its nearing its completion and being sent out to protect the city's commerce.

37 Miller, "The Federal City," 196.

Chapter 5. "The Only Work of the Kind"

1 Janice G. Schimmelman, "A Checklist of European Treatises on Art and Essays on Aesthetics Available in America Through 1815," *Proceedings of the American Antiquarian Society* 93 (1983): 133, 148. Gilpin's *Three Essays*, 1st ed. (London, 1792) and Price's *Essay on the Picturesque*, 1st ed. (London, 1794) had made their way into the Library Company's collection in 1794 and 1798, respectively. In addition, Schimmelman (137) documents the arrival of Knight's *The Landscape: A Didactic Poem* at the Library Company in 1794, the year of the publication of the first edition.

2 Robert Clark, "The Absent Landscape of America's Eighteenth Century," in *Views of American Landscapes*, ed. Mark Gidley and Robert Lawson-Peebles (Cambridge: Cambridge University Press, 1989), 81–99.

3 Stephen Fender, "American Landscape and the Figure of Anticipation," in Gidley and Lawson-Peebles, *Views of American Landscapes*, 52.

4 As Clark ("The Absent Landscape," 95) notes, in his well-known description of the Natural Bridge in *Notes on the State of Virginia*, Thomas Jefferson includes his almost overwhelming physical reaction to the place but little about its aesthetic qualities beyond characterizing it as "sublime." Jefferson concludes with a "reassuring note of utility" in regard to Cedar Creek, which flows under the bridge and is "sufficient in the driest seasons to turn a grist-mill."

5 For an intelligent and detailed discussion of related understand-ings, see Robert Lawson-Peebles, *Landscape and Written Expression in Revolutionary America* (Cambridge: Cambridge University Press, 1988), 1–17.

6 The Springland property had clearly been occupied previously, as he suggests in his discussion of moving his family to Springland while working on the *City of Philadelphia*. He says that he "settled [his] family, in a small tenement till I could form a plan for building." He may have had a structure thrown up quickly, but it is more likely he bought the property with some sort of house on it. His references to a lawn on the site may also suggest earlier settlement. As noted later, he refers to his nearby "lodge" in a description of a thunderstorm on the property.

7 Lawson-Peebles charts many of the facets of this convention, in *Landscape and Written Expression*, 100–134.

8 One should note James Thomson's *Seasons* as the most famous instance of climatic discursion.

9 Martin Snyder also notes this failure in "Country Seats," 233–34.

10 The landscape garden Hamilton created at the Woodlands in the 1780s was one of the most publicly admired in the early republic. On the Woodlands and its cultural role, see James A. Jacobs, "William Hamilton and the Woodlands: A Construction of Refinement in Philadelphia," *PMHB* 103, no. 2 (2006): 181–209.

11 The drawings were sold at public auction by C. G. Sloan & Company, Washington, D.C., on June 5–8, 1980. In the catalogue (pp. 136–41, numbers 2297–2333), the group was described as "Drawings and Prints from the Personal Scrapbook of William R. Birch." Included were three drawings used in the *Country Seats* not relating to Springland (those for Lansdown, Montebello, and Echo; catalogue numbers 2300, 2301, and 2323, respectively) and two views of Springland. The watercolor for Montebello was purchased for the collection of the Baltimore Museum of Art (BMA). I am grateful to L. Carol Murray of the BMA for providing me with copies of material from the curatorial file for the Montebello drawing. Some of the other drawings were purchased by private collectors, and others were purchased by the Corcoran Gallery of Art.

12 The ancient Roman concept of *otium* encompasses the peace and quiet, the rest, the positive "nothing"-ness of country life, and was the opposite of *negotium*, or business.

13 For this reason, they are often omitted from art historical

studies of the subject of American landscape representation. This is true, for example, for Nygren, *Views and Visions*. On the general subject, see Parker and Winkelbauer, "Embellishments for Practical Repositories."

14 For example, *Scenographia Americana*, published in London in 1768, consisted of twenty-eight views "made up of several sets that had been issued earlier by Thomas Jefferys." E. McSherry Fowble, *Two Centuries of Prints in America, 1680–1880: A Selective Catalogue of the Winterthur Museum Collection* (Charlottesville: University Press of Virginia, 1987), 74.

15 See Bruce Robertson, "Venit, Vidit, Depinxit: The Military Artist in America," in Nygren, *Views and Visions*, 84, and Fowble, *Two Centuries of Prints in America*, 77.

16 Nygren, "George Beck," in *Views and Visions*, 237.

17 On the New York academy, see Miller, *Patrons and Patriotism*, 90–102.

18 Margaret Sloane Patterson, *Views of Old New York: Catalogue of the William Sloane Collection* (New York: Privately printed, 1968), 22.

19 Nygren, *Views and Visions*, 269.

20 Karol Ann Peard Lawson, "An Inexhaustible Abundance: The National Landscape Depicted in American Magazines, 1780–1820," *Journal of the Early Republic* 12 (1992): 308.

21 Ibid., 305.

22 Cornelius Stafford, *Philadelphia Directory for 1804* (Philadelphia: William Woodward, 1804), 3.

23 See Chapter 3.

24 The plate text, "the Sun reflecting on the Dew, a Garden scene," indicates that this was also the only example of his work that Birch included in his didactic "College" collection at Springland.

25 Birch had issued a larger version of the Mt. Vernon plate in 1804, which differs slightly in detail from the plate published in the *Country Seats*. Subscribers for this larger Mt. Vernon view are listed in the manuscript subscription lists to the *City of Philadelphia* (Historical Society of Pennsylvania), 15, and include "R. Peters," perhaps Richard Peters, whose Belmont is shown in the *Country Seats*.

26 For further information about the property, see William Russell Birch, *The Country Seats of the United States*, ed., with introduction by Emily T. Cooperman (Philadelphia: University of Pennsylvania Press, 2009), 56.

27 This diminutive villa was occupied by Penn for a brief period while he was in Philadelphia trying (futilely) to assure his family's rights to lands in Pennsylvania. Birch dined there, probably soon after his emigration, with John Guillemard, the British commissioner, who was renting the property. See Chapter 3.

28 The text also records that the original drawing was supplied by Birch's son George, "Cornet of Light Dragoons, U.S. Army."

29 Smith was elected to the Senate in 1803 after having served previously in the House of Representatives.

30 On the renovations at the Woodlands, which were based on plans by an unknown London architect, see Richard J. Betts, "The Woodlands," *Winterthur Portfolio* 14 (August 1979): 213–34.

31 Grapes were very meaningful for Americans in the early nineteenth century. A key feature of their symbolic importance was their association with both biblical and classical traditions. See Emily T. Cooperman, "The Graperies and Grapes of Nicholas Biddle's Andalusia: A Study in Greek Revival Landscape Pursuits" (master's thesis, University of Pennsylvania, 1993).

Editor's Note

1 Charles Willson Peale, Lillian B. Miller, and Sidney Hart, *The Selected Papers of Charles Willson Peale and His Family*, vol. 5, *The Autobiography of Charles Willson Peale* (New Haven, Conn.: Yale University Press, 2000), xvii.

The Life and Anecdotes of William Russell Birch, Enamel Painter

1 Reynolds's propensity to experiment with pigments caused many of his paintings to deteriorate. This problem was noted by his contemporaries, hence Birch's reference to "while his pictures were fresh." See Chapter 1.

2 On *terre verte* see Carol A. Grissom, "Green Earth," in *Artist's Pigments: A Handbook of Their History and Characteristics*, ed. Robert L. Feller (Cambridge: Cambridge University Press and the National Gallery of Art, 1986), 1:141ff.

3 Van Dyck brown (a term still in use) is a "soft black" named in

honor of Flemish-born Antony van Dyck (1599–1641), who achieved renown as a portrait painter in the highest levels of English society in the early seventeenth century.

4 Haward also subscribed to Birch's *Délices de la Grande Bretagne*. See Chapter 1.

5 Anglo-American painter John Singleton Copley (1738–1815) created the *Death of the Earl of Chatham* in 1779–81, which showed the collapse of William Pitt (1708–78) in Parliament (see figure 9). This "contemporary history" painting was as much a collection of portraits of the members of the House of Lords as the representation of a significant moment. Copley went on to make individual portraits based on his sketches for the larger painting, including one of Mansfield, which Birch copied in enamel. Copley also subscribed to the *Délices de la Grande Bretagne*. See Chapter 1 and Appendices A and B.

6 See Chapter 1.

7 On Reynolds's portraits of the marquess including the replica remarked here by Birch, see Mannings, *Sir Joshua Reynolds*, cats. 1858–63. The replica of Reynolds's portrait of Mansfield was painted for the Archbishop of York in 1788. See Mannings, *Sir Joshua Reynolds*, cat. 1320. See also Chapter 1 and Appendix A for the enamel of the same painting Lord Fitzwilliam commissioned from Birch. Lord Fitzwilliam also subscribed to the *Délices de la Grande Bretagne*.

8 See Mannings, *Sir Joshua Reynolds*, cat. 2186.

9 Painter James Northcote (1746–1831), one of Reynolds's pupils, wrote *The Life of Sir Joshua Reynolds* (London, 1819), the earliest published biography of the elder artist. The only direct reference to Birch in Northcote's work is in connection to this pastiche, which he refutes as Reynolds's work (184).

10 No author of a work on the antiquities of Wales by this name has been identified. Birch may have been referring to a member of the Robinson family of eighteenth-century London booksellers.

11 William Dugdale published his *History of St. Paul's Cathedral* in 1658, with accompanying plates by Wenceslaus Hollar (1607–77), which include depictions of the refacing of the western façade by Inigo Jones (1573–1652). Golding is otherwise unidentified. Dutch painter Jan Griffier (ca. 1645–1718) worked in England, depicting the Great Fire of London (1666). As Birch suggests, author Thomas Pennant (1726–98)

added a note about Birch's engraving to the third edition (1793) of his *Of London* (first published 1790). Ludgate, an entrance through the London wall, was originally a Roman structure but came to be understood as the first-century work of King Lud. Rebuilt in the thirteenth and sixteenth centuries, Ludgate was demolished in the eighteenth.

12 See Mannings, *Sir Joshua Reynolds*, cat. 1532. Birch also engraved this painting of the actress Mary Robinson as *Contemplation*. See Chapter 1. Reynolds painted himself in doctoral robes "without cap" twice ca. 1773–74, following his honorary Oxford degree awarded in July 1773. See Mannings, *Sir Joshua Reynolds*, cats. 12–14 (47–48). See Appendix A for Birch's enamels.

13 English portrait painter Tilly Kettle (1735–86) was in India in the 1770s. See Chapter 2 and Appendix A for Birch's reference to a related enamel.

14 The identification of this artist is uncertain but may be one of the members of the Wierix family of Flemish artists active in the sixteenth and seventeenth centuries.

15 The duchess was a crucial figure in the Whig Party in the 1780s. Most of Birch's patrons were also Whigs; many can be connected directly to her. See Foreman, *Georgiana, Duchess of Devonshire*. See also Chapter 1 and Appendix A.

16 Birch's claim of introducing Chauncey and Reynolds cannot be corroborated, but it is plausible, given the date of Reynolds's portrait of the antiquarian. See Chapter 1.

17 Chauncey's "Enchanted Castle" by Claude Lorrain (1604–82) is properly called *Landscape with Psyche and the Palace of Amor*, 1664, collection the National Gallery, London. It acquired the other name in 1782, when it was engraved by William Woollett (1735–85). The "Angel in the Trouble Waters" is presumably *Landscape with Psyche Saved from Drowning Herself*, 1665 (collection Wallraf–Richartz Museum, Cologne), which was also Chauncey's and which is a pendant to the other painting. See Marcel Röthlisberger, *Claude Lorrain: The Paintings* (New Haven, Conn.: Yale University Press, 1961), 1:384–85, 396–97.

18 Pope first formed a friendship with Murray when the young lawyer was still in training and in fact tutored Murray in elocution. The two remained close until Pope's death.

19 Mansfield's niece Anne Murray and his grandnieces Elizabeth

Murray and Dido Elizabeth Belle lived with him at Kenwood. He and his wife, Elizabeth (d. 1784), had no children. See Chapter 1.

20 This initial meeting with Mansfield took place before 1780, when his Bloomsbury house was destroyed in anti-Catholic rioting. See Summerson, *The Iveagh Bequest*, 7–8.

21 See note on p. 172 above.

22 Gray subscribed to Birch's *Délices de la Grande Bretagne* and represented him in connection with his inheritance.

23 Thomas Paine's (1737–1809) *Rights of Man* (1791–92), which defended the principles of the French Revolution, was banned as treasonous, and Paine was tried in absentia in England for its seditious passages. Birch's "spouting" risked his imprisonment on the same basis. See Chapter 1.

24 John Bull, who subscribed to the *Délices de la Grande Bretagne*, is otherwise unidentified. Painter and engraver William Hogarth (1697–1764) is arguably best known for his satirical series of works, including the *Rake's Progress*. Horatio (Horace) Walpole, the fourth Earl of Orford (1717–97), is perhaps remembered as a man of letters, a collector, and an author as much as for his political career. The drawings referred to here are documented as part of Walpole's collection in Peter Hill, *Walpole's Art Collection* (Twickenham: Jacksonhill Publishing, 1997), 21. Walpole was also a subscriber to the *Délices*, and his property, Strawberry Hill, was depicted in the volume. See Chapter 2 and Appendix B.

25 In his discussion of caricature in Hogarth, Birch follows the earlier artist's own formulations; this was the subject of *Characters and Caricaturas* (1743). As Ronald Paulson has noted, for Hogarth the distinction between the two "relied on distortion or reduction of the human face" in caricature. See Paulson, *Hogarth's Graphic Works*, rev. ed. (New Haven, Conn.: Yale University Press, 1970), 1:188. No graphic work of Hogarth's corresponds to either Birch's description of the image of the Italian opera dancer or a scene of "reading the will"—he was most likely remembering the work of another artist or artists. Hogarth's *The Bench* (1758) may correspond to Birch's "Master Wilkin in his Quarter Day": the print, which shows Chief Justice Sir John Willes, is one of Hogarth's studies in character and caricature. See Paulson, *Hogarth's Graphic Works*, 1:238–39. *The Bruiser* (1763), which depicts Charles Churchill (1731–64) as a "slovenly clergymen who drinks and writes brutal satires"

(Paulson, *Hogarth's Graphic Works*, 1:258), was a response to a published attack on Hogarth and a reworking of a self-portrait by Hogarth. The *Rake's Progress* (1735) charts the course of a young member of the gentry from the moment of inheritance through its squandering through gambling and his eventual insanity; *Harlot's Progress* (1732) follows the narrative of a country woman tempted into prostitution in London through her imprisonment and death from venereal disease.

26 Chase, although older than Birch, was technically his nephew by Chase's father's second marriage to Birch's older sister Ann in 1763. See Chapter 3.

27 Lady Charlotte Wentworth also provided one of the paintings that Birch engraved for the *Délices de la Grande Bretagne* and purchased several enamels from Birch. See Appendix A.

28 Erskine Newman is otherwise unidentified.

29 Reynolds's 1785 portrait was commissioned by the Prince of Wales. See Mannings, *Sir Joshua Reynolds*, cat. 1145.

30 Birch is referring to Napoleon and his imperial ambitions, and his defeat by Nelson at the battle of Waterloo. As Birch recounts, Napoleon appropriated the four gilded horses from the front of the Basilico San Marco in Venice in 1798, taking them to Paris, uniting them with a chariot, and placing them on top of the Arc du Carrousel in 1805. The resulting quadriga, Birch's "Venice Car," is a fitting symbol of imperial ambition, since the horses themselves had originally been taken from Constantinople in 1204 to Venice as part of the crusaders' conquest of the city. The gilded horses of San Marco were returned to Venice in 1815. There has been some debate on the subject of the ancient origin of the horses, but one school of thought continues to support the notion that they were the creation of Lysippus or his followers. See, for example, *The Horses of San Marco*, Venice (Venice: Olivetti, 1977 and 1979), passim.

31 Russell exhibited a full-length portrait of George Whitefield (1714–70), an early leader of Methodism, in 1770 at the Royal Academy. See R. J. B. Walker, "Russell, John (1745–1806)," *Oxford Dictionary of National Biography*, Oxford University Press, September 2004, http://www.oxforddnb.com/view/article/24321 (accessed May 2006). Russell had converted to Methodism in his teens.

32 Birch misremembered the location of the window: it is in New College, Oxford. Reynolds's design (commissioned in 1777) for the cha-

pel's west window was painted on glass by Thomas Jervais (d. 1799) and depicts the Nativity over the three Christian virtues (Faith, Hope, and Charity) and the four cardinal virtues (Temperance, Fortitude, Justice, and Prudence). See Mannings, *Sir Joshua Reynolds*, cats. 2106–21.

33 The engraver "Obracon" is unidentified. Reynolds's ownership of the portrait of Milton by Cooper became something of a cause célèbre, and accounts of Reynolds's purchase and appraisal of the miniature appeared in the May 1785 issue of the *Gentleman's Magazine* (374ff.), among other places. It was reported that Reynolds paid one hundred guineas from a print-seller and painting dealer named Hunt who had bought it from a "broker." The dispute over the ownership of the painting did not appear in print.

34 Birch here distinguishes between prints that were intended as original works of art and those that merely reproduced paintings, such as his own reproductions of others' images in the *Délices de la Grande Bretagne*.

35 Dalton, who was first appointed librarian to George III (then Prince of Wales) in 1755, and not Chamberlaine, however, subscribed to the *Délices de la Grande Bretagne*. See Chapter 1 and Appendix B.

36 Samuel Chase was in London in 1784 to attempt to recover the state's Bank of England stock from fugitive loyalists. See Chapter 3.

37 See Chapter 1.

38 The August departure of the William Penn from London was reported in the *Pennsylvania Gazette* on October 8, 1794.

39 Bingham was one of the wealthiest men in the United States at the time. Birch depicted his house on Third Street in the City of Philadelphia.

40 For text of the letter, and those referred to in the following, see Appendix C.

41 By "full size" Birch presumably means full length. Birch confused generations in the Baring family here. Sir Francis Baring (1740–1810) was a merchant and merchant banker connected to William Bingham initially through Thomas Willing (1731–1821), partner with Robert Morris (1735–1806) in the important mercantile firm of Willing, Morris & Company. Baring forged a business relationship with Willing, Bingham's father-in-law, and then with Bingham himself, before the Revolution. These personal and mercantile alliances continued into the next generation with the marriage of Baring's sons: his son Alexander married Ann Louisa Bingham and Henry Baring married her younger sister Maria.

42 The experience of the Russells (wife Martha, son Thomas Pougher, and daughters Martha and Mary) in Philadelphia, including their social encounters with President Washington and others, are documented in Jeyes, *Russells of Birmingham*, 202ff. Thomas Russell described the city as a "vortex of luxury and dissipation" during their stay in 1795–96. Priestley remained at the settlement in Northumberland, Pennsylvania, for the rest of his life.

43 Onion came to Cecil County, Maryland, in the 1720s as the ironmaster for the Principio Iron Company, which established a furnace in Cecil County east of the mouth of the Susquehanna River on what is now known as Principio Creek. The partners in the Principio Company included Thomas Russell, Birch's grandfather (Onion's father-in-law), Onion, and others, among them Augustine Washington, George Washington's father. On the Principio, see Michael Robbins, *The Principio Company: Iron-Making in Colonial Maryland 1720–1781* (New York: Garland, 1986).

44 Hanley Castle, near Upton upon Severn, is in Worcestershire. Thomas Pougher Russell (1775–1851) spent the last three decades of his life working as a banker in Gloucester. See Jeyes, *Russells of Birmingham*, 299.

45 Coles appears in the account books of William Russell while he was in Philadelphia in 1797 (Russell Papers).

46 Grimwade, *London Goldsmiths*, 560, 565. The discussion of Jones and the anecdote that follows about the Earl of Mansfield originally appeared only in the Barra copy of the manuscript in connection with Birch's discussion of his accidental encounter with Coles near Elkton, Maryland (p. 229), and has been moved for continuity.

47 Birch's assertion that Mrs. Knightly was the earl's daughter is notable, given the fact that he and his wife were childless. Per e-mail correspondence between Emily Cooperman and Julius Bryant, Keeper of the Word & Image Department at the Victoria and Albert Museum, London, and former curator of Kenwood (November 20, 2007), she has not been previously known to specialists in the earl's life. Research found no published source that identifies her as the earl's daughter.

48 Stuart came to Philadelphia "expressly to paint George Washington's portrait" (Barratt and Miles, *Gilbert Stuart*, 129).

49 This remark praising Stuart's paintings is an indirect criticism of Charles Willson Peale, who had been the principal creator of portraits of Washington before Stuart.

50 McHenry also subscribed to the *City of Philadelphia*. See Appendix D.

51 Note added to the Carson copy of the manuscript, in graphite: "This full length of Washington was not bespoke by Mr. Bingham, but by the Marquis of Lansdowne himself before G. Stuart left England for America. Mr. Bingham asked the priviledge of presenting the picture to the Marquis after offering to pay Stuart first.

"This Mr. Stuart told me, and so have I described the affair in Dunlap's History of American Arts & Artists. J. Neagle.

"P.S. Mr. Bingham sent the picture to the Marquis & the manner in which it was done, though unintentionally, caused poor Stuart to lose the advantage of a copy right. J. Neagle."

It is not known how painter John Neagle (1796–1865) came to add this note to Birch's manuscript. Neagle addresses a question in the history of this, the famous Lansdowne portrait of Washington. Specifically, as Neagle indicates, the origin of the commission to paint Washington's full-length is uncertain, although it is clear that William Bingham paid for the portrait painted for William Petty, first Marquess of Lansdowne. On the portrait, see Barratt and Miles, *Gilbert Stuart*, 166–83. Bingham was connected to Lansdowne through the Barings.

52 Birch's assertion about the number of enamels of Washington is corroborated by the number of them known to survive; many are in museum collections. Surviving enamels of Washington after Stuart by Birch include versions of the Vaughan and Athenæum type. See Chapter 3.

53 Birch refers here to the house Echo. Little is known about this property or the owner. An unpublished drawing by J. P. Malcom labeled with this name (Snyder, figure 97) and showing a small, cubic house is the only known image of the house. "Beveridge" also appears on the western shore of the river just above the upper ferry on the 1796 Varlé map (Snyder, 198), indicating the site of the property, and David Beveridge, an insurance broker (the only person listed with this surname), appears in contemporary Philadelphia directories. Birch engraved a view of a wooded scene from a part of the property and included it in his *Country*

try Seats. The watercolor on which this print was based was displayed at Springland. See Appendix E. A watercolor of the subject, presumably the painting shown at his property, survives in the collection of the Corcoran Museum of Art, Washington, D.C.

54 Stuart had painted de Jaudenes and his wife, née Matilda Stoughton, a New York native, in his New York studio in 1794, and most likely made the introduction to Birch. On the Stuart portraits, see John Caldwell et al., *American Paintings in the Metropolitan Museum of Art 1* (New York: Metropolitan Museum of Art, 1994), 168–72, and Barratt and Miles, *Gilbert Stuart*, 124–27.

55 See previous note.

56 Burlington lies across the Delaware River from Philadelphia. Birch's survey of the city, the Assicunk Creek, which corresponded to the northern limit of the town and which is still known by this name today, and of Burlington Island, which sits just to the northwest of the town in the river, was published in 1797 with the title *A Plan of the Island of Burlington: And a View of the City from the River Delaware*. See Chapter 3.

57 For the details of Birch's purchase of the property, see Snyder, "Country Seats," 225–54.

58 On van Braam, see Jean Gordon Lee, *Philadelphians and the China Trade, 1784–1844* (Philadelphia: Philadelphia Museum of Art, 1984), 82–91. The construction workers sued van Braam and caused him to be jailed for nonpayment. The most extensive descriptions of the house itself were written by eighteenth-century foreign visitors. See, for example, Niemcewicz, *Under Their Vine and Fig Tree*, 61–62. Birch included a representation of the house with a view downstream of the river in the *Country Seats*. See Chapter 3.

59 See H. G. Lyons, "John Lewis Guillemard (1764–1844)," *Notes and Records of the Royal Society of London* 3 (April 1940–September 1941): 95–96. Guillemard also subscribed to Birch's *City of Philadelphia*. See Appendix D.

60 Birch depicted both Solitude and Lansdowne—built by Governor Penn–in his *Country Seats*.

61 William Moore Smith (1759–1821), was, contrary to Birch's recollection, never American consul; a respected attorney, he did serve as agent to settle claims that resulted from the Jay treaty, and traveled to London in 1803 for that purpose.

62 Frederic Franck de la Roche was an aide to General Lafayette rather than Washington. Birch depicted Fairy Hill and its surroundings in one of his engravings for the *Country Seats*. See figure 94.

63 Parkyns was among the artists before Birch who attempted to publish sets of views in the United States. Birch included a drawing by Parkyns in his collection exhibited at Springland (see Appendix E). Before coming to the United States, Parkyns had published his original "Six Designs for Improving and Embellishing Grounds" in London in 1793, which appeared as an appendix to Soane's *Sketches in Architecture*. See also Eleanor M. McPeck, "George Isham Parkyns: Artist and Landscape Architect, 1749–1820," *Quarterly Journal of the Library of Congress* 3 (July 1973): 171–82; and A. A. Tait, "The American Garden in Milburn Tower," in *British and American Gardens in the Eighteenth Century*, ed. Robert P. McCubbin and Peter Martin (Williamsburg, Va.: Colonial Williamsburg Foundation, 1984), 84–91.

64 Birch included a view of Hamilton's (1745–1813) Woodlands, on the west side of the Schuylkill, in his *Country Seats*, including a longer description than for the other properties included. The Woodlands survives as part of a cemetery established in the 1840s. Birch records Hamilton's approval of his work at Springland. See p. 214.

65 As Kathleen Foster has noted, Birch was here recalling James Greenleaf's relatively brief ownership of Eaglesfield between 1808 and 1810, perhaps because the owners commissioned Birch's son Thomas to paint a view of the house. The house and grounds had been designed by Parkyns for merchant James Egglesfield Griffith. See Foster, *Captain Watson's Travels in America: The Sketchbook Diary of Joshua Rowley Watson, 1771–1818* (Philadelphia: University of Pennsylvania Press, 1997), 40–46. The house stood on the west side of the Schuylkill River north of Solitude. Greenleaf also briefly owned Lansdowne, also formerly on the west side of river, since his wife, née Ann Penn Allen, had inherited the property from Ann Allen Penn, the wife of John Penn (1729–95), who built the house shortly after assuming office as Pennsylvania's last colonial governor in 1773. See Margaret Brown, "Mr. and Mrs. Bingham of Philadelphia," *PMHB* 61 (July 1937): 286–324.

66 Birch met his nieces Elizabeth and Ann for the first time after coming to the United States. They had been raised in Annapolis by their older half brother, Samuel Chase, after their parents' death. See Chapter 3.

67 The Lenoxes raised their niece Sarah Lukens Keene (1784–1866) from childhood. See Alexandra Alevizatos Kritley, "The Painted Furniture of Philadelphia: A Reappraisal," *Magazine Antiques* 169, no. 5 (May 2006): 142; the Lukens-Lenox papers are preserved in the Pennsylvania State Archives, Harrisburg. Lenox served as a U.S. marshal and later as president of the Bank of the United States and of the Philadelphia Bank.

68 Thomas Jefferson's copy of the publication survives in the collection at Monticello.

69 Samuel Seymour was also a British emigrant. His life dates are unknown.

70 Birch depicted merchant and financier Robert Morris's (1733–1806) house in his *City of Philadelphia*. This extravagant but never completed mansion was designed by Pierre Charles L'Enfant (1752–1825) and located on Chestnut Street in Philadelphia near Eighth. To contemporary Philadelphians, this house was the visible demonstration of the financial failure of this prominent Revolutionary figure whose vast fortune was lost speculating on western lands.

71 Two of the buildings on the Green Hill estate survived to be recorded by the Historic American Building Survey in 1936 (HABS MD-459).

72 Russell's widow Ann, née Thomas, was born in 1751. See Jeyes, *The Russells of Birmingham*, 305. Sheredine was also involved in the Principio forge and was presumably related to Major Thomas Sheredine, who was as well. The Principio was established in the 1720s and was located in Cecil County on the Principio Creek, which empties into the Chesapeake Bay north of the mouth of the Susquehanna River. The forge had been established by Birch's uncle Thomas (1696–1760), with Stephen Onion (1694–1754), his future brother-in-law. Onion married Thomas's sister Deborah, and remained in Cecil County, as Birch indicates, in connection with the business of the iron forge. Because the younger Thomas Russell sided with the colonists in the Revolution, he was given control of the Principio forge after it was confiscated. Russell also operated another forge at North East. See Michael Warren Robbins, "The Principio Company: Iron-Making in Colonial Maryland, 1720–1781" (Ph.D. diss., George Washington University, 1972), 248. On the Principio Company, see Henry Whiteley and William G. Whitely, "The Principio Company," *Pennsylvania Magazine of History and*

Biography 11 (1887): 63–68, 190–98, 288–95. Augustine Washington, George Washington's father, was also among the Principio Company's partners. On Sheredine's involvement, see Whitely, "The Principio Company," 195, and Robbins, "The Principio Company," 83.

73 The artist Miller is not easily identified, and there is no well-known portrait of Shenstone by an artist of this last name. While connections between the poet and Sanderson Miller (1716–80) can be easily traced, Miller is better remembered as an architect than as a portraitist and is unlikely to have created the images of Birch's relatives. A painter with the last name of Miller and the first initial of J. is known to have been active in Birmingham in the 1760s and may be the most likely candidate.

74 Gale also subscribed to the *City of Philadelphia*. See Appendix D.

75 Samuel Hughes was one of the most important producers of cannon and other ordnance for the colonists during the Revolution, and he purchased the Principio Furnace after Thomas Russell's death, renaming it Cecil Furnace. Robbins, "The Principio Company," 288–89. In 1802, Hughes purchased Mount Pleasant, a property of over eight hundred acres (grown to nearly twice that by Hughes within a decade) to the southwest and above Havre de Grace. As Birch's description suggests, the estate's lands extended from a substantial height to the shore of the Chesapeake to the south of the town. The house on the property was originally constructed in the mid-eighteenth century; it was improved by Hughes. The eighteenth-century house was replaced by a Colonial Revival dwelling in the early twentieth century. See Christopher Weeks, *An Architectural History of Harford County, Maryland* (Baltimore: Johns Hopkins University Press, 1996), 76–77.

76 No such "lines" are included in any of Birch's manuscripts.

77 Charles Carnan Ridgely (born Charles Ridgely Carnan, 1760–1829) inherited the Hampton estate from his uncle "Captain" Charles Ridgely in 1790. Hampton, already substantial in size, would grow to over 25,000 acres during the younger Ridgely's tenure there and included not only agricultural lands but also a substantial iron forge that had been in operation since 1761. On the ironworks, see Robbins, "The Principio Company," 302–3. Ridgely served as the governor of Maryland from 1816 to 1819. As Birch's comments suggest, thoroughbred horse-breeding was among the activities of the estate. Ridgely's attendance at races at

Bristol, Pennsylvania, brought him to Birch's property, Springland. See p. pp. 222–3. Hampton, which would become the subject of one of the plates of Birch's *Country Seats*, survives as a property in the care of the National Park Service.

78 See p. 189.

79 Charles Carroll of Carrollton (1737–1832), prominent Maryland landholder and signer of the Declaration of Independence. Carroll's son, Charles Carroll "of Homewood," also subscribed. See Appendix D.

80 Birch's manuscript gives this as "Easton shore," indicating that he was traveling to the eastern shore of the Chesapeake Bay in Maryland, specifically to the area of Talbot County near the town of Easton. His subscription list to the *City of Philadelphia* indicates he traveled throughout the peninsula in Maryland.

81 At the time, Pinkney was Maryland attorney general. He did not serve as U.S. attorney general until 1811.

82 On Birch's design work for the Stier/Calvert family, see Chapter 3.

83 George Calvert was a member of the founding family of Maryland and married Stier's daughter Rosalie.

84 Thomas Law married George Washington's step-granddaughter Elizabeth (Betsey) Parke Custis (1779–1832), the oldest child of John Parke Custis and Eleanor Calvert. Law came to the United States just a year before Birch and married Custis in 1796. Although they divorced in 1811, Law remained in Washington, D.C., until his death and, as Birch suggests, made considerable developments there. Law also subscribed to the *City of Philadelphia* (see Appendix D).

85 In 1799, Lewis married Eleanor (Nelly) Parke Custis (1779–1852), Elizabeth Custis Law's younger sister. Lewis inherited a substantial portion of the Mount Vernon estate, and built Woodlawn, designed by William Thornton, in the first decade of the nineteenth century. The house survives as a property of the National Trust for Historic Preservation. Birch's discussion of the state of completion of the building indicates that he visited the property between 1802 and 1805, the period in which the wings had been finished but the central block was not yet built. The state of construction of Arlington (see p. 218), the house of Nelly Custis's younger brother, indicates that Birch's visit was closer to 1805. On Woodlawn, see Carole McCabe, "Woodlawn Plantation,"

Early American Life 19, no. 1 (1988): 50–55. Lewis subscribed to Birch's *City of Philadelphia* (see Appendix D).

86 Atkinson maintained a "painting room" (studio) for traveling artists, where Birch worked in the fall of 1805. See Mona L. Dearborn, "Guy Atkinson and the Itinerant Artists of Fairfax Street, Alexandria," *Journal of Early Southern Decorative Arts* 22, no. 1 (1996): 1–41. Albina Birch Atkinson predeceased her husband and her father.

87 As in the construction of Woodlawn and in accordance with conventional practice, the wings were built first; in the case of Arlington, this phase of the completion of the house was accomplished by about 1804, thus providing a terminus post quem for Birch's visit. Custis, like his sister Nelly, had lived with the Washingtons at Mount Vernon in his childhood and had started construction at Arlington only after a failed attempt to purchase Mount Vernon from Bushrod Washington in 1802. Technically, Custis had inherited the Arlington estate (later known for its association with the Lee family through Robert E. Lee's marriage to Custis daughter Mary) from his father, not from George Washington. The central portion of the house was not completed until the mid-nineteenth century. On the construction of Arlington, see Murray Nelligan, "The Building of Arlington House," *Journal of the Society of American Historians* 10, no. 2 (1951): 11–15.

88 Chase was a member of the Maryland House of Delegates and the Continental Congress, participated in the Constitutional Convention in Philadelphia in 1788, and was chief justice of the federal court of appeals. He was Samuel Chase's first cousin once removed (the son of Richard, Samuel's older cousin). They had a close relationship, however: Jeremiah had been raised by Thomas, Samuel's father, after the death of Jeremiah's own father in 1757. Jeremiah and his better-known relative Samuel were also allied by politics and career: both were jurists and anti-federalists. See Haw et al., *Stormy Patriot*, 6. On Birch's nieces, see Chapter 3.

89 Among other associations, Mercer was an ally of Jeremiah Chase. Mercer subscribed to the *City of Philadelphia* as well (see Appendix D).

90 See note 81.

91 After graduating from the College of New Jersey (which later became Princeton University) in 1799, Forsyth moved to Augusta. He studied law there and was elected attorney general of Georgia in 1808.

The fact that Birch does not mention this office suggests that the trip in question occurred before that date. Both Forsyth and Morris Miller, who was from Savannah, subscribed to Birch's *City of Philadelphia* (see Appendix D).

92 See Appendix C for the text of the letter.

93 Birch also reproduced this, the Medallion Portrait of Jefferson by Gilbert Stuart (finished 1805) in enamel. See Alfred L. Bush, *The Life Portraits of Thomas Jefferson* (Charlottesville, Va.: Thomas Jefferson Memorial Foundation, 1987), 60–63.

94 See Appendix C for text of the letter.

95 John Coles appears in the account books of William Russell while he was in Philadelphia in 1797 (Russell Papers).

96 Birch's account indicates that he ate with Morris (1752–1816) at his family's estate, Morrisiana, which occupied a large portion of what is now the Bronx and Westchester County, New York. Morris's extensive political career included the post of U.S. minister to France in 1792–94; he also served as a U.S. senator. Morris also subscribed to the *City of Philadelphia* (see Appendix D).

97 Stephen Jenkins records that Courtenay lived at a house called Claremont located on a bluff above the Hudson River near 123rd or 125th Street (and Claremont Avenue) in what is now Riverside Park, later occupied by Joseph Bonaparte. Jenkins asserts that Courtenay was later the Earl of Devon and that he remained in New York until the War of 1812 (Jenkins, *The Greatest Street in the World* [New York: G. P. Putnam's Sons, 1911], 298, 300). Jenkins also indicates that Courtenay "came to this country, so it was supposed, on account of political or social troubles in England." This, along with other sources, suggests that perhaps this was William Courtenay (1768–1835), viscount and later ninth Earl of Devon. Courtenay was notoriously embroiled with William Beckford in the Powderham scandal of 1784, in which hints of a homosexual relationship between Beckford and the boy forced Beckford's exile from England. At the time, sodomy was a crime punishable by execution. While Courtenay did not leave the country immediately, he did do so later and lived in Paris at the end of his life.

98 The property of Gracie, a merchant, survives today in New York City as Gracie Mansion. Birch depicted the area of a group of country seats (including Gracie's) along the East River in a view included in his *Country Seats*. The North River is now known as the Hudson.

99 This allusion to furniture painting is most likely a reference to work like that of Baltimore artists and brothers Hugh and John Finlay, who, among other decoration for "fancy" furniture, painted landscape views, particularly those of country seats, on the backs of chairs and settees, including a reproduction of Birch's view of Hampton from his *Country Seats*. Examples of their work survive in a number of museum collections in the Baltimore region, including the Baltimore Museum of Art.

100 In addition to well-known Renaissance Italian painter Raphael (1483–1520), Birch refers here to Gaspard Dughet (1615–75, called Poussin) and Nicolas Poussin (1594–1665), both French artists active in Italy known for their landscape paintings.

101 Bullock is otherwise unidentified; the place noted is probably Charlestown, Maryland.

102 Birch lost Springland to creditors in 1805 but continued to live there, presumably as a tenant, given that he advertised the *Country Seats*, issued in 1808, as being available for purchase there. As Birch notes, the purchaser, John Barker, brought suit against him. Birch nonetheless repurchased the land in 1813 and sold it again in 1818 at a significant profit. Whether he lived in his Green Lodge during this entire period is not known. See Snyder, "Country Seats," 234.

103 Given the consistencies of Birch's phonetic spelling, "Dickerson" was probably Dickinson but is otherwise unidentified.

104 Birch had two sisters. His elder sister, Ann, married Thomas Chase in 1763 (see p. 33). His other sister, Sarah, who was apprenticed to a London milliner, married George Cooper in 1781. See Chapter 1; George Cooper to Priscilla Birch Barnes, 13 August 1845, Barra Collection the Athenæum of Philadelphia.

105 See Chapter 1. The practice of teaching Latin and Greek rather than English was conventional. The Earl of Warwick at the time of Birch's childhood was Francis Greville (1719–73); his son and successor, George (1746-1816), owned the view of Warwick Castle by Abraham Pether engraved for Birch's *Délices de la Grande Bretagne*. The younger earl subscribed to the volume, as did two of his brothers (see Appendix B).

106 Joseph Onion Birch became a physician, like his father, and remained in Warwick. He subscribed to his brother's *Délices* (see Appendix B).

107 Richard Beauchamp, Earl of Warwick, funded the construc-

tion of a chapel off the south transept of St. Mary's in the mid-fifteenth century. See Pevsner and Wedgwood, *Warwickshire*, 444.

108 Lord Mansfield traveled to Warwick, then the county town, to preside as judge over the Quarter Sessions Court, which tried crimes that were more serious than those that could be dealt with by a justice of the peace and less serious than those, such as capital cases, that were heard by the Court of Assizes.

109 See Chapter 1.

110 See Chapter 1.

111 Birch quotes Priestley verbatim in his description in his *Memoirs of the Rev. Dr. Joseph Priestley to the Year 1795 . . .* (London, 1809), 83. Priestley goes on to say that "my obligations to him were various and constant, so as not to be estimated by sums of money. At his proposal I doubt not, some of the heads of the congregation [of the New Meeting in Birmingham] made me a present of two hundred pounds, to assist me in my theological publications." This assumption is supported by Russell's personal account book (fol. 127, Russell Papers).

112 This suggests that Birch believed himself to be descended from William Russell (1613–1700), the Duke of Bedford, who fought on the side of Parliament for a time in the Civil War (but subsequently fought for the king). See Chapter 1.

113 Russell's house at Showell Green was destroyed in the Birmingham Riots, along with the property of his brother George. See Chapter 1.

114 As Birch's discussion of his older brothers suggests, he was, by the time of his maturity, the oldest surviving son.

115 The original section of the Birmingham Canal was completed in 1769. The prominent Birmingham manufacturer and entrepreneur Matthew Boulton (1728–1809) established the Soho Manufactory metalworks on Handsworth Heath in Birmingham in the 1760s.

116 An undated memorandum in the Barra Collection gives this, not much more clearly, as "Smithwick and the Crossways in the Parish of Scarborough, and County of Stratford."

117 The practice of surgery was still a relatively new aspect of professional medicine in the early eighteenth century and had been the province of barbers in the Middle Ages. Birch's "School of Surgery" is most likely either the Ecole de Chirurgie or the Académie Royale de Chirurgie, founded in 1724 and 1731, respectively.

118 Birch presumably means that Worlidge was very talented in representing clothing in his portraits.

119 The reference here to Walpole is of course Sir Horace Walpole (1717–97). "Kit-Cat" refers to the general size of the painting and the (relatively large) scale of the sitter within the overall image established by Sir Godfrey Kneller's portraits of the members of the Kit-Cat club in the first decades of the eighteenth century. On the Kit-Cat portraits, see Solkin, *Painting for Money*, 32–36.

120 See Chapter 1.

121 It is not known how Birch came to befriend Thomas Bangham, a government bureaucrat who worked as "Computer of Off-Reckonings in the Office of the Paymaster General of the Forces" in the 1780s. See *The Parliamentary Register, or History of the Proceedings and Debates of the House of Commons . . . During the Second Session of the Fifteenth Parliament of Great Britain*, vol. 7 (London, 1782), 423. Bangham also subscribed to the *Délices de la Grande Bretagne* (see Appendix B).

Index

Groombridge, William, 91, 137
Guillemard, John Lewis, 72, 92, 202

H

Hamilton, William, 97, 120, 139, 153, 203
Hampstead Heath, London, 27, 54, figure 105
Hampton, Towson, Maryland, 82, 83, 94, 120,
 144, 222, 233, figure 129
Harrisburg, Pennsylvania, 66
Hartley, Mary, 48; *View in Wentworth Park,*
 Yorkshire and Birch print after, 48, 58,
 figure 29
Havre de Grace, Maryland, 224
Haward, Francis, 18, 44, 172, 173
Hazard, Ebenezer, 98
Heap, George, 100
Hearne, Thomas, 42, 48; *Appleby Castle* and
 Birch print of, 42, 48, figure 18
Hell Gate villa district, New York City, 154,
 230, figure 93
Henry IV, 63
Hoboken, New Jersey, 97, 139, 149, figure 80
Hodges, William,; *View from the Breakfast*
 Room in a Gentleman's House in Pall Mall
 (collaboration with Richard Cosway),
 and Birch print after, 48, 57, figure 27
Hogarth, William, 20, 183, figures 107–8
Hollar, Wenceslaus, 39, 100, 177
Houckgeest, Andreas Everardus van Braam,
 69, 93, 159, 200
Howard, John, 177
Howe, Lord, 20, 183
Hudson River, 79, 149, 230
Hughes, Samuel, and wife, 219–21
Humphrey, Ozias, 19
Humphreys, John, Jr., uncle, 9, 49

Hunter, William, 240
Hutchins (London auctioneer), 190
Hutton, William, 8, Appendix F
Hycana, "Mr.," 231

I

Independence Hall, Philadelphia. *See*
 Philadelphia, Pennsylvania State House
Ipswich River, Suffolk, England, 58

J

Jaudenes y Nebot, Josef de, 72, 93, 197–98,
 figure 112
Jaudenes y Nebot, Matilda (née Stoughton),
 93, 197, figure 113
Jefferson, Thomas, 68, 75, 85, 93–94, 115,
 164, 204, 219, 227, 262
Jefferys, Thomas, 11–12, 14, 49, 98, 193, 197,
 230, 239
Johns Hopkins University, 81
Johnson, Samuel, 49
Jones, Inigo, 39, 177
Jones, William, 14, 49, 194

K

Keene, Sarah Lukens, 203
Kennedy, David, 96
Kennedy, Robert, 102
Kenwood House, Hampstead Heath, London,
 23–26, 46, 64, 67, 69, 82, 84, 159, 177,
 181, 239, figure 106
Kew Gardens, near London, 57
Kettle, James, 8, 177, 241
Kettle, Tilly, 39

Kit-Cat Club, 8
Kneller, Godfrey, 8
Knight, Richard Payne, 31, 46, 129, 131, 132
Knightly, Mrs., 195

L

L'Enfant, Pierre Charles, 117, 217
Lafayette, General (Marie-Joseph-Paul-Yves-
 Roch-Gilbert du Motier, Marquis de
 Lafayette) 12, 89, 231, figures 5, 50
Lake District, England, 54
Lake Windermere, England, 54
Lancaster, Pennsylvania, 66
Lansdowne, Marquess of, 197
Lansdowne, Philadelphia, Pennsylvania, 67,
 144–46, 153–55, figure 81
Latrobe, Benjamin Henry, 68, 82–85, 96, 106,
 124–25, 153
Law, Thomas, 222
Lazzarini, François, 120
Lee, Henry, 115
Lenox, Tacy (Mrs. David, née Lukens), 203
Letters from a Farmer in Pennsylvania, 102
Lewis, Lawrence, 222–24
Library Company of Baltimore, 81, 222
Lindsay, Sir John, 20, 27, 183, 245
Llanberis Lake, Wales, 54
Llanrwst Bridge, Wales, 54
London Magazine, 94
Lorrain, Claude, 23, 34, 120, 130, 177
Louisiana Purchase, 144
Loutherbourg, Philip Jacob de, 44; *View of*
 Lake Wynandermeer, Westmoreland, and
 Birch print after, 44, 54, figure 21
Ludgate, London, 39, 177

Acknowledgments

My work on Birch and his career has put me in the debt of many who have helped over the course of the project; I am pleased to have the opportunity to thank them here. David B. Brownlee and Elizabeth Johns of the History of Art Department of the University of Pennsylvania must be thanked first. My investigations on Birch's trail were aided by the staff of a number of institutions who provided assistance: L. Carol Murray and William Voss Elder at the Baltimore Museum of Art, Lynne Dakins Hastings at Hampton National Historic Site, Edmund Day and Pat Miller at Riversdale in Bladensburg, Maryland, James Green of the Library Company of Philadelphia, and Michael Ryan, now of Columbia University, and John Pollock of the Special Collections department of the Library of the University of Pennsylvania. Jeffrey A. Cohen of Bryn Mawr College and Maria Thompson also deserve thanks. I would also like to thank Julius Bryant, Keeper of Word & Image of the Victoria and Albert Museum, London, for his kind assistance in pursuing biographical details on the Earl of Mansfield, Birch's important patron, Elizabeth Milroy of Wesleyan University for sharing the fruits of her scholarly labors on Philadelphia's landscapes, and Therese O'Malley, associate dean of the Center for Advanced Studies of the National Gallery, for sharing information on the locations of Birch's watercolors of Springland. My greatest thanks go to John Dixon Hunt, whose gracious, longstanding support and invaluable aid and advice have seen this project from the earliest stages to its conclusion.

This book would never have come into being without the generous assistance, interest, and support of Roger W. Moss, past executive director of The Athenæum of Philadelphia, who has not only maintained his support of this project over a long period but has made possible the crucial initial connection to the members of the Carson family. Lea Carson Sherk has been a stimulating and tireless collaborator, and it has been a great pleasure to work with her on this project and to share the enthusiasm for the richness of Birch's career and writing. The assistance of her sister, Wynne Curry, has also been most valuable. Many details of Birch's early life and work were made clearer to me by the scholarship and writing of Wynne's husband, Glenn Curry, who very generously shared his own manuscript on Birch's life at the beginning of this project. Without the dedication of the late Robert McNeil of the Barra Foundation and Marian S. Carson, the two versions of the artist's manuscript autobiography, and thus a significant chapter of American art and cultural history, might have been lost to world. Many thanks are due to the Barra Foundation for making their version of Birch's "Life" and the accompanying Birch manuscript collection—now a gift to The Athenæum of Philadelphia—available for this project from the beginning.

I am also very grateful to Sandra Tatman, executive director of the Athenæum, for seeing this publication through its key final phases. I would like to thank several members of the Athenæum's staff for their assistance: Bruce Laverty, cura-

tor of architecture, Michael Seneca, director of the Regional Digital Imaging Center, and Jim Carroll, imaging specialist.

EMILY T. COOPERMAN

The success of this project owes a great deal to Emily Cooperman's excellent scholarship, patience, and attention to detail. Glenn Curry's research and knowledge about Birch provided me with information that I could not possibly have acquired on my own. Roger W. Moss of The Athenæum of Philadelphia carefully guided our efforts from beginning to end, offering invaluable advice and enthusiasm. The staff of the Athenæum provided assistance and support. The Barra Foundation generously allowed me access to its copy of Birch's "Life" before its recent gift of the volume, family letters, and other interesting related manuscript material to the Athenæum.

Finally, I am grateful that my late mother, Marian S. Carson, had the perspicacity to acquire a copy of the Birch autobiography so many years ago. Parts of it, particularly "The Discovery of Springland," were read to my sister and me as bedtime stories. This early familiarity with Birch as author and artist has made the editorial project especially meaningful.

LEA CARSON SHERK